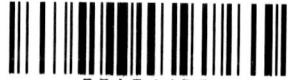

Chrisoula Lionis is a researcher and curator based in Sydney and Athens. She teaches at UNSW Art & Design (UNSW Australia) and is Curator of the Palestinian Film Festival in Australia.

'This impressively happy-sad book tracks the development of artistic practices by Palestinians in their homeland and in exile. It is an ambitious book drawn from deep engagement and is testament to a kind of familiarity with one's subject that is indeed very rare. The reading of works by Mona Hatoum, Raeda Saadeh and Emily Jacir is among the best I have seen. This book contains the bittersweet wisdom of a painful but uplifting joke – spread it around!'

Nikos Papastergiadis, Professor, School of Culture and Communication, The University of Melbourne

'This book is a must-read for anyone interested in humour and/or the history of the Middle East conflict.'

Sharif Kanaana, Professor, Department of Anthropology, Birzeit University

'Lionis offers a marvellous introduction to the way Palestinian art and cinema reflect the shifting dynamics of Palestinian politics,… Rich examples… reflect on how laughter in the face of trauma and political disappointment can actually sustain hope and solidarity.'

Lila Abu-Lughod, Joseph L. Buttenwieser Professor of Social Science, Columbia University

CHRISOULA LIONIS

LAUGHTER IN OCCUPIED PALESTINE

COMEDY AND IDENTITY IN ART AND FILM

I.B. TAURIS

LONDON • NEW YORK • OXFORD • NEW DELHI • SYDNEY

I.B. TAURIS
Bloomsbury Publishing Plc
50 Bedford Square, London, WC1B 3DP, UK
1385 Broadway, New York, NY 10018, USA
29 Earlsfort Terrace, Dublin 2, Ireland

BLOOMSBURY, I.B. TAURIS and the I.B. Tauris logo
are trademarks of Bloomsbury Publishing Plc

First published in Great Britain 2016
This paperback edition published in 2021

ISBN: HB: 978-1-7845-3288-8
PB: 978-0-7556-4625-8
ePDF: 978-0-8577-2781-7
eBook: 978-0-8577-2979-8

Typeset by Newgen

To find out more about our authors and books visit
www.bloomsbury.com and sign up for our newsletters.

In memory of my father Dennis Lionis
and for all those who find laughter through tears.

Contents

Illustrations

Acknowledgements

This book would not be possible were it not for the laughter, generosity and *sumud* I have found in Palestine. My thanks first and foremost to all the anonymous Palestinian pranksters who have incited and shared laughter that defies darkness.

I am grateful to many friends and colleagues for their support and discussions that contributed to this book. I wish to extend special thanks to David McNeill for being a constant source of light through his unwavering enthusiasm as both friend and PhD supervisor. To my colleagues and friends Uroš Čvoro, Philip George and Veronica Tello for their cheekiness, persistence and constant support. My thanks to Assad Abdi for his self-effacing encouragement and above all – his steadfast 'pessoptimism'.

This book began as a PhD project completed through the National Institute for Experimental Arts at UNSW Art & Design. I am grateful for the dynamism, opportunities and mentorship of Jill Bennett over the years and for the continual support and advice offered by Jennifer Biddle throughout the PhD. I also thank the UNSW Art & Design Faculty for supporting the *Beyond the Last Sky* exhibition and symposium that were crucial to the development of this project as well as their funding of several travel grants for research trips to Palestine.

Many of the ideas cultivated in this book came through my work as a curator working both on the *Beyond the Last Sky* exhibition at the Australian Centre for Photography and the Palestinian Film Festival in Australia. I would like to thank the ACP and its staff for their dedication to the project. I also would like to thank the Cultural Media Organisation and in particular Naser Shakhtour and Mia Zahra for their tireless efforts on the Palestinian Film Festival alongside their patience through years of debate, far too many long nights and drawn out coffee dates.

I am grateful to I.B. Tauris for believing in this project and for offering the opportunity to turn my research into a book. I would like to extend thanks to Lisa Goodrum and the visual culture editors Philippa Brewster,

Baillie Card and Anna Coatman for their insight, advice and commitment to the project. I also wish to extend a special thanks to my copyeditor Lisa Mulholland for her creativity, attention to detail and ability to always appreciate a joke.

I have been privileged to have the encouragement and support of Nikos Papastergiadis, Lila Abu-Lughod and Sharif Kanaana on this project. I thank you all for producing inspiring and influential work and for your generous and astute advice on this project.

To artist Khaled Hourani – thank you for making me laugh equally in both art and in life and for your endless low-fives. I am so grateful for your insight and support, and for taking the time to contribute to this project through the preface. My thanks also to Ala Hourani for his enthusiasm and generosity in working to translate the preface of this book.

My deepest gratitude to all the artists and filmmakers who have both contributed to *and* inspired this book. In particular, I would like to thank Taysir Batniji, Larissa Sansour, Areen Omari, Mona Hatoum, Emily Jacir, Raeda Saadeh, Sharif Waked, Khaled Jarrar, Tarzan and Arab, Sliman Mansour, Amer Shomali and Yazan Khalili. Thank you for your feedback and generosity throughout the course of this project – I am humbled by your kindness and encouragement.

This project would not be possible without the love and laughter of many friends – you know who you are! My thanks in particular to Maria Savvidis for always being the first in line for an adventure and a razor-sharp quip. My family are a crucial pillar in both my life and work. To my Cretan mama Alexandra, I can never thank you enough for your fierce and occasionally terrifying love – there is never a day that I am not in awe of you. To my siblings Peter and Penny for always being in my corner and to my little people Alexia, Jorge and Mia for bringing me endless joy.

Finally, this book is dedicated to the memory of my father Dennis Lionis. For his commitment to justice, his sacrifice in leaving the country he loved and for providing opportunities of which he could have only dreamed. And finally – for his laughter that still rings in my ears.

Foreword

When considering humour in the context of Palestine, the writers Ghassan Kanafani and Emile Habibi, two great names from the sphere of literature, immediately come to mind. It must be understood that the immediate association to Kanfani and Habibi should not suggest that humorous writing is commonly found in the recent history of Arab literature. This is perhaps not surprising given ongoing crises in the Arab world and the heavy weight of the Palestinian struggle that has resulted in a prevailing sense of collective trauma and sadness. Further still, there remains a common belief that humour contradicts both the sacredness of collective sadness and the reverence conventionally associated with literature and art.

Nevertheless, it is important to note that the documented culture of Palestine was not void of humour (or as we say in Arabic, 'light blood'), that triggered one to laugh whilst also awakening and evoking self critique as a serious strategy in the face of unfolding realities, ideas and power relationships. Unfortunately, this sense of humour was only observed in literature and did not make its way into other art forms until more recent times.

Let us return to the example of Ghassan Kanafani, the renowned Palestinian revolutionary writer and intellectual, who chose to mask his identity by working under the pseudonym Faris Faris to publish various articles in *Assayad* magazine and the *Al Noor* newspaper supplement throughout the 1960s. Through his use of a pseudonym, Kanafani created for himself a space where he was able to escape his fame and readers' expectations, thus establishing an oasis where he was free to write about matters other than the Palestinian struggle and offer a critique through humour. Kanafani's pen, or rather the pen of Faris Faris, was life affirming precisely because it offered an emphasis on the value of freedom, creativity and art whilst at the same time offering a searing critique of frivolity, essentialism, backwardness and art that lacked substance and talent. The humour of Faris Faris thus generated laughter that came from our hearts.

Importantly, it was only through the use of a pseudonym that Kanafani was able to enjoy and escape the heaviness of tragedy, his revolutionary responsibility as a leading figure in the People's Front for the Liberation of Palestine (PFLP) and his reputation as the writer of *Men in the Sun, Returning to Haifa* and *Sad Mother*. Despite working at a time when Palestinians and Arabs were living through the trauma of the defeat of 1967 (and whilst working as editor of *Al-Hadaf* magazine), Kanafani was able to carve a space that utilised humour as a way to focus on the dysfunction, apathy and inertia of art and what he saw as a lack of talent. Within this new space as Faris Faris, the author was able to shift smoothly between various issues, including poetry, cinema, jokes, history and politics. Thus in this space he was able to both critique political and social realities whilst generating humour that exposed what he saw as ingenuous and vacuous art.

In Kanafani's work we see a clear difference between humour and facetiousness. Humour is at its core a serious art form and therefore humour that appreciates itself as such is emblematic of an authentic manifestation of culture. Given this understanding, one important question remains – why did Kanafani work under the pseudonym of Faris Faris? And as an extension to this question, why operate beneath a creative mask when Kanafani himself stated (through the voice of Faris Faris) that 'humour is not for entertainment and it is not a waste of time, but is an attitude and a commitment at the highest level'?

This question lingers and remains unresolved. However, it seems that the mask Kanafani wore generated an invisibility and cultivated a third voice that allowed him to write free of 'himself'; free from his official position and responsibility as a writer in the PFLP and free from the obligations of acting as editor in his revolutionary magazine. Crucially, operating under a pseudonym meant that Kanafani also separated the PFLP and its official political commitments from engagement and association with his artistic critiques forged through the use of humour. In such a way, Faris provided a point of balance between the political Kanafani and the artistic Kanafani without jeopardising the author's official political position. More importantly, what the story of Kanfani tells us is that the space created through the name of Faris Faris, is one that artists and critics need to create and to find for themselves, particularly in periods

when societies and populations are confronted by suffering, disaster, defeat or tremendous loss.

When society – any society – experiences adversity or immense defeat there is a resulting breakdown that affects all spheres of life. Although various studies have revealed the political, economic and (to a limited extent) the social impact upon Palestinian society that resulted from the 1967 defeat, a great deal of cultural side effects have been ignored – these include changes to Palestinian cuisine, clothing, storytelling, music, and importantly, changes to a collective sense of humour.

In contrast to Kanafani, the writer Emile Habibi (author of the masterpiece *The Secret Life of Saeed: The Pessoptimist*) worked without reliance upon a pseudonym. Charging his writing with humor in texts such as *Luka Ibn Luka* (*Luka the son of Luka*) and *The Pessoptimist*, Habibi's humour created a style and fictional characters that are to a large extent rare in the history of Palestinian literature. His work depicted disorder and focused upon antiheroes that were able to accurately reflect and mediate upon Arab heritage, history and literature.

What is significant here is that Kanafani and Habibi, two of Palestine's literary giants, were practitioners that carved the way for later generations of Palestinian artists. The space they created was amplified with consequent political changes, in particular those that came as a result of the Oslo Accords. In the years that have followed the Accords, Palestinians have lived through an era when political slogans and answers have no longer sufficed and have ceased to capture the popular imagination. This has resulted in people living through confusion whilst inquiring and confronting this dramatic and disordered reality with humour. Humour has therefore become a means to unpack reality and give evidence to buried desires. Further, humour offers a transcendence of tragedy and pronounces clearly that art is a sphere of knowledge and enquiry where artists are now the players 'in the know'.

In *Laughter in Occupied Palestine*, Chrisoula Lionis provides a similar space to take us through the broader issues and strategies artists have created through contemporary artistic practice in order to both reconnect and disconnect to their cultural capital and heritage. The artistic practices she focuses on here are characterised by the fact that they operate without the need for pseudonyms or didactic metaphor. These practices are anchored

in the belief and understanding that humour can sometimes be more elo-quent than books, research or in-depth analysis, and, more importantly, that humour offers introspection, knowledge and hope for a better future.

Khaled Hourani
Ramallah, Palestine

Introduction: Why Humour?

'Even in laughter the heart may ache.'[1]

St. John Chrysostom

In early 2008 I met with a group of Palestinians from a local Sydney community interest group. The purpose of our meeting was to organise an exhibition commemorating the sixtieth anniversary of the occupation of historical Palestine, an event known as Al-Nakba, or the Catastrophe.[2] Throughout the course of our meeting, conversation meandered around various events in Palestinian history, drifting further and further away from the Nakba. At one point, discussion moved to the Lebanese Civil War and the 1982 Israeli invasion of Lebanon. Perhaps inevitably, the conversation's focus then turned to the massacres at the Sabra and Shatila Palestinian refugee camps in Beirut.[3] At this point, one of the gentlemen in the room proceeded to explain 'the massacre was so horrible that we didn't bother counting the dead, only the survivors'. To my bewilderment, everyone else in the room responded to this comment with an explosion of laughter.

I found myself falling completely silent in the face of this laughter; shocked by what I saw and heard around me. At the time, it was entirely beyond my comprehension how a group of Palestinians could ever laugh at the traumatic events of Sabra and Shatila. It was in this moment of my

silence – and their mirth – that I felt a profound sense of complete cultural outsiderness. As a Greek-Australian, I was the only non-Palestinian in the room, and it was as if my silence only served to amplify further the reality of difference between my identity and experience and that of the others in the room. I left the meeting deeply troubled by what I had just seen and heard but equally determined to understand the phenomenon I had witnessed. I was affected so profoundly by the event that I began taking mental notes of all the incidents of humour I saw reflected in Palestinian visual culture, particularly in art and film. These mental notes sparked the germination of an enquiry that has culminated in this book.

The title of this book, *Laughter in Occupied Palestine: Comedy and Identity in Art and Film,* makes clear that my work here centres around the relationship between humour and Palestinian occupation and exile, or in other words, laughter and collective trauma. My more specific aim in this text however is to illustrate how art and film both shape, and are shaped by, changes in collective identity. To this end, my work here not only engages with examples of the impetus of humour and its consequences, it provides a critical account of the historical trajectory of Palestinian art and film to reveal how both mediums reflect changes in identity over the last century. By providing an overview of significant events in Palestinian history over the last century and mapping changes in both art forms, this book contends that Palestinian visual culture has arrived at a 'punchline'. This 'punchline' is an outcome of the failure of the peace process, which ushered in a shift in Palestinian collective identity and experience, resulting in the employment of humour by artists and filmmakers.

Following from this, my analysis of art and film is interlaced throughout with a discussion of Palestinian history. My work here would not have been possible were it not for the enormous growth in publication of scholarship dealing with the history of Palestine in recent decades. This vital research is marked by a revisionism that aims both to unearth previously unpublished material, and to substantiate oral history by placing it in the historical archive. As such, it provides a historical account in order to explain the present political realities facing Palestinians. My project draws from many texts in its discussion of Palestinian history, including the seminal work of Rashid Khalidi and Ilan Pappe, two of the most notable historians working in the field.

The proliferation of texts dealing with Palestinian history has been mirrored by an increase in published material dealing with Palestinian art and film. The expansion of scholarship in this area has resulted from the growing international profile of both these art forms over the last two decades. The fact that Palestinian art and film now circulate in international screening and exhibition contexts is also of vital importance in this regard. This relatively new international profile allows art and film to function as a form of cultural export that offers international audiences a new perspective of Palestinian identity, culture and experience away from the media lens that has long dominated the representation of Palestine and Palestinians – this book is but one measure of the international impact of Palestinian cultural output. While scholarship in this area continues to grow, audiences ought to be aware that discussions around cultural output are always fraught with politics of who owns the right to narrate history. In other words, although the presence of art and film in international contexts also creates opportunities for analysis and discussion by writers and commentators from around the world, this in itself has already proved to be problematic.[4]

My work here owes much to the influential work of artist and art historian Kamal Boullata when dealing with art, and film theorists Nurith Gertz and George Khleifi when analysing film. Two recent texts written by these authors: *Palestinian Art: From 1850 to the Present* and *Palestinian Cinema: Landscape Trauma, and Memory*, are the most substantial scholarly enquiries into Palestinian art and film to date, and both uncover previously unpublished historical material.[5] Without such seminal primary research and its publication in English, projects like this one would not have been possible.

While building on the scholarship around these two Palestinian art forms, this book takes the hitherto unpronounced stance that in the last two decades Palestinian art and film have been marked by a distinct use of humour. Admittedly, in the early stages of my research I believed that laughter was, at best, too speculative a cultural phenomenon on which to focus energy, particularly given the ongoing trauma of exile and occupation facing Palestinians. This of course is a continuing struggle. As I write these words, Israel is again inflicting collective punishment on a blockaded Gaza – bombing schools, hospitals, mosques and Gaza's only power plant, actions tantamount to crimes against humanity. At times like these

3

it is difficult to forge a smile, let alone consider laughter. That said, I have found that the ideal way to overcome this struggle is to return to Palestine, or in the very least, remind myself of my first extended fieldwork visit to the West Bank where any residual concerns about the validity of research around humour quickly dissipated. The timing of this visit happened to coincide with the Gaza War of 2008–2009. Despite the tense political climate, I was confronted with laughter everywhere I travelled in Palestine. Although this laughter manifested in everyday exchanges and conversations rather than in art and film, I realised its importance was not only narrating the Palestinian experience in a charged political climate, but also in forging a line of intimate connection and communication between myself and the individuals I met.

As much of the laughter I encountered was directed towards the experience of exile and occupation, it was at this time that I realised that my own laughter in response to humorous provocation actually signalled a momentary solidarity with the individuals with whom I was laughing. In contrast to my attitude in Sydney, I felt the need to laugh for two reasons: because I began to *appreciate* the humour and because I understood that failure to laugh would indicate a sense of disapproval or disagreement. It was here, literally surrounded by the Israeli occupation, that I began to realise the discernible, albeit slippery, difference between laughing 'at' and laughing 'with' or 'alongside' Palestinian suffering under occupation. In short, I understood the social bond formed by laughter and the joint aggression it engenders against outsiders.[6]

What I came to understand, and indeed aim to illustrate in this text, is that laughter draws a line between 'insider' and 'outsider', and that this line demarcates a point of difference contingent on the appreciation of cultural references and signifiers that are employed to elicit laughter. A keen understanding of Palestinian history and culture is vital in regard to Palestinian humour, as an appreciation of laughter elicited from the works discussed throughout would otherwise be impossible. Many of the works explored in this book required that I rectify the gaps in my own knowledge of Palestinian history and culture. Laughter became my litmus test that exposed the gaps in my understanding, particularly when I did not get the joke or find something funny. Throughout this book I spend considerable time taking the reader through key Palestinian historical events,

thereby making clear the line of insider/outsiderness demarcated by laughter. However, an analysis of humour relied on more than an appreciation of history and cultural signifiers, it is also contingent on an understanding of the mechanics of humour, that is to say humour theory, or the field of humorology.

Although my analysis of manifestations of humour is inevitably shaped by my subjectivity towards the 'funniness' of the material discussed, a critical approach to laughter is maintained throughout. The elements of this critical approach are twofold. Firstly, all examples of humorous cultural output are framed by their relationship and dependence upon historical events and their surrounding social and political context. Secondly, works are analysed according to the discursive approaches of visual culture; employing memory, trauma and identity studies along with post-colonial and subaltern theory. This critical approach and my emphasis on Palestinian history marks an attempt to theoretically unpack the social biases and influences behind humour. I do this in the belief that there is no such thing as a distinctly 'Palestinian humour', but rather that there are examples of humour in cultural output that are informed by Palestinian history and experience. In this way, the book posits the idea that humour in Palestinian art and film is idiosyncratic insofar as the events that shaped Palestinian collective identity and experience are particular to Palestinians as a cultural group.

Working primarily in the field of visual culture, I began my research on humour somewhat guilelessly, assuming incorrectly that there would be a breadth of scholarly work on the subject. Clearly, I am not the only writer to have fallen victim to this assumption. As many authors have noted, laughter is a serious business, and though it takes a central role in our daily lives, it remains theoretically elusive.[7] This observation is frequently qualified by authors' attempts to humorously convey the irony of their pursuit of critical engagement with the phenomenon of laughter. Given the following reflection, it would appear that I am not immune to this trend: it is often said that a person becomes a critic because they have failed as an artist, so too with humorological research, where it is proposed that theorists are drawn to the discipline only because they are intimidated humourists.[8] Unfortunately what this might suggest in my case, is that as an author observing and writing around humour within a visual culture perspective is both lacking in creativity and seriously unfunny.

This ironic conclusion should however not dissuade researchers from taking a interdisciplinary approach, because this has the potential to locate unique insights into the meaning and consequences of humour in contemporary visual culture. This book aims to highlight this latent potential in the study of humour by analysing the meaning and consequences of humour in the specific case study of Palestinian visual culture. The decision to look at both art and film was also a deliberate one, because although several texts have been written about both art forms individually, these texts have neglected to put both art and film together to trace the common themes that run through these art forms over the last century. Throughout this book I refer to Palestinian art and film using the shorthand 'cultural output'. Although this term might initially suggest an emphasis beyond the mediums of art and film, other art forms such as theatre, literature and dance were intentionally omitted from the discussion. Although they are all important forms of culture, discussion of these art forms was not possible in a text of this length. Further, art and film are the two mediums that have proliferated most in international markets and exhibition spaces, making them arguably the most significant for scholarly analysis and discussion in contemporary discourse.

Throughout the text I analyse Palestinian art and film using a variety of critical and disciplinary approaches that come together through the field of visual culture. These disciplines include history, cultural studies, art history, critical theory, philosophy and anthropology.[9] It is important to note here that although visual culture is itself a multidisciplinary field, this text aims to highlight the benefits of broadening visual culture to include a humorological approach. The humorological theory discussed in this book is drawn largely from the humanities and the social sciences. Although much research on humour has been conducted in other fields such as behavioural psychology, neuroscience and evolutionary biology, these disciplines are both less relevant to my visual culture approach and beyond the scope of this book.

In terms of research concentrated on the relationship between humour and the fields of art and film, a large body of work exists on the genre of comedy in film; however, the same cannot be said of humour in art.[10] The scarcity of scholarship on the role of humour in art is

particularly problematic given the growing use of humour in contemporary art practice. Sheri Klein, the author of *Art and Laughter* (one of the few texts to engage with this theme), comments that this paucity of scholarship may come as a result of humour being defined too narrowly within art history.[11] Klein draws on the fact that though parody, irony, satire, absurdity and caricature, for example, have formed the basis of many art historical endeavours, until very recently few authors used a broad definition of humour in their discussion and analysis of art. The problem with these historical approaches is that they limit the scope of research by demarcating each humorous characteristic as distinct, thereby restricting the complexity of humorous phenomena that would be better understood if discussed holistically under the umbrella of the terms 'humour' or 'laughter'. For this reason, manifestations of laughter are denoted in this book by the words 'humour' or 'laughter'. Although various techniques of humour (mockery, absurdity, pastiche etc.) are referred to intermittently, I have deliberately called upon the umbrella term 'humour' to describe the elicitation of laughter.

That having been said, a primary question remains: why humour? Laughter is increasingly pronounced in Palestinian art and film and yet there is almost no scholarly research focusing exclusively on humour and its corresponding impetuses and consequences. This paucity of analysis is astounding given the proliferation of works of humorous Palestinian cultural output over the last two decades. The growing emphasis on laughter in Palestinian art and film also corresponds with the tremendous growth of the international profile of Palestinian cultural output over the same period. Importantly, the emphasis on humour in Palestinian art and film mirrors the interest and expectations of the global art world over the last twenty years. As will be shown in the chapters that follow, humour functions as a passport to international recognition because it is in keeping with wider trends in art that have increasingly turned towards the critical use of laughter. Although this may be the case, the scarcity of scholarly analysis surrounding the emergence of humour in Palestinian art and film is further amplified by a dire lack of scholarly research into humour in contemporary art and visual culture. This text thus marks an attempt to begin to fill this scholarly chasm and to urge others to follow this line of inquiry in future studies.

Humorology

The pages that follow presuppose some knowledge of the history of humour theory which, although relatively under researched, spans over 2,000 years. For this reason, it is useful here to provide a brief account of the history of humorology, looking first to the three main theories of humour (Superiority Theory, Relief Theory and Incongruity Theory) and the pioneering work on humour by writers Henri Bergson, André Breton and Mikhail Bakhtin. The purpose of outlining these theories is not to provide an evaluation of each framework, but rather to illustrate the key concepts that emerge from each theory to form the bedrock of contemporary humorological research in the humanities. My process here is thus less concerned with an investigation of the validity of each theory as a stand alone framework, but rather their pertinence to visual culture, and for the purposes of this book, their relationship to the understanding of humour in Palestinian cultural output.

Superiority Theory is by far the oldest theory pertaining to the understanding of humour.[12] Though the theory of Superiority is often argued to stem from Plato and Aristotle, in recent times it has been more readily associated with the work of philosopher Thomas Hobbes and his text *Human Nature* (1656). Writers continue to draw upon Superiority Theory, adopting Hobbes's well known idea that laughter presents us with a 'sudden glory', arising from a conception 'of some eminency in ourselves, by comparison with the infirmity of others, or with our own formerly'.[13] For the last one hundred years, writers and theorists have drawn upon this theory to treat laughter as a controlled form of aggression, some going so far as to suggest its evolutionary role, where laughter is akin to the primitive baring of the teeth as a way of asserting one's prowess.[14]

Standing in contrast to more positive psychological analyses of humour, Superiority Theory maintains emphasis on the social order function of humour. In so doing, it concentrates on humour's role in the maintenance of power and ideological self-deception while challenging the now popular acceptance of humour as fundamentally 'good'.[15] Despite this contemporary relevance, Superiority Theory cannot be endorsed as an encompassing framework for all manifestations of humour and laughter. For Superiority Theory to be entirely correct two conditions must be met: a point of comparison to

our current selves and a comparison to where we find ourselves superior.[16] The deficiencies of these central criteria in accounting for all forms of laughter are what led to further analysis of humour by theorists of multiple disciplines in subsequent years.

The Relief Theory of humour, championed by Sigmund Freud in his seminal text *Jokes and Their Relation to the Unconscious* (1905), is essentially an extension and extrapolation of Superiority Theory. The text continues to draw interest and scholarly reference as it not only lends insight into Freud's life, context and scholarly trajectory, but also because it takes an enviable systematic approach to the understanding of the psychological underpinnings of humour.[17] The most important contribution of Freud to the subject of humour comes in his discussion of what he described as the 'tendentious joke'. Though the discussion of the tendentious joke makes up only a small part of *Jokes and Their Relation to the Unconscious*, Freud argued that these jokes marked a release of repressed feelings of anger and criticism towards people or institutions. These jokes therefore offer the possibility of saying what was otherwise forbidden. This aspect of Freud's analysis has led contemporary theorists to look at humour as emancipatory for oppressed peoples, rather than as an expression of 'sudden glory' in the Hobbesian sense. However, the primary deficiencies of Freud's work are a suffering from a lack of generalisability, and that his theory does not adequately address one of the most frequent and obvious laughter situations; that which relies on incongruity.[18]

The Incongruity Theory of humour remains the most persistently subscribed to theory for the analysis of laughter. This appears to be because Incongruity Theory is the most encompassing and generalisable of the three prominent theories of laughter. The central premise of Incongruity Theory is that laughter situations are induced by incongruous situations, revelations or observations. The thesis of incongruity becomes most apparent when looking at the structure of most jokes, which rely on an incongruity being felt between what we expect or know to be true and what is said in jest or is present in a gag. This is evidenced by the following joke about Yasser Arafat. 'How did Arafat survive his 1992 plane crash in Libya? He landed on his lips.' This joke (or any joke about a chicken crossing the road for that matter), exemplifies why Incongruity Theory is often associated with the nonsensical and/or the absurd.[19]

9

Though Schopenhauer, Kant and Kierkegaard are the philosophers most readily associated with Incongruity, it can also be witnessed in the musings of Aristotle.[20] Incongruity Theory, in effect, subsumes Superiority Theory, recognising its validity while addressing its deficiency by broadening the scope of what creates and constitutes humour.[21] Following on from this, one might conclude that the chronological progression of Superiority Theory, Relief Theory and Incongruity Theory is an exercise in the broadening of the scope of humour, a process akin to fishing with an increasingly large net, to capture the origins of laughter. The benefit of the expansion of humour theory's scope is that it allows analysis to elude the threat of being bogged down in primarily examining the intentions of the individual eliciting laughter. In this sense Incongruity Theory rescues humour from suspicion, something that is intrinsic to the Hobbesian perspective of Superiority Theory. This stance is supported by Michael Billig, who observes that Incongruity Theory is less about finding the origins or motives of laughter in the individual than focusing on the incongruous features of the world.[22] The ability to apply Incongruity Theory to the incongruous or nonsensical features of the world makes it an ideal framework for the consideration of absurd realities that occur in life and in our perception of the world.

The Incongruity Theory of laughter is also in line with the work of Henri Bergson and André Breton. Both are significant figures in the history of humour theory because of their insistence that humour was always shaped by the context of its time. Appearing at the end of the Victorian era, Bergson's seminal essay *Laughter: an Essay on the Meaning of the Comic* (1905) was largely influenced by industrialisation.[23] Similarly, Breton's work on humour *Anthologie de L'Humour Noir* was inextricably linked to the trauma of the First World War. Bergson was explicit about the importance of placing humour within its social context, writing that 'laughter must answer to certain requirements of life in common. It must have social signification.'[24] Bergson's contention that humour must have 'social signification' is a notion that underpins much contemporary scholarship on humour, particularly that which concentrates on the humour of marginalised groups.[25]

The relationship drawn between marginality and humour is a discussion that finds its ancestry in the Bergsonian idea that laughter can shake

us from the callousness we hold toward the world. Bergson alleged that laughter and comedy successfully captured real life because of humour's ability to move beyond the individual. Bergson contends that tragedy is concerned with individuals and comedy with the 'classes', highlighting the social and emphatic dimension of laughter.[26] Bergson's thesis that humour requires an environment of indifference to flourish becomes particularly appealing when discussing the humour of oppressed or marginalised people, in that it suggests political, cultural and social indifference may be fractured through laughter.

Bergson's argument that 'a humourist is a moralist disguised as a scientist', so that humour is really a transposition from the moral to the scientific, adds gravity to his thesis.[27] In this sense, for Bergson, humour marked an attempt to pursue the utilitarian aim of general social improvement. The utilitarian function of laughter promotes a subversive moralism that Bergson describes as 'the robber robbed'.[28] This notion also suggests that humour allows authority, or indeed an authoritative voice, the potential to be destabilised and delegitimised.[29] Bergson's argument also suggests that the comic may facilitate an intimacy with vice, both within ourselves and in others. Within this understanding, he argues that our laughter created an awareness of the wrongdoings and degeneracy in ourselves, and in humankind more generally. Maintaining that 'laughter corrects men's manners', Bergson proposes that our laughter 'makes us at once endeavour to appear what we ought to be, [and] what some day we shall perhaps end in being'.[30] It was for this reason that Bergson argued that laughter was a 'social corrective'.

The social corrective role of humour is central to the Bergsonian idea that a humourist's analysis of laughter will lead them to far less than jovial conclusions. Comparing humour to salty waves crashing in the sea, Bergson concludes his essay by writing that any philosopher who takes the water of the sea of humour to taste, will inevitably find that the after taste of laughter is bitter.[31] The bitter after taste of humour, was to become, in the years following Bergson's essay, witnessed increasingly in manifestations of humour and in humorological writing. This was most obviously pronounced in the early twentieth century, which saw the emergence of the term 'humor noir', a term coined by Surrealist writer, artist and theorist Andre Breton in his text *Anthologie de L'Humour Noir* (*Anthology of Black Humour*).[32]

Now used interchangeably with the terms 'dark humour', 'morbid humour', and 'bleak humour', humour noir has a clear lineage to Freud, as it was directly influenced by the psychologist's discussion of gallows humour in *Jokes and Their Relation to the Unconscious*, released only eight years prior to Breton's book.[33] Outlined by Freud as being the crudest type of humour, gallows humour is considered as a manifestation of the superego observing the ego and consequently creating an elevated or liberated feeling, rather than depression. It may be argued that the scale of collective trauma witnessed in the last century can account for the phenomenon of humour noir, which, far from receding, only continues to gather momentum. If we are to accept that black humour may come as a result of collective trauma, then the genesis of the term having sprung from the Surrealist André Breton is revealed as a direct consequence of its historical context.[34]

Although the Surrealist fascination with psychoanalysis has been written about ad nauseam, writers analysing Breton's conception of humour noir have not adequately addressed the influence of traumatic experiences during World War I. The *Anthology* used texts by a group of authors with diverse social, political and cultural backgrounds. These included Jonathan Swift, Frederich Nietzsche, Lewis Carroll, Franz Kafka, Charles Baudelaire and Francis Picaba, to name but a few. Drawing from Freud's gallows humour, Breton's anthology of writers is compelling because, as Doug Haynes writes, 'behind its Freudian mask, it demonstrates a critique of aesthetic language from a specifically *social* perspective'.[35] This social perspective of humour was implicit in Breton's plea that the book be published in its historical context of economic depression and political upheaval, which laid the foundation of black humour. Breton's plea also makes it clear that he believed that humour noir was inherently tied to the collective trauma of the Great War.[36]

Translated into English as recently as 1997, the *Anthology* has regrettably not received adequate scholarly recognition. In spite of the neglect of Breton's seminal work on the subject, the popularity of the term humour noir continues. Humour noir received a surge in popularity most notably in the 1960s, when it was taken up by critical theory. Humour noir was not the only theory of humour salvaged by critical theory. The 1960s Critical Theory movement also reclaimed the work of Russian scholar Mikhail

Bakhtin whose work was not translated into French and English until the late 1960s.

Since it was rediscovered by scholars in the 1960s, the work of Mikhail Bakhtin is now difficult to overlook when considering the social value of humour. It is his work on the carnivalesque and grotesque, both appearing in his text *Rabelais and His World*, that makes up the core of his influential work in the field of humour research.[37] Bakhtin's work identifies the political and social potency of peasant laughter, thereby marking him as one of the few modern theorists to not conflate laughter with comedy, and more importantly, this marks him as the first author to take the laughter of the disempowered folk masses rather that the hegemonic elite as his theoretical focus.[38] In his discussion of the renaissance social system and the carnival, Bakhtin suggests that laughter carries the potential to overcome traditional fears, to crack official and hierarchical barriers and to upset the status quo.[39]

The discussion of the subversive quality of the carnival and the laughter induced is reminiscent of Henri Bergson's idea of laughter as being a 'social corrective'. Despite the undeniable influence of Bergson on Bakhtin's work, the Russian philosopher manages to go significantly further in his reading of the 'corrective' dimension of laughter by suggesting that it decentralises power structures. This cannot be said to be an obvious thread in Henri Bergson's work which, in contrast to Bakhtin, does not associate laughter with fear or with disempowered masses. By associating fear with laughter, Bakhtin's interpretation of humour addresses its relationship to ethical revolt and the need for collective freedom and rights.[40]

Bakhtin contends the carnival to be a temporary liberation from the prevailing truth of the established order, establishing it as an event that subverts social norms.[41] Sharing with humour noir and gallows humour the emphasis on physical injury, death and illness, Bakhtin's discussion of the grotesque in relation to the carnival identifies it as a form of laughter that emerges from damage or threat to the human body.[42] The grotesque is therefore capable of revealing the reality of horror and degradation while also creating a sense of hope for renewal and change.[43] This tenet of the grotesque is argued by Bakhtin to have been overlooked, with laughter

alleged to be bound to the grotesque because it shares with it both ambivalence and the duality of despair and optimism.[44]

The real argument springing from the criticisms in Bakhtin's discussion is essentially whether laughter really holds the key to social, political and ideological change or subversion or whether it simply maintains the status quo. Put simply, Bakhtin's discussion of laughter might be said to raise the question of whether the laughter of the oppressed functions as a release of a social valve that frees just enough tension to maintain social order or whether it allows for a real and substantive moment of power granted to the powerless.[45] This argument continues to feature in the debate in the literature around ethnic, minority, race and marginalised humour and is far from reaching a theoretical and scholarly consensus.

This humorological debate inevitably finds its way into this book because Palestinians remain an oppressed cultural group that are marginalised politically, socially and culturally.[46] Rather than seek to answer conclusively, or resolve the debate around the laughter of the oppressed, my work argues that humour produced by Palestinian cultural output is capable of both releasing pressure on the social valve *and* allowing a substantive moment of power granted to the oppressed. This is evidenced by the fact that this book does not choose a single theory of humour with which to analyse Palestinian art and film. Rather, it draws from all theories of humour through the understanding that no single theory is entirely apt for the discussion and analysis of Palestinian cultural output. Implicit in this approach is an acknowledgement of the primary deficiency of humorological theory, namely that it often attempts to pin the psychological impetus behind laughter to a single theoretical framework.

Drawing upon a multitude of humorological theories, this text inverts the conventional approach of humorology by placing emphasis first on humorous content and second on theory. Looking first at the context, meaning and production of specific objects of art and film and then applying humorological theory for analysis allows humour theory to be grounded in the 'real world', with contemporary repercussions, meaning and significance created by the 'real' texts of art and film. Although the theorisation of humour is slippery, a turn towards an emphasis on humour is both necessary and revelatory. Humour is an ideal cultural phenomenon

to investigate because despite its fluidity and renegade character, it has the potential to bring together the past, the present and the future. Humour, like identity, has very long tentacles that stretch across time, coming together in a moment of laughter. In the case of Palestinian cultural output, this moment of laughter signifies an understanding of Palestinian cultural signifiers, history and experience. Without an awareness of these signifiers, laughter is rendered impossible. Only through an understanding of Palestinian history and experience can we momentarily break through the line of laughter that demarcates 'insiders' and 'outsiders'. In other words, only with an understanding of the Palestinian past and present can one participate in what philosopher Simon Critchley describes as the 'secret code' of humour.[47]

Critical Junctions

In order to understand the 'secret code' of laughter in Palestinian art and film, one must be aware of significant events in Palestinian history. These moments are described throughout this book as 'critical junctions' of identity. They are described as such because each of these significant historical events radically transformed Palestinian collective identity and experience. Further, each of these junctions is argued to have marked a shift in the construction and narration of Palestinian national identity. Thus these critical junctions in Palestinian history can each be traced in art and film that usurped, reflected and shaped these shifts in nationalist ideology, collective identity and experience.

This book examines the history of art and film according to critical junctions that occurred from the end of the Ottoman Empire through to the present. It focuses on this period of approximately one hundred years because it argues that it is during this time that a distinct modern Palestinian national identity became pronounced. There are five historical periods this text explores, and each is shown to have been spurred by a particular event that in turn spurred a critical junction in identity. These critical junctions, and their corresponding historical periods are the Balfour Declaration (1917–1948), the Nakba (1948–1968), the Battle of Al-Karameh (1968–1982), the Israeli Invasion of Lebanon (1982–1993) and, finally, the Oslo Accords (1993–to present). Although these historical

periods and events are offered as a conceptual framing device throughout this book it is useful here to run briefly through a chapter summary.

Chapter One explores the first three junctions of Palestinian identity; The Balfour Declaration, the Nakba and the Battle of Al-Karameh. This chapter provides an overview of Palestinian art and film prior to the emergence of humour and maps what is described as a transition from 'Palestinianess' to 'Palestinianism'. Beginning with an analysis of cultural output in the British Mandate period, discussion begins by looking at how art and film from the pre-Nakba period is evidence of an emerging Palestinian national identity; thereby delegitimising claims that Palestinian nationalism only emerged after 1948. Chapter One goes on to map the consequences of dispossession and exile on the Palestinian population, contending that the Nakba coalesced a collective identity, or sense of 'Palestinianess', whilst also developing the first iconography of modern Palestinian nationalism. This sense of Palestinianess and its consequent iconography is argued to have been transformed with the Battle of Al Karemeh, an event that reconfigured the perception of Palestinians away from that of being refugees into the realm of the revolutionary thus marking a transformation from 'Palestinianess' to 'Palestinianism'.

Chapter Two investigates the critical junction of the 1982 invasion of Lebanon and the exile of the Palestine Liberation Organisation (PLO) to Tunis and considers the impact upon art and film produced in the wake of these events. Through a discussion of two case studies, looking at the work of artist Mona Hatoum and filmmaker Michel Khleifi, this chapter argues that the generation who came of age during the events of the Lebanese Civil War and the destruction of Beirut all experienced a form of 'double exile' or 'exile²'. This experience had the effect of sustaining the trauma experienced by previous generations through a process of 'postmemory', leading the generation who witnessed the destruction of Beirut to understand 'that the past is not yet passed'.[48] Chapter two discusses the destruction of Beirut as a surrogate capital and argues that, paradoxically, it was the city's destruction that opened a new door for Palestinian filmmakers and artists to explore the representation of Palestinian identity and experience because, for the first time in decades, Palestinian cultural production became geographically and politically decentralised. This chapter argues that although the emphasis on the experience of exile remained,

practitioners were more able than ever before to relay the Palestinian story (both collective and personal) in less didactic, militaristic and revolutionary forms. This is argued to have laid the groundwork for the emergence of humour in Palestinian cultural output.

Chapter Three posits the argument that the official 'peace process', beginning in Oslo in 1993, marked a critical junction in Palestinian identity that is still being lived through and has on-going effects. This chapter discusses the events that built up to Oslo, namely the first intifada, the Gulf War and the end of the Cold War and how these events roused a Palestinianism that lay dormant following the devastation of 1982. This chapter reveals Oslo as the event that signalled the death knell of the re-emerged Palestinian revolutionary identity and the event responsible for pushing revolutionary nationalism to the sidelines, thus marking a turning point in the narration of Palestinian identity and experience. The decline in nationalist hope following Oslo is argued to have been responsible for the ushering in of humour in contemporary Palestinian cultural output.

Chapter Four begins with analysis of the Palestinian Declaration of Independence and its on-going significance. Theoretically unpacking the ambiguity of the Declaration, Chapter Four explores the fluidity of the word 'Palestine' and its multiple identifications that range anywhere from the West Bank and Gaza or historical Palestine to present day Israel. Considering Palestine as a borderless state, Chapter Four examines how Palestinian artists and filmmakers such as Larissa Sansour, Taysir Batniji, Raeda Saadeh and Areen Omari use humour to delineate the borders of Palestine and to explore the connection to place and homeland.

Chapter Five centres on a discussion of how contemporary Palestinian cultural output employs humour as a way of articulating the consequences of the on-going Israeli occupation. This chapter argues that the failure of the peace process means that Palestinians live in a constant 'interim' period that is characterised by a form of 'banal evil'.[49] Discussing the failure of the peace negotiations to establish a Palestinian state, this chapter contends that many Palestinian artists including Khaled Jarrar and Khalil Rabah are engaged in an 'anticipatory practice' and that their work takes on the role of the absent state by fulfilling the functions typically assigned to state apparatuses.[50] Drawing on diverse theoretical models of humour, Chapter Five argues that the laughter incited by Palestinian art and film, artists and

filmmakers (such as Tarzan and Arab, Sharif Waked, Rashid Masharawi and Raed Andoni) has the potential to destabilise the political status quo, function as a mature defence mechanism against trauma and call attention to Israeli systematic violence.

Chapter Six draws from theories of humour by Henri Bergson and Simon Critchley to assert that laughter is always that of a group. Accordingly, this chapter suggests that there are two groups (or 'circles of laughter') formed by the humour of Palestinian art and film. The first is made up of Palestinians and the second of international audiences. Exploring these two circles of laughter, Chapter Six contends that humour has the ability to teach us something about ourselves. For Palestinians, the laughter incited by cultural output is argued to reinforce a shared understanding of the world and a 'general will' that comes together in collective identity. For non-Palestinians, the increased exposure to Palestinian humour in international exhibiting and screening contexts is argued to engender a new encounter with Palestine and Palestinians. Discussing the work of Emily Jacir, Khaled Hourani, Ihab Jadallah and Sharif Waked, Chapter Six concludes by arguing that the new encounter forged by humour is marked by a greater intimacy, solidarity and, perhaps, even empathy with the Palestinian experience.

That said, my decision to focus on humour remains for many people a peculiar choice of investigation and discussion. When considering humour with regard to Palestine, one is often presented with the assumption that humour may not be ethically the ideal aspect of Palestinian experience and cultural output to place emphasis upon. Undoubtedly, the everyday life of many Palestinians is marked by a lived experience of real emergency, and therefore is often approached with a seriousness that, for some, occasionally verges on historical and political reverence. As humour can be seen as almost irrational and even irrevent, it too can fall victim to being viewed as the least appropriate vehicle for discussion of the Palestinian experience.

This attitude is reminiscent of Theodor Adorno's well-known assertion that there can be no poetry after events of enormous collective trauma and to do it would be barbaric.[51] This book seeks to challenge the parameters of Adorno's assertion by revealing how there can be not just poetry, but also laughter, after tremendous collective trauma. In the

pages that follow I aim to prove how laughter in the face of trauma is not only an appropriate response to suffering, but also a necessary one. That is because humour is a vital tool for the comprehension of the world and the understanding of the suffering of others. For humour to function it must exist in a shared social world, where points of reference are mutually understood and played with.[52] This text attempts to illuminate the ways in which the humour of Palestinian art and film creates a shared social world that encourages the international community to understand the scale of political absurdity, violence and trauma that reigns in Palestine/Israel. Finally, this book aims to showcase what is ultimately the strongest manifestation of Palestinian *sumud* – the ability to laugh even though the heart may ache.[53]

1

Palestinianess to Palestinianism:
Balfour to Beirut

'They did not exist.'[1]

Golda Meir, Israeli Prime Minister, 1969

Palestinians are some of the most misrepresented people on earth, and, if we are to believe the depiction beamed to us through television screens, we would say that they could be simply divided into two groups: suffering refugees or political militants. Despite the deficiencies and propagandistic employment of these essentialised stereotypes, what is often misunderstood is the Palestinian agency integral to the development of these dichotomous characterisations. These two characterisations emerged as a result of several key historical events last century from the time of the Balfour Declaration (1917) and the Israeli invasion of Beirut (1982) that each radically impacted upon Palestinian collective identity and its representation. Art and film are inseparable from this circuit of identity and representation, serving to mediate changes wrought on Palestinians through history and to coalesce a collective Palestinian identity.

Considered more closely, the characterisation of Palestinian as either refugee or militant can be understood as differentiated by the characterisation of refugee as standing for 'Palestinianess' and militant as a form of 'Palestinianism'. The characterisation of Palestinian as 'refugee' came to be a defining aspect of 'Palestinianess' following the Nakba, or foundation

of Israel, in 1948. An often-overlooked event, the battle of Al Karameh in 1968 ushered in the purposeful remodelling of a collective Palestinian identity hinged on militancy and liberation, something that can be described as 'Palestinianism'. Analysing the first three critical junctions of modern Palestinian history – the Balfour Declaration, the Nakba and the Battle of Karameh – we can see how Palestinian cultural output has been continually called upon to validate Palestinian identity. This is a task that today manifests itself through the use of humour in art and film. Although art and film from this modern period is distinctly absent of humour, the laughter elicited from contemporary Palestinian cultural output cannot be appreciated without an understanding of the cultural and historical references of this period that were crucial to the development of Palestinian identity.

The long history of utilising cultural output as a validation of collective identity comes as a direct result of the historical contestation of the existence of Palestinians as a distinct cultural group. This denial has meant that Palestinian visual culture has found itself implicated in a contest of nationalist ideologies, serving on the one hand to validate Palestinian national identity, while attempting to delegitimise Zionist ideology on the other. To understand the ways in which Palestinian visual culture evolved, it is necessary to examine how it reflected shifts in its own nationalist ideology, that of Zionism and, later, of Israel. This is best achieved by turning attention to the historical context and cultural production of Palestine prior to the foundation of Israel.

The foundation of Israel is often, and very problematically, claimed to have signalled a process of modernisation of the land of historical Palestine. The belief that Zionism would herald modernisation in the Holy Land stemmed from the proposition of the founder of modern Zionism, Theodor Herzl, who claimed that the present possessors of the Palestinian territory should be set aside, arguing that a Jewish state would benefit from the area's development into a modern society.[2] This process of alleged modernisation by Zionist forces was an act of colonisation over the Palestinians that effectively disguised Zionist ideology beneath the veneer of modernist ideals.[3]

As Zionist settlers in Palestine were mostly Ashkenazi Jews, their movement also brought concepts of Westernisation to historical Palestine.

Among these, modernisation itself was of obvious paramount import and privilege. Another ideology to have entered Palestine during the time of Zionist settlement is that of nationalism.[4] This sentiment can explain the popular, albeit ideologically and propagandistically motivated assertion, that Palestinian national identity was formed largely in response to the Zionist presence.[5] This conception not only limits the roots of Palestinian identity as being a relatively recent construction, but also creates a binary opposition between Palestinian national identity and that of the Zionists. Put more clearly, this assertion implies that antagonism between the Palestinians and the Zionists is the foundation of Palestinian collective identity.

A germinating Palestinian national consciousness can be found to have existed well before the Nakba (or Catastrophe) of 1948.[6] Detailed studies of the political and cultural landscape of Palestine under Ottoman rule (and later in the British Mandate period) suggest that the growing shift toward nationalism in the Arab world came with the fall of the Ottoman Empire following World War I.[7] Although Arab nationalism appeared with the demise of the Ottoman Empire, the nationalist movement in Palestine was not to be as straightforward as that of its neighbours.[8] This is because the collapse of the Ottoman state had gravely affected Palestinians materially, politically and psychologically – something that was amplified by the occupation of the region by the French and British forces.[9]

The Balfour Declaration

Palestinians had witnessed and directly experienced important and substantial changes in government, social structures, education and ideology in the years between 1870 and 1914, yet this pace of change did not substantially alter Palestinian attitudes or self perceptions until after World War One and the enormous political ramifications of the Balfour Declaration of November 1917.[10] Commonly regarded as the seminal moment in the history of Palestine and Israel, the Balfour Declaration was a letter sent by British Secretary of the State for Foreign Affairs A.J. Balfour to Baron Rothschild, a leader of the British Jewish community, for transmission to the Zionist Federation of Great Britain and Ireland. The declaration expressed the British government's support for the 'establishment in

Palestine of a national home for the Jewish people'.[11] The influx of Jewish emigres that followed the Balfour Declaration during the British Mandate over Palestine (that began in 1923) forced Palestinians into a position where a re-evaluation of collective consciousness took shape, spawning a more pronounced Palestinian nationalism that is articulated in art produced in the region at the time.[12]

The clearest case for considering art as a lens into a burgeoning Palestinian nationalism during the Mandate period comes in the work of artist Kamal Boullata, whose writing is crucial to scholarship on Palestinian art. Boullata makes the poignant observation that it was at this time of collective Palestinian transformation in the final years of the Ottoman Empire and the beginning of the Mandate period that easel painting made its way to Palestine.[13] Boullata's claim holds several vital revelations. The first of these is the suggestion that the formation of Palestinian national identity can be witnessed in art, and that painting signifies a Palestinian embrace of their own cultural modernity.[14] Boullata's observation undermines the idea that Palestinian art only emerged after 1948; a problematic suggestion that for decades formed the central argument in much of the scholarship on Palestinian art.[15] The inherent problem with this stance is that it both suggests that Palestinian art prior to 1948 was scant and insubstantial and that forms of cultural modernity did not exist in the Arab population of historical Palestine. More significantly, however, the real danger of this claim is that it potentially reinforces the notion that only with Zionist influence did Palestinians embrace modernity.[16]

In the years of the Mandate period, a national Palestinian art began to become more pronounced. This was a direct result of changes that occurred during the late Ottoman Empire when Christian missions of varying denominations began to compete for cultural hegemony in Palestine as Ottoman influence waned. These churches competed through the establishment of missions, hospitals, publishing facilities and educational institutions. In the midst of this process, the visual culture of each religious denomination began to find a place in Palestine. Photographers, landscape artists and Orientalist painters visited the region concurrently, and with increased frequency. The work of Russian Orthodox painters in this period was particularly influential, as they trained many young Palestinian artists who eventually moved away from iconographic painting towards secular

art. The allegorical paintings of these Palestinian artists are the first clear examples of artworks that directly represent a rising sense of Palestinian national identity.[17]

This is most obvious in the work of Nicola Saig, who is claimed to be the first painter to have also used his training in iconographic painting to paint landscapes and narrative scenes based on historical events. Described as a Palestinian art 'legend', Saig's greatest contribution to Palestinian art was the establishment of a studio at the turn of the twentieth century, a place that would, in time, become a meeting and teaching space for future Palestinian artists.[18] The most notable of these young artists were Daoud Zalatimo, Zulfa al Sa'adi and Mubarak Sa'ed. Of the three, the work of Zalatimo is particularly important as it is now considered crucial to the establishment of Palestinian art of the early Mandate period. This is largely because Zalatimo, an allegorical painter with nationalist inclinations, trained several key figures in the history of Palestinian art. The most important of these was Ismail Shammout who would later become one of Palestine's most important painters and whose work would eventually become synonymous with the Palestinian struggle for liberation.

These artists were part of a growing artistic scene during the Mandate Period that found its nucleus just beyond the Jaffa Gate in Jerusalem. This location, being the doorway to the new neighbourhoods of Jerusalem where increasing numbers of the Palestinian middle class were relocating, symbolised an embrace of Jerusalem's modernity. At this 'doorway' to a new modern Jerusalem, one could find antique dealers, art and craft studios, photographic studios and even the first Arab Bank. This new artistic nucleus also comprised studios of artists working in the studio art forms, a practice that had developed since the turn of the century. Importantly, although the traditional crafts of Palestine were reinvigorated during the Mandate Period, there is also strong evidence of avant-garde modernist practices emerging in Palestine during this time.[19] This can be evidenced in the work of artists such as Jabra Ibrahim Jabra and Jamal Badran, who both studied art internationally and brought back to Jerusalem cutting edge trends in Western art (including Futurist and Fauvist aesthetics).[20]

The work produced by artists working in Jerusalem at this time is symptomatic of the rapidly changing artistic landscape of the city that emerged

largely due to immense social and political transformations evident in Palestine during the late Mandate period. This transformed cultural landscape embraced avant-garde practice while sustaining an emphasis on the importance of maintaining traditional art and craft. This was particularly the case in Jerusalem where the Palestine Archaeological Museum and the Islamic Museum had been opened to the public, and concerts, theatre productions, public lectures and art exhibitions became increasingly frequent. This shift was also reflected in the rest of the country and thus might be argued to signal the beginnings of a Palestinian cultural renaissance.[21]

Importantly, the scale of this cultural renaissance was not reflected in cinematic output from Palestine. The scale of Palestinian cinema in the years prior to 1948 pales in comparison to other artistic mediums such as visual arts, theatre, music, craft and literature. The reasons for this are many and varied, however, it is the very *invisibility* of early Palestinian film that is ironically its most important characteristic. Literature concerned with this early stage of national cinema does exist but is scant and primarily published in Arabic, with much owed to the work of writers Nurith Gertz and George Khleifi whose 2008 book *Palestinian Cinema: Trauma, Landscape and Memory* informs almost all recent scholarship on the subject of Palestinian cinema.

This period prior to the foundation of Israel remains particularly ambiguous and elusive for all scholars. Despite this, one poignant fact remains: the surviving cinematic content relating to Palestinians from this time renders the population of historical Palestine voiceless.[22] The only known surviving film of Palestinians from the years prior to the Catastrophe are either in newsreels or Christian documentary films from the period, including the work of the Lumiere brothers. With their work entirely absent from the historical archive, the only known films made by Palestinians at the time are recorded through the oral history of filmmakers and the speculation of authors on the subject. The most notable example being the work of Iraqi director Kassam Hawal in his 1978 book *The Palestinian Cinema*. Up until the publication of Hawal's text, scholars worked on the assumption that Palestinian cinema found its origins in the films created and sponsored by the PLO in the years following 1968.[23] Though based on personal oral testimony, the most important revelation to come from Hawal's work relates to his encounter with a refugee named

Ibrahim Hassan Sirhan who made several films dating back to 1935 and, alongside Hilmi al-Kilani, founded the first Palestinian production studio named the Arab Film Company.[24]

Our knowledge of the germinating cinema of this period was to become lost beneath the weight of historical events Palestinians could not have foreseen. This early Palestinian cinema and the growing arts scene and industry of the region were to be proven short-lived as the shadow of tragedy loomed over Palestine. Despite the increased violence from Jewish and Arab armed groups, Palestinians were not prepared for the impending Catastrophe. The black cloud of what would come to be known as the Nakba, would shatter every aspect of Palestinian life and experience, destroying with it the germinating cultural renaissance that had emerged within the late Mandate period.

Al Nakba

The Nakba changed the face of the Palestinian arts forever. Many of the works created before 1948 were looted, destroyed or lost, creating a perceived historical vacuum for Palestinian visual culture. In the case of Palestinian art, the Nakba signalled a clear termination of the growing art scene of the region, with many of the artists from this period being forced into exile. Much of their work, like their homes, was lost to the Zionist occupiers. Film suffered a fate worse still than that of the studio arts. Amidst the escalating violence in early 1948, filmmaker Ibrahim Hassan Sirhan was forced to flee Jaffa, leaving his films behind. It is believed that films from the period were possibly handed over to an anonymous clerk during the violence of the Nakba and they might remain somewhere – unknown and untouched, a consideration that only adds to their enigma and potency as symbols of national loss.[25] The destruction and/or loss of films and artworks from this period encapsulates the historical climate and also serves to create a potent symbolism whereby the loss of a country also signalled the destruction of the historical visualisation of itself.

The Nakba was the most important junction in Palestinian history, and is responsible for the ongoing exile of millions of Palestinians around the world. Although a national Palestinian consciousness existed prior to 1948, it was the Nakba that was responsible for crystalising the sense of

'Palestinianess'; a collective identity centred on the shared experience of exile. The creation of the state of Israel was responsible for the exile of an estimated one million Palestinians.[26] These one million refugees were expelled to the West Bank, Gaza, Lebanon, Syria and Jordan, with only 160,000 Palestinians able to stay on their own land. The majority of these refugees were farmers and their exile from their land meant they were reduced to depending on United Nations handouts for survival.[27] Even the Palestinians who managed to stay in the newly formed state of Israel were subject to a continuing legislative campaign that provided a constitutional basis for the depopulation of Palestinian villages in the early years following the Nakba.[28]

The neighboring host countries in which Palestinians found themselves following the Nakba also competed for which of them would 'represent' Palestinians. This was particularly true of Jordan that had annexed the largest part of Palestine that had not been incorporated into Israel.[29] Jordan was not the only nation to take control of land previously belonging to Mandate Palestine: the same was also done by Egypt which took control of the Gaza strip. Crucially, this 'representation' of Palestinians offered by Jordan and Egypt did not extend to Palestinian political self-representation. In Jordan, almost every Palestinian organisation was viewed as a threat to the unity of the Kingdom and in Egypt the military authorities only allowed limited Palestinian activity for fear of destabilising the country's armistice with Israel.[30] The future of Palestinian politics, identity and indeed art, would be shaped by these policies toward refugees.

Of the approximately 800,000 displaced to countries outside the newly formed Israel, over 100,000 found themselves in Lebanon. From the beginning, their legal and economic marginality made them incredibly sensitive to Lebanon's fragile and turbulent political environment.[31] Refugees in Lebanon were treated as foreigners and few were ever granted citizenship. The Lebanese government's deliberate ethnic policy also meant that at least forty categories of employment were closed to refugees and public schooling was not offered to children.[32] Approximately half of these expellees were moved to refugee camps run by the United Nations Relief Works Agency (UNRWA) following their initial stay in transit facilities.[33] Although these camps offered minimal services including health care, education, water, garbage collection and

rent-free housing, they also made it possible for authorities to control refugees.[34]

In contrast to the misery of the refugee camps, the Lebanese capital of Beirut steadily grew from 1952 to become 'the metropolis of Arab Modernity'.[35] The economic advancement, cultural change and growing cosmopolitanism of Beirut in the early 1950s can be evidenced by the establishment of literary journals, the founding of the contemporary art museum (the Nicolas Sursock Museum) and musical and cultural events that all sprung up in the city at the time.[36] The Lebanese government's relaxed attitude to censorship meant that the city became a meeting place for political and cultural dissidents from the Arab world, creating a particular breed of cosmopolitanism that embraced Arab nationalism whilst also being open to culture from the West. For this reason, Beirut became the nexus of a diverse and pluralist Arab culture. Importantly, this also meant that Beirut was the most vulnerable to political movements erupting in the Arab world since the foundation of Israel. This was of course particularly true of all political movements that pertained specifically to Palestine.

Whilst Israel had by 1951 completed the systematic 'memoricide' of Palestine by actively erasing the Arab presence on the land through the renaming of places, mountains, valleys, springs and roads in the country with Hebrew names, Palestinians in exile maintained their connection to the homeland through social and cultural bonds reinforced in their host countries.[37] Therefore, as Israel transposed a Jewish identity over the land attempting to erase the Arab Palestinian presence, the collective trauma of 1948 ironically only served to strengthen Palestinian identity. The exile of the Nakba meant that Palestinians were faced with an 'existential test' of whether they would be able to remain together as a united people.[38] It was the shared experience of the Catastrophe that served to forge a distinct Palestinian collective whilst also rendering pre-1948 social divisions irrelevant, thus creating what Rashid Khalidi describes as a 'tabula rasa' for the re-establishment of Palestinian identity.[39]

This tabula rasa required an imprint of visual expression, or a visual language, for the narration of the Palestinian identity that emerged following 1948. The centre for this visual narration was Lebanon, where a new generation of Palestinian artists began recording their experiences, capturing

a new and emerging Palestinian national identity through art. Beirut became the artistic hub of this new Palestinian art, as artists from both within and outside refugee camps began to produce works.[40] Although this sizeable group of refugee artists established new roots in Lebanon, the ethnic policy of Lebanon influenced the wide diversity of experience, training and socio-economic background of refugee Palestinian artists. Despite the diversity of experience and training of Palestinian artists living in Beirut, they can broadly be separated into two groups: the refugee artists who worked in and remained primarily in refugee camps and those who were able to obtain working visas and made up what is called the *Ras Beirut* group.[41]

As Lebanon has always maintained an uncompromising policy of oppression toward Palestinian refugees and did not allow most refugees access to working visas, camp artists could not sell their works in galleries and indeed, none of these works ever found their way to the scores of galleries that had sprung up in Beirut at the time. The artists that did make it to Beirut's galleries and by implication into international museums, festivals and galleries, were known as the *Ras Beirut* group and include artists such as Kamal Boullata, Vladimir Tamari, Juliana Seraphim, Jumana al-Husseini and Paul Guiragossian.[42] Ras Beirut is a peninsula in West Beirut that during the Lebanese *Al-Nahda* became a centre for the city's galleries, arts and intelligentsia. The Palestinian artists that showed in the galleries of the cosmopolitan area of Ras Beirut came mostly from major cities in historical Palestine and were largely members of the middle and upper classes in Palestine. It is their socio-economic backgrounds that are the reason the majority of these artists were granted working visas and could be exhibited in the West Beirut peninsula of Ras Beirut.[43]

These non-camp artists enjoyed social and economic privileges not shared by refugee artists in Lebanon. Whereas most camp artists did not receive formal artistic training and had hardly stepped inside a gallery or art museum, the artists of Ras Beirut had formal training and exposure to international cutting edge artistic trends. This meant they were well versed in the trends of modern art capitals of Europe and the United States. In spite of the artistic merits and international recognition of the work of these Ras Beirut artists, the work of refugee camp artists remain the most recognisable form of Palestinian art from the first generation of exile artists.

The artists of Beirut's refugee camps were self-taught and their work was primarily figurative, concerning itself with the representations of the Palestinian homeland and the experience of dispossession. These works operated with a language and set of symbols that consisted primarily of the popular folk metaphors of the peasant, citrus fruit and the figure of the woman as an embodiment of the ancestral land of Palestine. Through their development and the repeated use of these symbols, these artists were responsible for cultivating an original iconography of 'Palestinianess'. In other words, they developed a set of primary symbols that were vital to the national building project because they articulated a new collective Palestinian identity – one that anchored on the experience of exile and refugeedom.

This visualisation of 'Palestinianess' was crucial to the construction of a shared sense of identity. The representation of 'Palestinianess' in the work of refugee artists of this early period was characterised by the use of particular motifs that drew clear nostalgic reference to the land of historical Palestine. The focus on the iconography of the land, particularly the figure of the peasant and the orange or olive groves, exposes a reliance on the nostalgic look to an irretrievable past before *Al-Nakba*. The emphasis on the citrus and olive groves (and the embodied memory of the landscape they evoke) is a counter collective memory to those manufactured through the process of memoricide by the newly formed state of Israel. The citrus fruit, the olive, the prickly pear and the peasant were, and continue to be, symbols of the Palestinian counter-narrative and are emblems of *sumud*, 'doggedness', or steadfastness in the face of adversity. As emblems of *sumud,* the representation of these symbols suggests the steadfastness of Palestinian memory.

The sense of *sumud*, the connection to the land of Palestine as well as the shared experience of exile, was essential to the creation of Palestinian national identity following 1948. Images of Palestinian refugees pushed into the abyss of exile as a consequence of the Nakba continue to visually haunt and inform the vocabulary of Palestinian history. These images continue to puncture books, films, conference papers and screens internationally because they are seen to carry the scale of Palestinian despair and destitution following the Nakba, a predicament for many continuing until this day. Capturing Palestinians at their most de-humanised and

humiliating historical point, these images paved the way for the under-standing of Palestinian as defined by a refugee identity. Despite their undeniable historical significance, these images present a double-edged sword; the proliferation of the Palestinian refugee image has meant that depending on the context of the viewer, Palestinians have been looked upon both with compassion and occasionally as burdensome. Repeatedly referred to politically as 'the refugee problem', this identity stripped a people of their dignity, pride and rich cultural history.

Although the refugee camp art from Lebanon did poignantly capture the weight of despair brought as a consequence of dispossession it did little to blunt the double-edged sword of representation of being expel-lees. Given that these early works focused on the experience of being a refugee, they visually reinforced a dehumanising and humiliating point in Palestinian history and experience. As icons of the Palestinian experience of the Catastrophe, these works bolstered the characterisa-tion of Palestinian as refugee. Framed by the experience of exile, the characterisation as refugee served to forge a shared identity that differ-entiated Palestinians from their new countries of habitation. Film from this period did little to challenge this new post-Nakba representational status quo.

Whilst art grew and evolved quickly in exile, the same cannot be said of film as it not only required far greater resources than the studio arts, but it also lacked any sense of medium history in that all the work of Palestinian filmmakers had been destroyed with the Nakba. The absence of cinematic self-representation from before 1948 was magnified in the first two decades of Palestinian exile. This is to be expected given the political and social cataclysmic events of the Nakba that there remains an almost complete absence of Palestinian film production in these two decades. Geographically, logistically and financially it would have been near impos-sible for filmmakers to create work in such a climate. Coupled with the deficiencies and lack of Palestinian leadership at the time, this meant that films dealing with Palestine were left to filmmakers of neighboring Arab countries.

Under the rule of Israel, Jordan and Egypt at the time, the germinat-ing Palestinian cinema of pre-1948 was increasingly overshadowed by the work of other Arab filmmakers. The films created by neighbouring Arab

countries were a symptom of the pan-Arab movement of the time and as Helga Tawil-Souri notes, 'although films focused on Palestinian issues, they were more socio-political commentaries on the commitment and responsibility to a pan-Arab unity'.[44] The subtext to this analysis is that films of this period were marked by the same predicament facing Palestinians politically, that is to say that their representation was under the control of their neighbours and used for the purpose of forging pan-Arabism rather than Palestinian self-determination.

As Palestinian refugees were forced to reside in neighbouring Arab countries that shared the same language and also held similar cultural and religious practices, it was their status and characterisation as refugees that drew the parameters of separation between Palestinians and their 'host' nations. This important social distinction was responsible for the unfolding of Palestinian thought and action as separate and distinct to that of their host countries.

Yezid Sayigh explains that 'the experience of Al-Nakba made for distinct Palestinianess, but not necessarily for Palestinianism'.[45] The potency of Sayigh's distinction extends beyond semantics and suggests that though the Catastrophe may have created 'Palestinianess' in the sense that it was responsible for forging a collective identity anchored on refugeedom and exile, it cannot necessarily be credited with creating a politicisation of Palestinians centred on revolutionary ideology. This shift to Palestinianism would occur with the birth of the *jeel al-tharwa*, or the generation of the revolution.

The Battle of Al Karameh

Though it is difficult to pinpoint the beginning of the Palestinian revolution, and in turn, the birth of Palestinianism and the *jeel al-thawra*, it is generally agreed that the revolution began in the years between 1965 and 1968. In the geographically and culturally specific context of the Palestinian revolution, these three years encompassed a string of events, all significant and each contributory to the eventual battle at the village of Karameh in Jordan in 1968. Albeit a short time frame, these years served to separate and define the differences between the generation that experienced the Catastrophe as adults (*jeel al-Nakba*) and those whose formative

years were spent in exile from the homeland of Palestine, and whose collective experience was divorced from understanding the comforts that come alongside living in a homeland of one's origins.

One of the prime consequences of this chasm for the generation raised in exile was the thirst for self-representation and a desire to resist both Israeli occupation and the social and economic oppression of their host nations. This desire for resistance spurred both a national and social revolution determined to never repeat the mistakes seen as responsible for the Catastrophe. It is this shift in generational orientation that lead to what is known as the Palestinian Resistance Movement (PRM), or alternatively, the National Liberation Struggle. Influenced by the significant activist work of George Habash and the Arab Nationalist Movement, the trigger for the Palestinian revolution is argued to lay with Fatah.[46] Established by members of the Palestinian diaspora living in the Gulf states, Fatah was founded in 1954 and shaped by those who were members of the General Union of Palestinian Students, most notably Yasser Arafat. Drawing inspiration from the Arab Revolt against Zionist forces in Palestine between 1936 and 1939, Fatah adopted an ethos of national struggle that encompassed the spectrum of politics, military pursuit, social and cultural change.[47] This new national struggle was responsible for a significant shift in Palestinian consciousness and its effects were vast and wide-ranging. The consequences of this shift would become pronounced with the June War of 1967.

The origins of the June War rest in the growing popularity and fervor of the pan-Arab movement. The years between 1956 and 1967 can retrospectively be seen as the zenith of the pan-Arab movement, with confidence in Gamal Abdel Nasser and his allies rising with great speed throughout the region.[48] For many Palestinians, Nasser represented the Arab unity seen as a necessary strength to combat Israeli occupation. Emphasising this is a popular catch phrase from the period that proclaimed 'unity is the road to the liberation of Palestine'.[49] The unity of the Arab world was seen by advocates to transcend race, religion and family ties to reinforce a single Arab identity.[50] Despite the grand claims of Nasserists, the pan-Arab movement appeared for some Palestinians as suspect.

The Arab League summit conference of 1964 decreed the establishment of the PLO, which under the toothless auspices of Nasser and the Arab League held the aim of allowing Palestinian people to liberate their

homeland and to determine their destiny.[51] Sceptical about the pragmatism and tenor of pan-Arabism and Nasser in the face of Israeli occupation, Palestinians who doubted Nasser were accused of 'regionalism', by placing their interests above those of the Arab League. Under this configuration, Fatah held little trust in Arab governments and their willingness to support the kind of war for liberation that they were preparing.[52] This would prove a wise strategy for Fatah in the years following the defeat of 1967.

Thwarting the mythology of Arab unity and the dependence of many Palestinians on this mythology for the liberation of Palestine, the victors of the June War were, at first glance, undoubtedly the Israelis. As is well known, Egypt was delivered with a deeply humiliating defeat in 1967, one that resulted in the loss of territories from three states. Taking control of the West Bank and the Old City of Jerusalem, the war resulted in 600,000 Palestinians living under military control in the West Bank and 200,000 Palestinian refugees crossing into the River Jordan.[53] From an international perspective, the war lead to the passing of the United Nations Resolution 242 on 22 November 1967 – a controversial resolution that today continues to form the framework and basis of peace talks.[54] For Palestinians, the outcome of the war encouraged an acceptance that they would no longer ride the wave of aspiration carried by pan-Arabism. In light of this new political context, Fatah became engaged in its own guerilla war, one that would make all future negotiations in the conflict impossible without a Palestinian voice.

It is for this reason that the June War also signalled a significant victory for Fatah and for its leader Yasser Arafat.[55] Following the war, Fatah capitalised on the new political context and further developed its guerrilla movement, establishing bases in Jordan near the hilly village of Karameh that held a strategic position a mere six kilometres from the River Jordan. From this village (whose name translates to mean 'dignity') repeated attempts were made to infiltrate the West Bank, causing relatively little impact but serving nonetheless to infuriate Israel. Eventually, the irritation of the raids conducted by the *fedayeen* caused Israel to prepare a decisive attack on Fatah's bases and on the village of Karameh.[56]

On the spectrum of battles and operations that make up the history of the Palestine/Israel conflict, the battle of Al-Karameh (described by Israel as 'Operation Inferno') caused relatively few casualties and is often

overlooked by historians that discuss the broader conflict in the region. However, the significance of the battle rests in the fact that Fatah's *fedayeen* engaged in battle with Israeli forces in spite of knowing that to do so would mean certain suicide.[57] Completely outnumbered by men and weaponry at Karameh, the Palestinians (and the Jordanians who fought alongside them) suffered far more casualties than the Israelis when the battle broke out on 21 March 1968. Despite this, it was in fact the Israelis who were forced to withdraw, suffering more casualties than they had anticipated.[58] The Israeli withdrawal from the battle was heralded as a victory throughout the Arab world, and stories of the *fedayeen's* heroism spread like wildfire. The victory at Karameh radically shifted the Palestinian role 'from potential politization into political action' ushering in a period of Palestinian political agency anchored in militancy.[59] Karameh therefore was the moment that transformed 'Palestinianess' forged through the shared experience of the Nakba, into 'Palestinianism'.

The success of Karameh was to build a new national identity that recovered the mythology and narrative of resistance, inclusive of the Arab revolts from before the Nakba.[60] Consequently, Palestinians began to see themselves as people who have always struggled against occupation and oppression and, as a result, Palestinians of all social orders began to take part in national politics and resistance.[61] The liberation struggle was conceived as a multidimensional process that extended beyond military struggle to include a new emphasis on cultural production.[62] To this end, Palestinian leadership harnessed the arts' ability to disseminate the Palestinian story, to invite political action and to create a visual archive for the revolution. This new emphasis in cultural production would influence Palestinian art and film in ways still resonating today.

Crucially, despite the fact that the construction of a Palestinian identity that is anchored on resistance is something that can be traced back to the battle of al-Karameh, it also was undoubtedly a product of the conscious efforts of the PLO. From its very outset, the PLO appears to have appreciated the political and indeed propagandistic potential of art.[63] Testament to this was the fact that the PLO established its art department as early as 1965 with Ismail Shammout, who had by this time achieved considerable artistic recognition, chosen to lead the department. Shammout was well placed to take the position of figurehead for the arts in the PLO because he

Fig 1. General Union of the Palestinian Students (GUPS), *Anniversary of Al-Karameh Battle*, Poster, 1969
Credit: Image Courtesy of Assad Abdi

was one of the few artists of his generation to have received formal train-ing and to have gained experience in marketing during his time designing film posters in Egypt. Under his stewardship, Palestinian cultural output underwent a distinct change in aesthetic.

Following Karameh, the PLO swiftly engaged art in the promulgation of a revolutionary collective identity for Palestinians. In an immediate sense, this might be understood as an attempt to rapidly facilitate political propaganda. However, it must also be seen as a crucial attempt to reframe Palestinian collective identity into one anchored not only on the shared experience of dispossession, but also on the strive towards liberation of the homeland. Under Shammout's guidance, artists began to hold meetings congregating around the PLO as early as 1969 and several art exhibitions were held in Jordan where the PLO was based until the events of Black September in 1970.[64] Once the PLO was forced to relocate from Jordan to

Lebanon, it rapidly expanded its emphasis on the production and dissemination of the Palestinian arts. In Lebanon, the PLO continued the work of its art department but also established an arts and heritage department, led by Shammout's wife Tammam al-Akhal with the support of the Union of Palestinian Artists (UPA), which was led by Shammout.

As the head of the PLO's art department, Ismail Shammout both designed and supervised the production of PLO publications, pamphlets and posters. Working from the PLO's Beirut offices, Shammout's paintings, which were reproduced as colour posters, not only became items that adorned the walls of PLO offices but also became fixed on the walls of most Palestinian homes.[65] For this reason, many Palestinians continue to have a familiarity with Shammout's work, even if they do not recognise his name or are not familiar with the rest of his oeuvre.[66] The undeniable influence carried by Shammout's work extended not only to painting and design but also to film, as he also produced several films based on his paintings during this time. These included *Youth Camp* (1972), *Stubborn Call* (1973), *The Road to Palestine* (1974) and, most notably, *Memories and Fire* (1973).

Under Shammout's stewardship, the UPA also facilitated major debates around the role of art and aesthetics in the liberation movement. UPA's emphasis on the role of art in liberation went so far as to have seen the union organise a symposium in Lebanon in 1979 to discuss these concerns, drawing Palestinian artists from around the world. These debates around the role of art in Palestinian liberation created the impetus behind the Dar al-Karameh, a gallery established in Beirut by the UPA in 1980. The Dar al-Karameh was a meeting place for artists and hosted several exhibitions of young artists whose works had emerged from refugee camps.[67] The name chosen for the gallery, Dar al-Karameh, is of particular importance because it directly references the battle of al-Karameh that had taken place only ten years prior to the gallery's foundation. As the Karameh battle might be interpreted as the beginning of the Palestinian revolutionary identity, it is fitting that its name was adopted for the gallery that would represent the Palestinianism that emerged in the work of refugee camp artists belonging to the *jeel al-thawra*.[68]

The efforts of the UPA during the 1970s and 1980s were echoed by artists working in the Occupied West Bank where the League of Artists was

set up in 1973.[69] The League organised a number of art exhibitions during the 1970s and 1980s, despite being denied a licence to operate by the Israeli military governor until 1980.[70] Impressively, the League operated in spite of tremendous Israeli military pressure that criminalised the representation of the Palestinian flag and even the use of its four colours, as well as enforcing the random closure of galleries and the confiscation and destruction of art.[71] Instrumental to the organisation of a number of the League's activities was artist Sliman Mansour, who became active in the League after 1975.[72]

Mansour's work drew upon the iconography of 'Palestinianess', focusing on motifs of refugeedom and symbols associated with the landscape, most notably the depiction of woman as a symbol of Palestine. Although several of his works have become central to the history of Palestinian art, it is his widely reproduced painting *Camel of Hardships* from 1973 (Fig. 2 Sliman Mansour, *Camel of Hardships*) that remains as one of the most recognisable works of Palestinian art. Depicting an old man dressed in traditional garb, carrying on his back a sack in the shape of an eye filled with the city of Jerusalem, the painting suggests not only the heavy burden of exile but also the importance of memory. Although Mansour's images do build on the significance of remembering the lost homeland, they, as well as the works of other artist's from the League, carry an important distinction: they were created on Palestinian land. In a sense, this draws these artists apart from the Palestinian artists working in Beirut and elsewhere, who faced a different set of obstacles and endured a different experience of exile.

In effect, the work produced by refugee artists living in Beirut is characterised by an oscillation between 'Palestinianess' and 'Palestinianism', vacillating between a militant aesthetic and an emphasis on the nostalgic recording of life in Palestine prior to 1948. However, an important exception is the work of artist Naji al-Ali, who would become one of the most recognisable Palestinian artists around the world. While the work of other refugee camp artists in Lebanon was characterised by didactic symbolism and political metaphor, often relying on a Social Realist aesthetic, al-Ali preferred to work with unconventional materials and actively avoided overt nationalistic and nostalgic iconography. Despite this, there has been little emphasis on al-Ali's early work as it is now overshadowed by the

political cartoons that brought him fame all over the world and most notably his most famous character Handala who remains a popular symbol of the Palestinian struggle.[73] Although al-Ali's early work did not share the didactic political and ideological representation evident in the work of his refugee camp peers, his work in Lebanon illustrated a keen sense of what might be understood as a 'revolutionary aesthetic'.

This revolutionary aesthetic was anchored on a new nationalist iconography made up of symbols including the keffiyeh, the gun, the *fedayeen* and the map of historical Palestine. This aesthetic was visible not only in the artworks but also in his writings and commentary from the time.[74] This aesthetic characterised the work of refugee artists who faced limitations much more severe than those faced by Ras Beirut artists. The refugee camp artists who received recognition did so because their work was invested with political significance within the Palestinian cause. In part, this was a direct consequence of the PLO's involvement in educating artists from the camps and exhibiting their work. As a result, the recognised refugee camp artists of this period of Palestinian art history were, in a financial and pragmatic sense, bound to the nationalist cause as a result of their employment limitations.

Patronised and exhibited by local and international collectors, many Ras Beirut artists did not openly identify with the artists of revolutionary themes emerging from Beirut's refugee camps; however, their work, as Boullata makes clear, did not cease to reveal the varying facets of Palestinian experience and identity.[75] Despite formal, social and economic differences between the two, the art of both the refugee camp and Ras Beirut artists can today be seen as a phenomenon of art history: indicative of a new cultural and artistic movement that manifested itself in the Arab cultural capital of Beirut. Sadly, the cultural renaissance of Beirut did not last. For the Palestinian artists working in Beirut, the 1975 Lebanese civil war was to destroy the economic and political structures that allowed for their creation and success. The political exile of the PLO to Tunis and the attacks on Palestinian refugees by Lebanese Phalangist forces made living and working near impossible for Palestinian artists, with the events of 1982 sounding the death knell of the *al-Nahda* of Palestinian cultural output in Beirut.[76]

Fig 2. Sliman Mansour, *Camel of Hardships*, Oil on Canvas, 1973
Credit: Image Courtesy of the Artist

The Invasion of Beirut

The Israeli invasion of Beirut in 1982 was absolutely catastrophic to the city and ultimately signalled the demise of Beirut as the centre of modern Arab culture, a position it had enjoyed for three decades. The scale of violence (with 100,000–150,000 fatalities during the civil war) meant that the Arab intelligentsia that had settled in Beirut almost all fled. For Palestinians, the civil war and the events of 1982 meant that they could no longer continue fostering their new, albeit haphazard and socially stratified, collective identity and culture in one central location. For almost all Palestinian artists, 1982 forced their dispersal from their surrogate homeland.[77]

The tragic events of the Lebanese civil war and the Israeli invasion of 1982 undeniably held direct consequences not only for Palestinian art but also for practitioners themselves. The same can be said for Palestinian films and for filmmakers from this era, whose work was also characterised by

a militant or revolutionary aesthetic until 1982. Art and film during this revolutionary era had a symbiotic relationship that articulated a growing sense of 'Palestinianism'. Like art, film was seen as a vehicle within the Palestinian revolution, both in terms of its propagandistic potential and for its ability to harness a collective identity and to build a nationalist movement. In the case of film, an investigation of what theorists have come to describe as the Palestinian 'militant cinema' in the years between 1968 and 1982 reveals the crucial role cinema played in the facilitation of a new collective identity. Further, film like art, radically changed following Karameh when Palestinian leadership came to acknowledge the need to create a filmic record of the liberation movement.

The Palestinian leadership was drawn to photography and film as a result of three Palestinians of formidable self-initiative, who laid the foundations of funding, interest and importance of film prior to the battle of Karameh. The most important of these three was Sulafa Jadallah Mirsal, a Palestinian who had studied photography in Cairo and, in 1967, founded a small photography unit working from her kitchen. Operating later from an Amman apartment, Sulafa was joined by two other Palestinians, Mustafa Abu Ali and Hani Johariya, who both studied cinema and lived in Jordan.[78] Working together, the three established what came to be known as the Department of Photography to document demonstrations and political and cultural events pertinent to the Palestinian struggle.[79]

Despite the cinematic training of Abu Ali and Johariya, the work of the three was, for some time, confined largely to still photography, relying on Mirsal's own equipment. Indeed, it was only after the battle of al-Karameh that their work became esteemed and received further funding and supplies. The event that shifted both the perceived value of their work and Fatah's perspective of photography and film was an exhibition at the al-Wahdat refugee camp, showing photographs of the battle of al-Karameh. The exhibition impressed Fatah members to such an extent that they agreed to supply the group with modern equipment (albeit only for still photography), allowing them to officially establish Fatah's Department of Photography.

Despite Fatah's initial reluctance to embrace film, it is of particular importance that they chose to put money and resources into the Department of Photography only after the battle of al-Karameh. As the first decisive and

substantial military engagement of Fatah following the June War, Karameh ultimately placed Fatah in an undeniably strong position within the PLO. Yet despite their victory, Fatah and other political factions within the PLO were all struggling to define their ideological positions, often renegotiating or adopting new political ideologies. The factional divide also affected each faction's view of the role of film, resulting in a plethora of film production units, each funded, shaped and effectively controlled by various factions. The division of factions, and consequently film production units, came after the events of Black September.[80]

In the years following Karameh and Black September all political factions began to understand the significance of film. Importantly, all Palestinians and their representative political figures had experienced the Nakba personally. As Haim Bresheeth explains, 'a whole generation of Palestinians had to grow up with hardly any cinematic representations of the great catastrophe of 1948 as well as the acts of resistance that were part of their history'.[81] It would seem that all factions became determined to make their experience cinematically and photographically visible, thereby denying the possibility of their experience being yet again sublimated within the visual archive.[82]

It is near impossible to imagine the chasm that would have been experienced by a generation with no cinematic legacy, having only images of newsreels and tourist film as forms of cinematic representation. Without a cinematic trajectory from which to draw, Palestinian filmmakers were forced, quite literally, to cinematically imagine and create themselves for the first time. Though it may be sufficient to suggest, as George Khleifi and Nurith Gertz do, that film production was shaped by the Marxist–Leninist ideology of the PLO at the time, it is also important to understand the complete lack of cinematic material filmmakers had to draw from. Without a Palestinian historical cinematic point of connection, the production of films from this militant period was shaped instead by global resistance movements of the time.

Palestinian militant cinema was itself located chronologically and geographically in the post-colonial moment. In so keeping, the cinema of this period was very much in dialogue with international liberation movements spreading throughout the world.[83] Although Palestinian militant cinema carries the markers of the now problematic term 'Third World Cinema', it also holds the same characteristics of the 'Third Cinema' model

developed in the South American Liberation movement.[84] The experimental technique and theoretical approach behind Third Cinema made it revolutionary both in content and in production, repositioning the attitudes that global resistance groups held towards cinema. The resonance of Third Cinema in militant film is most clearly seen in the statement submitted by the Palestinian delegation to the Round Table of the Afro-Asian Film Conference of 1973:

> The people's war is what granted the revolutionary Palestinian cinema its characteristics and its mode of operation [...] A film's success is measured by the same criteria used to measure the success of a military operation [...] the revolutionary film is dedicated to the tactical objectives of the revolution and to its strategic objectives as well. A militant film, therefore, must become an essential commodity for the masses, just like a loaf of bread.[85]

The Palestinian submission to the Afro-Asian Film Conference makes clear that cinema was viewed as a tool integral to liberation and, as such, Palestinian militant cinema followed the objectives of Third Cinema, where films could be made by anyone, anywhere, 'as long as they are opposition and liberationist'.[86] The revolutionary approach heralded and harnessed in Palestinian militant cinema attracted the interest of French New Wave cinema, in particular the exalted filmmaker Jean Luc Godard. Though Palestinian militant cinema was only germinating at this stage, Godard visited Jordan in 1968, touring bases and filming material with the group from the Department of Photography.[87] The result of his time in Jordan was the film *Ici et Ailleurs* (released in 1976). Although the work has achieved iconic status for its fragmented documentary style and its mediation upon the meaning of filmmaking, what is of particular interest here is the fact that Godard visited camps and worked with *fedayeen* on the production of the film.[88] In such a way, *Ici et Allieurs* is testament to the fact that international directors from Europe and elsewhere held interest in the militant cinema of this period and they 'influenced the Palestinian discourse and encouraged a dialogue concerning the essence of Palestinian cinema'.[89]

Following this, one would assume that the audience for Palestinian cinema became widespread and even international. However, this

was not the case because, although European audiences were becoming acquainted with Godard's reflections of the Palestinian Liberation movement, the films of the PLO and its factions were largely confined and limited in their scope. This was a consequence of the politically and financially unfavourable conditions of the time. In part a result of the lack of funding, the films relied too heavily on individual initiatives, limiting their viewership.[90] Although the films of the *fedayeen* rarely made it into the territories or outside the nations in which the films were made, militant cinema did often reach refugee camps and several film festivals, warranting its continuation into the early 1980s.[91] This meant that militant cinema continued to draw factional funding, leading to the establishment of Palestinian film archives.

The various Palestinian political factions had their own film departments and, consequently, established their own separate film archives. However, the most substantial film archive was the PLO's Film Foundation/Palestine Film Unit, which grew to become a vital resource for all Palestinian filmmakers until 1982. Established in 1975, the archive was housed in the hall of the Film Institute and contained raw footage from before 1948 (purchased from foreign news agencies), as well as copies of all films produced by the Film Institute.[92] More importantly, the archive offered unremitting documentation of battles, bombings, political and cultural events and interviews with politicians, military leaders and notables from intellectual circles of the time.[93] As a result, the footage housed in the archive allowed filmmakers to construct films centring on the liberation movement. For the first time, the archive allowed an organised and systematic repository for Palestinian cinema. Although the practical benefits of the archive's establishment are not to be underestimated, its symbolic weight was also crucial. For the Palestinian people, the archive represented the political and cultural promise of visual self-representation, something that had come to be seen as paramount within the liberation struggle.

During this period of Palestinian revolutionary identity, the acts and processes involved in the recording of the Palestinian story were crucial within the construction of collective identity. Emerging from the crippling weight of both Jewish and Arab history, Palestinian cultural output was revolutionary, not only in terms of its struggle towards liberation but also

for its sweeping attempt to record the specificities of Palestinian history and culture. In such a way, it is clear that the revolutionary identity saw the recording of Palestine as a cultural characteristic where visual representation and narration was an act of 'Palestinianism'. The documentary compulsion was a marker of a kind of Palestinianism, which saw the nation's narration as integral to its political framework. At this time, the reconfiguration of identity around narratives of revolutionary struggle was politically and socially contingent on the PLO having established its base in Beirut, making Beirut a surrogate homeland for Palestinians. This was of course to be short-lived, and the political consequences were to weigh heavily on all Palestinians.

The escalating violence of the Lebanese civil war came to a climax for Palestinians in 1982 when Israel invaded Lebanon and the PLO was forced to leave the country. All cultural organisations established by Palestinians, particularly in Beirut, suffered tremendously, most of them destroyed or dismantled. The film archive suffered the same fate. With escalating violence between 1980 and 1981, attacks on PLO offices in West Beirut became frequent, and consequently, the film archive was moved to the distant Sadat neighbourhood, in the hope that it could be saved from the destruction. Costing an estimated half a million dollars, reproducing multiple copies of the archive's rare films was out of the question given the stretched financial resources of the PLO at the time, but the fact that Yasser Arafat, Abu Jihad and Abu Iyad all sought to keep the archive safe illustrates its political and cultural gravitas.[94]

The loss of the film archive signified a double erasure of Palestinian cinematic presence. Like the films of 1948, militant cinematic period output now exist primarily in the domain of memory. Paradoxically, the Palestinian revolutionary period was more popularly captured in the films of European filmmaker Godard, whose film *Ici et Alliuers* has since become a cult classic. Comparable to their silence within pre-1948 films, Palestinians were again rendered as mere subjects of a European cinematic lens. The valiant attempts to record the Palestinian story and liberation movement in film were rescinded with the Lebanon civil war. Only three decades after exile from the homeland following the Nakba, Palestinians were again forced to leave – this time their surrogate 'home' of Lebanon – creating a double exile. The Lebanon civil war and the destruction of the

archive enforced a new understanding of national narration for Palestinian filmmakers. Though the enigma of the archive continues to rouse interest, its destruction prompted a new wave of Palestinian filmmakers to re-imagine the narration of Palestine and, in turn, the conception of Palestinian national cinema.[95]

The impulse towards national narration in militant cinema, though experimental in its production, still carried the documentary as its primary form. The documentary was arguably the ideal genre for Palestinians until 1982 because its corresponding linear and didactic characteristics paralleled the need to construct a coherent national narrative, one without space for testing the incongruities and deficiencies of national identity. For a people long denied their historical place and story, the documentary was seen as a necessary tool for constructing a nationalist discourse. Homi K. Bhabha reflects on this in *Nation and Narration* when he explains that 'nationalist discourses persistently produce the idea of the nation as a continuous narrative of national progress'.[96] Following Bhabha's analysis, the militant and revolutionary attributes of Palestinian cinema at this time were a reflection on the profound move to create a cohesive Palestinian nationalist discourse anchored on the idea of resistance.

With very few feature films made before the Lebanon civil war, Palestinian filmmakers almost entirely neglected the outcomes and impetus towards other cinematic genres. Looking at the documentary as revolutionary in and of itself, it was not until the mid-1980s that Palestinian film took a critical stance toward nationalist discourse. It was the destruction of Beirut as a Palestinian proxy capital and the loss of the PLO's film archive that called into question the Palestinian nationalist narrative of national progress. Thus, ironically it was the devastation brought from the events of the civil war that opened the space for a new investigation of Palestinianess and Palestinianism – one that for the first time moved beyond the parameters of didactic and documentary cinematic representation.

The destruction of Beirut opened a new space for the representation of Palestinian identity and experience in art and film. Forcing Palestinians into a 'double exile', the decade between the invasion of Lebanon and the

signing of the first Oslo Accord in 1993 ushered in a new decade of Palestinian art and film that reassessed the pertinence of the iconography of 'Palestinianess' and 'Palestinianism' developed as a response to the first three junctions of Palestinian identity. This period would pave the way for the emergence of humour in cultural output.

2

Double Exile: 1982–1993

'What I, as the daughter of someone who lived through the Nakba learned [...] was that for Palestinians, both memory and Postmemory have a special valence because the past is not yet passed.'[1]

Lila Abu-Lughod

The generation that came of age during the events of the Lebanese civil war and the destruction of the surrogate Palestinian capital of Beirut experienced first-hand what might be described as a form of double exile. This experience sustained the trauma of exile of the *jeel al-Nakba* and led a new generation to understand 'that the past is not yet passed'.[2] Paradoxically however, it was the destruction of Beirut as a surrogate capital that opened a new window for Palestinian artists and filmmakers to explore the representation of Palestinian identity and experience. For the first time in decades, Palestinian cultural production became geographically and politically decentralised. Although the emphasis on the experience of exile remained, practitioners were more able than ever before to relay the Palestinian story in less didactic, militaristic and revolutionary forms. In such a way their work began the process of breaking out of the iconographic boundaries of 'Palestinianess' and 'Palestinianism'. Without the move beyond these boundaries, the emergence of humour in contemporary Palestinian art and film would not have been possible.

The decade between the Israeli invasion of Lebanon in 1982 and the signing of the first Oslo Accord in 1993 was crucial to the eventual emergence of humour for several reasons: the first being that in this period the international profile of Palestinian art and film grew considerably. This was the result of increased access to international training and exhibition of works, something that also had the consequence of gearing Palestinian art and film toward a global audience. Secondly, although the works produced in this decade were marked by a continued use of the symbols of national identity and collective experience, they also exhibit a clear refusal of essentialist nationalist narration – something that stands in stark contrast to the 'Palestinianism' that defined art and film of the *jeel al-thawra*. This shift toward a new self-critical approach to Palestinian art and film is best evidenced through the case studies of artist Mona Hatoum and filmmaker Michel Khleifi, who remain the two most well-known Palestinian figures to produce art and film in the period between 1982 and the mid-1990s.

This new self-critical approach to art and film is characterised by a collapse between the personal and collective experience of exile. This circuit between personal and collective experience is perhaps unsurprisingly hinged on an emphasis upon memory. This impetus toward memory was poignantly explored in the work of Edward Said and most clearly in his assertion that images associated with memory and aspiration are, for Palestinians, often the only symbolic substitute for their citizenship or relationship to place.[3] Images are, thus, invested in as tools of historical, political and cultural confirmation. Memory and the oral tradition are often the most relied on conduits of Palestinian history, as their archival history has been placed in a subordinate position to that of Jewish experience in the Holy Land and documentation often appears scant in comparison to the expanse of documented Jewish history. Therefore, memory and the oral tradition remain a potent force in the facilitation of Palestinian art practice.

Although the emphasis on memory can be clearly seen in the art produced in the three decades after the Nakba that often depicted a nostalgic view of life prior to 1948, the pertinence of memory was amplified in the years following 1982. The destruction of Beirut as a surrogate Palestinian political, social and cultural capital compounded the experience of exile so that the Nakba was understood as an ongoing event that continues to shape Palestinian experience. An understanding of the ongoing 'Nakbaization' of

Palestinians and the new pertinence of memory following 1982 is clearly witnessed in the works of Mona Hatoum. Although the artist's work is notable for evading didactic political narration, clear historical references particular to the Palestinian experience are found throughout Hatoum's oeuvre and can be seen as central to her emphasis on the broader issues of trauma, gender, orality and corporeality. Beneath the deliberate political opacity of her work, many of the Hatoum's works might be said to clearly reference the Nakba and collapse the collective traumatic experience of exile of 1948 with her own experience of 'double exile' brought about by the Lebanese Civil War.

The complex engagement with memory witnessed in Hatoum's works must be considered as more than a mere representation of collective memory. As a theoretical and analytical framework, collective memory, with its associations to nationalism and its frequent affiliation and manipulation as a tool of propaganda, is not a sufficient term or structure to describe the nuances and potency of memory in the work of Hatoum or in Palestinian discourse more broadly. It is precisely the essentialising character of collective memory that renders it unable to suitably describe the Palestinian association to memory. Collective memory in Palestinian art requires a more refined framework, one that includes not only the collective and often essentialising experience but also personal memory. It is the notion of Postmemory that accommodates the personal association to collective recollection and is, thus, a more refined concept, one that is more suitable to the diversity of Palestinian experience and understanding of memory.

The concept of Postmemory is founded on Kaja Silverman's notion of heteropathic recollection. Silverman's theory is based on the concept that one is able to carry surrogate memories of another through a process of heteropathic identification, creating a method and relationship where an individual takes on the memories of another.[4] Marianne Hirsch has elaborated on the concept of heteropathic recollection with the ensuing model of Postmemory. Hirsch describes this model of memory as being a departure from preconceived ideas of memory and history as a result of its basis in generational distance and deep personal connection. She elaborates by explaining that 'Postmemory characterises the experience of those who grow up dominated by narratives that preceded their birth, whose belated

stories are evocated by the stories of the previous generation shaped by traumatic events that can be neither understood nor recreated'.[5]

In *Return to Half Ruins*, Lila Abu-Lughod, celebrated anthropologist and daughter of the prolific Palestinian intellectual Ibrahim Abu-Lughod, writes that Postmemory takes on a different character for Palestinians: for them, 'the past is not yet passed'.[6] Abu-Lughod's statement suggests that Hirsch's Postmemory model is one that relies heavily on the idea of a disparity between the traumatic experience of Holocaust survivors and that of their children. Strictly speaking, Hirsch's model cannot entirely adhere to the contemporary Palestinian experience, as post-Nakba Palestinian offspring are subject to the ongoing trauma that has arisen as a result of the Catastrophe. Consequently, Postmemory in the Palestinian experience is not only grounded in the surrogate memories of the Catastrophe but also carried over into the contemporary experience of exile and dispossession. Memory, in effect, transcends generational and historical divides and makes its way into the present as a living history.[7] In spite of this, however, the children of the Nakba survivors are argued to experience an everyday reality that is overshadowed by the memory of a significant past lived by their parents, comparable to the children of Holocaust survivors.[8]

The presence of Postmemory in the work of Mona Hatoum, particularly in artworks that hold possible reference to the repercussions and memories of the Nakba, exemplies traumatic memory – a form of memory that breaks the sense of an ongoing narrative and therefore blurs the connections between the past, the present and the future.[9] It is commonly understood that the clear linear narration of one's traumatic memories is a significant step in the process of recovery and that this process of transformation from traumatic to linear memory is reliant on an audience as they are crucial to the facilitation of recovery by acknowledging the trauma inflicted on others. This supports the popular assertion that violence and suffering will not cease for Palestinians until there has been an acknowledgment of their suffering.[10]

Understanding this, one can come to see that the mode of memory recounting the Nakba and the process of exile evident in Mona Hatoum's work is defined by traumatic postmemory.[11] Hatoum's emphasis on memory is more broadly mirrored by Palestinian discourse. The memory and Postmemory of the Nakba is paramount within the discourse because of

both its traumatic consequences and the lack of archival history on the event. The deliberate destruction of the Palestinian presence in historical Palestine and the Zionist ethos that disavowed their existence entirely, only serves to further the reliance on memory and Postmemory as validation of the Palestinian presence and experience.

It is essential to understand that oral history shares the importance of narrative and archival history and both are equally plagued with historical inaccuracy. Beyond existing in a dialectical relationship, constantly competing for historical legitimacy, oral and archival histories are also heavily reliant on one another. Susan Slyomovics states that history 'need not be opposed to witness memories; rather, memory is a source for, indeed it propels, history by instigating the inquiry'.[12] The characterisation of memory as a tool that instigates the inquiry into Palestinian history is witnessed in Hatoum's work, despite the artist's insistence that her art is not wholly characterised by her Palestinian identity.[13] In contrast to the generation of artists who employed a militant aesthetic, Hatoum's work often draws on personal memories (both her own and those of her family) to engage with Palestinian history and, for the most part, refrains from overt emphasis on the Palestinian political struggle.[14]

In spite of Hatoum's refusal to characterise her work as predetermined or defined by her Palestinian background, many of the occurring themes and symbols in her work could be seen to come as a result of her cultural heritage. The departure from explicit associations to her Palestinian background is cited by Hatoum as being instigated by the completion of her 1988 work *Measures of Distance*. The work signalled a moment of catharsis for Hatoum, and she claims that she felt a burden being lifted after its completion, for she could 'get on with other kinds of work, where every work did not necessarily have to tell the whole story, where I could just deal with one little aspect of my experience'.[15]

Measures of Distance is a touching portrayal of Mona Hatoum and her mother's experience of exile. The fifteen-minute video work involves static Arabic text superimposed over the naked figure of the artist's mother. The text consists of letters reflecting the pain of exile from Hatoum's mother and is read aloud by the artist, creating a fluid connection between the story and narration of both mother and daughter. The video is filled with aesthetic and visual distances between mother, daughter and audience. The

viewer never achieves a clear view of Hatoum's mother, who is captured on grainy fragmented video. Distance is created between Hatoum and her mother by the fragmented Arabic text of her mother's letters, and Hatoum, whose body is held from view through the entire video, also does not achieve a clear view of her mother, as it is obscured from view by her letters. The mother's letters serve to simultaneously distance and bind mother and daughter. Visually, the Arabic text creates a semantic bond between mother and daughter, while remaining a visual measure of distance.

The work includes two overlapping soundtracks: the first a conversation between mother and daughter and the second an English translation and narration of her mother's letters by the artist. The visual distance between mother and daughter, as well as the disorientating overlapping soundtrack, serves to reinforce an overriding sense of distance, not only between Hatoum and her subject but also with the audience. The Arabic text, inaccessible to most Western viewers, further distances the audience from the messages of Hatoum's mother and the text loses some of its potency in translation.

Translating letters from her mother in the work, Hatoum reads:

> Can you imagine us having to separate from all our loved ones, leaving everything behind and starting again from scratch, our family scattered all over the world [...] And now that you and your sisters have left Lebanon, you are again living in another exile and in a culture that is totally different to your own. So, when you talk about a feeling of fragmentation and not knowing where you really belong, well, that has been the painful reality of all our people.[16]

Hatoum's narration exposes her experience of Postmemory. Her mother's experiences and memories of the processes of exile have been articulated to Hatoum throughout her life. Further, as suggested by Lila Abu-Lughod, the exile that was brought about as a consequence of the Nakba is a history not yet passed for the generation of Hatoum. The artist's experience of a double exile is indicative of Abu-Lughod's suggestion that Palestinian offspring not only carry the surrogate Postmemory recollections of their parents but also experience the consequences of these memories directly in their own reality. *Measures of Distance* is a representation of the multitudes

of distance between mother and daughter, including storytelling and narration, history and the present, writing and reading, Arabic and English and subject and artist. The Arabic text in the video is also reminiscent of barbed wire separating the bodies of mother and daughter and insinuates a sense of distance created with threat.[17] As one views *Measures of Distance* from the perspective of the camera and, as a consequence, the viewpoint of Hatoum, the audience is implicated in the intimate space captured and created by the work. Thus, one is empathically caught in the intimate space between mother and daughter. The separations between subject and artist, whether semantically, bodily or visually, serve to highlight the notion that it is exile that binds Hatoum and her mother in *Measures of Distance*.[18]

The intimacy in *Measures of Distance* is further facilitated by the naked figure of Hatoum's mother. The naked body of the older Palestinian woman brings to the work a series of Western conceptions of gender and sexuality ascribed to Middle-Eastern women. The Western essentialising perception of Middle-Eastern women does not allow for the culturally diverse roles and perceptions of women in various Middle-Eastern cultures. In the case of Palestinian women, this consideration disavows the specific significance of women's storytelling and the symbol of the female body as a metaphor for the land of Palestine. Further, the mother's naked figure is literally layered with stories of exile and the effects of the Nakba. Thus, the naked figure is used twice as the nexus between Hatoum and the Palestinian homeland: here the artist's mother is her conduit to the experience of the Nakba and historical Palestine, as well as a more universal Palestinian symbol of the lost homeland.

Gannit Ankori rightly observes that *Measures of Distance* 'unravel[s] a tale of traumatic rupture and shattered lives; transmitted from mother to daughter, from generation to generation'.[19] Considering trauma as a corporeal discourse, Hatoum's preoccupation with the body and her somatic emphasis can then be explained as a response to the traumatic rupture in her life, as a consequence of exile. The importance of the body is acutely apparent in the artist's work during her student years and in her performance works throughout the 1980s. With her departure from performance and her move towards installation and sculpture, the role and the importance of the body, though not always explicit, still features prominently. Hatoum explains 'when I moved into the field of installation I wanted to

create works where the viewer is implicated. So that the viewer's own body is implicated in the work […] the work is still about the body. It is present despite its absence'.[20] The use of the body as the conduit of meaning and experience is perhaps related to traumatic memory: a breed of memory marked by its dependence on corporeal interaction and experience.

Hatoum's experience of traumatic Postmemory and its somatic visual expression in her oeuvre is best evidenced in her works that I see as being reminiscent of the massacre at the village of Deir Yassin in 1948.[21] Destroyed by Zionist forces in 1948, Deir Yassin is at the centre of Palestinian collective memory of the Nakba and in the last seven decades has been invested in as a symbol of the Palestinian experience of the Zionist occupation. Importantly, Deir Yassin was not an isolated event or attack, but is merely the most notorious and well documented of the 1948 massacres of Palestinians by Zionist forces.[22] Often cited by Palestinians as the event that instigated the mass exodus of 1948, the events that transpired at Deir Yassin involved stories of 'Irgun butchery' that include horrific attacks focused on women.[23]

The attacks on women at Deir Yassin are particularly chilling because they focused brutality toward pregnant women, and oral history suggests that several women had been sliced open, disembowelled and thrown into wells.[24] These oral testimonies have now been documented in research and archival projects that analyse the effects of gender politics in the 1948 Zionist victory to reveal how honour was for Palestinians intimately related to both the possession of land and the maintenance of kin women's virginity or exclusive sexual availability.[25] Therefore, the sexual and physical attacks at Deir Yassin are argued to have been acts of deliberate psychological warfare by the Zionist forces, as they were aware that such attacks on women would spread fear amongst the local population.[26] Though the stories of brutality that occurred in Deir Yassin are disseminated through oral history, Deir Yassin is exceptional in that only 4 of its 144 houses were destroyed in 1948. The village itself is still largely intact and is now located in the Har Nof district of West Jerusalem and has been converted into an Israeli mental hospital. As Deir Yassin has (however problematically) achieved a place in archival history, a covering up of the massacre was impossible, as reports of the killings surfaced immediately.[27] As such, the village is an exception

amongst villages depopulated in 1948, which in contrast to Deir Yassin, rely almost exclusively on oral history to record the events and experiences of the Nakba.[28] However, it is not archival documents and history of the village that deliberately inform Hatoum's work; instead, what we see here is an unintentional yet profoundly affecting transmission of traumatic Postmemory.

In the aftermath of the Sabra and Shatila massacres on Palestinian refugees in 1982 during the Lebanese civil war, Hatoum recounts a dream relating to the Nakba and the massacre of Deir Yassin. She describes the dream saying;

> I went to Beirut looking for my parents and in the wreckage of their home I found two plastic boxes – a pink one and a blue one. I opened the blue box and it was full of tiny toy soldiers that exploded out into the air around me becoming a cloud of flies that took on the shape of a black gravestone – 'We were only obeying orders!' I heard them say [...] When I turned back to the pink box, the lid was open disgorging human entrails in an endless stream. I heard my mother's voice saying, 'They were disembowelling pregnant women, that's why we had to leave'.[29]

The blue and pink boxes of Hatoum's dream are representative of a gendered Palestinian differentiation of the reasons for the 1948 mass exodus. One might understand the pink box as being symbolic of the female experience. It is significant that Hatoum claims to have had this dream at the time of the Lebanese civil war. Her own experience of violence, oppression and massacre of Palestinians is indicated through this dream to be subconsciously bound to the events of the Nakba. This collapsed connection between the Nakba and contemporary events experienced by the artist is indicative of Postmemory. The trauma of the Nakba passed down through her parents and, in the case of her dream, literally residing with them, is carried over into her own experience. Thus, as Lila Abu-Lughod suggests, as a Palestinian, Hatoum's cultural past is not yet passed and its trauma carries itself into the present. Although the artist explicitly states that her work is not a direct reflective of her cultural identity or the events at Deir Yassin – many of Hatoum's display a form of Postmemory that can be argued to be evocative of Deir Yassin. The

clearest examples are her works *The Negotiating Table* from 1983 and *Socle du Monde* from 1992–1993.

Hatoum describes the Israeli invasion and the attacks on refugees in camps during the Lebanese Civil War as the most shattering experience of her life.[30] To understand why these events had such a profound impact on Hatoum, it is important to remember that the artist has resided in the United Kingdom since 1975, when she was unable to return to her home in Lebanon following the outbreak of the civil war. The civil war therefore marked the beginning of Hatoum's personal experience of 'double exile' and put her in a position where she witnessed the horrific attacks on refugees in her country of birth whilst in exile in the United Kingdom. It was in response to the events of that war and the Sabra and Shatila massacre that the artist conceived of and performed her 1983 work *The Negotiating Table*. Performed five times, it consisted of Hatoum lying motionless on a table with empty chairs on either side. The artist's body was covered in beef entrails, bloodstained and wrapped in plastic with her head covered in surgical gauze, while calls for peace by Western leaders and reports of the events of the war were playing in the background.

The juxtaposition between the media reports of the events, the peace discussions by Western leaders and the seemingly brutalised body of Hatoum, highlights the chasm between the physical experiences of war and brutality and those that are reported and discussed. It is here that the artist's decision to use animal entrails becomes a point of significant importance. Hatoum's recounting of her dream of Deir Yassin and her mention of entrails were made within the same year that the artist performed *The Negotiating Table*. Beyond being an indication of her Postmemory of the Nakba, references to the haunting nightmares of Deir Yassin in *The Negotiating Table* bring to the surface issues surrounding the controversy between archival and oral accounts of the massacre. The disembowelment of women at Deir Yassin features prominently in the oral history of the massacre but is almost entirely absent in archival accounts of the event.[31]

The visual references to the massacre of Deir Yassin become less invested with political rhetoric and obvious allusions to Palestinian history in the latter years of Hatoum's oeuvre. The departure from overt political reference and rhetoric coincides with Hatoum's conscious move to do so after the completion of *Measures of Distance*. Nonetheless, when one

becomes aware of the significance of the imagery of entrails and their possible reference to Deir Yassin, Hatoum's recurrent employment of them begins to take on a different significance. The entrails motif also finds itself in Hatoum's work *Socle du Monde*, a large minimalist cube that references Piero Manzoni's influential work of the same title from 1961. *Socle du Monde* translates to 'pedestal of the world' and, as such, Manzoni's 1961 version of the work (a sculpture or pedestal placed outside) is suggestive of the notion that everything in the world – all vegetative, animal and mineral forms – is a work of art.[32] The line between what constitutes the work of art and what structures support or influence it becomes bound in Manzoni's work. Hatoum's appropriation of *Socle du Monde* is covered in iron fillings that are evocative of entrails. Hatoum's work suggests that her foundation, or pedestal of the world, is literally covered in entrails.

If we return to Hatoum's 1982 dream where she recounts her mother's terror: 'They were disembowelling pregnant women, that's why we had to leave', we can make a connection to Deir Yassin, the event most recognised as the cause of exile. As exile can be described as the determining state of being in the Palestinian experience it is pertinent that entrails cover Hatoum's pedestal to the world. For in doing so, the work suggests a world that literally has its foundations in exile. If we accept the idea that Manzoni's work suggests that the work of art gains meaning from its surrounding world, then Hatoum's version takes on a new meaning. *Socle du Monde* exemplifies Hatoum's perception of the 'entire world as foreign land'.[33]

The historical debate surrounding the massacre of Deir Yassin and the various attempts at creating a memorial museum commemorating the event are indicative of the anxiety toward the absence of Palestinian archival history.[34] Hatoum's work *Self-Erasing Drawing* from 1979 could be interpreted as a reflection of the anxiety concerning the erasure and exclusion of the Palestinian presence and history.[35] Completed during Hatoum's student years, *Self-Erasing Drawing* is a conceptual and minimalist work made up of a small 28x28cm square box filled with sand. The kinetic object consists of a small rotating arm that concurrently draws lines in the sand with one side of its arm and then proceeds to erase them with the other. This process of mark-making and consequent erasure results in an anticipation of the sand drawing's inevitable disappearance. The expression 'to

Fig 3. Mona Hatoum, *Socle du Monde*, Sculpture, 1992–1993
Photo: Edward Woodman, Credit: Courtesy of the artist

draw a line in the sand' is to imply that a particular idea or activity will not be supported or tolerated. To actively erase or refute this idea is to suggest that steadfastness can be overridden and, in the case of Hatoum's work, literally overwritten. Thus, the kinetic arm's process of erasure forges 'a sense of existence accentuated by a fear of disappearance'.[36]

The dialectic between absence and presence evident in *Self-Erasing Drawing* is also articulated in Edward Said's many remarks about the archival absence of the Palestinian presence and history, just as it informs studies on the systematic Israeli campaign to erase the Palestinian physical and environmental presence. When one considers these studies of the landscape alongside Hatoum's *Self-Erasing Drawing* and the later + *and –* (1994), the marks made in both of these kinetic works appear as though they are plough lines, ready-made for the plantation of seeds, only to be swiftly erased as soon as they are created.

As an ideological and physical war over the land, the collective memories of both Palestinians and Israelis are bound to the landscape. Consequently, there is constant antagonism between both their collective memories of and about the land. Carol Bardenstein's studies clearly indicate how the landscape of Israel has been systematically manipulated by both Israelis and Palestinians as a repository of both their collective memories. As these studies show, the result of the Jewish National Fund's planning activities over the sites of villages destroyed by the Zionist forces between 1947 and 1948 are, in essence, an act of historical cover-up.[37] The fund's widespread planting is an act that attempts to erase Palestinian collective memory of the landscape. Though pared back and minimal, Hatoum's self-erasing sand seems to tap into the history of Palestinian erasure within the landscape and may be interpreted as a loaded minimalist and conceptualist work, operating and discussing in an astute aesthetic language, the process of erasure of the Palestinian presence. Further, it is as if Hatoum's kinetic machines concurrently reveal and erase Palestinian *sumud*. The Palestinian steadfastness in the face of adversity, their metaphorical line in the sand, is repeatedly destroyed and erased only, like the prickly pear, to re-surface over and over again.

Hatoum's emphasis on memory and the transmission of personal and collective experiences of trauma form the affective charge in her work. In a radical departure from the militant aesthetic that typified Palestinian visual art prior to 1982, Hatoum's work is less concerned with political struggle, revolutionary themes or a didactic narration of collective Palestinian experience. Though Hatoum insists that interpretations of her work not be predetermined as contingent on her Palestinian identity, the success of her work ultimately signals that a Palestinian artist was capable of exploring themes pertinent to their cultural identity, while operating within an international context of 'high art'. The success of Hatoum's work on the international stage was instrumental in transforming conceptions of Palestinian art as being more than peripheral art, thus capable of operating as part of the avant-garde within centres of the art world.

Educated in the UK, Hatoum, like Michel Khleifi, belonged to a generation of artists and filmmakers educated and trained in Europe. Ultimately, this context allowed both Hatoum and Khleifi to cultivate a plurality of vision, international audience and a self-critical approach in their work.

Far from the political and economic structures that funded and supported Palestinian militant cultural output, both practitioners were free to diversify the representation of Palestinian experience. In the case of Michel Khleifi, this allowed the freedom to engage critically with Palestinian culture and history in ways that disavowed heroicised visions of the revolutionary struggle nurtured in previous years. Just as the events of 1982 opened a space for visual art to move away from didactic and propagandistic representation, a new window opened for film to move beyond documentary modes that prevailed during the period of militant cinema.

The space now opened to move beyond documentary modes was most pronounced in the work of Michel Khleifi, who was undoubtedly the most prominent Palestinian filmmaker of the 1980s. A closer analysis of his cinematic style, approach to filmmaking and the reception of his work from the 1980s and, in particular, his most well-known work *Wedding in Galilee,* reveals the new direction Palestinian cinema was to take after the devastation of the Lebanese Civil War. Seen as the torchbearer of contemporary Palestinian cinema, Khleifi's work occupies a crucial place within the course of Palestinian film history; that is, his work allowed Palestinian film to be self-critical for the first time, moving beyond its established didactic nationalist role.

Michel Khleifi's sensibility is arguably informed by the fact that he was born in 1950, shortly after the Nakba in Nazareth and was, thereby, born a Palestinian with Israeli citizenship. Born within the boundaries of the recently established Israel, Khleifi belongs to the group that often has been burdened with a particularly complex cultural identity: granted the rights of citizenship, while still living in a virtual exile in the land of historical Palestine. For Khleifi, his childhood in Nazareth laid the foundations for the anger and revolt that is evidenced in his films from the 1980s. His personal, political and cultural experiences of the 1950s and 1960s, as he explains, made Nazareth 'a place that was a ghetto at the heart of the Galilee under Israeli rule'.[38] As a Palestinian citizen of Israel, Khleifi walked the tightrope of Palestinian insider/outsider, lending him his ability to be self-critical of both Palestinians and Israelis, avoiding stereotypes on both sides.

It was after the events of 1967 that Khleifi made the conscious decision to leave Nazareth to enter his own 'double exile', a decision he describes

as an entrance into 'voluntary exile'.[39] Faced with what he saw as three options: 'to become a militant, to become part of the silent majority, or to leave', Khleifi decided to move to Belgium in 1970 to study theatre and film at the Institut National Superieur des Arts du Spectacle (INSAS), a place where many Arab filmmakers sought training in the 1970s.[40] Though, in subsequent years, he ended up teaching at INSAS, Khleifi's original intention when moving to Brussels was not to pursue cinema but, rather, theatre and television. To this end, Khleifi filmed reports on the West Bank and Lebanon in the 1970s and by 1980 he directed his first feature length documentary *Fertile Memories*.

Although it was his first feature length work, the film did travel across the film festival circuit, attracting criticism for both its depiction of the Israeli occupation and for the citizenship of Khleifi himself. Indeed, some audiences expressed shock at the fact that Khleifi still held onto his Israeli passport (alongside his Belgian passport) some 12 years after having left Nazareth.[41] For many critics, *Fertile Memories* was not strong enough in its criticism of the occupation, as critic Khayria al-Bashrawi wrote in 1987, 'the director made us feel as if the occupation of the Palestinians by the Israelis is a given situation that worries no one'.[42] Although these criticisms are of Khleifi's earliest work, they are judgements that continue to plague many Palestinian filmmakers, who continue to be laden with the responsibility of upholding the national narrative and any deviation from this course is often greeted with hostility.

This having been said, *Fertile Memories* managed to evade the full brunt of criticism that Khleifi faced in his later works. This was, perhaps, because *Fertile Memories* still had grounding in what was by then the prevailing genre of documentary. His film *Wedding in Galilee*, released in 1987, exemplifies the spectrum of responsibilities and expectations bestowed on Palestinian cinema, particularly during the 1980s. Interpreted as the first self-critical Palestinian feature film, *Wedding in Galilee* did not rely on most of the characteristics of the documentary genre. Though *Fertile Memories* 'waged war on the Israeli story via discursive, not violent means', *Wedding in Galilee* took this discursive approach even further, shifting almost entirely away from the militancy that had come to characterise the Palestinian cinematic approach.[43] For Nurith Gertz and George Khleifi (the filmmaker's brother), *Wedding in Galilee* represents a 'third space' in

the representation of the Palestinian story, something that is made possible by the director being a Palestinian citizen of Israel and because of Khleifi's ability to traverse Palestinian culture and Western cinematic conventions. As they explain, Khleifi's work operates 'within Western culture while subverting it in the name of the Palestinian culture it expresses. At the same time, it operates within Palestinian culture while criticizing it and deviating from it by giving voice to "others" who have previously been excluded from it...'[44]

The director's ability to simultaneously employ insider and outsider perspectives allowed him to defy stereotypes in the film; in other words, *Wedding in Galilee* was able to evade the 'Manichean schema' that reduces the oppression of Palestinians to a dichotomy of good Palestinians versus evil Israelis.[45] This result is made possible precisely because of Khleifi's departure from the modes of militant documentary towards his privileging of avant-garde aesthetics that do not allow the filmmaker to use his work as a narration of collective history and struggle. In such a way, Khleifi's cinematography produces a subtle call for a deeper knowledge through the acceptance of the benefits of ambiguity.[46] Despite the merits of the filmmaker's sensibility, it is precisely his subtlety that is at the core of most criticisms of his work.

Wedding in Galilee was banned in most of the Arab world for many years and, though this may have been as a consequence of the nudity and perceived eroticism of the film, Khleifi saw this as more a reflection of a fear that he depicted a contradictory worldview and political perspective. In a 1996 interview with Livia Alexander, he explains the Arab world's response to his work: 'for them, Palestine is a question of politics, propaganda and ideology [...] they might support a few Palestinian films [...] but certainly not films that challenge society and call for change'.[47] *Wedding in Galilee*'s failure to succumb to straightforward Palestinian nationalist narration warranted a string of criticism from Arab critics, so much so that, when the film premiered at the Cannes Film Festival, Khleifi was attacked by Egyptian reviewers for not demanding the destruction of Israel.[48] Importantly, however, *Wedding in Galilee* was supported by the PLO, who awarded it the Hani Johariya award (the PLO film award), thus, deeming it both legitimate and culturally esteemed. This however did not stop severe criticisms of the film in Arab audiences; when the work premiered at the

1988 Carthage Film Festival, a Tunisian youth in the audience attracted considerable attention, calling Khleifi a Zionist. Though, in retrospect, these responses do seem extreme, they signify both the political climate of the late 1980s and the audience's lack of familiarity with Palestinian film that deviated from the course of the militant cinema of the recent past.

Wedding in Galilee and its reception typify the ambiguity that comes with changing modes of the representation of collective trauma. Mirroring the Israeli historiography of the Holocaust, as Esther Webman suggests, 'Palestinian cinema reflected the shift from national to private memory, as well as the masculine to a feminine point of view'.[49] This transition is marked in Khleifi's practice and in *Wedding in Galilee* in particular. Nurith Gertz and George Khleifi echo this transition, stating that the filmmaker is notable for his experimentation with evocations of 'class, gender, ethnic and other identities that earlier cinema silenced'.[50] The director's focus on the complexity and potency of personal narratives over collective narratives allowed *Wedding in Galilee* to also move beyond the preoccupation with depictions of Palestine before the Nakba, preferring instead to concern itself with understanding the contemporary moment rather than a reductionist and nostalgic view of the past.[51] For Khleifi, the importance of personal expression over national narration is what allows for a decolonisation of cultural action and ideological discourse.[52] This process of expressive cultural decolonisation is acutely witnessed throughout the film.

Wedding in Galilee is, in essence, a story about a Palestinian wedding that can only take place with the attendance of the Israeli military governor of a village in the Galilee region, where the film takes place. The film centres on the desire of the protagonist Abu-Adel, the *mukhtar* of the village, to hold a large, memorable and traditional wedding for his son, despite the military curfew and the subsequent opposition and humiliation of much of the village's population, including the *mukhtar's* brother.[53] Using his renowned complex poeticism, Khleifi unpacks this basic plot not only to reveal the complicated interaction and relationship between Palestinians and Israelis but also to be critical of the obstacles created by Palestinian traditional patriarchal society.

Focusing on the events associated with the wedding, which take place over two days, *Wedding in Galilee* braids together a series of subplots, which

include that of young men planning to attack the Israelis at the wedding, the illness of a young Israeli female soldier who is comforted and treated by village women, the loss of the *mukhtar's* prized mare and the efforts of Sumaya (the *mukhtar's* daughter) to dissuade her boyfriend and other village youths from attacking the Israelis. These subplots are united in their articulation of the friction and tension inherent in Palestinian/Israeli society and identity. Set in Israel, Khleifi represents the insidious manifestations of occupation on Palestinians living in Israel, something that is markedly different from the overt visibility of the occupation in the Territories.

Though the film carries a message of collective struggle for liberation, it does this in a way that is careful to demarcate the various incarnations of the occupation for Palestinians. For some commentators, this signals a problematic treatment of the occupation. One might take Ella Shohat as an example, who suggests that the film might have been called 'Wedding in Palestine', as this would have matched the film's emphasis on a single national identity, linking the destinies and dreams of the various Palestinian exiles, 'insiders' and 'outsiders'.[54] Yet, if Khleifi were to do this, the film would have lost its potency and would have been limited in both its subtlety and scope, arguably falling into a pattern visible in earlier Palestinian films, where the Palestinian experience of exile is often portrayed as uniform experience.

However, the shared aspects of the traumatic experience of Palestinian exile are still visible in the film, only they lurk beyond the title, dialogue and central plot. Instead, they are represented in the topography and treatment of the landscape within the film's cinematography. Filmed across five different villages, two in the West Bank and three in the Galilee, the film presents a unified view of the landscape.[55] This created a space that does not actually exist and is, in effect, removed from both place and time. In doing so, the work constructs a Palestinian connection to the landscape that is forged by the recovering of an invisible realm from within the visible landscape, thus, exposing the traumatic Palestinian consciousness and experience of dispossession.[56] The Palestinian right and connection to the land is conveyed most strongly in the scene depicting the loss of the *mukhtar's* mare. A symbol of dignity and loyalty, the horse is lost and then trapped in an Israeli minefield. Though the Palestinians from the village work alongside the Israeli army to save the horse, only the *mukhtar's* devotion and connection to the animal (he even risks his own life) is able

Fig 4. Michel Khleifi, *Wedding in Galilee*, Film Still, 1987
Credit: Image Courtesy of Sindibad Films Ltd and Michel Khleifi

to coax it back to safety. This scene, therefore, carries several potent messages: only with cooperation and dialogue can Israelis and Palestinians navigate their shared political and geographical minefield, the *mukhtar* is committed at all costs to his own dignity and land, and it is the Palestinians that hold the strongest connection to the land itself.

Though the *mukhtar* represents the historical connection to place and custom, he also signifies the hindrances of patriarchal society. His attitudes towards his sons and the women of his family encapsulate a reoccurring theme in Khleifi's films: the role of women and children in Palestinian society and within the conflict. The director's treatment of women functions to show how the national liberation of Palestine will involve a more active role for women, entailing a shift from the margins to the centre.[57] The women in *Wedding in Galilee* all play the strongest roles in mediating the conflict and preventing violence on all sides. This

comes to a climax with the bride of Adel, who – when faced with her groom's impotence as a result of the humiliation of the Israeli presence and his anger towards his father – chooses to take her own virginity, asking 'if this is a women's dignity, then where is a man's?'.[58] Samia and all the female characters in *Wedding in Galilee* push the boundaries of Palestinian traditional society and the conflict through their relationship with the camera.

The camera in *Wedding in Galilee* often features as a meditative force, reflecting on the landscape in a way that demonstrates a longing and traumatic relationship between the Palestinian characters and their surroundings. These lingering and tender depictions of the landscape reinforce a political message that constantly reminds the viewer of the Palestinian historical relationship to the land.[59] In the moments where the film does not employ these camera methods, it often uses a circling and enclosing technique. This gives rise to enclosures that signify the binding force of the family, and an extension of this metaphor to encompass Palestinian society more broadly.[60] It is only the women in the film that manage to rupture these cinematic enclosures; this is most evident in the case of the *mukhtar's* daughter, Sumaya, who often runs out of the field of vision, denoting her attempt to break-away from the restrictions of her family, her society and the conflict that surrounds her.

There is no doubt that this treatment of women in the film serves to heighten Western audience's appreciation of the work through undermining stereotypes of Arab women by portraying an acutely feminist perspective. Sumaya, in particular, also subverts any prejudice that perceives Arab women as 'backward', 'uncivilised' or 'primitive'. This is most clear in the scene where the Palestinian women are taking care of Tali, the female Israeli soldier. When Tali's absence begins to arouse suspicion in her fellow male soldier, Tali impudently tells him that the Palestinian women will eat her once they are finished with her, thus playfully alluding to the projection of primitivism on Palestinian women. Attempts, such as this one, to break stereotypes towards Palestinians is also witnessed in Khleifi's approach to religion in the film, where Christian and Muslim customs are merged, creating a united national and cultural Palestinian cohesion that extends beyond religious difference.[61] The success of *Wedding in Galilee*

with Western audiences is measured not only by the ongoing prominence of the film in contemporary film scholarship but also by the accolades it was awarded at the time of its release. These include the Best Belgium Film (1988), the San Sebastian Grand Prize (1987) and the Federation of Film Critics Award at the Cannes Film Festival (1987).

This can largely be attributed to the film's brave departure from the visual conventions that had come to dominate representations of the Palestinians, both the modes of the documentary genre and television journalism. For Khleifi, there is an important stress placed on drawing a schism between cinema and television. For the director, the dominance of television in the representation of Palestinian experience is a sign that 'we have gone backwards, we are always bound to narrative, to the pollution of television'.[62] Khleifi explains that it was the Lebanese civil war that prompted a shift in his approach away from television and documentary. This was because, though the Middle East was saturated with television coverage during the end of the civil war, this was not, to Khleifi's mind, the only appropriate way to represent the conflict. Speaking of his experience at the time, he explains, 'as far as I was concerned, the Palestinian cause was a just one, but the way it was being fought was wrong. We have to provide the world with a different way of talking about us'.[63]

It was with this rationale amidst the devastating atmosphere of the final stage of the civil war that Khleifi began to write the script for *Wedding in Galilee*.[64] The importance of this timing is not to be underestimated. The events of 1981–1982 and the PLO's departure from Beirut, alongside the exile of thousands of Palestinians from Lebanon, was a symbol of the destruction of the ideological and political foundations that had taken root in Lebanon over the years. Though Khleifi was only starting to write the script for the film at the time that the PLO's film archive was lost, it makes for a tremendous coincidence. This is because Khleifi is famed for his use of cinema as a tool of remembrance, as the archival site of '*lieux de memoires*' (repository of memory).[65] As *Wedding in Galilee* is his most famous film for this reason, it then stands to logic that it would inherit a new gravity following the loss of the actual repository of Palestinian film memory: the PLO archive.

In this sense, the loss of the archive and the destruction of the proxy homeland for Palestinians in Beirut opened up a window for Khleifi and others to experiment with new modes of cinematic representation. For the director, the militant cinema of earlier years was always seen as laden with contradictions and problems visible just below the surface. This is something that Khleifi sought to unearth, even in the documentary *Fertile Memories*, for, as he explains, 'this film turned militant cinema upside-down. It demonstrated that it is more important to show the thinking that leads to a political slogan rather than the expression of this slogan that is political discourse'.[66]

The ambiguity of Michel Khleifi's work often comes as a result of his deliberate and successful attempts to blur the boundaries and characteristics of genre. The failure of singular genres in the articulation of a deep and profound depiction of the Palestinian experience is, perhaps, at the heart of the director's movement between genres. He elucidates on this by saying that it is always important for him to 'integrate drama, actions, theatre and reportage in single works'.[67] The premeditated ambiguity of Khleifi's practice is anchored on the privileging of freedom of individual expression over political ideology or the presentation of a collective or national narrative. This would suggest that Khleifi's films fall under the umbrella of Youssef Ishaghpour's concept of the cinematic trinity, where cinema functions to 'redeem reality' by using image, fiction and emotion.[68] As acts of redemption, they do construct a portrait of Palestinian reality but certainly not one that claims to encompass the entirety of Palestinian life, identity and experience.

Wedding in Galilee deconstructs the national traumatic narrative of Palestine, while still being able to forge a representation of the unified Palestinian experience of dispossession and occupation. The overt denial to tell the national story in a straightforward manner sets the film apart from previous cinematic output. Indeed, it is only the character of the *mukhtar's* father that recounts any substantive Palestinian national narrative. Yet, ironically, in a way reminiscent of King Lear's fool, the grandfather appears senile, confusing the Israeli occupation with that of the Ottomans and the British in a way that is reminiscent of Postmemory. The senile grandfather is often dismissed by the rest of the village within the film and thus, operates on several symbolic levels to simultaneously

69

suggest the impossibility of national narration, the Palestinian history of resistance and the Palestinian claim to the land. Importantly, the grandfather also subtly conveys the political message that the Israeli occupation, like others before it, is only temporary. As one of the only characters to lend humour to the film, the grandfather, far from being a coherent narrator or embodiment of Palestinian history, serves only to reinforce the complex interplay of generational and experiential difference in the film. The collision of his experience with his sons and his grandchildren subverts any sense of cohesive collective narration. Through this generational conflict, Khleifi creates a world that 'defies national totality, which was created at the expense of an ignored variety of identities and individual stories'.[69]

The individual stories represented in the film take the shape of subplots followed throughout the work, serving to intensify the polarities that exist between various generations of Palestinians. The film portrays all generations of Palestinians, spanning from those born under Ottoman rule, to those born before the Nakba, to the generation of the revolution and, finally, with Abu-Adel's youngest son, Hassan, to the generation of the first intifada. Hassan plays a particularly important role in the film, one that is most pronounced in the repeat dream like sequences between him and his father. In these scenes, Abu-Adel attempts to bestow Hassan with his own dreams, a metaphor for his own experience, beliefs and perspective. Towards the end of the film, Hassan rejects these attempts and refuses to carry his father's dreams. This is particularly meaningful because Hassan's decision delineates the points of difference between his generation and their experience of the occupation with that of his father.

The youngest son's rejection of the aspirations, values and attitudes of his father signifies the reason why many commentators came to see *Wedding in Galilee* as a film that anticipated the first intifada.[70] Hassan represents a new generation of Palestinian resistance, one that, following the role of youths in the events of the first intifada, would come to reshape the global perspective of the Palestinian struggle. Importantly, Hassan's rejection of the mores of his father signals more than a mere generational difference. The tension between Abu-Adel and Hassan was also representative of the shifting attitudes of Palestinians with Israeli citizenship at the time.

As a group whose struggle against Israeli occupation has been sublimated beneath the narratives of Palestinian refugeedom, Palestinians with Israeli citizenship became arguably visible for the first time during the intifada. Following on from this, the character of Hassan is symbolic of a new generation of Palestinians in Israel who engaged in resistance and protest against Israeli occupation.

The first Palestinian intifada (translating literally to 'shaking off' or 'uprising') was formed by the shifting political landscape of the Middle East, which had formed a series of ideological and economic changes for Palestinians. For those living in the territories, it had become increasingly obvious by the mid-1980s that the Arab world had placed the Palestinian occupation at the very bottom of their political priorities.[71] While the PLO was now operating out of exile in Tunisia, the occupation was becoming increasingly restrictive and humiliating for Palestinians, both in Gaza and the West Bank, with more constraints on movement, increased arrests and frequent beatings. With this Israeli restriction and brutality fraying the fuses of Palestinians in the territories, it is surprising, yet understandable, that the remarkable events of the first intifada were in fact ignited by rumour and speculation.[72]

The intifada is now burnt into global memory as an event characterised by the Palestinian youth who bravely protested against the humiliation of occupation with often little more than stones. Their uprising tapped into a demographic anxiety that had been nurtured and used as political propaganda by both Israelis and Palestinians for many years. Both described the Palestinian youth bulge of the time as a demographic time bomb. However, the Jerusalemite intellectual and political activist Sari Nusseibeh was right in proclaiming, only weeks before the outbreak of the intifada, that 'the demographic bomb will never explode without a fuse. The fuse will be our demand for equal rights'.[73] As the intifada found its origins in Gaza's camps, where the average age was 27 and one-third of camp inhabitants were under the age of 15, it is no surprise that images of Palestinian youth have now become synonymous with this uprising.[74] These young people came to be known as the *atfal al-hijara* or 'children of the stones'. As symbols of the resistance movement, these youths did, as Dina Matar notes, pay 'for the acts of resistance to Israeli occupation practices, paradoxically providing visual proof of the brutal Israeli response'.[75]

Suggested to be the first mass-based and sustained popular revolt by the Palestinians, the intifada was a reinvigorated move to end the occupation and push towards self-determination.[76] The uprising was not something that came from the top down; rather, it was a movement that sprung from grassroots resistance. This made it stand in contrast to the PLO, who was deafeningly silent in the first few months of the intifada.[77] Then operating out of Tunis, the PLO had always advocated an armed rebellion, not factoring in the possibility of the massive act of grassroots resistance increasingly being evidenced throughout Gaza, the West Bank and Israel itself.[78]

The role of Palestinians within Israel during the intifada was both particularly important and surprising. Within the first few weeks of the intifada, Palestinians in Israel had coordinated strikes and demonstrations and thus had become a source of inspiration that led to bolder, extended acts of resistance.[79] It is in this sense that Michel Khleifi's *Wedding in Galilee* is often interpreted as having anticipated the intifada; that is, it centred on the plight of Palestinians within Israel and their willingness to engage with acts of resistance against the Israelis. *Wedding in Galilee,* in many senses, anticipated and represented the struggle for liberation that was witnessed in the intifada and, despite highlighting the divisions within Palestinians themselves, also anticipated the united struggle against occupation that characterised the intifada.[80] The united struggle of Palestinians during the intifada was something that found itself almost permanently emblazoned across international television screens at the time, making the world witness Israeli's forms of control, and thereby actively undermining the normalcy of the occupation.[81] This process of subversion of the normalcy of the occupation went beyond the Palestinians taking part in the uprising, extending to international spectators. Though the intifada obviously did not bring about the end of the occupation, it did send a clear message to Israel and its allies that the status quo was no longer tenable.

The years following the first intifada would see tremendous political change in both Israel/Palestine and throughout the Middle East. These changes became most pronounced with the outbreak of the First Gulf War in 1990, a conflict that continues to shape the geopolitics of the region. For Palestinians, the Gulf War delivered a devastating blow, arguably setting back the international popularity of their political struggle. Despite

this, the intifada was also instrumental in raising global recognition of Palestinian suffering under Israel occupation. The growing international profile of Palestinian cultural output during this time, particularly the work of Michel Khleifi and Mona Hatoum, only serves to reinforce an understanding that Palestinian life in exile and under occupation was not all it seemed through the media lens that had for decades framed Palestinians as extremists or terrorists. This slow shift in international understanding and perception of Palestinians, when coupled with changes in the political, economic and cultural landscape of the region in the 1990s, created a context that would serve to further diversify Palestinian cultural output. Most surprisingly, these changes were responsible for a seemingly unanticipated turn in Palestinian art and film: the emergence of humour.

3

Oslo: Reaching the Punchline

'Why didn't Arafat take Suha with him to Oslo? Because he would have given her away too!'

<div align="right">Anonymous</div>

Officially described as the Declaration of Principles on Interim Self-Government Arrangements (or DoP), the Accords were supposed to lay out the framework for all negotiations and relations between Israel and the Palestinians, working towards the final aim of achieving a viable two-state solution. Oslo called for both sides to recognise the political legitimacy of the other; for the Israelis this meant acknowledging the PLO as the representative of the Palestinian people, and for the Palestinians this meant denouncing terrorism and recognising Israel's right to exist. Despite the optimism surrounding the Oslo Accords when they were first signed, most analyses draw the same conclusion: that the Accords were an epic failure. In retrospect, we could go so far as to look upon them as a tragic joke.

In this sense, Oslo was a critical junction in Palestinian history that can be described as a 'punchline', and it is with the beginning of the peace process that we can witness the explosion of humour in Palestinian art and film. To unpack the significance of the 'Oslo punchline', it is necessary to understand the impact of events that built up to culminate in the Accords; namely the first intifada, the first Gulf War and the Madrid Peace

Conference. It is also vital to examine the political ramifications of the Accords on Palestinians, as well as their symbolic pertinence as an iconoclastic gesture. Finally, we also need to consider the way in which Oslo changed Palestinian art and film by destabilising the reliance on documentary genres and by introducing humour.

As we have seen, the history of the Palestinian experience is shaped by the Israel/Palestine conflict and is marked with collective trauma, national struggle and political oppression. Given this, humour does not instinctively appear as a predictable choice for the narration of the Palestinian story. Crucially however this laughter provides us with more than merely a new way for representing and understanding the Palestinian experience. It also yields new potential for understanding how visual culture speaks truth to power and how laughter destabilises the relationship between reason, domination and suffering; therefore, extending the inquiry of critical theory and the work of thinkers such as Edward Said and Theodor Adorno. To understand the relationship between humour and trauma, one must begin with the acknowledgement that laughter appears when tragedy exists in excess, as is undeniably the case in Palestinian history.[1]

The failure of Oslo delivered a cruel blow to Palestinians by effectively destroying any hope of a sovereign state in the foreseeable future and thus is a moment that can retrospectively be understood as signifying tragedy in excess. It is for this reason that humour enters Palestinian cultural output at the time of the failure of the peace process. The kinship between laughter and tears, or humour and trauma, is characteristic of humour in Palestinian art and film. Hence, it is fitting that its advent in cultural output appears at a time of political despair and indeed absurdity. In this context, 'Palestinian humour' refers to humorous cultural output produced by Palestinian practitioners. Though an explosion of laughter can be traced in Palestinian art and film since 1993, this shift in emphasis away from didactic modes of representation towards humour became most apparent in the years following 2000. This correlation is no coincidence. These dates correspond to a historical junction in Palestinian experience and identity that occurred as a consequence of the peace process, beginning in Oslo in 1993 and with the events that signalled its death knell – the Camp David Summit and the outbreak of the second intifada (both in the year 2000). Since that time the Accords framework continues to fail, and as year by year new incarnations

of the peace process continue to stall, it is increasingly clear that negotiations spawned from the framework of the Oslo Accords are doomed to failure.

In order to comprehend the meaning and significance of manifestations of Palestinian humour in art and film, one must be aware of the history of both, as well as the Palestinian national story. The interdisciplinary approach towards art, film and humour can harness a variety of perspectives allowing for an integration of findings and observations. This reflects the current trend in humour studies, where interdisciplinary research has become an influential strategy precisely because it allows for the sharing of concepts, models and metaphors.[2] To witness humorous Palestinian art and film without an understanding of Palestinian history would almost certainly create a 'lost in translation' effect, where audiences would be closed off from the meaning and indeed enjoyment encouraged by these humorous works. To achieve this understanding, one must understand Palestinian history more broadly but also understand the events of the first intifada, a period that not only shifted the collective mindset and identity but also instigated the first dedicated study of Palestinian humour.

It is important to note here that practitioners engaging with humour are aware that, at some stage, their works will meet with an international audience. Although these works may reflect historical events and their consequences, they are not didactic. While conventional devices (irony, pastiche, parody) are clearly in use, audiences' capacity to 'get the joke' is contingent on their understanding of the history with which they are engaged. Humour allows multiple points of entry to the work. Humour is the litmus test that is understood by some or prompts an enquiry by others. The generation responsible for the utilisation of humour in art and film are those who came of age in the first intifada.

The intifada and the corresponding mindset of the generation known as 'children of the stones' would probably not have come about when it did were it not for the economic, political and ideological changes in the years prior to 1987, including Israel's retreat from Lebanon in 1982, the loss of Arab oil revenues and the unification of PLO factions in 1987.[3] In addition to these factors, the tense political climate of the intifada was only bolstered by the growing high unemployment rate in the territories that came about as a result of the Israeli government's attempts to reduce reliance on Palestinian workers.[4] These political and economic realities created a

climate where the Palestinians in the territories 'felt there was little to lose if they broke the rules of the game'.[5]

Though the major success of the grassroots struggle of the first intifada might be said to have been the transformation of both the way Palestinians perceived popular resistance and the international growing recognition of their struggle against the occupation, there were also several concrete political consequences to the uprising. The first of these was King Hussein of Jordan's decision in July 1988 to terminate all forms of administrative and legal ties with what he called the West Bank.[6] The second was the loss of Israeli Defense Forces (IDF) morale, which, having been trained for war situations, struggled to keep up with its role as a policing agent during the intifada.[7] Yet, the most important of the political actions to come about as a result of the uprising was the proclamation of the independent state of Palestine by the Palestinian National Council in November of 1988.[8] Put together, these political transformations formed a new way for Palestinians to carry out and represent struggle. This transformation became evident in the humorous folkloric practices of the time, something that forms the emphasis of the research of the anthropologist Sharif Kanaana.

Kanaana's body of research has centred on Palestinian identity in relation to the role of folk tales in its revival and understanding. Though Kanaana has published widely on political folklore, it was not until the outbreak of the first intifada that he turned his attention to Palestinian humour and jokes. This interest was sparked by his observation of the proliferation of humour at that time alongside the realisation that 'jokes and humour could co-exist with so much pain and misery, or even could be generated by it'.[9] Further still, he argues that jokes and humour could react to political events faster than other forms of folklore.[10] Rather than framing the humour he witnessed with the outbreak of the intifada within humorological analysis, the anthropologist chose instead to start collecting intifada humour without a theoretical frame or hypothesis.[11]

The jokes of this period signified a change in Palestinian self-perspective. This was because they mirrored a growing sense of positivity around Palestinian identity, with jokes often portraying Palestinians as victorious or superior, something that stood in contrast to pre-intifada humour which 'reflected a mood and attitude of self-hatred, disrespect, self-depreciation, even contempt'.[12] Though Kanaana's work does unpack the class divisions

and intra-/inter-group conflicts witnessed in the humour of the uprising, it also suggests that, overall, Palestinians felt confident they would succeed in their liberation struggle, thus in many ways harking back to the legacy of the *jeel al-thawra*.

It is clear that the first intifada was a signal of an impending junction for Palestinian identity, created not only by the generational divide of those who participated in it, but also the revolutionary history that preceded it and the disillusionment that was to follow with both the first Gulf War and the Oslo Accords. As a result, the children of the stones found themselves approaching a crossroads of Palestinian identity, and their role in this was something that is echoed in the humour of the period where they feature heavily. In many ways Kanaana's work came before its time, showing tremendous foresight in its discussion of the benefits of Palestinian humour, including its ability to narrate the Palestinian story and coalesce a sense of solidarity.[13] His work set the foundations for the analysis of Palestinian humorous cultural output witnessed ever more frequently today.

Central to our concern here is the fact that the children of the stones would grow to be the generation of artists and filmmakers who ushered in a new era in Palestinian cultural output – one that was marked by a shift toward humour. Understanding this, the intifada, the first Gult War and Oslo take on new gravitas as the events that shaped their experience, world view and sense of 'Palestinianess'. Although humour is documented to have profilerated during the first intifada, the use and dominance of humour changed with the events of the first Gulf War and later with the Oslo Accords. The Gulf War in particular can, in retrospect, be seen as central to this change. It was the event that quashed the optimism witnessed in the years leading up to the conflict and marked a political crossroads that challenged the Palestinian liberation movement and strained the growing international sympathy towards it.

The lead up to the Gulf War created several challenges for Palestinians that were to become amplified with Arafat's decision to support Iraq in the conflict. Although with the benefit of hindsight we understand this to have been an incredible political mistake, Arafat and indeed Palestine, had become embroiled in the changing geopolitics of the time. With the perceived cessation of the competing global superpower framework in the final days of the Cold War, it became clear to the Arab world that it had

entered a new era of American political dominance and implicit in this shift was Israel's regional hegemony.[14] For Palestinians this was made blatantly obvious when the US delivered the PLO several blows. The first of these was in the spring of 1990, when both sides of the American Congress affirmed Jerusalem as Israel's capital. This was then followed by the US vetoing a United Nations resolution condemning Israel's violent responses to the intifada, and then, President George Bush's suspension of dialogue between the US and the PLO in June 1990.[15]

Within this strained new political context, it is understandable why some went so far as to characterise Saddam Hussein as the new Salah ah-Din capable of uniting the Arab world and transforming it into a globally dominant force.[16] This characterisation was symptomatic of pan-Arabist rumblings of the time that heartedly took up the case of Palestine's liberation as political fodder. Although the Iraqi leader's past was not approved of by many political groups in the region, Arafat went against the advice of many (including Palestinian leaders such as Hanan Ashrawi and Abu Iyad) to support Hussein's annexation of Kuwait. The eventual swift victory over Iraq by coalition troops immediately revealed Arafat's decision to be a disastrous mistake that was fuelled by a pan-Arabist poltergeist that promised the Palestinian people something it would not, and indeed could not, deliver.[17]

The coalition's victory over Iraq held devastating consequences for the Palestinians. Second to the Iraqis and the Kuwaitis themselves, the war brought the most political devastation to the Palestinians, with 400,000 expelled from Kuwait and a liberation struggle now tarnished again in the eyes of the West. Yet in spite of this, the Palestinian disillusionment that followed the fall out of the Gulf War was replaced with a brief wave of optimism that came with the peace conferences facilitated after the conflict. The demise of Iraq as a leading power in the Middle East opened the potential for a new order in the region, something that was taken up by both the now diminishing Union of Soviet Socialist Republics (USSR) and the United States.

This was most clear in the Madrid Peace Conference of October 1991 that was instigated by the United States and co-convened by the USSR with the deliberate intention of seeking to lay the groundwork for a new order in the region. Hosted by Spain and involving American, Soviet, Israeli, Syrian,

Jordanian, Lebanese and Palestinian authorities, the three day Madrid conference was framed and conceived as an early step in the Arab/Israeli peace process. For Palestinians, the event allowed an opportunity to improve their image in the globally-mediated sphere, which had suffered a heavy blow after Arafat's public support for Saddam Hussein.[18]

Although the Oslo Accords are often credited as the historical moment when the Palestinians denounced armed struggle in favour of diplomacy, Arafat had in fact suggested that the PLO turn to diplomatic means as early as 1988. In speeches in Algiers and Geneva he stated that reliance on armed struggle would not be enough to achieve Palestinian statehood and that diplomacy was now necessary. The Gulf War appeared as an intermission to this diplomatic sentiment, but with Iraq's eventual loss in the conflict, the Palestinian leadership had to embrace diplomacy in the early 1990s as never before. The Palestinian address at the Madrid Peace Conference utilised these earlier commitments to diplomacy to affirm the re-invigorated Palestinian commitment to peaceful negotiations, claiming that 'ever since then [Algiers and Geneva] our people have responded positively to every serious peace initiative'.[19]

The conference based its quest towards peace negotiations around the principles of the UN Resolutions 242 (1967) and 338 (1973). These resolutions called upon Israel to withdraw its armed forces from the territories occupied in the June War of 1967 and for all states in the region to respect and acknowledge the sovereignty and independence of their neighbours.[20] Though building on these resolutions some two decades after their declaration, the conference was given new gravity as a result of the changing international public sphere that was increasingly adopting televised political summits. Given that this was the last international conference attended by the USSR before its collapse, Madrid stands as a symbol of the ushering in of a new period of 'political reality', which allowed for television to grow into a genuinely international institution with the ability to play an autonomous role in world politics.[21] For Palestinians, this new political reality offered the ability to overcome invisibility and silence, key themes in the Palestinian address at Madrid.[22]

The other salient point made in the Palestinian address at Madrid was around the ongoing Palestinian process of nation-building, with the intifada described as the driving exercise behind this process. In this way,

Madrid offered Palestinians the opportunity to present the essence and goals of their struggle to the global sphere via television. In other words, for the first time they could use their own voice in the narration of their liberation struggle on television screens. This opportunity to present the national narrative on international television contributed to the weight often attributed to the Madrid conference. Though the event delivered few political accomplishments, its legacy remains a symbolic one as the event that laid the foundations for the historical Oslo Accords, the first of which was signed two years later in 1993.[23]

One of the most crucial features of Oslo was that it called for the abandonment of the entire body of international law and resolutions relating to the Israel/Palestine conflict developed over 53 years. This, as political economist Sara Roy writes, was done 'in favour of bilateral negotiations between two actors of grossly unequal power'.[24] With only UN Resolutions 242 and 338 remaining as the international basis for peace negotiations, the international community, and indeed the PLO, believed that at the least this would require Israel to withdraw from land occupied in the June War of 1967. However, like so much else contained within the agreement, Resolutions 242 and 338 were open to manipulation by Israel. As an example, the accepted English version of UN Resolution 242 (of which 338 is in essence only a reiteration) refers to 'territories' occupied in 1967, not *the* territories, as stated in the French version. This ambiguity was symptomatic of the entire character of the accords that allowed Israel the leeway to continue its occupation of Palestinian territories.[25]

The ambiguity that came to typify the impotence of Oslo to deliver any longstanding peace in the region is magnified by the fact that the Accords were struck as a set of principles rather than legally binding conditions. This set the Oslo peace process in opposition to other more successful peace negotiations such as those of South Africa, Northern Ireland, Vietnam and Algeria. As a political and diplomatic document, the Accords are full of diplomatic ambiguity making them resources for those in power committed to the *principles* underlying the agreement, rather than a set of rules whose contravention will be treated as criminal acts.[26] This ambiguity has inevitably destroyed the credibility of Oslo, and in the years since has been manipulated with enormous sophistication and success by Israel to lead to the dire situation we continue to see in the region. Rather than heralding

a move towards a lasting peace, Oslo instead provides both an arsenal of public relations cannon fodder and a legal framework that prevents the transfer of territory to Palestinians while continuing to immunise Israel against its commitments.[27]

The damage suffered by Arafat as a result of the Accords is also significant. As the face of Palestinian leadership for decades, and as their voice to the international community, his delegitimisation trickled down to affect both the Palestinians and their supporters. Looking back at Arafat's decision to sign the Declaration of Principles, it is astounding that he would have conceded such an agreement. For when he did, he by proxy affirmed the Israeli position, which was the one that prevailed within all the Accords, none of which used the word 'occupation' or addressed Israel as an occupying power.[28] In addition, the agreements did not recognise borders or full Palestinian equality. Most alarmingly however, the agreement also failed to properly address Israeli settlements and Palestinian land confiscation, with neither practice clearly prohibited by the agreement. This is most distressing because it remains to this day the largest obstacle to peace. The failure to acknowledge these issues meant that the Palestinians now found themselves in a situation where Israel would decide for itself when, where and if it would withdraw from the occupied territories.

For the newly established Palestinian Authority (PA), Oslo created a role where they had the task of essentially managing the occupation of Israel by implementing interim arrangements. The PA was given control over services such as health and education, but importantly Israel still held control over security in the West Bank and Gaza. This was worsened with the second Oslo agreement in 1995 when the West Bank was divided into Areas A, B and C. Area A was designated as under PA control and encompassed major Palestinian towns. Area B gave civilian control to the PA and security control to Israel in other remaining population centres. Area C was under complete Israeli control and was comprised of settlements and Israeli military bases. Though this agreement was signed as being temporary, and did grant some control to the PA, it did not serve to legitimise Palestinian sovereignty in any way. Norman Finkelstein perhaps put it best when he explained that 'the tacit, Pollyannaish assumption is that *any* new reality must improve on the present state of affairs. Yet, the new

reality will more than likely allow for the tightening of Israel's grip on the Palestinians'.[29]

Finkelstein's analysis could not have been more accurate because, since Oslo, the West Bank has become a fragmented land of Bantustans – and Gaza an unliveable open-air prison. The conception of Oslo as an orchestrated plan to continue and intensify the occupation of Palestinians is also understood by Israeli political analysts such as Meron Benvenisti, who when writing in regard to the agreements made in the DoP explains that Oslo 'is no more than permanent Israeli domination in disguise [...] Palestinian self-rule is merely a euphemism for Bantustanisation'.[30] Yet in spite of all this, the Oslo Accords continue to be the basis of peace negotiations, regardless of the grave and obvious deficiencies of the agreements.

Ali Abuminah, the founder of the *Electronic Intifada,* accurately describes the contemporary perspective on the accords: 'the lasting legacy of the Oslo process is that far from advancing the two-state solution, it in fact laid the groundwork for the fragmentation of the occupied territories'.[31] The obvious reference here is to the growth of settlements, the division of the West Bank into Areas A, B and C and the construction of the Separation/Apartheid Wall. Given the sorry state of affairs that currently reign in the region, Oslo runs the risk of appearing as a distant memory, a historical moment and opportunity lost under the weight of the Palestine/Israel impasse. Importantly, the traces of Oslo are marked daily for those living in the West Bank. One might say that West Bankers live in a perpetual Oslo interim period, waiting for final stage negotiations that now appear as a pipe dream. An interim period that was supposed to last a few years has now abominably come to define everyday life in the West Bank for two decades.

Laying witness to the Bantustanism that currently prevails in the West Bank, Oslo clearly marked a destructive change for Palestinians on the ground in terms of their rights, movement, resources and political power. Yet Oslo marked another significant change in the conflict; a radical shift in the way Palestinians saw themselves and their collective identity. In the years building up to Oslo, Palestinians were often framed in terms of a collective 'revolutionary identity'. Over the decades prior to the Oslo Accords, Palestinians had deliberately framed themselves within the scope of a revolutionary collective identity in order to elude the stigma of the

refugee identity projected on them as a result of the Nakba. The revolutionary identity was most pronounced up until 1982, when the PLO was forced to leave Beirut. The revolutionary identity visibly re-emerged prior to the end of the first Gulf War. The devastation brought by the events of the Gulf War served to diminish the popularity of this identity as it became clear that Palestinian oppression and the consequent striving towards liberation were a political issue that could be manipulated for the political benefit of others. The revolutionary identity had not delivered what it was originally thought to promise and a change in political approach and national and collective identification was in some senses now inevitable.

Oslo marked a clear turning point for the Palestinian revolutionary identity because the recognition of Israel and the consequent diplomatic relations that came as a result of the DoP was orchestrated to force the revolutionary Palestinian identity to the sidelines. Given that the PLO had to now accept the essential responsibility of all governments not to allow its citizens to attack their neighbours, Palestinians had to, at least officially, let go of the images of *fedayeen* freedom fighters and the idea of revolution by force.

Notwithstanding this transformation in self-perspective and the fact that on all fundamental issues (Jerusalem, water, repatriation, sovereignty, security, and land) Palestinians have essentially gained nothing, one must ask what good actually came of Oslo?[32] Surprisingly, the success of Oslo extends beyond the mere heartwarming photos of Yasser Arafat and Yitzhak Rabin shaking hands for the first time. More symbolic than even these images is the fact that Oslo marked the first real time that Palestinians achieved a certain stability. That is to say, that their identity, collective national struggle and right to the land – something that had been constantly under question over the years – finally became officially recognised internationally. The world's gaze had ultimately granted the Palestinians cultural legitimacy and recognition.

However, this recognition did come at a significant cost; it meant the abandonment of the long narrative of resistance and revolution that had underpinned Palestinian nationalism for decades. Leaving aside the catastrophic political consequences of Oslo for a moment, let us again consider the photograph of the Oslo Accords Signing Ceremony, this time remembering that

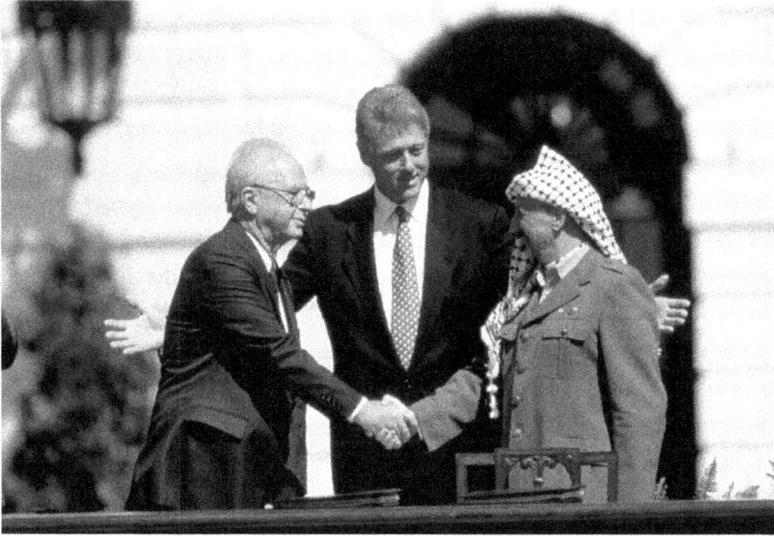

Fig 5. Oslo Accords Signing Ceremony, Press Photograph, 1993
Credit: Cynthia Johnson, The LIFE Images Collection, Getty Images

the image stands as a signifier of the moment Arafat agreed to acknowledge Israel and, at least officially, abandon the revolutionary struggle.

This image of Arafat stands in direct opposition to the revolutionary nationalist iconography that characterised Arafat, not only as the Palestinian political leader, but also as an icon of Palestinian nationalism. Despite wearing his distinctive militaristic garb and keffiyeh (referencing the Arab revolts prior to 1948), Arafat is depicted here not with an AK47, nor steadfastly looking into the distance. Rather, he is shown shaking hands with 'the enemy', even smiling while he does so. The radical disjunction between historical depictions of Arafat as a revolutionary hero and his depiction as a diplomatic partner to peace in the photographs of the Oslo Signing Ceremony leads one to suggest that the photograph of Arafat shaking hands with Yitzhak Rabin functions as a form of iconoclasm.

The photograph of the Signing Ceremony functions as an iconoclastic gesture because it actively destroys the iconography surrounding Arafat as a Palestinian revolutionary hero and visually signifies a shattering of Palestinian militant nationalism. Though it cannot definitely be said

whether Arafat was complicit or indeed conscious of the ramifications of this iconoclastic gesture, one thing is certain: the image both served to undermine Arafat's deliberately constructed iconography of Palestinian nationalism and it signaled an end to the dominance of the Palestinian revolutionary identity. Arafat's decision to agree to the DoP continues to astound writers and commentators, as the DoP not only fundamentally challenged Arafat's authority both politically and symbolically, but also because the Accords were arguably designed to fail from the outset.

Palestinians would become by far the biggest losers in the Accords, providing far more concessions in the agreement than Israel. This explains the popular joke about Arafat's refusal to take his wife Suha to the signing of the first Accord in Oslo. The joke suggests that at Oslo, Arafat gave away too much control to Israel, so much so that if he were to have taken Suha, he would have happily given her away too. The joke signifies how far removed Arafat had come from the revolutionary identity and iconic status that he had been previously associated with. In turn it also reveals the failure of Palestinianism and a departure from a mindset characterised by the ethos of 'revolution until victory'.

The signing of the Accords marked a moment of iconoclasm that signalled a critical junction in the reshaping of Palestinian identity and its narration. It is useful here to return to the idea of Oslo as the punchline of Palestinian identity. To unpack this comparison, it is beneficial to consider Oslo literally as a joke. We should consider for a moment what humorologists call Incongruity Theory. The Incongruity Theory of humour suggests that laughter comes as a result of a defiance of our expectations.[33] Take for example the structure of jokes we are most familiar with, where a long meandering story is told, leading to what we call a punchline. The punchline marks the moment where our expectations are fractured and as a result we laugh. It would seem that Oslo was the punchline of Palestinian identity, the end of a long narrative of resistance and nationalism centred on political revolution and militarism and the moment the world expected would bring about peace in the region. Instead, Oslo delivered to the Palestinians a cruel punchline, one that denied their expectations and hopes, reshaping their identity and leaving them in what is now the worst period in their history. It was with this Oslo punchline that we witness the explosion of laughter and humour in Palestinian art and film. The laughter

that followed Oslo continues to encourage a new experimentation with Palestinian identity, one that tests the very boundaries of 'Palestinianness'.[34]

The humour that emerged in Palestinian cultural output challenged 'Palestinianness' in essentially three ways: first, by calling into question the identification with the landscape and by attempting to delineate the 'borders' of Palestine, a place that remains both politically and symbolically 'borderless'. Second, this humour serves to draw attention to the ongoing Israeli occupation and its consequences for Palestinians. Finally, this humour can be seen to coalesce a sense of collective Palestinian identity. Broadly speaking, however, the emergence of humour in Palestinian cultural output signified a departure from the aesthetic modes that had previously dominated both art and film.

Following the critical junction of Oslo, Palestinian cultural output began to veer towards a new path, one that took a course away from the dominant esteem placed with the documentary genre and documentary modes. The reasons for documentary dominance are many and varied, yet the primary explanation for the popularity of the documentary genre and aesthetic can be attributed to the fact that first, in the case of film, documentaries are cheaper to produce, and second, that the documentary in both art and film seems an obvious choice for a cultural group sublimated within the historical archive.

The documentary form has not only been esteemed by Palestinian filmmakers and artists but also appears to be the genre and mode of choice for audiences. Film in particular carries a long legacy of the documentary and the continuing urge to tell the Palestinian national narrative explains why the divergence from the documentary form by Palestinians filmmakers is often treated with contempt, seen as an unnecessary folly that distracts from the urgency of telling the national story. Though fictional works that continue to didactically retell the national narrative appear impervious to this kind of criticism, others are not so fortunate. One excellent example is the harsh criticism received by Michel Khleifi for *Wedding in Galilee* and more recently *Zindeeq*. As the first major Palestinian filmmaker working outside the documentary form, Khleifi is the primary example of how straying from the national narrative continues to attract criticism.[35]

Given that the Palestinian story is still seen as under threat, censored and sublimated, the filmic approach to the documentary as best candidate

for the narration of the national story is symptomatic of the view of documentary as an 'assertoric' medium, a perspective that approaches the documentary as 'the film of presumptive assertion'. For film theorists such as Noel Carroll, this means that the documentary cannot be conceived of as fiction.[36] As a genre that might be included among the 'discourses of sobriety', the documentary is often problematically associated with the real – as direct, immediate and transparent.[37] Within a conception such as this, any move away from the documentary by filmmakers (and indeed artists) might be seen as straying beyond the narrative boundaries of 'Palestinianness'. These boundaries, however, present filmmakers and their output with a series of constraints that are now becoming more widely acknowledged and investigated.

The constraint of the Palestinian entwinement with the documentary form is poetically captured in Jean Luc Godard's 2004 film *Notre Musique*. In the film, the director is seen entering a classroom where he tells a group of students that in 1948 the Jews (or more appropriately, the Zionists) 'walked out of the water, the Jews became the stuff of fiction, the Palestinians became a documentary'.[38] Godard's ironic distribution of genres between the Israelis and the Palestinians echoes the sentiments of philosopher Jacques Rancière who notes that 'the division between the freedom of fiction and the reality of the news – is always a distribution of possibilities and capacities'.[39] For Rancière, this division creates a world divided between those who can and those who cannot afford the luxury of playing with images.[40] He elucidates upon this idea by explaining that in such a world, Palestinians 'can only offer the bodies of their victims to the gaze of news cameras or to the compassionate gaze at their suffering'.[41] Within this framework, the documentary takes the cinematic role of the news camera, depicting Palestinian life within the scope of predetermined possibilities and capabilities.

Ostensibly, the documentary and its corresponding didactic and linear characteristics seem an ideal genre for the case of Palestine. The appeal may correspond to a phenomenon discussed by Palestinian author Ghada Karmi, where the Palestinian conflict is argued to be presented as a series of news sound bites that often do not allow the listener to hear the story from the beginning, that is to say, starting from the Nakba.[42] To follow Kharmi's assessment is to realise the inclination towards documentary, in

that it more often than not allows the audience to hear and see the story from the start, with a coherent beginning, middle and end, and certainly without the threat of disorienting gaps and sound bites in between. This understanding is also nurtured by the conventional idea that the documentary practice and aesthetic can carry the weight of capturing the 'real' and the 'unseen'.

Though much of Palestinian documentary practice is wary of the pitfalls of placing too much esteem on the genre, much documentary output continues to subscribe to the idea that this genre of film can best reveal the Palestinian plight and change public opinion. Theorist T.J. Demos locates the problems with this perspective through a comparison to mainstream media: 'if mainstream reporting refers primarily to its own set of codes rather than to reality itself [...] then what hope can the documentary exposé have in challenging public perception in the media's regulated environment?'.[43]

The venture towards a conveyance of suffering under occupation is what buttresses the 'traumatic realism' commonly understood to characterise Palestinian cinema.[44] The danger implicit in the overabundance of this traumatic realism is that it plays into the notion of what has been described as 'Pallywood' cinema.[45] Coined by historian Richard Landes from Boston University, the term 'Pallywood' originally referred to the contested media coverage of the death of 12-year-old Muhammad al-Durrah in the second intifada. For Landes, 'Pallywood' is used to illustrate the perceived theatricality of al-Durah's death as emblematic of what he believes to be Palestinian propaganda and media manipulation. Though the impetus behind Landes' terminology is skewed to support Israel and his short online documentary on the topic named *Pallywood: According the Palestinian Sources* has all the hallmarks of conspiracy theory, his term does tap into a genre of Palestinian victim reportage, that as Demos writes, is 'clichéd – and all too easily dismissed'.[46]

Investigating this genre closely reveals that its dismissal extends beyond those that support the actions of the Israeli state. The central dilemma of this genre is that while it is intended to expose the brutality of the Israeli occupation and to encourage support of the Palestinian plight from audiences, it also runs the risk of maintaining the status quo by feeding into dominant narratives supporting the conflict.[47] As a result, one can also locate

the risk of exhausting the audience's ability to sympathise or bridge a point of connection with the trauma of Palestinians they see on their screens.

One avenue suggested to hold potential in eluding this problem, is that of opacity. Writing in regard to the London-based Otolith Group's documentary film *Nervus Rerum* (2008), a work that attempts to illustrate the Jenin refugee camp without anthropological insight or transparency, Demos suggests that 'drawing out the opacity of the image, unleashes its potential'.[48] This observation may also be channeled into discussion of the cinema that refuses to didactically narrate the Palestine story, thereby transgressing inscribed political roles and expectations. In Rancièrian terms, this achieves a 'dissensus', 'a way of reconstructing the relationship between places and identities, spectacles and gazes, proximities and distances'.[49] The creation of the dissensus is generated in order to achieve 'a space of play', a space where Palestinians may move beyond their place in the distribution of genre.

To return to *Notre Musique* as a film that deals with this issue quite directly, it is worthwhile to consider the words of Palestinian national poet Mahmoud Darwish, who in the film describes himself as a Trojan bard. Pondering whether the Trojans were defeated by the Greeks because of their lack of poetry, Darwish explains that he is looking for the poetry of the Trojans. Here he makes the point that as mere players in the Euripedean epic, the Trojans are voiceless and remain forever etched in history as victims. This point conveys the idea that cultural output that enjoys the luxury of playing with images and ideas is integral to freedom and empowerment.

Let us return to the two consequences of Oslo mentioned previously. That is, that the signing of the Accords granted international recognition of Palestinian cultural singularity and validated their rightful connection to the land. Oslo also signalled a moment of iconoclasm that destabilised Palestinian nationalism anchored on revolutionary struggle and militancy. When considering these two outcomes of the Accords in unison, one can understand how Oslo allowed Palestinian artists and filmmakers the ability to transgress pre-inscribed political roles and expectations. In addition, Oslo reconstructed previous perceptions of Palestinian identity and connection to place, thereby reframing the international gaze upon their

struggle for nationhood. In such a way, Oslo created a space for Palestinians to engage in 'dissensus' and to open up a new space of play.

This newly opened space of play provided Palestinian practitioners the ability to break out from the confines of nationalist iconography, thus affording them the opportunity to participate in what Rancière describes as 'the luxury of playing with images'. This meant that artists and filmmakers could use their work to push the boundaries and to question the terms of Palestinian national and collective narration. It was in this newly formed space of play that followed Oslo that one begins to detect the growing use of humour in art and film. This employment of humour brought with it a new set of narrative tactics and consequences for the understanding of Palestinian identity and the expression of national struggle.

The emergence of humour in Palestinian art and film has reframed the approaches, consequences and indeed the ethics of representing the collective trauma of the Palestinian experience. Faced with the failure of the peace process, collective punishment, ongoing exile and dispossession, humour initially seems not only surprising but also perhaps problematic. It begs the question, what does it mean to laugh at – or with – heartbreak?

This question is reminiscent of the suggestion put forth by the foremost philosopher of the twentieth century Theodor Adorno in his statement that there can be no poetry after Auschwitz. At its core, the inquiry into the relationship between laughter and repeated collective trauma extends the parameters of Adorno's assertion and encourages a new model from which to reconsider the philosopher's argument that reason has become entangled with domination and suffering. This new paradigm rests at the heart of why the humour that has emerged in Palestinian art and film is so compelling: it demonstrates how the laughter instigated by oppressed and marginalised groups – whose lives continue to be punctured by the experience of trauma – provides a new way of thinking about *and* thinking through human suffering.

The emergence of humour in Palestinian cultural output following the failure of the peace process can also be considered through another of Adorno's statements: 'rational cognition has but one limit: its inability to cope with suffering'.[50] Humour emerged in cultural output at a moment of Palestinian suffering, that came as hopes for peace and a sovereign Palestinian state were diminished as the peace process was continually

seen to fail. Further, it emerged when there was an acute disavowal of the 'rationality' of both the international justice system and the Palestinian revolutionary struggle. It is perhaps for this reason that Palestinian cultural output turned to humour at a time of political despair, serving to amplify the failure of 'rationalism' associated with the peace process and the Palestinian nationalist movement.

Significantly, Oslo was also responsible for the influx of international funding into the Palestinian Territories from various governments and non-government organisations. With this funding came a growth in Palestinian arts organisations, the establishment of galleries and the opportunity for artists and filmmakers to participate in residencies around the world. These changes were partly responsible for the astonishing growth of the international profile of Palestinian art and film since the middle 1990s. It is important to note that Palestinian cultural output achieved a pronounced place in the international art and cinema market at a time when international trends in both of these media turned towards an emphasis on humour. This meant that Palestinian cultural output mirrored wider international trends in art and film that have for the last two decades been characterised by a critical use of laughter and a humour noir approach. In such a way, humour has lent Palestinian artists and filmmakers a passport to international recognition because they employed a technique and conceptual emphasis that was in keeping with work from the 'centre' of both industries.[51]

However, that is not to say that when Palestinian art and film is presented in international contexts that its humour is easily understood. Though we may laugh at instances of 'universal' humour such as slapstick in film, or incongruous elements depicted in art, our laughter or indeed silence at specific humorous cues signifies our participation in what philosopher Simon Critchley describes as the 'secret code' of humour.[52] For non-Palestinians, access to this 'secret code' is contingent on a familiarity with Palestinian signs and symbols and an understanding of Palestinian history. Our laughter (and indeed silence) towards humorous output instigates an inquiry into further understanding how or why a work is humorous, therefore calling for a deeper understanding of the issues explored in the work.[53] Here lies the greatest potential of humour in Palestinian cultural output: that it prompts viewers to understand the Palestinian 'secret code' at work in art

and film, thereby leading them into an inquiry of Palestinian history and experience.

Working in a space of play, the humour of cultural output also confronts audiences with their stereotypes and assumptions about Palestinians. These stereotypes are not always the overtly negative ones that pitch Palestinians as either terrorists or political fanatics. These stereotypes can also circle around the view of Palestinians as victims of history that must be looked upon with a compassionate gaze.[54] Forging a new lens for the comprehension of 'Palestinianness', humour provides audiences with an alternative way of engaging with the Palestinian experience. This potential of humour was perhaps best put by the philosopher Slavoj Žižek, notable for his crudeness, who when on a 2011 trip to Ramallah for a talk to Palestinian students explained 'I prefer to laugh at you than to give you charity and feel good about myself'.[55] Sounding initially like an abrasive statement, Žižek here is actually noting that humour can break the deadlock of the compassionate gaze, dislocating our familiar response to the Palestinian plight and providing an alternative path to understanding. More broadly however, Žižek's comment taps into the wider argument about the benefits and deficiencies of laughing at the humour of oppressed people. In humorological scholarship this debate lies within the discourse surrounding 'ethnic humour'.[56]

The most noteworthy research into the representation of foreigners in ethnic humour can be accredited to Christie Davies, whose book *Ethnic Humor Around the World* laid much of the groundwork for understanding the basis of ethnic humour and why it ought to be disassociated from prejudice.[57] Although Christie's text lacks an in-depth analysis of how ethnic humour is enjoyed by members of the same group, his work is distinguished for its criticism of the idea that ethnic jokes always indicate hostility towards targeted groups. Claiming that ethnic jokes in particular are shared because they can provide a momentary superiority (even for those who are themselves the victim of ridicule), the point of such humour is argued by Christie not to be about aggression but rather as a way of 'playing' with aggression.[58] Leon Rappoport consolidates Christie's argument by writing that 'to laugh at some aspect of your family or ethnic group can be an essentially healthy way of releasing conflicted negative emotions. It allows us, at least momentarily, to rise above them'.[59]

This stance towards ethnic humour is also implicit in the work of Simon Critchley and the theologian Jacqueline Bussie. Their work is notable for the ways in which they utilise all theories of humour to engage with the impetus behind laughter and its consequences. Though they refrain from the use of the term 'ethnic humour', their work deals with laughter's social role and its consequences for marginalised groups. For Bussie, humour is an invaluable tool of resistance for oppressed groups used to deconstruct ideology. Claiming that laughter might hold a certain redemptive or even messianic power, Critchley defends the idea that humour returns us to a familiar world of shared belief and cultural meaning while also revealing a situation and indicating how it might be changed. Humour's potential to allow us to imagine the world as a better place and to urge us to change the situation in which we find ourselves is why he considers laughter to be messianic, going so far as to compare jokes to shared prayers.[60] In the revelation presented by ethnic humour of what is morally and ethically wrong, we see the world's folly for what it is. Unlike religion, humour 'does not save us from this folly by turning our attention elsewhere [...] but calls us on to face the folly of the world and to change the situation in which we find ourselves'.[61]

These approaches are in line with my argument that humour has an emancipatory capacity. It enables a rethinking of our experience of suffering, oppression and marginality. It also provides a new point of access for understanding the trauma of others. Thus, through laughter, the marginality faced by oppressed groups is given a new passage for expression and a new mode for the narration of their experience. In the case of humour created by Palestinians, this extends an opportunity to relate political and cultural oppression in a way that re-imagines the current political status quo. The laughter elicited by Palestinian humorous output therefore implicates audiences in ways that might otherwise be impossible through normative forms of language and communication, forcing audiences to re-evaluate their understanding and position towards the Palestinian plight, experience and history.

Having now understood Oslo as the punchline of Palestinian identity that led to the emergence of laughter in Palestinian cultural output, one must look to how humour in contemporary art and film operates as an alternative vehicle for the representation of the current political, economic

and cultural experience of Palestinians in the wake of the failure of the peace process. In our time of increased contestation and ambivalence about where, or what constitutes 'Palestine', art and film can reveal how humour is a vital technique capable of framing the boundaries and indeed the borderlessness of the place we call 'Palestine'.

4

Finding Palestine: Humour and the Delineation of 'Palestine'

'Palestine is the state of Palestinians wherever they may be.'[1]
The Palestinian Declaration of Independence
(Algiers Declaration), 1988

Though undoubtedly we live in an age of globalisation and increased mobility, the description of work as 'Palestinian' is different to other national or cultural descriptors such as Australian, Italian, Canadian, or Egyptian because Palestinian mobility is a consequence of statelessness. Therefore, artists and their works may be described as Palestinian, even if the artists themselves have lived in exile away from Palestine for generations. Put simply, the tag 'Palestinian' instantly frames the work of Palestinian artists and filmmakers as being informed by a complex identification with place.

Perhaps surprisingly, artists and filmmakers have employed humour as a way of negotiating the question of where/what constitutes 'Palestine'. The laughter induced by their tactics of humour unveils a collective and cultural identity that implicates 'Palestinians wherever they may be'. Further, humour can be seen to act as descriptive vehicle that delineates the borders of Palestine and 'Palestinianness'. The struggle to delineate the boundaries of Palestine is an emphasis found in much Palestinian cultural output preceding forms that use humour. Being both of theoretical and political importance, the attempt to delineate the borders of Palestine is an ongoing

and continual process. This struggle is perhaps nowhere better articulated than in the Palestinian Declaration of Independence.

The Palestinian Declaration of Independence (otherwise known as the Algiers Declaration) of 15 November 1988 was pivotal in future peace negotiations because the document recognised Israel's right to exist – and renounced terrorism – despite its insistence on the right of the Palestinian people to fight against foreign occupation. Calling for the continuation of the first intifada that was going on at the time, the Declaration accepted UN Resolutions 242 and 338 as the framework for peace negotiations and a two-state solution to the conflict.[2] These points within the Declaration meant that the document carried tremendous weight with respect to shifting principles in the struggle for liberation. However, a single line from the Declaration continues to stand out for its potential ambiguity and poetic double meaning when addressing the point of the Palestinian collective experience of exile.

The line 'Palestine is the state of Palestinians wherever they may be' is in equal parts a clear declaration of the need for a Palestinian state, as it is a seemingly equivocal recognition of collective national identity for a people dispersed and exiled for generations. The Declaration also reinforced the notion that the Palestinian National Council was a parliament in exile and that the PLO was operating as a state in exile, with governing bodies that performed decisions that affected the lives of Palestinians living in Gaza, the West Bank and those in exile around the world. In spite of the practical and straightforward political implications of the statement, the line 'Palestine is the state of Palestinians wherever they may be', also prompts a theoretical enquiry into the collective experience of exile.

The double entendre generated by the word 'state' in the Declaration, no doubt comes as a consequence of the two celebrated Palestinian minds that penned the document: the poet Mahmoud Darwish, who drafted the Declaration, and Edward Said, who translated the document into English. This single line, poetically drafted by Darwish, is qualified in the document by the subsequent sentence 'the state is for them to enjoy in it a complete equality of rights'.[3] Regrettably, the failure of the peace process and the devastation brought as a consequence of the ongoing occupation means that Palestine still has some way to go before Palestinians can enjoy their 'collective national and cultural identity' and an 'equality of rights'.

Knowing this, the idea of Palestine being the 'state' wherever Palestinians may be continues to carry tremendous political, ideological and theoretical significance. Palestine is not yet an officially recognised state, with even the recent move towards recognition within a UN observer state status causing international debate and a diplomatic scramble. For those engaged in the task of discussing Palestine within a public forum, the problem of what the word 'Palestine' actually entails will be a familiar one. Depending on the context, the noun 'Palestine' can signify a plethora of places, including Gaza and the West Bank, Israel, land defined in pre-1967 borders or indeed historical Palestine. Inevitably this problem signifies a much bigger question – what does 'Palestine' mean?

This question inevitably arises when dealing with the presentation of Palestinian culture within an international context. Given that many Palestinian artists and filmmakers were born, trained and practice in exile, the term 'Palestinian' becomes an issue of identification rather than a question of citizenship or residency. By implication, this means that a Palestinian survey exhibition or film festival inevitably becomes an event made up of work from all around the world.[4] Increasingly artists and filmmakers have turned to humour as a way to explore both the connection to Palestine and to describe where/what Palestine is in an international exhibition context.

A clear example of this employment of humour is the actress Areen Omari's directorial debut short film *First Lesson* (2012). A reflection of the actress's own experience of first leaving Palestine for Paris, *First Lesson* chronicles the story of a character named Salma, an actress who relocates to Paris in an attempt to settle in a city far away from the daily stressors of her hometown. *First Lesson* is marked by the deliberate attempt to convey a 'real' account of the filmmaker's own experience: to this end Omari both decided to both star in her own film (as Salma) and to shoot scenes in Paris in her own apartment.[5] The only substantial deviation from this was the director's decision to depict her hometown as Jerusalem rather than Ramallah. Omari's justification for this decision comes, as she explains, because 'symbolically I want to be at the place Israelis say is our capital [...] I want this to be documented in a film because I believe cinema protects memory'.[6] Despite the film starting in Jerusalem and featuring many of the director's peers in the Jerusalem theatre scene, *First Lesson* is essentially

a reflection upon Omari's first language lesson in Paris. This experience was so troubling for the filmmaker that she chose to star in her directorial debut in the belief that this would render the film closer to a documentary and a 'real' depiction of her experience.[7]

Capturing the surprising expressions of national identity that emerge when one finds themselves away from home, *First Lesson* blurs geographical boundaries and the line between fact and fiction and laughter and tears. The main scene from the short begins with Salma's arrival to her first French lesson, where she is greeted by classmates from around the world including students from Russia, Japan, Israel and the US. As is typical of most first lessons, the teacher of the class asks each student to stand up, introduce themselves and explain where they are from. When it is Salma's turn to address the class she explains that she is from Palestine and then proceeds to point out Jerusalem on the map at the front of the classroom. Her gesture and proclamation of her identity in front of the class sparks outrage from two of her classmates. These classmates, one Israeli and the other American, begin to call Salma crazy while denying Palestine's existence, claiming that Salma is in fact pointing to Israel on the map. Although Salma is supported by one other classmate (who claims Salma's assertions are right and proceeds to justify his certainty with the words 'I know, because I am an Arab'), the class is left divided by the conflict they have just witnessed and the teacher decides to forcefully end the lesson.

The scene of Salma's first lesson, though beginning with humorous exchanges typical of the encounters between different cultural groups, quickly descends into a scene of anger and sadness entangled with political confrontation. The brief scene exposes the ongoing debate surrounding Palestine's political and geographical borders and indeed its very existence. Whether an intentional cinematic technique by Omari or otherwise, this debate on screen is visually amplified by the fact that each time Salma points to Palestine on the map during her argument with her Israeli classmate, her finger drifts further away from Palestine/Israel's location on the map.

First Lesson presents much more than just a reflection of the pain and struggle encountered with homesickness and the decision to move away from the homeland. Rather, *First Lesson* also depicts the ongoing

Fig 6. Areen Omari, *First Lesson*, Film Still, 2010
Credit: Image Courtesy of Areen Omari

ambiguity around where and what 'Palestine' is and the difficulties encoun-
tered when identifying as Palestinian. This is conveyed not just through
Salma's argument with her classmate, but is also communicated by subtle
cinematic techniques. The film creates repeated momentary confusions of
place, where Parisian streets look for a moment as if they are Jerusalem,
and Salma's Russian twin classmates bear an uncanny resemblance to her
theatre director friend in Jerusalem. This has the effect of momentarily
disorienting the audience by blurring the lines of distinction between Paris
and Jerusalem.

These repeated conflations of place in the film also serve to reinforce a
much bigger and overall more significant point: namely that we carry our
sense of home with us wherever we go. For Palestinians who have endured
the experience of collective exile for generations this notion is one with par-
ticular pertinence. In this sense, *First Lesson* arguably reveals the potency
of the Declaration of Independence's statement that 'the state of Palestine
is wherever Palestinians may be'. This has the effect of not only signify-
ing one's identity or identification with place but also results in every new
'home' becoming merged or blurred with the homeland.

First Lesson's equally humorous and tragic enquiry into the geograph-
ical location of Palestine and the fraught identification with Palestine as a

homeland is a theme that is also evidenced through much contemporary Palestinian art and film. The work of London-based artist Larissa Sansour also carries this line of enquiry, albeit in ways that draws upon popular culture and the genre of science fiction. Her works *Space Exodus* (2006) and *Nation Estate* (2012) reveal the capacity of humour to uncover the complex relationship of Palestinian identification with place and the question of what constitutes Palestine.

For the last decade, Sansour's work has been characterised by a distinctly critical or humour noir approach to issues pertaining to Palestine. Employing the language of popular culture, Sansour's multidisciplinary approach embraces photography, video art, documentary and installation. Sansour's decision to reference popular culture in her works dealing with Palestine has the consequence of layering multiple meanings, implicating alternative visual vocabularies and destabilising conventional associations to Palestine. Sansour's subversion of typical portrayals of Palestine marks a significant departure from the dominant iconographies surrounding Palestine that have prevailed in the past. The use of popular culture has the effect of simultaneously drawing from essentialised representation of Palestine while nullifying the essentialist readings they might have previously encouraged.

Tina Sherwell explains the history of essentialised iconography that exists for both Palestinians and Israelis, writing that:

> The mainstream Palestinian and Israeli nationalist discourses have both favoured essentialist representatives in the context of an uneven conflict compromising the historical claims of peoples in the same stretch of geographical terrain. And both have used different iconographies to represent their original, historical and eternal relationship to the land.[8]

The success of Sansour's work rests on her ability to conflate these Palestinian iconographies with those of popular culture. This technique is evident in her best-known works *Space Exodus* and *Nation Estate*.

A parody of Stanley Kubrick's *2001: A Space Odyssey* from 1968, the *Space Exodus* video work takes the audience on a five-minute journey with the artist through space, as she becomes the first Palestinian to land on the moon. Appropriating *2001: A Space Odyssey*'s recognisable musical score

altered to arabesque chords, *A Space Exodus* channels Kubrick's questioning of the deeper philosophical implications of humanity's origins and final destiny in the universe, creating parallels between these concerns and the contemporary political Palestinian impasse.

Sansour's decision to alter the score of Kubrick's film by using arabesque chords parodies not only *2001: A Space Odyssey* but also Strauss's original composition of *Thus Spoke Zarathusa*. Coupled with the image of Sansour's astronaut boots with upturned toes, the artist channels the Western Orientalist imagination of the Middle East. The conflation of the Orientalist imagination with the pop culture references to *2001: A Space Odyssey* have the effect of nullifying any essentialised view of the iconographies Sansour channels in her work. This has the effect of creating a hermeneutic impasse that links the work to the fundamental ambiguity inherent in the term, and concept of, history.[9]

The use of parody in *Space Exodus* has the effect of not only drawing out the ambiguity of the concept of history but also the latent ambiguity that exists in the narration of Palestine through national signifiers and iconography. Although Sansour relies on some of the iconography of Palestinian national identity, including the Palestinian flag and *fellahi* embroidery, her deliberate decision to omit signifiers of the Palestinian geographical terrain serves to differentiate her work from the dominant symbols of the land in Palestinian art history and also functions to project a future scenario where Palestinians are divorced from the land of Palestine completely.

Space Exodus begins with Sansour as an astronaut on board a spacecraft, attempting to make contact with her base at Jerusalem while saying 'Jerusalem, we have a problem', followed shortly with the words 'no, we are on track'. Ironically, although Sansour is 'on track' and does finally arrive on the moon, the moment she does so she loses all contact with Jerusalem. The moment Sansour finally plants the Palestinian flag on the moon, the dark realisation surfaces that this has meant losing all contact with the homeland and bidding farewell to earth itself. Arriving on the moon has thus in fact meant that the Palestinian astronaut now finds herself floating through space, wandering isolated and alone unfathomably far from home. As the astronaut drifts off into space and becomes invisible at the conclusion of the video, the viewer is prompted to realise that this final

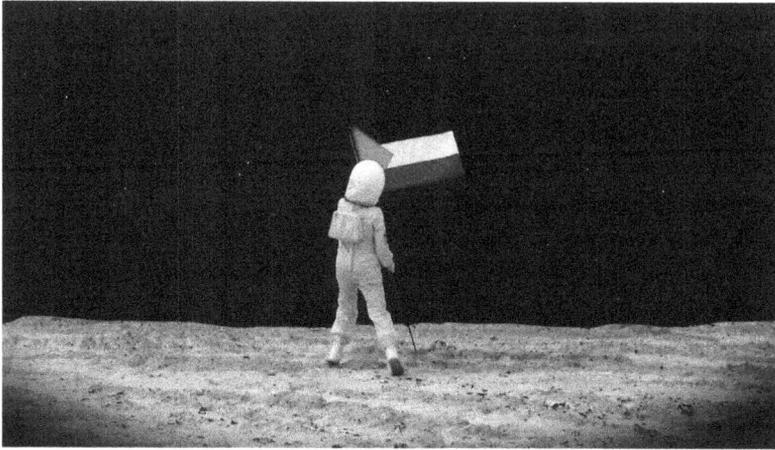

Fig 7. Larissa Sansour, *Space Exodus*, Video Still, 2009
Credit: Image Courtesy of the Artist

Palestinian space exodus is one that threatens to remain invisible, essentially a private grief for Palestinians and one that we cannot see.

It is here that we might be reminded of Mahmoud Darwish's poem *Earth Narrows Before Us* and the line 'where do the birds fly after the last sky?'[10] *A Space Exodus* provides a glimpse into a world where Palestinians have literally gone beyond the last sky, losing contact with both the beloved capital of Jerusalem and planet Earth. An image that initially appears as both humorous and politically empowering, Sansour's planting of the Palestinian flag on the moon can also suggest a sense of despair and helplessness. Importantly it also suggests a real disillusionment with the ability for Palestinians to achieve their own state and to maintain a connection to the land of Palestine. Sansour's declaration that it is 'one small step for Palestinians, one giant leap for mankind' implies with bitter irony that finally an outcome for the peace process has been achieved and a place for Palestinians has been established; however, this place is after the last sky and beyond the confines of our planet.

The interplay between reality and fiction is an interest that is cited by Sansour as running across her entire oeuvre. The artist's decision to focus on narratives that blur the line between utopian and dystopian worlds comes, as she explains, because of her fascination with 'how much of

103

reality ends up mimicking fiction, rather than the other way around'.[11] Despite her frequent use of motifs borrowed from the genre of science fiction, Sansour's work also carries an autobiographical dimension that the artist sees as integral to her 'artistic agency'. Almost always appearing in her own work and even casting her own siblings in her projects, Sansour draws upon the autobiographical to reflect upon both the personal and collective Palestinian experience. *Space Exodus* is an example of this as it not only reflects upon the exile from Earth but makes clear reference to the inability to reach Jerusalem. Revealing how this reflects upon her experience, Sansour explains that 'I was born in Jeruslem, but like most of Palestinian history and culture evidence of this [the Palestinian presence there] is slowly being erased [...] I cannot access Jerusalem and only memories of it remain, making reality as surreal as the universes I create in my work'.[12]

Sansour's *Space Exodus* is characterised by the use of two forms of humour; those of incongruity and humour noir. Although the most obvious popular culture reference in the piece is to the work of Stanley Kubrick, *Space Exodus* also alludes to the moon landing, the biblical narrative of the exodus of the Israelites as well as Otto Preminger's Hollywood blockbuster *Exodus* from 1960. The allusion to the biblical exodus and the Hollywood film in the work is explained by Sansour as being a deliberate attempt to counter 'their share of damage in influencing international understanding of Palestine and lending of credibility to the Israeli mythology [of] 'A land without people, for a people without land'.[13] Significantly, however, Sansour's work defies not only our expectations of pop culture, but also our assumptions of Palestinian art. This is achieved by using the symbol of the flag and placing it in a context that takes it beyond the framework of the nationalist iconography that dominated Palestinian art in previous decades. Sansour's parody of Kubrick also creates an incongruity between the contemporary political concerns of Palestinian statehood and the original film's questioning of humanity's future.

The congruity, or indeed conflation, between the present and future in the work has the effect of making us laugh despite the fact that the work is a melancholic reflection or the current dismal state of affairs for the Palestinian struggle for statehood. In this sense *Space Exodus* is characterised by the use of humour noir that draws together the tragedy of Palestinian exile and dispossession and our reply with laughter. Sansour's

bleak view of the prospect of Palestinian statehood represented in *A Space Exodus* is also evident in her work, *Nation Estate*. Where *Space Exodus* suggests a dystopian future where outer space might be the only home left for Palestinians, *Nation Estate* relegates Palestine to a skyscraper that holds almost all Palestinian cities, landmarks and national signifiers.

The work is a photographic and video project the artist claims was shaped by the important recent political events of the Palestinian bid for statehood at the UN and their recognition as a member of UNESCO in that it rests its emphasis upon the continuing struggle for a Palestinian national home.[14] Drawing attention to continuing Palestinian dispossession, the skyscraper depicted in *Nation Estate* is built outside the actual city of Jerusalem, with only the building's top floors having views of the Dome of the Rock. Ironically describing the skyscraper in the work as the Palestinian 'high life', Sansour draws parallels to housing estates and to Palestinian camps where the occupation has created an impossible density of living and crowded conditions have required refugees to continually build one structure on top of another.

In its initial form in 2011, the *Nation Estate* project existed as a series of 'sketches', while the video component of the work was in post-production due for completion in late 2012. Even before its formal completion, the work had already received its fair share of international controversy. In late December 2012, Sansour's international network all received a press release from the artist informing them of a 'quite severe act of censorship' she had just experienced.[15] The artist had recently been asked by the Swiss Musee a l'Elysee to produce a portfolio of images for the prestigious Lacoste art prize. In November 2011 three photograph 'sketches' from the *Nation Estate* project were accepted by the museum, and Sansour was congratulated as being one of eight artists shortlisted for the prize. However, by December, the prize's sponsor, the clothing brand Lacoste, made demands that Sansour's work be revoked from the prize on the grounds that it was 'too pro-Palestinian' to support.[16]

Although the work does not demonise Israel in a straightforward sense, Sansour's use of humour noir allows her to subversively reveal the trauma of occupation while evading any didactic representation of Israel's process of occupation and continuing violence. The black humour of *Nation Estate* is most clear when examining how Sansour utilises national symbols that

have previously dominated Palestinian cultural output. This is most clear in her use of the olive tree, which has long been utilised as a symbol of the Palestinian connection to the land. The olive tree that appears on one of the floors of the nation estate is depicted as removed from the land itself but continues to flourish through a concrete floor, nurtured by the artist herself. In addition, the artist's appearance in the work also taps into the role of women in Palestinian art history, who signify the land of historical Palestine itself.[17]

However, perhaps the strongest message to arise out of *Nation Estate* is the reflection on Palestinian land confiscation. This overt political message in the work means that *Nation Estate* reminds us that Palestinian land is shrinking not only year by year, but in fact week by week. In the work, the virtual Palestinian homeland is presented to the audience while the 'real' Palestine is just outside the confines of the estate skyscraper. The homeland has in effect been reduced to a simulation of real places, reflecting the current reality of the denial of the Right of Return, increasing land confiscation and restrictions imposed on movement.

Sansour explains her use of fiction to describe the contemporary Palestinian political reality by saying that 'reality in some cases could become so fictional that the only way to address it is to make work that exaggerates it even more'.[18] Sansour's use of science fiction motifs in her work has the effect of channeling the genre's characteristically associated questions: namely, do projections of the future have the real threat of becoming an actual reality? *Nation Estate*'s use of the techniques and aesthetics of science fiction thus has the effect of accelerating time and imaging a future where the current restrictions on life brought by the occupation have not been removed. This is clear not only by the fact that Palestinian dispossession is represented as through it has continued to such an extent that Palestinians live in a colossal skyscraper, but also through the function of the building's elevator and the advertisements found within it.

The elevator in *Nation Estate* has the role of the sole form of transport in the future Palestinian estate. Acting as the conduit between floors, and therefore cities, the elevator replaces the intercity checkpoints that Palestinians are faced with in the present. The elevator is not only the sole form of transportation, but also becomes the place for communication within the estate. This space of communication is also one of

commercialisation, as the elevator also displays advertisements for business within the estate. These advertisements encompass a range of daily issues and concerns including those that are commercial, social, official and political. As insights into the Palestine of the future, these advertisements are used as technique by Sansour to reflect on the chief contemporary issues of life under occupation while addressing future problems formed by issues standing in the way of the peace process today.[19]

These advertisements are very much tongue-in-cheek and among others include an advertisement for a sushi shop named 'Gaza Shore' that boasts romantic views, and an advertisement for weekly water supply from a company named 'Norwegian Fjords' that states that the water they supply is part of the 'water pipes for peace program'. These advertisements are indicative of the fact that *Nation Estate* reflects on the acceleration of the processes and instruments of contemporary occupation. Sansour's dystopian and humour noir representation of a potential bleak Palestinian future is informed by what she describes as an 'occupation that has manifested itself in the most absurd and heartbreaking ways'.[20] For Sansour, fiction is an ideal tool for exposing dispossession and occupation because it allows her to operate 'in the face of such acceleration [of occupation] and direct confrontation with an abject reality'.[21]

Projecting a view into the future where issues of the present remain unsolved, *Nation Estate* in effect accelerates time. In such a way, the humour of the work can perhaps be explained by Simon Critchley's thoughts on comic timing. Critchley explains that 'viewed temporally, humorous pleasure would seem to be produced by the disjunction between duration and the instant, where we experience with renewed intensity both the slow passing of time and its sheer evanescence'.[22] This acceleration of time described by Critchley is also clear in the poster work that also makes up part of the *Nation Estate* work.

The *Nation Estate* poster is an appropriation of the now highly politicised 1936 *Visit Palestine* poster. The original poster, designed by Austrian born graphic designer Franz Kraus, was initially published by the Tourist Development Association of Palestine and makes up part of what is known as the 'recruit Zion genre'. Initially intended to encourage the migration and support of a critical mass of Jews prior to the foundation of Israel, the poster depicts an idealised Jerusalem. Kraus's poster,

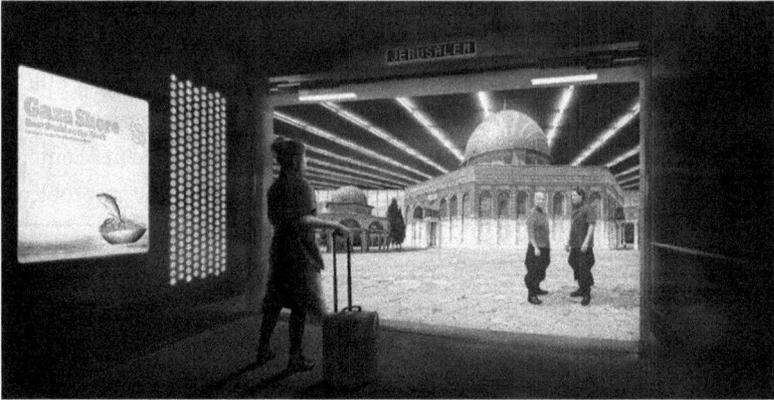

Fig 8. Larissa Sansour, *Nation Estate*, Video Still, 2012
Credit: Image Courtesy of the Artist

with its muted earth tones, illustrates the city of Jerusalem replete with urban dwellings, green parks and the significant Jerusalem landmark, the Dome of the Rock.

For supporters of the Palestinian right of return, the original *Visit Palestine* poster has come to be seen as an ironic reminder of their historical presence in the Holy Land, renouncing previous claims that they did not exist as a national group with a connection to the land of historical Palestine. Not only have unauthorised reproductions made their way into Palestinian homes all over the world, but the poster has been frequently appropriated by artists and designers. A keen example of this appropriation is the *Post-Visit Palestine* poster by designer, cartoonist and filmmaker Amer Shomali, who appropriates the poster to include the Wall, as a reflection on the current state of Palestine and its inaccessibility for both those faced with the denial of the right of return and Palestinians who live in the territories with restrictions on their movement.

Shomali's poster is reflective of his wider oeuvre as an artist and filmmaker who frequently deconstructs icons of Palestinian culture and identity with a humorous approach. Elaborating on the impetus behind this, Shomali poignantly explains that 'a nation who cannot make fun of its own wounds can never heal them'.[23] The wounds that Shomali targets

with humour are both contemporary and historical, and this approach is evidenced not only in *Post-Visit Palestine* but also in works such as his 2014 award-winning animated documentary *The Wanted 18*. Shomali's *Post-Visit Palestine* considers not only Franz Kraus's original poster but also graphic designer David Tartakover's reprint of the poster (1995) in the wake of the Oslo Accords and the optimism they generated. Shomali explains that 'the original and the reprint are so famous that in a way people don't see the wall in mine and it takes time for them to ask "what is new in this poster?" [...] knowing the history of the poster and its reprint is an essential part of the concept [of *Post-Visit Palestine*] and what makes it funny'.[24]

Where Amer Shomali's *Post-Visit Palestine* poster brings the original into the present, Sansour's appropriation of the original poster in *Nation Estate* parodies the original to imagine what a future visit to Palestine might look like. The 'sudden acceleration' of time in the poster achieves laughter, despite the work projecting an image of a bleak future created by the continued processes of dispossession. The response of laughter is, however, contingent on the audience's familiarity with the original poster and its historical context and political motivations.

Similar to the dark realisation of humour that is aroused in *Space Exodus* at the moment when the viewer realises the work is not necessarily about Palestinian empowerment, but rather is about exile, the *Nation Estate* poster, though undeniably tongue-in-cheek, also carries a bleak message. Sansour's work removes the words 'Visit Palestine' entirely, and though the Haram al-Sharif remains in the image, Al-Aqsa and the Dome of the Rock have been removed, replaced instead with the colossal skyscraper that is depicted as the future Palestinian state.

Significantly, Sansour's appropriation of the *Visit Palestine* poster in effect removes any distinct features of the Jerusalem cityscape, leaving only the separation wall as a reminder that we are in fact looking at the Palestinian landscape. This has the effect of removing not only the national signifiers of the landscape so closely bound to Palestinian national identity, but also obstructs and denies dominant iconographies that have utilised the Palestinian landscape as representative of 'Palestine'. This is a technique that is visible in the work of the artist,

Fig 9. Amer Shomali, *Post Visit Palestine*, Silkscreen Print, 2009
Credit: Image Courtesy of the Artist

curator and arts writer Khaled Hourani in his work *No News from Palestine* (2007).

Hourani's *No News from Palestine* is symptomatic of the artist's frequent rejection of any straightforward representation of Palestine or the Palestinian experience. Indeed, much of Hourani's work is characterised by its active obstruction of essentialist readings of what constitutes Palestine and the common view of looking upon Palestinians as either heroes or victims of Israeli brutality. In order to facilitate this obstruction, Hourani's work subverts his audience's expectations, actively refusing to satisfy any desire to look upon Palestine and Palestinians with what might be described as an oppressive compassionate gaze. With techniques of obstruction, Hourani's work presents a resounding incongruity between our expectations of Palestinian art, including nationalist symbols and revolutionary motifs, and the imagery included in his work. It is precisely this incongruity and obstruction of the essentialist and assumptive readings

typically witnessed towards the work of Palestinian artists that forms the humour underlying Hourani's work.

No News from Palestine is an excellent example of Hourani's use of humorous obstruction. The work can be described as essentially a series of unwritten postcards, all without stamps and all labeled 'Post Card Palestine', with the name of the artwork and the location and date of the each postcard's front image. The work functions by locating its emphasis on the fact that Palestine frequently appears as a topic of news coverage and debate because of the charged and frequently shifting politics of the region. However, rather than narrate news of political unrest, or Palestinian resistance or victimhood brought about as a result of Israeli brutality, the postcards appear to report no news whatsoever. Instead, they merely list the location of each postcard's accompanying photograph and the date.

The photographs that make up the front image of each postcard not only do not depict scenes of political unrest, but they also do not feature any of the notable places or landmarks typically associated with Palestine. Although most of the photographs are from Ramallah, they do not feature the city's well-known landmarks of Al-Manara Square, Arafat's Tomb or the PA Headquarters. Instead we find a pastry display from a bakery, an assortment of glassware from a restaurant, people going about their everyday business and parked taxis. In one sense then, *No News from Palestine* might be argued to actually represent 'news' from Palestine; however, this news is that of the banal and everyday. Stripping Palestine of sensationalism, glorification and nostalgia, *No News from Palestine* operates with a humour that 'defamiliarises the familiar'.[25]

One of the greatest potentials of humour is said to be its ability to ask us to take stock of our assumptions. It does this because, as Critchley explains, '[h]umour brings about a change of situation, a *surrealisation* of the real [...]'.[26] This process of the defamiliarisation of the familiar is something we witness in Hourani's *No News from Palestine*. However, the work takes Critchley's reading of the humour of defamiliarisation to a second stage of progression: by asking us to appreciate the fact that the representation of the 'real' Palestine is *already* one that is defamiliarised.

Despite the saturation of documentary modes and aesthetics used to capture the 'real' Palestine, the representation and definition of 'Palestine'

remains elusive. Without question, it is precisely this elusiveness that informs the impetus behind the documentary practices devoted to capturing the 'real' Palestine. Ironically, these documentary modes have arguably only served to mythologise Palestine even further. Though initially appearing as the polar opposite to nostalgic representations of Palestine that persist in the depiction of the landscape of the Holy Land and cities like Jerusalem, these documentary modes achieve precisely the same outcome as nostalgic representation. This is to say that the documentary conceivably defamiliarises Palestine equally as much as nostalgic and idealised representation. What is absent in both approaches is the representation of a 'familiar' Palestine, one that is void of sensationalism, whether it be political, historical or religious.

Understanding this, one can appreciate how Palestine is already defamilarised by the dominant forms of representation that surround it. These defamiliarised forms of representation are not just informed by the saturation of the documentary or nostalgic approaches to Palestine as the Holy Land, but also are figured by Palestinian art history that privileged a militant aesthetic (or 'Palestianism') and an idealised view of historical Palestine (or 'Palestinianess'). By obstructing typical representations, and therefore identification with Palestine, Khaled Hourani's *No News From Palestine* is less about a 'defamiliarisation of the familiar', but rather is characterised by a defamiliarisation of an *already* defamiliarised familiar.

In this sense, it is perfectly fitting that the *No News from Palestine* appeared in the publication *Subjective Atlas of Palestine*. The motivation behind the *Subjective Atlas of Palestine* project was to 'produce an atlas that was much more than a set of maps, but rather a collection of visual and textual "mappings" of the lived reality of Palestine – social, cultural, geographical and political'.[27] As such, the project was geared towards problematising any black and white representation of Palestine. The collaborative project that culminated in the production of the Atlas began as a workshop between the Dutch NGO, the Interchurch Organization for Development Cooperation, and the International Academy of Art Palestine (where Hourani acted as Director) and is an exceptional document for providing a fresh view of Palestine for international readers.

POST CARD
PALESTINE

حول العالم والسير دمجموعة مطاعم الفوارس

No News from Palestine
Fawarees Restaurants, Ramallah 2007

Fig 10. Khaled Hourani, *No News from Palestine*, 2007
Credit: Image Courtesy of the Artist

The introductory text to the *Subjective Atlas of Palestine*, written by literary critic Hassan Khader, is particularly illustrative of the driving force behind the project. Perhaps more importantly, Khader's text also sheds light on how the process of the defamiliarisation of Palestine has come to bear on Palestinians and on the representation of Palestine. Khader writes:

> The potential of Palestine as a metaphor has always been rich. The Palestinians are tired, they need a break. The energies they invest just to be like everyone else, their quest for a normal life and the hopes they nourish, are channeled into a tortured relationship with time and place.[28]

In a sense, Hourani's *No News from Palestine* offers a respite for Palestine and its people from this continuous metaphorical status. Focusing its emphasis away from metaphor, nostalgia and political sensationalism, the work instead attempts to turn towards a 'real' Palestine that can be potentially dull and void of any newsworthy discussion. As such the work momentarily breaks the often sensationalised 'tortured relationship with place', alternatively replacing it with the dull predictability of the everyday.

That said, the everyday 'real' Palestine captured in the work is undoubtedly that of Khaled Hourani, who as a resident of the West Bank has only restricted access to the nostalgic landscape and landmarks that dominate both the popular representation and identification with Palestine. This seems to reinforce the understanding that, although the postcards in Hourani's work depict Palestine, they portray a place laced with restrictions upon movement. These restrictions mean that even though one might live in Palestine, their experience of and access to the land is often confined and frequently divorced from the places that figure in the popular imagination of Palestine.

The laughter induced by Hourani's work in the *Subjective Atlas of Palestine* is echoed by other works included in the publication. *No News from Palestine's* reflection on the impossibility of representing Palestine in a didactic way and its obstruction of essentialist depictions of Palestine and Palestinian life is something that also characterises many of the other works included in the publication. The text's unique insight is garnered from the plurality of vision displayed in the work of its contributing artists, designers and photographers, who were brought together to map their

country as they saw it. The personal, unconventional and diverse responses they submitted almost all carry an element of humour that is formed by the incongruity between our expectations and projections and the lived experience of Palestinian artists and designers.

It is precisely this subjectivity and humour of the contributions included in the publication that allow it to shed light on the diversity of identification with Palestine. However, the idea of creating a subjective atlas for a nation that does not yet officially exist is in one sense a risky feat. The risk of the *Subjective Atlas* is that it calls into question the 'imagined community' of Palestinians. If Homi Bhabha's hypothesis is correct and an imagined community is made up of signs and symbols in the collective mind's eye, then the Atlas's subjective approach might be said to destabilise the unified vision of Palestinian identification that has been nurtured by decades of cultural output centred upon didactic national narration.[29]

The national narration of Palestine and Palestinian national identity drew together a set of imagined signs and symbols that coalesced a unified vision not only to refute claims that Palestinians did not exist as a separate group with a collective identity, but also to repudiate claims that they did not identify themselves as coming from, and belonging to, the land of historical Palestine. For this reason, symbols of the land became dominant in almost all forms of Palestinian cultural output. In the process, these symbols became charged with the capacity to work as vehicles for building an 'imagined community'. This in turn forged a collective imagined communion with the landscape, even decades after exile from the land itself.

This collective communion with the landscape forged by symbols of an idealised past served to reinforce a traumatic separation between the Palestinian past and present. Palestinian art and film's nostalgic preoccupation with the land was symptomatic of one of the phases of colonisation described by Frantz Fanon where colonised people enter into a passionate search for a national culture that existed before the colonial era. For Fanon, the affirmation of the existence of such a culture is said to represent a 'special battlefield'.[30] Fanon's elucidation of the impetus behind this search for national culture argues that the process allows for colonised people to hope for a time beyond the misery of their present experience, lending them a form of personal and collective rehabilitation that rises above

115

'self-contempt, resignation and abjuration'.[31] In short, these nostalgic representations of the landscape provide a source of comfort. Tina Sherwell draws upon this argument when explaining artworks in Palestinian art history. She writes that images 'were all discursive responses to war, a retreat to the comfort of the past, with emphasis on the social unit of the family and the nation as family'.[32]

It would appear that the retreat to the past has ceased to hold the capacity for comfort in the decades following the Oslo Accords. Images of an idealised landscape and depictions of the nurturing soil of the homeland became increasingly inapplicable following the shift in mobility and the changes in the political, economic and cultural landscape of the region. Although nostalgic images of the landscape continue to stand as signifiers of an imagined past prior to occupation, they also represent a bitter reminder of the impossibility of that connection in the present. Following Oslo, nostalgic images of the historical landscape were re-evaluated to reveal their construction as imaginary images conjured as a consequence of collective trauma. In such a way they might be argued to in fact represent *dis*comfort for Palestinian artists. As images that held paramount place in the collective imagination and national visual vocabulary, these representations of the landscape have in the last two decades increasingly become the object of scrutiny, dissection and re-evaluation.

For Adila Laidi-Hanieh, the idealised Palestinian depictions of the historical landscape are argued to stand as memento mori in that they were created in anticipation of the disappearance or expected appropriation of the landscape.[33] Her argument would suggest that images of the landscape were reminders of the collective traumatic rupture from the land and way of life that existed prior to Israeli occupation. Though her argument is legitimate, it is essential to expand upon this reading of images of the landscape as memento mori.

One might argue that the images of the landscape functioned as memento mori for decades while exiled Palestinians were entirely divorced from the homeland through exile. However, the form of momento exchanged following Oslo when many diasporic Palestinians with foreign passports were allowed back to visit Palestine and Palestinians within the territories experienced a loosening of travel restrictions. Following these changes, the Palestinian encounter with the homeland could not

have been further away from the imagined and idealised depictions of the landscape that prevailed in previous decades. It is these changes in the encounter with the homeland that created a divergent memento mori that is in fact a signifier of the death of nostalgia and idealism that exists in exile.

This notion of a transformed form of memento mori in the depiction of the landscape is reinforced by Laidi-Hanieh's own observations on the changing political, economic and cultural climate in the West Bank following Oslo. She is well placed to write about this shift in the political and cultural landscape, having been in charge of the Khalil Sakakini Centre in Ramallah between 1996 and 2005. Her position meant that she witnessed first-hand the return of 150,000 diasporic Palestinians to the West Bank and Gaza, the relaxation of travel restrictions for Palestinians with Western passports and the unprecedented emergence of Palestinian cultural events across not only Palestine but also in the international art and film circuit.[34]

These changes were amplified by the inpouring of foreign funding from international not-for-profits and NGOs. This funding allowed for the emergence of new educational possibilities in the arts both locally and internationally and also nurtured a cultural boom that materialised in the creation of arts festivals, cultural centres, art awards, galleries and cultural foundations. These transformations meant that Palestinians living in the Occupied Territories were living through a cultural overhaul brought about by an introduction to the globalised world.[35]

This emergence of globalisation is responsible for the abandonment of previous political problematics. Laidi-Hanieh explains that 'the transformations and the entry of Palestine, or at least part of its population, into globalisation meant a new representational paradigm in contemporary Palestinian culture'.[36] The transformation brought by globalisation and changes in the political and economic landscape meant that the cultural context for artistic production changed tremendously. This new context freed up representational paradigms for artists in ways that were not possible in previous decades. Not only was the direct relationship to the land vastly different to that of artists working in the past, but so too was the economic backdrop that supported the production of art. Where artists from previous decades (Ismail Shammout, for example) depicted the landscape from a distance and with the support of the PLO who could use their work

for political (and propagandistic) purposes, artists who produced work following Oslo were in a better economic and experiential position to challenge idealised and nostalgic representations of the landscape.[37]

Despite the shift in emphasis towards the landscape and the exposure to funding and exhibition space brought by globalisation, Laidi-Hanieh argues that Palestinian photography is the only medium exempt from the trends of self-criticism and irony witnessed in other art forms. She maintains that photography continues in a 'probing' representational paradigm which, although starkly different to commercial photographs that produce a highly aestheticised depiction of the landscape and Palestinian life, continues to insist upon a documentary mode geared towards exposing the effects of occupation.[38] Although this may be the case for the majority of Palestinian artists working in this medium, there are increasing examples of photographic artists who use humour, pastiche and irony to undermine the saturation of documentary and its association to objectivity. Notable in this regard is the Gaza born artist Taysir Batniji.

A keen example of Batniji's subversion of the documentary is his 2008 work *Watchtowers*. The seed of Batniji's *Watchtowers* was planted when the artist visited the Centre Pompidou's retrospective exhibition of Bernd and Hilla Becher's work in 2004. Subverting the history, meaning and artistic processes of the Bechers, Batniji's series negotiates the difficulty in attempting to follow the Becher method to create a typology of military watchtowers in the West Bank. Not permitted to visit the region, Batniji commissioned a Palestinian photographer instead. The impossibility of manoeuvring heavy equipment to frame the perfect shot with the ideal light means that *Watchtowers* appears out of focus and imperfectly lit. The resulting series of works challenge viewers to consider the impossibility of Palestinian mobility, while also calling the architectural heritage of military constructions into question, consequently revealing their role as symbols of surveillance and control.

With this reading alone, Batniji's work undoubtedly functions as an 'exposing tool' in much the same way as other Palestinian photographic practice described by Laidi-Hanieh's. The exception in Batniji's work, however, is his use of pastiche and parody in the appropriation of the Becher method and aesthetic. The initial effect of *Watchtowers* is to produce an

unheimlich response from the viewer. This uncanniness is informed by the familiarity with both the images of Israeli watchtowers and the work of Bernd and Hilla Becher. The cognitive dissonance produced by Batniji's *Watchtowers* functions equally as a source of discomfort as it does potentially as a source of laughter.

Acting as something of an art historical joke, Batniji's work's ability to incite laughter creates an altogether more complicated documentary photographic representation of the landscape than those described by Laidi-Hanieh. Highlighting the impossibility of the Bechers' formalist method, Batniji draws attention to the political and cultural constraints he faces as a Palestinian artist whose work is always pre-inscribed as being from the periphery of the art world. This stands in opposition to the Bechers, who hold pride of place within the canon of photographic history. Further, *Watchtowers* also highlights the position of privilege of the Bechers, who enjoy the liberty of movement in order to capture typologies of architecture. Hence Batniji's *Watchtowers* employs a self-critical approach, not only to his own work, but also art history more broadly. In the process his work dislodges romanticised visions of both the Palestinian landscape and also the methods of canonical photographic practice.

Batniji's ironic approach and his utilisation of pastiche places his art within the trend that is witnessed in Palestinian art more broadly following Oslo. In this regard, Batniji's work and its mediation of the landscape fits within the approach outlined by Adila Laidi-Hanieh, even though his work is photographic. This shift is described by Laidi-Hanieh as being one where 'revolutionary or romanticised representation was replaced by irony, self-criticism, the exploration of subaltern identities, nihilism and self-narration'.[39] This transformed approach towards the representation of the landscape following Oslo, although informed by a multitude of changes including international art trends, the effects of globalisation and increased Palestinian mobility, is remarkable for how distinctly different it is to the processes of representation described by Frantz Fanon.

Fanon described the emphasis on capturing the landscape of a precolonial past as a process that allowed a transcendence of 'self-contempt, resignation and abjuration'. Although Palestinian artists still find themselves under Israeli occupation and they continue to articulate Palestinian

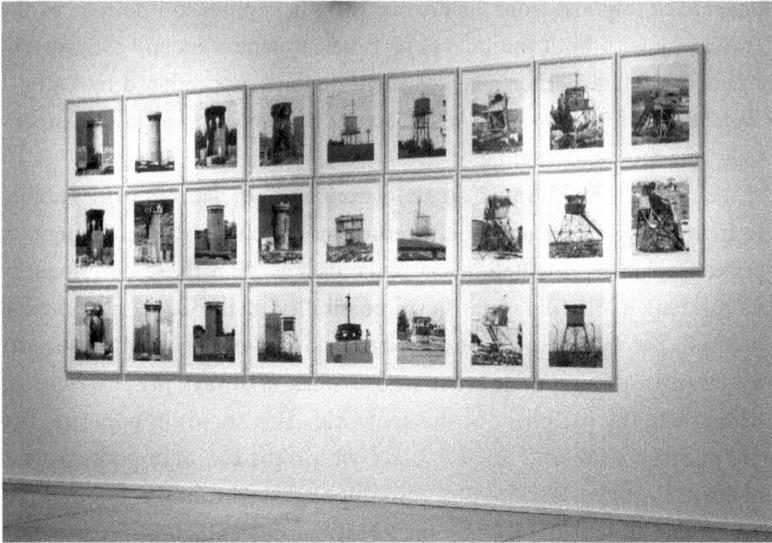

Fig 11. Taysir Batniji, *Watchtowers*, Photographic Series (Installation View), 2008
Credit: Image Courtesy of Susannah Wimberley and The Australian Centre for
Photography, 2012

culture in their work, the art produced by contemporary practitioners
might superficially appear to convey all three of the negative hallmarks
described by Fanon.[40] However, it is through the use of humour and its var-
ious techniques that artists are able to engage with self-contempt, resigna-
tion and abjuration while also challenging colonial control and articulating
a collective identity both before and after occupation. As a consequence,
their work calls into question not only their own experience and its sub-
sequent representation, but also the modes and aesthetics that have domi-
nated the representation of national culture in the past.

Raeda Saadeh is another artist who employs humour to query the rep-
resentation of Palestinian life and the landscape in both the past and pre-
sent. Saadeh's work is focused primarily on her experience as a Palestinian
woman, and using the mediums of photography, video and performance,
she investigates the complex relationship with the homeland. Concerned
with issues such as displacement, identity and gender, Saadeh's work ques-
tions the forces of political occupation of Palestinians collectively while also

engaging with the effects of personal occupation brought by traditional cultural and social expectations. It is Saadeh's use of humour to engage with these themes that lends her work the ability to evade didactic interpretation. Saadeh's humour often relies on the use of parody and irony that draws upon the artist's appropriation of female figures within the canon of Western art.[41]

A keen example of this humour can be evidenced in Saadeh's 2007 work *Vacuum*. A 17-minute two-channel video installation, the work depicts Saadeh performing the absurd task of vacuuming the desert. Shot in the desert between Jericho and the Dead Sea, the immersive work is striking for the absurdity of Saadeh's action, the imposing desert landscape and the haunting constant sound of the hum of the vacuum cleaner. Appearing initially as though Saadeh is performing a meaningless Sisyphean task, upon further consideration the work presents a profound reflection upon the Palestinian connection to the land.[42]

Although *Vacuum* has been described as a reflection on the neverending work that needs to be done to survive daily life in Palestine, the work is perhaps better interpreted as a meditation upon the processes of Palestinian dispossession and erasure from the landscape.[43] Israel has long promoted its state's purported ability to 'make the desert bloom'. As if in direct contradiction to this adage, Saadeh depicts an imposing barren desert landscape that runs counter to the Israeli maxim. The Israeli process of 'making the desert bloom' has relied on the physical and symbolic erasure of the Palestinian presence. In this regard, Saadeh's work is particularly menacing because the work may suggest Saadeh's own complicity in the act of ethnic cleansing. Although vacuuming the hills of the desert might be interpreted as a deliberate act that presents a landscape contrary to Israeli propaganda, the work is not clear about who or what Saadeh is attempting to clear away from the land.

The ambiguity behind Saadeh's seemingly absurd action is what brings humour to the work while also encouraging the audience to draw their own conclusions about its meaning. If we are to consider *Vacuum* as a reflection on dispossession and the deliberate processes of erasure of the Palestinian presence on the land, the work can be seen as one that makes visible process that are so insidious they cannot be clearly witnessed. By drawing attention to a gesture of erasure and a clearing away of the landscape,

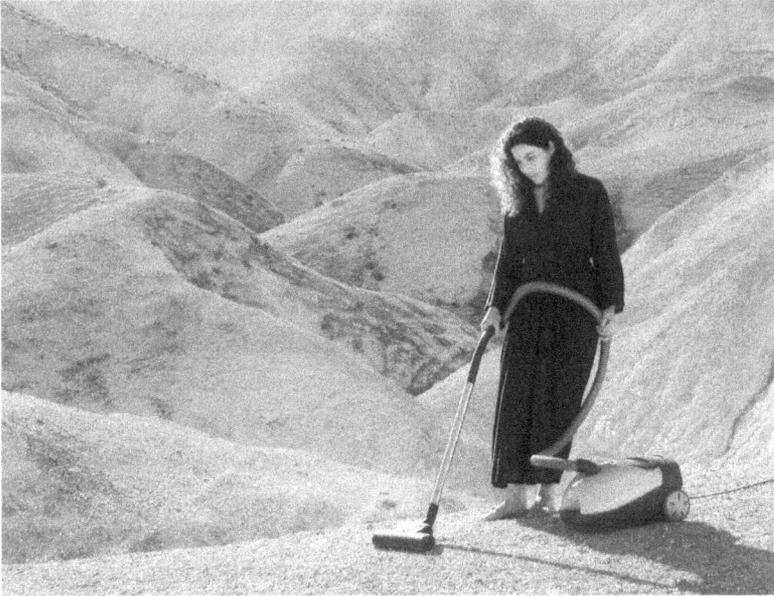

Fig 12. Raeda Saadeh, *Vacuum*, Video Still, 2007
Credit: Image Courtesy of the Artist

Saadeh reminds us of the manipulation of the landscape within both the Israeli processes of ethnic cleansing and the Palestinian resistance to it.

Significant in this regard is Saadeh's appearance as the lone figure within the video. The artist's appearance in the work calls into question not only her experience as a Palestinian and the role of women in the Middle East (two central concerns in the artist's oeuvre) but also the depiction of women in the history of Palestinian art. The depiction of women as allegorical figures is a well-known theme in the history of Palestinian art and has been the subject of consideration by many commentators examining the history of Palestinian art. The depiction of women as a symbol of homeland is of course not unique to Palestinian practice; however, Palestinian visual art is notable for being replete with metaphors that equate Palestine with national and/or beloved female figures.[44]

The allegorical figures in the history of Palestinian art are noteworthy for being often depicted as literally part of the landscape. This gynomorphic landscape presented idealised depictions of women, who standing as

symbols of the land and mother earth, were embodiments of the collective connection to the land. Although in most instances these women were depicted as nurturing mother figures, they often displayed other collective sentiments around the conflict and occupation. These representations saw women depicted holding doves, crying, leading resistance or giving birth to thousands of workers or farmers.[45]

Understanding this history of the role of women in Palestinian art provides a different conceptual framing of Saadeh's *Vacuum* work. Although the artist seemingly continues the trope of women as providers within the landscape, Saadeh's cleaning of the landscape might also be interpreted as suggesting the very opposite of a nurturing Palestinian connection and approach to the landscape. By vacuuming the landscape, Saadeh may also be seen as participating in an act of clearing away the Palestinian connection to the land and in effect possibly erasing even herself from the landscape.

Barefoot and dressed in traditional garb, Saadeh's absurdist action within the landscape brings together the historical depiction of the role of women in Palestinian art, while also calling attention to the erasure of the Palestinian presence on the land. With an absurd performance of domesticity in the desert, Saadeh presents an acutely self-critical work that collapses the collective identification to the gynomorphic landscape in Palestinian art with her own experience of a Palestinian woman living in Israel. Though *Vacuum* might induce laughter when first viewed, the absurdity of the work is informed by a distinct humour noir approach. The humour noir of Saadeh's work is created by the juxtaposition of her absurd action with the traumatic divorce and erasure from the land that the work represents.

The humour of Saadeh's work is translatable in both local and international contexts. Where *Vacuum* articulates concerns pertinent to the Palestinian experience and understanding of the landscape while drawing upon the history of Palestinian art, well-known works from the artist's *Great Masters Series* (2007) such as *Mona Lisa*, *Diana* and *The Milk Maid* project a humour that is accessible to international audiences because the works draws from canonical works of Western art. The 2007 *Great Masters Series* and more recent additions in 2010 including *Rrose Selavy* and *Little*

Red Riding Hood are responsible for earning Raeda Saadeh the title of the 'Cindy Sherman of the Middle East'. Gallerist and curator Rose Issa writes that 'at first glance there appears to be nothing inherently political about her photographs, yet they link to specific times, places and events'.[46] It is Saadeh's use of humour that allows her work to elude the strictly political reading that is often witnessed in writing around Palestinian art in international contexts. Saadeh's ability to evade the 'political' tag often attached to work by Palestinian artists may be one of the reasons her work is so prominent within international circuits and might explain why her work has been collected by the likes of the Victoria and Albert Museum and the British Museum.

Saadeh's presence in collections, exhibitions and art festivals internationally is symptomatic of Palestinian art that now functions as one of the chief forms of cultural export from the region. Articulating issues and experiences pertinent to Palestinians while remaining acutely aware of an international gaze, contemporary Palestinian art and film are the tools at the forefront of the instigation of an international dialogue around Palestine. Moreover, the international gaze places Palestinian art and film in a context where investigations of notions of collective identity and connection to place become a public performance. In the case of Palestinian film, this is most apparent in the work of Elia Suleiman.

Arguably the most celebrated of all Palestinian filmmakers working today, Suleiman's films are notable both for their success with international audiences and for their radical departure from the aesthetics, structures and political emphasis that dominates Palestinian filmic output. Marked by the technique of non-linear episodic narratives, Suleiman's films are also typified by an emphasis on film structure, editing and sound track rather than plot and characterisation to create meaning. This is in direct opposition to the majority of Palestinian films that rely on storytelling and verbal narration and are in essence 'issue films'.[47] If we are to consider the occupation as having made Palestine in a 'story factory', then Suleiman obviously works from outside the factory walls.[48] This is because the filmmaker's active dismantling of all forms of teleological storytelling disrupts all conventions, conclusions and certainties of Palestinian cinema. In effect Suleiman's works mark a dismantlement of the very act of storytelling.[49]

Suleiman's refusal to didactically record the Palestinian story is a trait of Palestinian cinema arguably instigated by Michel Khleifi.[50] Both film-makers have one important thing in common; they are both Palestinians with Israeli citizenship. This means that conceptually, ideologically and even economically, they work within the interstitial place between these cultures.[51] As Haim Bersheeth observes, 'this interstitial mode of pro-duction is forced and justified by the normative state of Palestinians in Israel – living on the seams of Israeli society: they always are situated between two other points, Israeli and Hebrew points, on the virtual map of Palestine'.[52] Working from with this interstitial place, Suleiman, like other Palestinian artists and filmmakers with Israeli citizenship, has a lived experience and therefore vision that operates both inside and out-side of his 'Palestinianness'. This lends Suleiman the ability to broaden the parameters of national identity by challenging the nationalist tropes that characterise Palestinian cultural output.

Suleiman achieves this through the use of almost the entire register of symbols of Palestinian culture, ranging from the keffiyeh the map of Palestine, Arafat's face to the Kalashnikov. However, in stark contrast to the ways that these symbols have been employed in previous cultural out-put, Suleiman exposes the fictitious nature of these nationalist symbols. He achieves this by subjecting them to scrutiny using the humorous tech-niques of absurdity and parody. Although the microscope of humour dis-lodges the mythical status of their nationalist symbols, Suleiman's work also searches for the meaning behind them, thus renewing their significance.[53] Put together, the destabilisation of national signifiers and the disavowal of normative structure and storytelling might superficially suggest that Suleiman's work is expunged from nationalist tropes. This perception of Suleiman's cinema remains a point of contention for many, who continue to burden Suleiman with the task of national narration because of his status as the most renowned of Palestinian filmmakers in international cinema. The ambivalent response of Palestinian audiences to Suleiman's work is acutely apparent in his film *Awkward* (2007) that came as result of *Chacun son Cinema*; a collection of short-films commissioned by the Cannes Film Festival to celebrate its sixty-year anniversary. The premise of the com-mission was to create a short film about the nature of cinema and its place within the lives of filmmakers. *Awkward* is a poignant reflection on the

disinterested and antagonistic approach of Palestinian audiences toward Suleiman's films.

Though there is no obvious correlation between the characters in Suleiman's films and the nationalist tropes they might represent, Suleiman's work explores national identity and experience in what can be described as 'anti-moments'.[54] These 'anti-moments' focus on the mundane, revealing the effects of occupation that exist in everyday acts of aggression, oppression and resistance. This is clear in Suleiman's highly acclaimed work from 2002, *Divine Intervention: A Story of Love and Pain*. A surreal black comedy, the film chronicles a love story between E. S., the film's protagonist (played by Elia Suleiman), who lives in Nazareth and East Jerusalem, and his lover, who lives in Ramallah. Comprised of a series of vignettes, *Divine Intervention* refuses to didactically represent the history of the Palestinian conflict or the reality of occupation. Rather, it chooses to focus on the absurdity of occupation and Israeli violence, blending scenes of checkpoints with computer-enhanced fantastical vignettes.[55]

One of the tropes of Palestinian identity explored in *Divine Intervention* is that of the enduring Palestinian connection to the land. This is most apparent in a scene from the film involving a Palestinian prisoner, a tourist and an Israeli police officer. The scene depicts the tourist asking the Israeli police officer for directions. Unable to provide directions for the tourist, the police officer releases a blindfolded Palestinian prisoner from his van. When asked to provide directions, the prisoner turns repeatedly to his left and right, eventually providing the tourist with directions. Though seemingly out of place in the narrative of the film, the absurd scene clearly conveys the idea that Palestinians, even if blindfolded, have a stronger knowledge and connection to the land than the Israelis.

This 'anti-moment' in *Divine Intervention* signals Suleiman's ability to broaden the parameters of nationalist tropes while avoiding didactic nationalist narration. Suleiman is critically aware of this and insists that there are no solutions in his films, proclaiming 'I do not teach history in my films'.[56] This destabilisation of nationalist tropes in his films facilitates an oscillation between a 'straight' representation of the Palestinian narrative and a parody of it. This oscillation signifies a new language that revives the discourse of Palestinian cinema.[57]

This new language of cinema that oscillates between the 'straight' narrative and its parody is one that can also be extended to Palestinian art. Like Suleiman, artists such as Raeda Saadeh, Khaled Hourani, Taysir Batniji and Larissa Sansour employ humorous techniques such as parody and absurdity to simultaneously narrate the story of Palestine and the Palestinian connection to the land while at the same time dislodging nationalist mythologies that have prevailed in previous Palestinian cultural output.

Through their use of humour, these artists and filmmakers explore the consequences of the Palestinian experience of exile. Locating their focus on exilic identity, their work simultaneously reinforces the Palestinian connection to the land while problematising the national signifiers of the landscape in nationalist iconography. In so doing their work addressed the 'borderlessness' of Palestine. This borderlessness is both symbolic and material. As Palestine is not yet a state and has no fixed borders its material location and geographical space is constantly in flux. Borderlessness is also symbolic because the word 'Palestine' can refer to a multitude of spaces identified as the Palestinian 'home'.

This important trope in Palestinian art and film comes as a direct consequence of Israeli occupation. Although the exploration of the connection to the land is one of the primary themes in contemporary Palestinian humorous cultural output, the overarching effects of the occupation have created another trope that focuses on the failure of the peace process. Artists and filmmakers dealing with the occupation through the use of humour reveal the capacity of laughter to fracture the political status quo and to challenge the banal evil that characterises life under Israeli occupation.

5

Occupied Laughter: Humour and Statelessness

'Your beauty is harder to define than Israeli borders.'[1]
#PalestinianPickupLines

The failure of the peace process has meant that Palestinians in effect live in a state of perpetual limbo. This is most apparent when considering the administrative divisions of the Oslo Accords that created the 'temporary' administrative breakup of the Palestinian Territories. The division was created as a consequence of the Oslo II Accord (or the Interim Agreement on the West Bank and the Gaza Strip) of 1995, which dictated that the Palestinian Territories be divided into Areas A, B and C.[2] Although allegedly established as a temporary agreement serving until a final status accord was established, the division of the Territories remains in place today, two decades after the signing of the Accord. Understanding this, it is not at all surprising that retrospective accounts of the Oslo process are now discussed by some senior Israeli politicians as being pre-determined to fail. This is clearest in the words of former Israeli foreign minister Shlomo Ben-Ami, who explains that Oslo was 'an exercise in make-believe'.[3]

The failure of Oslo has meant that daily life in the Palestinian Territories is one long-lasting groundhog day of unabating occupation. Thus, in a twist of perverse irony, the long-lasting legacy of the Oslo Accords is anything but an advancement of the two-state solution.

Instead, the Accords mark a process that laid the groundwork for the Bantustanism we see in the West Bank that culminated in the construction of the Separation Wall. Far from granting Palestinian autonomy, Oslo legitimised the Palestinian government as having the primary role in maintaining the occupation and protecting Israeli settlers from their Palestinian subjects.[4] This can be witnessed most clearly in the popular disillusionment with the PA following Israeli arrests and retribution attacks in the West Bank that came after the deaths of teenage Israeli settlers in the summer of 2014.

The effects of the failed peace process have led to what can be described as a slow death for Palestinians in the territories. The ongoing occupation and the inability to maintain and predict an economic and political infrastructure and future mean that Palestinians live in a constant state of emergency. Though Israel has been subject to increased international criticism in recent years following the attacks on Gaza (2014, 2012 and 2008/2009), the Mossad passport scandal and the attack on the Mavi Marmara flotilla – and while Palestine has achieved the status of non-member observer state (an implicit recognition of statehood) and membership of UNESCO – occupation in the Territories remains a humanitarian emergency. Understanding this, it is perhaps surprising that the failure of the peace process and the ongoing occupation form a central emphasis in the humour of contemporary Palestinian art and film.

The prominence of humour during this time of ongoing political crisis can be explained in part by theorist Paolo Virno. Providing an explanation of jokes, Virno writes that they need 'an indifferent audience to exist'.[5] Comparing the need for an indifferent audience to the success of a joke as being the same as for a revolution, Virno's discussion might also be broadened to account for manifestations of humour more generally. This can also be said of his discussion of jokes as innovative actions where he explains that 'the innovative action is an urgent action [...] those who accomplish it are always in a state of emergency'.[6] When Virno's discussion of humour is applied to Palestine, it becomes understandable why Palestinian artists and filmmakers have turned to humour. They are faced both with a state of emergency that is both an experiential 'state' and a political 'state'. Adding to the fact that they are operating within a relentless 'interim' emergency period, these artists and filmmakers are also confronted with an indifferent

Fig 13. Sharif Waked, *Beace Brocess*, Video Still (Installation View), 2010
Credit: Courtesy of Susannah Wimberley and The Australian Centre for Photography, 2012

international audience who, both confused and wearied by the conflict, have developed trauma fatigue.

Sharif Waked is an excellent example of an artist who employs sharp use of humour to investigate the ongoing occupation. Waked's works appear acutely aware of the trauma fatigue of audiences towards the political turmoil faced by Palestinians. Working with video, installation and painting, Waked's richly diverse practice both reflects and dissects political history in order to examine present-day issues including propaganda strategies and the globalised images of conflict that have emerged in the media. His 2010 work *Beace Brocess* is a keen example of the artist's use of humour to investigate the failure of the peace process.

Beace Brocess references the well-known news clip of Yasser Arafat and former Israeli Prime Minister Ehud Barak engaging in a display of hospitality that involved rotating in a circle, playfully fighting over whom should first enter the negotiating chamber during the 2000 Camp David talks. This footage made international headlines as being much more than a sign of norms of hospitality but rather a clear indication of a contest of

wills between the two leaders. The appropriation of this well-known clip serves to highlight both its absurdity and our investment in it. As Uroš Čvoro notes, the work reveals a 'deadlock of politeness as the reverse "civilised" image of ongoing violence'.[7]

Beace Brocess draws on this archival footage to uncover how the peace process raised the symbols of sovereignty only to make a mockery of them.[8] Set to a carnivalesque soundtrack, the work is presented in a loop with the feel of silent cinema. This has the effect of making the video appear as simultaneously historical and contemporary, thus symbolically reinforcing the Camp David talks as a historical event responsible for the current state of perpetual limbo. The work's title also makes a mockery of the Declaration of Principles negotiations common title of 'peace process' by playing with the fact that native Arabic speakers are frequently unable to pronounce the letter 'p'. This might be said to allude to the Palestinian criticism of Arafat, who participated in the peace process, signing Accords that resulted in the devastation of his people. Given that the failure of past resolutions have often been argued to have come in the legal wording of documents, Arafat's failure to understand the ramifications of his approval of the documents may be highlighted in his inability to even enunciate the words 'peace process' correctly. Further, this also operates as an allusion to the fact that Arafat was consistently blamed for the breakdown of negotiations during Camp David, something that was later proven to be false.[9]

Waked's decision to place the appropriated footage in a loop reveals the absurdity, repetition and tedium of the long drawn out and increasingly fraught peace process. By appropriating the original Camp David footage where Barak and Arafat initially appear to be engaged in a 'bromance', *Beace Brocess* causes us to distance ourselves from our familiarity with the event, thereby subverting the ways in which the event sits within international media history. Drawing reference to an event that has contributed to the current crippling political status quo in the region, *Beace Brocess* is in line with Waked's wider oeuvre, which is marked by the use of subversive humour. Using subversive humour requires a good dose of self-criticism, which at its best, is capable of destabilising the status quo by asking us to re-evaluate our basic assumptions and values.[10]

Beace Brocess therefore signals both rumination on the status quo brought about by the failure of the peace process and a subversive

intervention upon the political and representational status quo. Waked's meditation upon the breakdown of the peace process and the inability of Palestinians to achieve their own state is echoed, and indeed amplified, by the work of other Palestinian artists, curators and organisations that have used art to forge a sense of statehood. Acknowledging the limbo of Palestinian statehood, contemporary art is increasingly marked by the performance of the functions of the state. In some instances parodying and in other examples actually fulfilling these functions, these examples of Palestinian contemporary art intervene in the performance of the roles of a state that is yet to be actualised.

The role of art and culture in forging the nation state forms the emphasis of a study by the anthropologist Chiara De Cesari, who perceptively analyses and describes shifts in cultural production by Palestinian practitioners. For De Cesari, Palestinian art practices of recent years represent a form of 'anticipatory practice'. In this regard, contemporary Palestinian art is contended to resonate with current political anticipatory practices, most notably the PLO bid to obtain full UN membership.[11] In order for art to be conceived as politically anticipatory, De Cesari draws upon the work of art theorists such as Hal Foster, who writes of the artist as ethnographer, and Claire Bishop (among many others), who argues that relational art practices and the shifting roles of both artists, audiences and art institutions mean that art can no longer be seen as 'discrete or portable, nor can it be any longer understood as autonomous with the ability to transcend its context'.[12]

The current popularity of theorists such as Claire Bishop and the continued interest in the relational aesthetics theory of Nicolas Bourriaud over the last decade might explain the ongoing current interest in Palestinian art.[13] This is because contemporary Palestinian art practice, whether within organisational structures or individual works of art, signals a clear convergence between art, politics, community and institutional practice operating outside of the state. The 'anticipatory' dimension of Palestinian art might therefore be understood as one of the reasons Ramallah is now said to be full of 'art missionaries' who are keen to explore Palestinian art practice.[14]

The never before witnessed surge in international interest in Palestinian art and film over the last decade is evidenced by the Palestinian Film Festivals appearing in new cities around the world almost every year and the growing number of Palestinian art exhibitions internationally. This is

further supported by the participation of Palestinian artists in premiere art and film festivals around the world, including Sundance, the Toronto Film Festival, the Venice Biennale and Documenta, to name but a few. This international profile has been supported by events within the Palestinian territories and in Jerusalem, including the Jerusalem Film Festival, the Riwaq Biennale, the Qalandia International and the A. M. Qattan Young Artist of the Year Award/Hassan Hourani Award. These local and international events have created a new environment for Palestinian art and film that is increasingly open to interest from international audiences. The establishment of galleries within the West Bank and Jerusalem, the increase in artist's residencies and the training of artists in West Bank institutions including the International Academy of Art Palestine in Ramallah have in effect provided an infrastructure for Palestinian art. Although this infrastructure is supported by the PA, Palestinian NGOs and international funding from various governments and cultural organisations, the infrastructure remains anticipatory insofar as its consequent cultural output might initially appear as though it is supported, or indeed orchestrated, by a Palestinian state that does not yet exist.

Though the practices of Palestinian NGOs and intellectuals in the representation of Palestine and Palestinians are constantly under scrutiny for not being in touch with the needs and desires of 'ordinary Palestinians', many artists and theorists have taken a 'fake it until you make it' approach. An excellent example of this is the *Ramallah Syndrome* work that appeared at the 2009 Venice Biennale. Focused on the changes and delusions of normality that crept into Ramallah after the Oslo Accords, the work questions the 'hallucinations of normality' in the city to culminate in the suggestion that 'if the establishment of a Palestinian state is indefinitely postponed it will be achieved through pure illusion'.[15] The *Ramallah Syndrome* work appeared within what is perhaps one of the most well-known examples of the performance of state cultural sovereignty; the Palestinian pavilion at the 2009 Venice Biennale.

The *Palestine c/o Venice* exhibition at the Biennale was significant both in art historical and political terms because 2009 was the first Venice Biennale in which Palestine had its own pavilion, after failed attempts in previous years.[16] Inevitably, this raised questions, both political and symbolic, as Palestine was granted a pavilion even though it is not an official state,

therefore making it an exception within the Venetian Biennale model that only recognises formal nation states. As the Venice Biennale functions as a form of state-supported cultural export, Palestine's inclusion at the event was a performative statement of statehood. At once both an affirmation of Palestine's historical status and an evocation of the future of the Palestinian state, the pavillion was a prefiguration of an institution and a nation yet to fully exist.[17]

The struggle to establish the Palestinian pavilion at the Venice Biennale and the political, cultural, theoretical and practical constraints of achieving this are echoed in the struggle towards establishing a Palestinian museum. Although Palestinian exhibition spaces have been set up by various societies, NGOs, foundations and other organisations in Palestine and abroad, a Palestinian Museum operated and solely funded by the state remains a practical impossibility.[18] Without a state, these museums and exhibition spaces remain supported by various organisations in the way they have for decades. Though undeniably they have grown in number and have established further support by way of funding, these institutions remain makeshift and improvised until a Palestinian state with an appropriate state cultural apparatus is established.[19]

Perhaps the most exciting example of museological 'anticipatory representation' is the ongoing Contemporary Art Museum Palestine (CAMP) project. Accounting for a collection of contemporary art safeguarded by the Al Ma'mal Foundation of Contemporary Art and Gallery Anadiel since 1994, the CAMP project consists of a series of agreements signed by 35 Palestinian artists to donate work to a national contemporary Palestinian art museum once it has been established in Jerusalem. Previously, the museum existed in a nomadic physical form across various international instutions including the Van Abbemuseum in the Netherlands. In its various 'surrogate homes' CAMP has been exhibited as a collection of artworks held on loan by museums as a cultural promise of an institution to come.[20] Though CAMP is a nomadic and exilic museum by necessity, currently there are encouraging investigations underway into the feasibility of establishing a physical museum through international collaboration and support. That said, the project currently functions as a revelatory reminder of the current political situation in Palestine and the practical impossibility of having a Palestinian national institution in Jerusalem.

The problems associated with establishing a contemporary art museum in Jerusalem have ramifications for the privately funded Palestinian Museum project due to be opened in Birzeit in 2016. Well-known Palestinian curator Jack Persekian observes that part of the fundamental problem with establishing a Palestinian museum in the current political context is the obstacle of where it would be located. For Persekian, the museum should be located in Jerusalem, the symbolic, political and spiritual capital for Palestinians. The impossibility of establishing a museum in Jerusalem signals the current restrictions on Palestinian mobility and Israeli opposition to a Palestinian institutional presence in the city of Jerusalem.[21]

Beginning as a project for a museum dedicated to Palestinian memory led by Ibrahim Abu-Lughod, the Palestinian Museum project is currently under the stewardship of Persekian. However, for several years Beshara Doumani led the strategic planning for the creation of the Palestinian Museum funded by the Welfare Association (WA) NGO. Although he was charged with the task of creating a national museum, Doumani was critical of such an endeavour being taken by an NGO rather than a state. For Doumani, one of the ways of circumventing the overarching problem of an NGO taking up the role typically assigned to state apparatus (including ongoing funding, long term commitment etc.) is to create a 'mobilising and interactive cultural project' that is capable of stitching together the fragmented Palestinian body politic by reaching out to Palestinians, wherever they may live, through transnational projects.[22] The attempt to bring together the fragmented Palestinian national narrative has perhaps inevitably created a blurred line between instutitional critique, an emulating of museological conventions and a mockery of standard national museum forms. However, as De Cesari rightly explains, both the CAMP and WA projects mock the museum format, but in doing so they plant the seeds for future national institutions.

The transnational nature of attempts to create a Palestinian museum highlight both the exilic experience and identity of Palestinians while revealing the real-politik of the region and the political constraints of creating a national museum, both in economic and geographical terms. Through anticipatory processes, the CAMP and WA museums prefigure the role of a future Palestinian state and its interest in creating a national museum. Importantly, however, they also offer a critique of state museological

practices, highlighting the difficulties in creating a monument represen-
tative of national identity and ownership or connection to geographical
space. At a time when national museums are more than ever the subject
of enquiry and scrutiny in theoretical discourse, these Palestinian projects
offer insight into problems of museums at a time of globalisation, trans-
nationalism and economic crisis.[23]

Most interestingly, the Palestinian museum projects in their current
form exist in ways that are more akin to ongoing art projects than national
museums. To accept these museological practices as ongoing art projects
is to lend to them a different form of immediacy, acknowledging that they
are revelatory projects capable of unveiling the contemporary political, eco-
nomic and cultural climate. As art projects perceived as transnational muse-
ums, these projects also exist as international exhibitions and in such a way
might be seen as 'live events'. As theorist Jill Bennett explains, 'an exhibition
itself is always in part a live event, unfolding in the here and now: an orches-
tration of present affects rather than a retrospective analysis'.[24]

As art projects, these museological endeavours also resonate and
carry similar concerns and consequences to individual artworks that
both mimic and mock the role of the state and parody its representa-
tion. An example of such an artwork is Khaled Jarrar's *The State of
Palestine* passport stamp project. The concept of the work is relatively
simple: to stamp people's passports with the seal of the 'State of Palestine'.
Beginning in Ramallah in January 2011 and ending in Oslo in September
2012, Jarrar stamped the passports of individuals from around the world
as a way of welcoming them to Palestine.[25] A subversive political gesture,
Jarrar's stamp, which features the words 'the State of Palestine' in English
and Arabic accompanied by the Palestinian sunbird, appears initially as
a parody of state security and authority. For Jarrar, the passport stamp
project was, as he explains, about wanting 'to provide the whole idea of
the state'.[26]

Mimicking visa and entrance stamps from other established nation
states, Jarrar's work is undeniably politically provocative but not technic-
ally illegal – similar passport stamps exist for visitors to Machu Picchu,
the Tower of Pisa, and Check Point Charlie. However, as anyone who has
experienced security checks at Israel's Ben Gurion airport would know,
a stamp such as this within any passport would rouse serious concerns

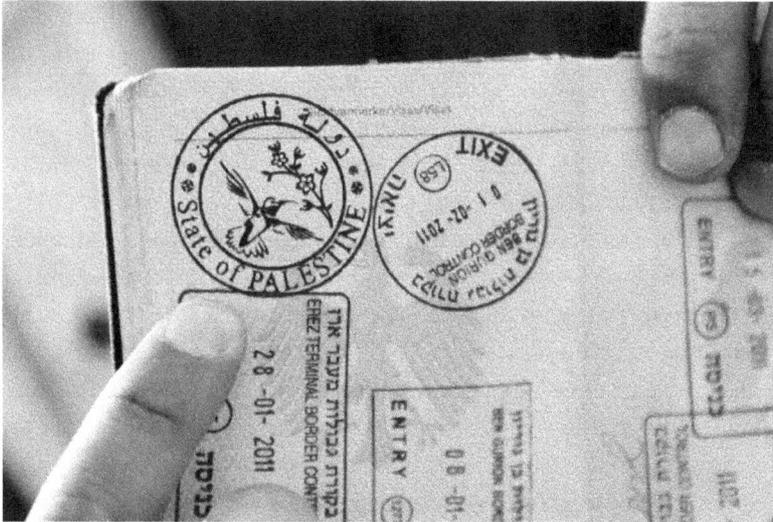

Fig 14. Khaled Jarrar, *The State of Palestine*, Stamp, 2011–2012
Credit: Image Courtesy of the Artist

and questioning, if not interrogation, by Israeli security. Implicating audiences in what Jarrar describes as a 'participatory experience', the stamp created concrete consequences for audiences.[27] Although some participants merely had their passports photocopied and queried by Israeli security, others have faced interrogation and at least one Israeli passport with the Palestinian stamp has been cancelled.[28]

Perhaps more interestingly, Jarrar's stamp project involves participants around the world and not just those visiting the West Bank where Jarrar resides. Jarrar stamped passports with the seal of the Palestinian 'state' in various countries where the artist travelled, including Egypt, Jordan, Serbia, Italy, France and Germany.[29] In so doing, Jarrar renders the state of Palestine as one that is mobile and that can appear at any given city where the artist is permitted to travel. Following from this, the stamp project resonates with Darwish's line from the Palestinian Declaration of Independence that 'Palestine is the state of Palestinians wherever they may be'.[30] Through Jarrar's stamp work we see the creation of a transnational state that collapses the personal restrictions of Jarrar as an individual and the consequences of the collective identification with a state of Palestine.

137

Symptomatic of 'anticipatory representation', Jarrar's work mimics the symbols of a future state in ways that have real life consequences in the present; again reminding us of Jill Bennett's assertion that art offers present affect and not just retrospective analysis.[31]

Whereas Jarrar's stamp project functions as an anticipatory representation of the future Palestinian state within a single artwork – and the CAMP, WA and Biennale projects function as anticipations of national institutions prior to the establishment of the state – the work of Khalil Rabah behaves as an anticipatory museum within a single work of art. For several years, Khalil Rabah has worked on an ongoing project involving a functional nomadic museum that collects and classifies the national environment of Palestine, *The Palestinian Museum of National History and Humankind*. Each of the man-made and natural specimens Rabah presents appear 'authentic' yet the objects, ranging from meteorites to lumps of coal, are fabricated by the artist out of olive wood. Questioning the formation of knowledge, museology and the dematerialisation of the art object, Rabah's museum parodies cultural institutions and their role in the shaping of national identity and state authority. Mimicking the institutional displays of nature and culture and styled according to the conventions of national museums of natural history, Rabah's work serves as a critique of museological practice while at the same time drawing attention to the current impossibility of establishing a Palestinian museum.

For all intents and purposes, Rabah's museum initially appears authentic, travelling its collection around the world with sponsors and even a newsletter. Upon closer inspection, however, the audience begins to sense that the artefacts are forged by the artist and that the sponsors of the museum are not real. One of the most well-known aspects of Rabah's project was the *3rd Annual Wall Zone Auction* that was staged at the Khalil Sakakini Centre in Ramallah in March 2004. A performance documented in a two-channel video work, the auction involved the sale of materials and objects from the area surrounding the Wall with audiences bidding to buy objects ranging from stones, olive branches and a mesh fence. The absurd action appears as a real event designed to raise funds to support *The Palestinian Museum of Natural History and Humankinds* 'permanent' collection while functioning as an expose of the consequences of the Wall. The farcical nature of the event – selling objects of oppression to raise money for a state museum – is at once both an empowering humorous gesture and

a melancholic reflection on Palestinian oppression and the current impossibility of institutional representation of Palestinian history and presence in the Holy Land.

When considered alongside the efforts to establish Palestinian state museums, the work of individual artists such as Khalil Rabah and Khaled Jarrar can be considered as exercises in nation-building. The humour that resides in each of these nation-building works and parodies of the state acknowledge the current political impossibility of a Palestinian state while simultaneously disavowing this political reality. This collision between avowal and disavowal is at the heart of humour. This is best explained by Alenka Zupančič, who points out that humour 'involves a strange coincidence of realism (it is supposed to be more realistic and down-to-earth than, say, tragedy) and utter unrealism (defying all human and natural laws, and getting away with things that one would never get away with in "real life")'.[32] This collision between the real and the utterly unreal is what informs the absurdity that characterises Palestinian art and film dealing with the occupation. In the case of cinema this is nowhere more apparent than in the work of Elia Suleiman and his film *Divine Intervention: A Chronicle of Love and Pain* (2002).

Lacking any clear narrative structure, *Divine Intervention* presents a world where humour and tragedy exist in a poetic symbiosis that blurs structure and genre. If one was forced into confining the film to a synopsis they might say that *Divine Intervention* centres on its protagonist's return to Nazareth from New York and his love affair with a woman who resides in the West Bank and also fantastically manifests as a symbol of Palestine itself. Almost entirely absent of dialogue, the film sees Suleiman examine the ways that images relate to reality, only to deconstruct them and again reconstruct them as political intersections pregnant with multiple meanings. It is in these junctions that the Palestinian story of life under occupation appears as a narrative that cannot be told, but is recounted nonetheless.[33] Indeed, *Divine Intervention* can be interpreted as a parody of narrative structure itself, refusing to make the story of Palestine and Palestinians comprehensible. Dense with references from popular culture, biblical mythology, cinematic history and Palestinian nationalist iconography, Suleiman's film articulates an ironic identity that escapes the narrow confines of nationalism while maintaining an expression of identity and experience in the face of aggressive negation and appropriation.[34]

Fig 15. Khalil Rabah, *The 3rd Annual Wall Zone Auction*, Video (Installation View), 2004
Credit: Courtesy of Susannah Wimberley and The Australian Centre for Photography, 2012

To avoid being pigeonholed into nationalist confines, Suleiman engages both the absurd and the fantastical juxtaposed with 'reality'. This juxtaposition is clear when considering two vignettes from the film; the first is the film's climactic 'ninja' scene and the second scene sees the protagonist E. S. (played by Suleiman) stopped at a traffic intersection alongside a politically fanatical Israeli. Considered together Suleiman's cinematic language is revealed as one that 'juxtaposes two versions of reality – one present and the other absent, each concealing yet exposing the other'.[35] The ninja scene involves a female ninja figure facing off with Israeli armed men while dressed as though she is a member of the *fedayeen*. This image of the Palestinian that serves as target practice is then seen to transform before the eyes of the Israelis into a flying ninja with moves reminiscent of those from *The Matrix* film.

The ninja scene essentially casts the Israelis in the role of Goliath, as they are defeated in battle by a lone Palestinian woman who assaults them with all manner of absurd weaponry. The assault is both physical and symbolic as the Palestinian woman uses weapons that cover the spectrum of Palestinian

symbols including stones, an Islamic crescent dart, a keffieh and even a shield in the shape of the map of historical Palestine. As Najat Rahman observes, the confrontation in this scene 'presents the conflict and face off as one of representation, and hence of political existence: who has the power to represent, who creates images of others, who diffuses these images'.[36] The ninja scene exposes the mixed circuits in Suleiman's cinema; in this particular example, the mixed circuit is that between auteur film and commercial cinema. More broadly, however, Suleiman can be said to mix expected codes to create something new by bringing together the private and public, violence and laughter and the actual and the virtual.[37] Humour appears in Suleiman's work precisely because of these mixed circuits and because, as Incongruity Theory suggests, laughter occurs when there is a disavowal of our expectations. This denial of expectations is evident not only in Suleiman's fantastical scenes, but also in the way he approaches realism.

An example of Suleiman's 'realism' can be witnessed in the scene involving E. S. and a fanatical Israeli at a traffic intersection. The scene depicts a stand-off between the Palestinian protagonist and an Israeli driver whose car is plastered with nationalist paraphernalia and the Israeli flag. As the cars behind them beep, the two men remain in their cars staring at each other while E. S. blares Natascha Atlas's rendition of 'I Put a Spell on You.' The stand-off between the two drivers is accentuated by both their silence and the lyrics of the song coming from E. S.'s car. Interpreted within the context of the scene, 'I Put a Spell on You' becomes an expression of the nationalist message latent in the fantastical scenes of the film. The song's lyrics 'I put a spell on you, because you're mine' are transformed to reveal Suleiman's fantastical representations of Palestine as a 'spell' that signifies the Palestinian connection and ownership over the land.

Both the intersection scene and the ninja scene reveal the tensions between national affirmations of identity and globalised representations of them. Rahman evidently has this in mind when she explains that Suleiman's depiction of the sociopolitical reality of Palestine is linked by both the absurd and humour noir. In this representation, 'the absurd is thenceforth an index of power and of violence, a manifestation of state violence'.[38] Using the fantastical and the absurd to present experience that evades representation, Suleiman's cinema is in line with Palestinian films more broadly that

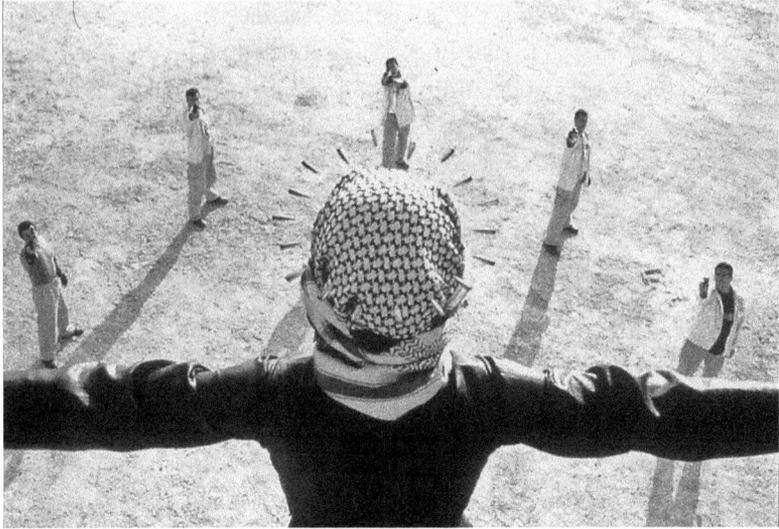

Fig 16. Elia Suleiman, *Divine Intervention: A Chronicle of Love and Pain*, Film Still, 2002
Credit: © 2002 – Ognon Pictures, Arte France Cinema, Gimages Films, Lichtblick

are argued to exist at a series of exilic interstices, including fact and fiction, between narrative and narration, between storytelling and its telling – and importantly – between documentary and fiction.[39] The interstice between documentary and fiction is particularly significant given the prominence of documentary forms in Palestinian cultural output and the saturation of the documentary in the chronicling of Palestinian life under occupation.

The division between the genres of documentary and fiction might be said to form a representational occupation of Palestine. This representational occupation is a point of reference in Jean Luc Godard's *Notre Musique* where he is depicted explaining to a group of students that in 1948 the Jews 'walked out of the water into the Holy Land – The Palestinians walked into the water, the Jews became the stuff of fiction, the Palestinians became a documentary'.[40] Godard's distribution of genre between Israelis and Palestinians is also echoed by Jacques Ranciere, who explains that the division of genres always entails distribution of possibilities and capacities.[41] For Rancière, this division creates a 'world that is divided between those who cannot afford the luxury of playing with images'.[42] It is with this in mind

142

that Suleiman finds his greatest importance within the history of Palestinian cinema. Confusing the expected codes of fiction and the documentary and operating at the interstice between realism and unrealism, Suleiman cracks open the representational history of Palestine and dislodges the documentary's pride of place in the depiction of life under occupation. The collision of genres and his use of humour have the consequence of representing what is essentially not representable: traumatic experience.

Just as in his previous film *Chronicle of a Disappearance* (1996), the protagonist of *Divine Intervention* serves as a silent witness to the ongoing cycle of violence brought by the occupation and the trauma that surrounds Palestine. Yet he is defiant. Though E. S.'s slapstick/deadpan role is comparable to Buster Keaton or to Charlie Chaplin, the character's incessant gaze into the camera, and therefore at the audience, is both a depiction of defiant witness to occupation and a call to recognise our complicity in the representation of Palestine. This is an act of creative resistance to power and violence and an act of aesthetic emancipation.[43] It is in the humour noir of Suleiman's films and their employment of absurdity that creates the seeming lightness of purpose in the filmmaker's approach. As Hamid Dabashi observes, it is this 'dead-serious frivolity that flies in the face of trauma and tragedy, a flightiness that can no longer be captured, nailed, checkpointed, jailed, expelled or called a terrorist'.[44]

The emancipatory aesthetic of Suleiman's films can also be traced in contemporary Palestinian visual art that operates within the interstice between realism and unrealism. This is evident in the work of Sharif Waked, whose absurdist humour noir approach also takes aim at the representation of the Palestinian experience of occupation. This is acutely apparent in Waked's 2003 work *Chic Point*. The 9-minute video work begins with a presentation of a fashion catwalk with music and set design reminiscent of Fashion TV. However, as the male models parade down the runway their outfits start to become increasingly bizarre.

Despite being outlandish, the clothing on display does resemble avantgarde fashion from the early 2000s (most notably that of Alexander McQueen) and the bizarre designs all have one thing in common: the exposure of their male model's midriffs. Although the video is a humorous parody of fashion parades, the exposure of the mid-section of the Palestinian male bodies, when considered alongside the work's title, begin to alert the viewer

that Waked is drawing a line of reference to the Palestinian experience of Israeli checkpoints. Once this realisation is made, the artist's exploration of the nexus between politics, consumption and desire is revealed as a clear artistic agenda.

The parade of Palestinian bodies dressed in their bizarre ensembles is captivating as outfits become increasingly absurd, drawing both the audience's laughter and attention. In this sense, *Chic Point* can be compared to the structure of many humorous exchanges (primarily jokes), where a long meandering story is told in the lead up to a punchline. Although the punchline typically signals an incongruity that urges laughter, Waked's *Chic Point* inverts this process, whereby a humorous build-up is established only to reach a punchline that is not one of delight, but rather of horror. This is established when the video of the fashion parade is cut short and replaced with black and white documentary stills from around the West Bank during the second intifada. These stills are all of Palestinian men subjected to humiliation at Israeli checkpoints, most of them forced to expose their midriffs to soldiers.

The collision between these documentary stills and the absurd fashion parade earlier in the work, signals a merge between the utterly unreal and the real. This collision alerts us to the necessary reliance and symbiosis between fiction and reality in the facilitation of affect. Highlighting the collective humiliation of Palestinians, *Chic Point* reveals the occupation as one not just of land but also of the Palestinian body that is interpreted as a dangerous weapon and therefore subject to the same surveillance and control enforced upon the land. Importantly, Waked's fashion parade can be interpreted as not only a shock tactic to reveal the humiliation suffered at the hands of the Israeli army, but can also be read as an attempt to emancipate Palestinians out of the image of victimhood that is reinforced by the images of the occupation.

It does this both through the use of humour to reinforce a shared experience of occupation among Palestinian viewers, but also subverts the oppressive intentions behind military strip searches suggesting instead that they are also informed by desire. For Gil Hochberg, *Chic Point* is argued to signal an empowering artistic gesture in that it forges a sense of community that is organised outside of injustice, subjugation and humiliation. Through parody, Waked takes control of the gaze and scrutiny imposed on the Palestinian body, replacing it instead with one of sexuality and forbidden desirability.[45] Understanding this, *Chic Point* is viewed as a work that plays

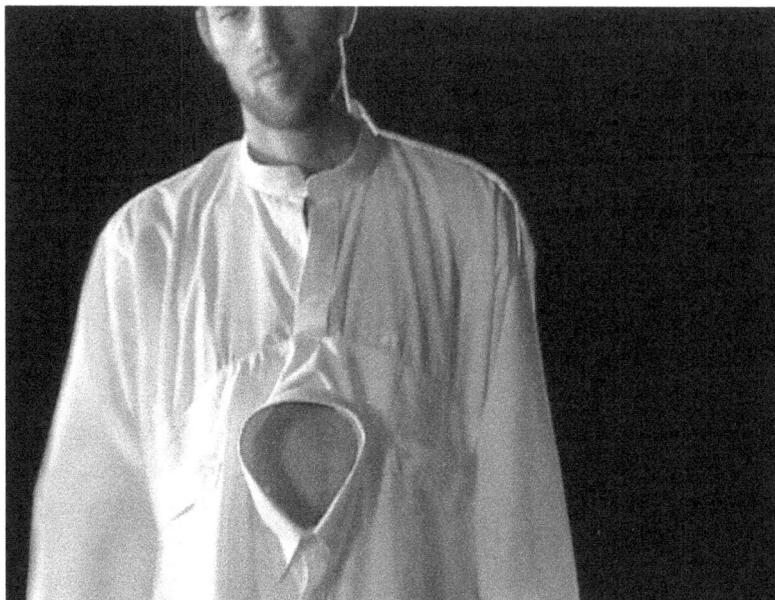

Fig 17. Sharif Waked, *Chic Point*, Video Still, 2003
Credit: Image Courtesy of the Artist

with perversity, both in regard to the fashion parade and the documentary stills featured in the video. According to Hochberg, 'there is something about that perversity that is very important to explore, precisely because it is so politically daring'.[46] It is humour that calls into attention the perversity of our gaze looking at Palestinian bodies, whether they are shown in a fashion parade, humiliated at a checkpoint, or indeed as corpses. By locating an emphasis on desire, Waked's *Chic Point* challenges audiences to dislodge understandings of representations of power and counter-power, asking us therefore to not only look out for them, but also to embody and host them.[47]

Through *Chic Point's* channeling of sexuality and forbidden desirability, the audience is implicated through a transmission of affect. This transmission leads to the questioning of the impetus behind the gaze upon the Palestinian body. This is an uncomfortable question precisely because it may point to the perversity of our gaze. It is the 'forbidden desirability' of the Palestinian male body in *Chic Point* that arguably reveals our

perversion as an audience as our desire is suspended throughout both the hypersexualised fashion parade and the documentary photographs that follow.[48] Despite a fracture between the 'real' and the 'unreal' imagery in *Chic Point*, our desire is in both instances directed at an occupied body. Within the collision between the sexualised gaze and a compassionate gaze, *Chic Point* asks us to acknowledge whether they are one and the same, both informed by a certain perversity.

We can look to the saturation of documentary images of Palestinian suffering as evidence of the forbidden desire to look gaze upon Palestinian misery and occupied bodies. Despite the fact that these documentary endeavours are geared towards exposing the effects of the occupation on Palestinian life, they maintain an emphasis on the humiliation, despair and death of Palestinians. This again can be reinforced by Jacques Rancière's observation that the division of genre between 'fiction' and 'reality' has created a world where Palestinians 'can only offer the bodies of their victims to the gaze of news cameras or to the compassionate gaze at their suffering'.[49] The sustained dominance of these forms of representation begs two important questions; the first being what are the consequences of a continued emphasis upon victimhood and horror? Secondly, what is the impetus behind (and consequence of) the compassionate gaze?

The continual emphasis upon images of Palestinian suffering is informed by an attempt to unveil the continued horror that Palestinians have been repeatedly subjected to as a result of Israeli violence. The emphasis on bodies that have been maimed, disfigured, burned or indeed reduced to unrecognisable corpses, undoubtedly initially induces a visceral affect when viewed. Though these images proliferate the representation of most Israeli assaults, notable instances in terms of documentary footage include the Sabra and Shatila massacre of 1982, the 2006 war and the assaults on Gaza in 2008/2009, 2012 and 2014. Though these images may rouse compassion, there is also a danger that they might encourage audiences to a sense of pity. This sense of pity correlates to feeling trauma fatigue that does not incite compassion or political action; instead it encourages audiences to emotionally switch off.

Trauma fatigue in regard to the suffering of Palestinians can partly be attributed to the proliferation of such images. Rather than function as a call to understand the Palestinian experience, these images demarcate a line

of irreconcilable distance; a process that teeters on the edge of dehuman-isation. These images thus become disempowering for both their subjects and their audience, potentially closing off a circuit of affect that provokes critical inquiry or compassion.[50] The possibilities and dangers of this visu-alisation of suffering have most notably been taken up by Hannah Arendt, but continue to draw interest and analysis in recent visual culture stud-ies, most significantly in the work of Luc Boltanski, Slavoj Žižek and Jill Bennett.[51] Although these images are an implicit call to action, their danger in the case of Palestine and Palestinians is that they reinforce an image of repeated victimhood. In this sense they operate as 'status-enforcing' images and as the dominant form of representation they mark a sublimation of the diversity of Palestinian experience and the repeated efforts (both historic-ally and in the present) to remove 'Palestinianness' outside the boundaries of victimhood.[52]

The dominance of these documentary forms comes not only as a con-sequence of ongoing violence and occupation, but also because they are cheaper to produce and remain extremely popular with audiences. The dominance and popularity of the documentary genre is clearly evidenced in the programming of Palestinian film festivals internationally where documentaries almost always far outnumber other genres. This poses a dilemma for those involved in curating festival programs. For them, the inevitable question arises as to whether high audience numbers from non-Palestinian or Arab backgrounds attend screenings in an attempt towards understanding a clear narration of the conflict, or whether there is a latent desire in audiences to gaze at other people's suffering. Though this question can never be conclusively answered, the work of contemporary Palestinian artists and filmmakers signals an awareness of the problematic international gaze that is at once compassionate, piteous and possibly per-verse. The increasing use of humour in Palestinian cultural output there-fore intimates an understanding of laughter's ability to unhinge the latent oppression in the international gaze.

The channeling of the compassionate gaze can also be witnessed in the art that deals with what is today the greatest symbol of both Israeli oppression and Palestinian resistance to it: the Separation/Apartheid Wall. The Wall features in countless documentaries, art projects and books, and the in case of art, interest in the Wall has been bolstered

since the work of Banksy appeared on it.[53] As artist, curator and architect, Yazan Khalili observes 'taking photos of the Wall has become the common image of Palestine and the Palestinians'.[54] For Khalili, the fixation on the representation of the Wall has replaced other images of the beauty of the Palestinian landscape, including the Baha'i gardens in Haifa that are today the image of Israel. Khalili rightly notes that images of the wall hold as their aim the attempt to see Palestinians within a frame of pain and suffering. Acutely aware of the dangers of the fixation upon images of suffering, Khalili explains that 'the image alone cannot be political if it stays fixated in the realm of mere documentation that proves fodder [of] victimhood that makes visible everything that should be fought against'.[55]

Though the Wall is the strongest contemporary symbol of Palestinian suffering under occupation, images of Palestinian homes, whether bombed, occupied by settlers, or bulldozed, also feature prominently in news coverage of Palestine. The potency of these images comes because they stand as symbols of the issues that are at the heart of the occupation and the failure of the peace process. For every Palestinian home that is confiscated or destroyed, there is a reminder of the shrinking of Palestinian land, the aggressive growth of Israeli settlements and the violation of human rights in the occupation. Most importantly, however, these images of Palestinian homes carry symbolic pertinence because they are a reminder of the current impossibility of achieving a safe and stable Palestinian 'home', both in the personal and the collective sense. This conflation of issues at the heart of the conflict means that artworks and films dealing with Palestinian homes are loaded with political and symbolic significance.

In the work *GH0809*, artist Taysir Batniji has imagined a real estate agency offering homes for sale in Gaza, but in this scenario, the properties 'for sale' are those that were damaged or destroyed in the 2008/2009 military campaign Operation Cast Lead. Mimicking the aesthetic language and display of real estate agencies, *GH0809* (short for Gaza Houses 2008/2009) is temporarily misleading, particularly when the work is installed in the front window of gallery spaces, as was first the case when the work was exhibited in Sydney as part of the *Beyond the Last Sky* exhibition at the Australian Centre for Photography.[56] The momentary

disorientation created by the work that initially appears as local real estate display serves to defer the compassionate gaze often projected by audiences upon the Gazans who experienced the violence of the 2008/2009 assault. This deferral, or momentary disorientation, serves to obscure the circuit between fantasy and reality. At once humorous and traumatic, *GH0809* investigates the representation of the destruction of Gaza and the impact upon Gazan lives while questioning, or indeed imagining, the possibility that Gaza might one day enter into a 'normalised' world of commercial activity, investment and political freedom.

Though born in the Strip, Batniji is unable to return to Gaza and therefore the images of the houses in *GH0809* were commissioned by the artist and taken by a local photographer. The homes in the photographs are surprising for their diversity, ranging from the grandiose to those that have been reduced to mere rubble. It is Batniji's inclusion of text that disrupts these images, lending them humour that disavows the compassionate gaze and our expectations of Gaza, a place heavily marred by suffering. The artist's description of each house draws upon the language of real estate and focuses on the assets of each property's locale. However, Gaza is not a place we associate with capitalist investment potential. When installed behind gallery windows, the work operates by drawing the attention of the audience via the conventions of real estate sales and advertising – thus calling the audience to address their own capitalist aspirations whilst signalling the development potential of Gaza. More obviously however, Batniji's work draws upon each house's description as a simultaneous reminder of the beauty of the Gaza landscape and the possibilities of enjoying its topography while also serving to bitterly remind the audience of the trauma of each house's inhabitants.

Each house therefore stands as a signifier of both the suffering and possible future of the Gaza strip. This is amplified by the black humour of the text Batniji uses to describe each property. These descriptions range from claims that houses are 'calm and sunny', have 'beautiful exposure', 'unobstructed views' with lush gardens and proximity to the sea. The disjunction between these descriptions and the damage evident in the documentary photographs alongside them produces laughter because there is a denial of our expectations and recognition of the subversion of melancholia that resonates from each image.

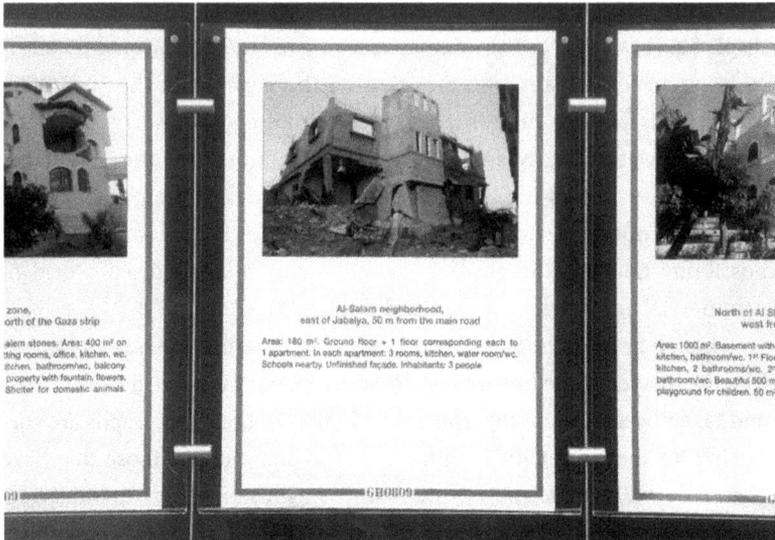

Fig 18. Taysir Batniji, *GH0809*, C-Print Photographs (Installation View), 2010
Credit: Courtesy of Susannah Wimberley and The Australian Centre for Photography, 2012

Batniji clarifies the impetus behind GH0809 explaining that 'I had to look at a form of representation that allowed me to keep a kind of distance… and to show the Palestinian reality, as I always do, from a new angle different from media images and clichés people are used to'.[57] Batniji was aware of the disjunction between the conventions of real estate advertising, his collected photographs and information about inhabitants of each house. He explains that he was careful 'to evacuate any form of pathos or strict reportage […] because the risk was falling into mockery or irony' – something he was adamantly against.[58] Batniji's deliberate move away from pathos and strict reportage does however facilitate a bleak humour in *GH0809* that importantly serves to obstruct the compassionate gaze by redirecting the typical responses to Gazan suffering.

GH0809 also disavows another of the most common projections upon Palestinians; that which looks to heroicise them as symbols of resistance against a much stronger and better-equipped oppressor. This view of Palestinians is arguably equally as oppressive as the fixation upon Palestinian suffering, as it creates yet another essentialised characterisation

of a cultural group. Though these essentialist characterisations as victim and hero seem as though polar opposites, they exist within a circuit where one can be interchanged with the other so long as a single constant remains; that Palestinian identity and experience is defined in opposition or as a consequence of Israeli occupation. The use of humour again can be seen to topple these projections, often doing so by parodying the roles of victim and revolutionary associated with Palestinians.

The performance of the roles of both victim and hero/revolutionary are implicitly examined in the work of the filmmaker and artist duo Tarzan and Arab. Twin brothers Tarzan and Arab (Ahmad and Mohammad Abu Nasser) were born in Gaza after the last cinemas closed there in 1987.[59] In spite of the growing international recognition of their work, Tarzan and Arab produced their films under exceptionally difficult circumstances in Gaza, with limited resources, infrastructure and funding. Since leaving Gaza for the first time in late 2011 (when they travelled to Texas to screen their first short film *Colourful Journey* and to watch a film in a cinema for the first time), the twins have produced *Condom Lead*, the first Palestinian short film to make the official selection at the Cannes Film Festival (2013) and the acclaimed feature *Dégradé* (2015).[60] However, it is their 2010 body of work *Gazawood* that provides the strongest example of Tarzan and Arab's awareness of both the projection upon Palestinians (and Gazans in particular) as either victims or heroes and the capacity of parody and pastiche to subvert these projections.

Gazawood takes its name from the media production company established by the brothers with clear reference to the Hollywood and Bollywood industries. With this title, Tarzan and Arab draw reference to the cinematic genres of these leading industries to imagine a cinematic future in Gaza and a new mode for representing the Israel/Palestine conflict. Lacking the resources to produce feature films in Gaza, Tarzan and Arab instead created posters for movies they would like to make. As if in direct opposition to the films deemed as 'Pallywood', the artists' works displays a sharp subversion of the dominant mode of documentary film centred on capturing 'real' violence directed at Palestinians.[61] Further, their artistic titles of 'Tarzan' and 'Arab' indicate a willingness to perform the role of 'primitive' Other. This does not, however, preclude the artists from dealing with 'real' events. All the posters in the *Gazawood* project take their names from Israeli Defense

Force military campaigns, drawing attention to the depth and breadth of Israeli military history.

With titles ranging from *Autumn Clouds*, *Operation Cast Lead* and *Santorini*, each poster stars one or both of the brothers in an exaggerated caricature of images that typify a broad spectrum of cinematic genres including thrillers, westerns, war drama and horror. Once the audience is aware that each *Gazawood* poster corresponds to a fictional film, yet real event, the work becomes entangled in an interstice between fiction and reality. This interstice is punctured by a parody of both cinematic genre and military terminology, revealing the sensationalism of both. It is the humorous techniques of pastiche and parody that allow the work to hover between fact and fiction, thus obstructing any attempt to essentialise understandings of life in Gaza under occupation.

Gazawood thus makes visible audience's preconceptions of Palestinians as either tragic victims or heroes. Eluding both these characterisations by performing both roles, *Gazawood* displays an awareness of pre-inscribed views of Palestinian experience and identity. However, this evasion is even more significant because the work functions as though it is a mirror, reflecting back an exaggerated performance of Western popular culture. The work thus signals a double imagining where a circuit of imaginary representation exists between popular views of the Palestinian conflict *and* a Palestinian view of cinematic genres dealing with conflict. In such a way *Gazawood* reveals the ways in which parody and pastiche may defend against essentialised views of the Other. The work's ability to harness humour to undermine conventional perceptions of life under occupation is symptomatic of the fact that humour and the incitement of laughter might be described as a 'mature defence mechanism'.

The investigation of humour as a mature defence mechanism is widely researched and discussed in psychological discourse. This discursive conception of humour argues that as a psychological defence, humour is a protective process that allows individuals to maintain their integrity in the face of threat and danger.[62] As a mature defence mechanism, humour finds itself in company with other psychological processes including suppression, rationalisation and sublimation that all guard against the detrimental psychological effects of trauma.[63] These psychological inquiries into the benefits of humour for Palestinian political prisoners who have been

152

subject to torture reinforce the significance of manifestations of humour in Palestinian art and film that address the occupation. These discursive inquiries reinforce the understanding that laughter defends against trauma, redirecting the personal and collective response to the everyday threat, danger and anxiety brought by occupation.

Perhaps the most lucid example of the utilisation of humour to examine the psychological effects and trauma brought by occupation is the documentary film *Fix Me* (2009). *Fix Me* revolves around the story of its director Raed Andoni as he strives to remedy a seemingly incurable headache that he contends may have existed for generations. Following Andoni through twenty therapy sessions as he tries to cure his condition, *Fix Me* uncovers the filmmaker's repressed memories of his time as a political prisoner as the root of his ailing health. With each appointment and exercise with his psychologist in Ramallah, *Fix Me* further investigates the effects of displacement and alienation on not just Andoni and his family and friends, but also upon Palestinians at large. Rendered with a sly humour, Andoni's film traces the faultlines of traumatic memory with a self-criticism that exposes the limitations of Palestinian *sumud*.

Exploring the standards Andoni believes Palestinians are measured against, *Fix Me* chronicles the stories of other West Bank men of the generation of the stones who suffered torture while imprisoned. This proves to embarrass the filmmaker who believes that he is weak in comparison to most men of his generation. He explains that since childhood Palestinians are told that 'we are the Palestinians, we are the tough guys, we will return, we won't be beaten'.[64] Critical of his own weakness but also the impossible collective standard of psychological and political willpower, Andoni exposes the collective trauma of Palestinians to insist that *sumud* may in itself be an occupying force that restricts personal freedom and frames all creative endeavours as acts of resistance. It is Andoni's self-critical humour that punctures the bleak narratives presented throughout the film. Offering respite, hope and relief, *Fix Me* is exceptional because it engages with humour while being a documentary. In so doing it validates humour as appropriate in the documentary narration of 'real' trauma; a previously unthinkable union.

There is also a growing interest in Palestinian humour internationally. This is evidenced by the recent documentary *(No) Laughing Matter* (2010),

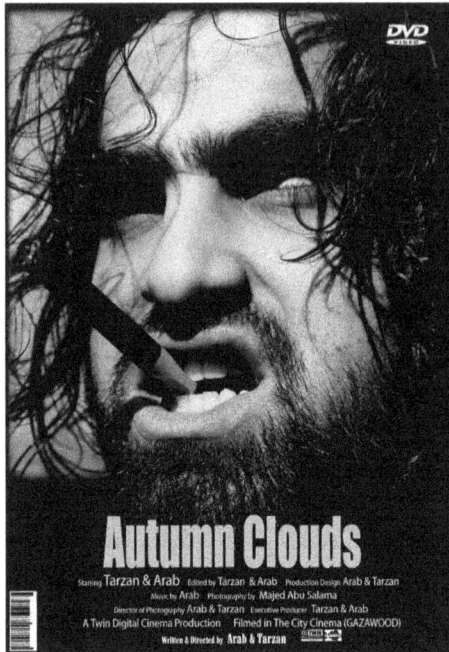

Fig 19. Tarzan and Arab, *Autumn Clouds* from the *Gazawood Project*, 2010
Credit: Image Courtesy of the Artists

by French filmmaker Vanessa Rousselot. The film is currently the only documentary to deal specifically with Palestinian humour by a cultural outsider. As such, the film signifies an international interest, and acknowledgement of, Palestinian humour.[65] The attention to humour in Palestine suggests two lines of interest for non-Palestinians. The first of these is informed by an element of surprise that Palestinians laugh. This view is hugely problematic because it draws from the idea that foreigners are often viewed as misoglasts.[66] It is reinforced by the fact that stereotypical representations of Palestinian focus on their suffering or upon a perceived political fanaticism that frames them as terrorists. Within this view, however, humour enters as a destabilising process that fractures stereotypes and depictions of Palestinians in the media and in popular culture. The second attraction to humour for audiences is informed by an interest in how humour can exist in Palestinian lives marred by occupation. This interest focuses on the

emancipatory potential of laughter as well as its ability to open channels of understanding towards the Other. It also suggests an acknowledgement of humour's potential to rupture 'banal evil' and to render the authority of Israel's occupation as suspect.[67]

If we are to consider Israel's occupation as signaling a banal evil, there is perhaps no clearer manifestation of this evil than the Palestinian experience of waiting. The experience of waiting shapes the lives of Palestinians everywhere. For those in exile, there has been a seven-decade wait for the Right of Return. For those in Palestine, everyday life is characterised by waiting; waiting at checkpoints, waiting for permits, waiting during curfews and most importantly, waiting for the creation of a sovereign state. The experience of waiting acts as a form of psychological warfare that is often neglected in news stories and documentaries focusing on more visible materialisations of occupation. In such a way, the experience of waiting and the international failure to understand or focus upon this central tool of occupation indicates that it is a form of banal evil. Failing to arrest our attention or to stimulate a response, the act and experience of waiting is so commonplace that it elicits apathy rather than moral condemnation.

This experience of waiting is a banal evil precisely because it engenders a 'slow death'. Describing the restrictions on movement, Edward Said explained that a 'Palestinian has to resort to improvisation or persistent stubbornness...for the most part, Palestinians wait [...] Eons of time wasted, gone without a trace'.[68] The experience of waiting is witnessed in countless artworks and films. Though these works are too many to list, there is one stand out example: Rashid Mashrawi's film *Waiting* (*Intizaar*) from 2005. The film follows the story of a director named Ahmad (Mahmoud Al-Massad) who is set to leave Palestine to settle abroad but decides to accept one last job before he leaves. This final job involves auditioning actors for the new grandiose National Palestinian Theatre in Gaza that is under construction with European Union funds. Although the theatre is being built with underground parking for 500 vehicles and its opening will be attended by foreign leaders, there are no actors in Gaza to perform within it. Ahmad is joined by an interviewer named Bissan and a cameraman named Lumiere to travel to numerous Palestinian refugee camps in Jordan, Syria and Lebanon to find actors to

155

play in the theatre.[69] Each of these hopefuls is enticed into auditioning because the role would mean permission to visit Palestine.

The emphasis on Palestinian refugees and refugee camps is a distinctive trope of Mashrawi's work. Masharawi's cinematic vision is shaped by his birth in the Shati camp in Gaza, and despite having lived in Tel Aviv, the Netherlands and now residing in Ramallah, Masharawi maintains an emphasis on the camp as a site of Palestinian identity.[70] Mashwarawi's characteristic avoidance of explicitly political filmmaking is evidenced in *Waiting*, where he prefers to focus on characters' incessant existential battles.[71] Blurring the line between fiction and documentary, *Waiting*'s cast of auditioning actors were all themselves not actors but refugees from camps and the film was shot on location at the Bakaa camp in Amman, Shatila in Beirut and at a refugee cultural centre in Damascus. When each actor comes to audition in the film, it is made clear to Ahmad that most are not actors, but are simply using the audition as a chance to return to Palestine or to pass messages to loved ones they have not heard from. All the 'actors' seek direction from Ahmad for the audition and his decision to ask each refugee to perform the act of waiting, produces an absurd humour that is also a poignant reminder of the denial of the Right of Return.

As each audition hopeful performs the act of waiting in diverse and humorous ways, they are in fact being asked to carry out an activity that not only marks their everyday lives but also the lives of Palestinians in exile everywhere who are awaiting a return to the homeland. In such a way, each audition is marked by two performances of identity; the first is that of the refugee, and the second is that of the exile. This irony is picked up by one of the actors during their audition who explains, 'waiting isn't acting, it is something I've been doing my entire life'.[72] Deeply aware of the poignancy and significance of waiting within the Palestinian experience, Masharawi observes that 'waiting has become an integral part of our lives. It is at the root of our entire being'.[73]

Operating in the interstice between fiction and reality, *Waiting* reveals the banal evil of an occupation that prevents Palestinians from exerting control over their everyday lives and their destinies. It achieves this by unveiling the enforcement of the act of waiting as a central tool in the

everyday infrastructure of the occupation. By making refugees perform their own identity and experience, *Waiting* is marked by an absurd humour that forces a recognition of a banal evil that has now become commonplace. In so doing it utilises laughter as an interruption that creates an awareness of an aspect of the occupation that otherwise goes unnoticed.

Using laughter as a tool of exposure, *Waiting* is in keeping with other Palestinian cultural output that addresses the occupation with humour. The laughter incited by film and artworks centred on the failure of the peace process remind us that humour destabilises the status quo, that it challenges reality, and that it can reveal the perversity of our gaze while shielding against it – working as a mature defence mechanism against trauma. Understanding this, laughter acts a tool against occupation because it is an expression of will that calls attention to the oppression created by the Israeli systematic violence and banal evil.[74] Most importantly, however, humour renders the authority of Israeli oppression as suspect and calls us to recognise it as such.[75]

The failure of the peace process has engendered a situation where Palestinians live in a constant 'interim' period. The trauma fatigue in the international community towards the Palestine/Israel conflict has served to reinforce a political deadlock in the region. The employment of humour challenges the political status quo by asking audiences to acknowledge the lived experience of Palestinians under occupation and to question the validity of the ongoing occupation and political deadlock. Further still, humour also serves to function as an anticipatory action that both imagines and enacts the roles of a future Palestinian state. Although humour acts as revelatory vehicle, unpacking the effects of occupation, it also plays a vital role in the narration and coalescence of collective Palestinian identity.

6

Who Is Laughing?: Humour and the Boundaries of Identity

'So where are you from?'

'I'm Palestinian'

'Pakestilian? What the hell is that? So, where is Pakestilia?'

'There is no such country as Pakestilia…but I guess there is no Palestine either. Ever heard of Israel?'

'So you're Jewish?'

'How many rocks do we have to throw? God damn!'

<div align="right">Palestinian standup comedian Aron Kader,
<i>Axis of Evil</i> Comedy Tour 2009</div>

In his seminal text *Laughter: An Essay on the Meaning of the Comic*, Henri Bergson observed that 'our laughter is always the laughter of a group'.[1] Bergson goes on to suggest that the experience of shared laughter can travel through a wide circle of people, yet the circle of laughter remains nonetheless a closed one.[2] The 'circle' of humour to which Bergson alludes is one that is contingent on a shared understanding of the world, and therefore a shared appreciation of humour. When looking to Palestinian humorous cultural output, Bergson's observations raise an important question: namely who makes up the 'group' laughing at/with Palestinian humorous art and film?

If we are to concede that laughter is dependent on a shared experience of the world, it is also therefore contingent on a shared sense of identity.

Knowing this, the humour of Palestinian art and film can then be said to draw out two circles of laughter. The larger of these two circles is that of international audiences responding to humorous Palestinian cultural output. The smaller of these two circles is that made up of Palestinians, who through shared laughter, can be said to be reinforcing a sense of identification with one and other. Within this smaller circle, laughter is transformed into a litmus test that probes the boundaries of Palestinian identity and verifies a sense of Palestinianess. One can look to the *SEXY SEMITE* artwork as evidence of how the Palestinian circle of laughter demarcates a sense of collective identity.

In the years between 2000 and 2002, a series of peculiar personal advertisements appeared in the New York *Village Voice* newspaper. These personal advertisements all appeared to be placed by Palestinians seeking romantic liaisons with Jewish readers. An example of one of these advertisements reads as follows: 'Palestinian Flamenco Dancer semetic sex pot SKG: Jewish M (any race) for LTR and to share our lives in Israel. I love Palestinian falafel, Akka and the Gaza beach.'[3]

All the advertisements ran a similar line, each seeking a Jewish reader willing to possibly marry a Palestinian, thereby facilitating a return to the homeland using the Israeli Law of Return. Though there were over sixty advertisements placed between 2000 and 2002, it was not until the Valentine's Day edition of the *Village Voice* that concerns were raised about the true nature of these personals.

As media outlets began to report on the story, it became clear that the adverts were an act of political agitation. The lack of understanding of the intention behind the adverts, and indeed the failure of the newspaper to make contact with the individuals that ordered them, led some media outlets to speculate that the personals were part of a Palestinian terrorist plot.[4] Far from terrorist activity, the advertisements were in fact an artwork by artist Emily Jacir. The artist orchestrated the work by commissioning sixty Palestinian participants, who along with Jacir placed these advertisements in the *Village Voice* with the intention of highlighting the continuing denial of the Palestinian Right of Return. The advertisements came to be known as the *SEXY SEMITE* artwork and have been displayed in exhibitions with an archival aesthetic that when installed, sets out the advertisements alongside newspaper reports.

Appearing initially as innocent adverts, the texts take on a different character when installed in exhibition. In the gallery context, these advertisements are stripped of their ambiguity and are revealed as a distilled tongue-in-cheek commentary on the continued denial of the Right of Return. In this context, the initial concerns that the advertisements might have been part of a terrorist plot are rendered laughable. The gallery space therefore serves to frame the advertisements as a deliberate act of subversive political defiance. Further, it is the gallery space that gives license to audiences to appreciate the humour in each advertisement by revealing the intentions behind each personal.

Contextualised by the gallery space, each advertisement appears as though a parody of genuine newspaper personals. It does this by drawing from acronyms characteristic of personals, including LTR (long term relationship), or SKG (seeking), and clichéd personality descriptors such as enjoying walks on the beach, enjoying sunsets etc. These clichés are also set alongside stereotypes of Palestine and Israel in each advert, including suggestions that applicants enjoy olives, falafel, the land of milk and honey etc. This has the effect of fusing together two forms of the banal in the artwork: the first is the inclusion of commonplace descriptors of the land of Israel/Palestine and the second is the banality of the medium of the personals themselves. Importantly however, Jacir's use of the banal also brings to play the 'secret code' quality of humour.[5]

It is vital to remember that *SEXY SEMITE* was a relational artwork, a collaborative work between a Palestinian artist and other Palestinians commissioned to submit advertisements. When commissioning the advertisements, Jacir insisted that participants adhere to certain guidelines. These included an insistence that writers use the word 'semite' to describe themselves, that the Right of Return was mentioned and that each advert highlight the fact that Palestinians are indigenous to the land.[6] The adverts that followed from Jacir's commission not only adhered to these guidelines but also were loaded with subtle references easily recognizable to those privy to the Palestinian perspective.

These included references to citrus fruit, the mention of house keys and a description of the city of Acre with the Palestinian name of Akka rather than the Israeli Akko. These heavily loaded references each draw upon Palestinian nationalist iconography that reinforce a connection and

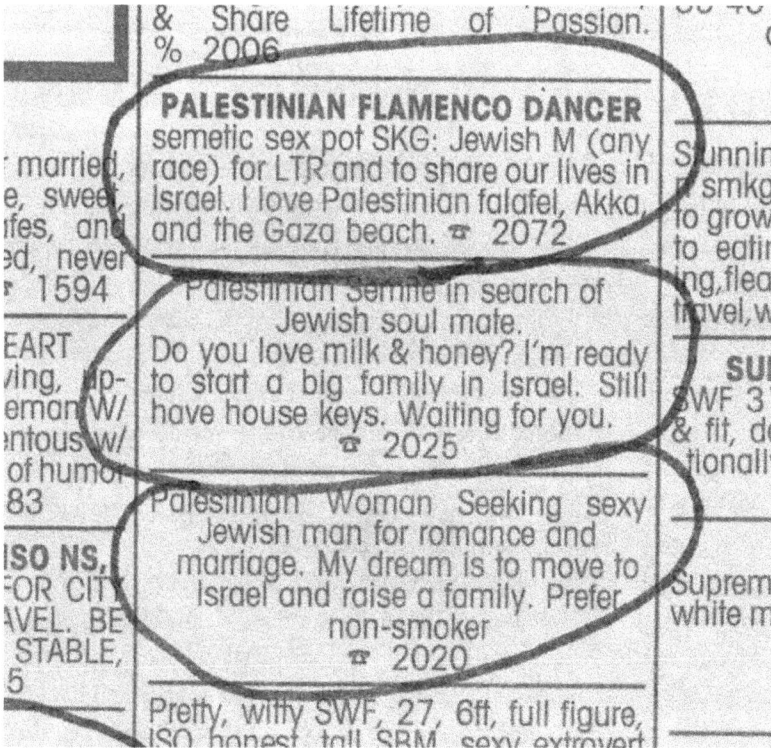

Fig 20. Emily Jacir, *SEXY SEMITE*, 2000–2002: *documentation of an intervention*, Personal advertisements, 2000–2002
Credit: Personal ads placed in the *Village Voice* (Palestinians placed personal ads seeking Jewish mates to return home utilizing Israel's "Law of Return")
Courtesy Emily Jacir, © Emily Jacir 2002

ownership over the land. This is perhaps most clear in one advertisement (depicted in Fig. 20) that reads 'Do you love milk and honey? I'm ready to start a big family in Israel. Still have house keys. Waiting for you!'. The mention of house keys draws upon the nationalist significance of the key in Palestinian iconography. The key is a symbol that stands for the Right of Return as many Palestinians still have their house keys from the time of occupation and hold on to them as precious objects that are a reminder and validation of the appropriation of their land and property.

161

The inclusion of these national signifiers in the work makes the initial advertisements in the *Village Voice* instantly recognisable to Palestinian readers as a humorous act of political subversion. Their laughter precedes the context of the gallery because for Palestinians these banal objects are immediately understood as cultural signifiers and therefore do not require framing devices or contextualization. The immediacy of the Palestinian understanding of the humour within each artwork reinforces Simon Critchley's assertion that 'having a common sense of humour is like sharing a secret code'.[7] Although we might appreciate that having a sense of humour is a universal human trait, humour is undoubtedly context specific and importantly, it serves as a form of cultural insider knowledge.[8]

In such a way, *SEXY SEMITE* might be said to operate as an artwork that delineates Palestinian collective identity through the use of humour. It does this by drawing a line of division between those that understand cultural insider knowledge latent in each advertisement. It might be said that the delineation of identity is made visible (or rather audible) when or in which context a viewer laughs. The ability to appreciate the humour of each advert prior to the contextualization that occurs in the gallery space indicates an understanding of Palestinian collective iconography and national signifiers, as well as signalling a shared experience of exile. Understanding this, *SEXY SEMITE* is marked by a humour that reinforces a sense of collective identity and is, as Critchley argues, an indication of laughter's ability to return individuals to a circumscribed 'ethos' and 'ethnos'.

Using the term 'ethos' as it is understood in the Ancient Greek sense, Critchley elaborates on the connection between laughter and ethos by exploring how humour validates a shared understanding of custom and place but also disposition and character. With this in mind, humour is said to be the vehicle that connects us strongly to a particular place and leads us to predicate characteristics of that place while attributing certain customs and dispositions to its inhabitants. Humour therefore takes us back to the place where we are from, whether that is our neighbourhood or the nation.[9] In other words, laughter returns us to our ethnos.

The ability to laugh at *SEXY SEMITE* with immediacy therefore reveals a shared disposition and a return to place, in this case to Palestinianess and a return to Palestine. Although this ultimately frames Palestinian laughter at *SEXY SEMITE* as coming from a sense of identification, the humour of

162

the work must not simply be understood as the humour of recognition. The point of differentiation between the humour of *SEXY SEMITE* and humour of recognition is that the latter only serves to reinforce consensus and no way seeks to change a situation or to challenge the established order.[10] The immediacy of Palestinian laughter toward *SEXY SEMITE*, although indicative of a sense of identification, clearly challenges the established order by using humour to highlight the denial of the Right of Return by attempting to facilitate a Palestinian return to the land by way of marriage to an Israeli citizen.

This indicates that *SEXY SEMITE* both operates as a tool of non-violent resistance and engages with the redemptive power of humour by making visible the background meaning implicit in each of the Palestinian cultural signifiers in the advertisements. The work therefore reveals the potency of humour to coalesce a shared cultural identity by highlighting the collective experiences, understandings and aspirations that inform that identity. The humour of *SEXY SEMITE* functions as a Palestinian 'shared prayer' precisely because it reveals the injustices of the world but imagines a better world in its place.[11] It achieves this by using humour to stimulate a change in the way Palestinian exile is looked upon and understood and indeed actually suggests a path to ending exile.

The humour of *SEXY SEMITE* can also be said to operate at the frontier of national identity. This is because it harnesses reactionary quality of humour that tells us important truths about who we are.[12] Clear evidence of humour's ability to coalesce a shared identity can be seen in an experience that is familiar to many. When travelling abroad and meeting a stranger who we discover is from the same place as us, one of the first things we do is share a joke about the place where we are from. This serves to rapidly draw a line of connection between people who are otherwise strangers. The consequence of this exchange is a swift sense of intimacy that is informed by a common understanding of the world. Laughter shared by compatriots is therefore akin to sharing a secret code of cultural distinctiveness. Exchanges of this sort are observed by Critchley who writes that 'we wear our cultural distinctiveness like an insulation layer against the surrounding alien environment. It warms us up when all else is cold and unfamiliar'.[13]

Humour's ability to serve as a layer of insulation is nurtured by an understanding of cultural distinctiveness. This is particularly important for Palestinians who are divorced from their land and whose collective identity

is often seen as predicated on an experience of exile. The appreciation of the humour of *SEXY SEMITE* is in fact contingent on the understanding of Palestinian cultural distinctiveness. It is precisely the lack of understanding of the cultural signifiers in each of the adverts that caused the work to be misconstrued as a terrorist plot. Although *SEXY SEMITE* is indicative of humour's ability to delineate a shared experience and understanding of the world, it is not alone in this.

The humour of Palestinian cultural output almost always relies on some degree of appreciation of cultural particularities. In all examples of humour in Palestinian art and film, the speed with which one recognises the cultural signifiers within each work directly correlates with the time it takes one to laugh. The proximity of laughter to humourous stimulus is therefore an index of cultural understanding or 'insiderness'. Accordingly, the failure to appreciate the humorous cues in cultural output is an indication of a position of cultural outsider. Laughter is therefore shown to be a sign of tacit consensus, comparable to a game that players play when they both understand and follow the rules.[14]

Elliott Oring has explored the potential of humour to be nation specific in his work *Engaging Humor*. Exploring the humour of the settler/colonial nations of Israel, the United States and Australia, Oring contends that although we might assume that a nation's humour is unique because it is an expression of a peculiar character, the humour of different nations proves strikingly similar. Within Oring's analysis, it is only colonial nations (as new nations) that are better placed to consider humour as a 'national and original' form of expression. This is because new nations were established at a time when humour could be thought of as an expression of self, both in the personal and the collective sense.[15] Although Oring's analysis is both questionable and problematic as it does not adequately account for the humour of first nations or indigenous populations – his analysis of humour's relationship to national identity is a useful one. What is significant about Oring's discussion is his suggestion that 'new' countries are better placed to consider humour as an expression of their national singularity. Although Palestinians are not considered within his argument, Palestinian humour fits closely into the framework that Oring sets out for new nations.[16]

Oring's suggestion that humour developed alongside the establishment of the new states of Israel, the United States and Australia might be said to

correspond with Palestine. This is because humour emerged in Palestinian cultural output at the time when there was first a concrete international acknowledgement of Palestinians as a distinct cultural group with a legitimate right for statehood following Oslo. Oring's assertion that bourgeoning national humour is relayed and legitimised in settler societies because it was promoted in newspapers, books, novels and scholarly works also resonates with the humour witnessed in Palestinian cultural output.

These materialisations of 'frontier' humour are based and located in the local and it is only with their recording that they become established as authentic reflections of a national character. These materializations of humour are purveyed to the citizens of a new nation, who accept humour as their own. Humour is therefore held up as a mirror of the whole and accepted as such.[17] In the case of Palestine, humour in art and film might be argued to be materializations of humour that function as a national mirror. Since the time of Oslo, Palestine has been cast into the role of (re)emerging state, and the period of its emergence corresponds with materialisations of humour in Palestinian cultural output. Within Oring's conceptual framework, the humour in Palestinian art and film takes on a different symbolic resonance; it is capable of narrating national identity for Palestinians dispersed throughout the world, coalescing a sense of national character.

Though different nations and cultures have much humour in common, it is the shared experience of the world that forms a unique humour. To illustrate this point, it is useful to consider a breed of ethnic jokes we are familiar with. These jokes have a standard formula that altered to fit a local context. Examples include the English laughing at the Welsh, the mainland Australians at the Tasmanians, the Greeks at the Pontians etc. For Palestinians, the butt of the joke is most often the Hebronites, who are pitched as naïve, dimwitted and overly earnest. Although requiring some degree of local knowledge, many of these ethnic jokes are essentially formulaic.[18] Despite eliciting laughter, this form of humour does not harness the greatest potentials of laughter. It does not challenge the status quo, it does not challenge contemporary realities or stereotypes, and most importantly it largely does not oblige audiences to understand anything new about themselves, others, or the world.

To propose that humour has the ability to tell us about ourselves is importantly *not* the same as suggesting that the revelations that come from

laughter are all inherently positive. Accepting Alenka Zupančič's argument that the contemporary ideological climate is one that demands that we perceive all terrible things that happen to us as positive, warrants the expectation that only 'good' people feel good, and only 'bad' people express negative emotions.[19] For Zupančič, this contemporary ideology is argued to be one that perceives humour as a 'positive attitude' that stands apart from the 'rigid fanaticism' associated with ideology.[20] Despite this perceived dichotomy, laughter is able to transcend the divide between 'good' and 'bad' despite the perception that it is an inherently positive behaviour.

Laughter therefore subverts the contemporary ideological climate's emphasis on positivity because it arguably returns us to our ideological perspective. The spontaneity of laughter is responsible for the misconception that humour exists outside of ideology. Laughing and breathing freely, we appear as though we are beyond constraint and withdrawn from any immediate ideological claims.[21] It is perhaps for this reason that humorous Palestinian cultural output continues to draw international interest and acclaim. Engaging humour, Palestinian art and film appears as though it is absent of ideology, yet a reply of laughter to Palestinian art and film signals an ideological position. As an act of consensus, laughter reinforces the ideological perspectives projected in art and film. This is significant because in a period where contemporary discourse is seen to promote a distancing away from the glorification of ideology, humour returns us to our ideological position.[22]

The laughter toward *SEXY SEMITE* might then be said to reveal an ideology of nationalism. The laughter incited by the recognition of nationalist signifiers such as citrus fruit, olives etc. indicates a nationalist ideology that is based on the idea that Palestinians have a long-standing connection to the land and thereby have legitimate claims of ownership over that land. The utilization of nationalist symbols was in fact deliberately enforced by Emily Jacir who when commissioning the advertisements for the work, set the perquisite that all contributors include a reference to the fact that Palestinians were indigenous to the land of Israel/Palestine. The emphasis on the connection to the land is a long-standing trope in Palestinian art and film and was in previous decades deliberately used as a form of nationalist propaganda.[23] Although the acknowledgement of these nationalist symbols signifies an awareness of an ideological perspective, increasingly

166

the use of these symbols in Palestinian art and film also suggests a critical approach to nationalist ideology.

The critical approach to Palestinian nationalism can be evidenced in humorous cultural output that actively seeks to deconstruct existing national-ist iconography. This iconography was largely established by the *jeel al-thawra* following 1968. The generation of the revolution were responsible the delib-erate construction of a Palestinian nationalist iconography that marked an attempt to shift the collective Palestinian identification with refugeedom toward a nationalist ideology and national identity. This process in art and film corresponded with the construction of the Palestinian national move-ment that came after the defeat of Pan Arabism and the Palestinian takeover of the PLO. This period of 'militant' cinema and art actively sought to trans-form a sense of 'Palestinianess' into one of 'Palestinianism'.[24]

Perhaps not surprisingly, one of the most pronounced nationalist sym-bols to emerge during the revolutionary period was the Palestinian flag. Although the Palestinian flag was originally based on the flag of the Arab Revolt from the time of the Ottoman Empire, it was adopted by the PLO in 1964 prior to Palestinian control over the Organisation.[25] The flag took on new significance following the June War of 1967 when Israel banned the flag from the Gaza Strip and the West Bank when it occupied the Territories. Israel went even further in 1980 when it banned the use of the colours of the flag in artworks and repressed any overtly political imagery. So deep was the Israeli censorship that paintings were confiscated and exhibitions were closed for displaying anything that might be deemed as containing a political message. This meant that artworks were in effect treated with the same censorship regulations as other printed political material.[26]

Such censorship is an indication of the oppressive Israeli paranoia of the time that broached upon political absurdity. This absurdity meant that even banal objects could be invested in as national signifiers. Artist Sliman Mansour joked about the ludicrousness of Israeli censorship at the time explaining, "I am unable to paint a slice of watermelon".[27] The severe censorship of this era meant that national signifiers held utmost importance, a gravity that was only magnified by the revolutionary strug-gle toward achieving statehood. Although restrictions on the depiction of the flag were lifted in the Palestinian Territories following the Oslo

Accords, the flag naturally remains the paramount symbol of Palestinian nationalism.

The nationalist investment in the symbol of the flag can be made clear by looking to a statement by Yasser Arafat in the weeks prior to the official signing of the first Oslo Accord in 1993. Arafat proclaimed, "the Palestinian state is in our grasp. Soon the Palestine flag will fly on the walls, the minarets and the cathedrals of Jerusalem".[28] Here Arafat was describing the nation of the flag as a metonym of Palestinian nationhood. By discursively waving the flag, Arafat was hoping that flags would eventually be waved in a recovered Palestinian homeland. Yet, as Michael Billig notes, Arafat's longer view would be a hope that the flag waving would stop, for only then would Palestine have achieved the status of stable sovereign nation-state.[29]

As statehood is yet to be achieved, the flag remains a signifier of an urgent and vigilant nationalism. It is only when Palestinian state sovereignty is established that this symbol of nationhood will be absorbed into the environment of the established homeland. This process of transition for nationalist signifiers is discussed by Michael Billig as being a 'movement from symbolic mindfulness to mindlessness'.[30] Contemporary Palestinian cultural output's self critical approach to national symbols might superficially appear to resonate with a sense of 'mindlessness'. This veneer of mindlessness comes through the employment of humour toward national signifiers. The use of humour appears contradictory to a sense of 'mindfulness' toward nationalist iconography because it appears as though to ridicule these signifiers.

This veneer of mindlessness toward the nationalist symbol of the flag can be witnessed in the *New Flags for Palestine* project in the *Subjective Atlas of Palestine*. The project came as a result of the publication's commission of Palestinian artists and designers who were all asked to design a new flag for Palestine. Most of the designs were marked by an aesthetic deconstruction of the Palestinian flag with interventions that shifted the shapes of the flag or included additional symbols to reference the landscape, Palestinian suffering under occupation, or allusions to dispossession. However, one flag stands out from the rest, that of artist Khaled Hourani.

Hourani's flag is the only one out of the 36 included in the *Atlas* to completely depart from any clear reference to conventional flag design. Instead Hourani chose to submit an image of a piece of watermelon. Appearing as completely absurd within the context of the other flags, Hourani's submission

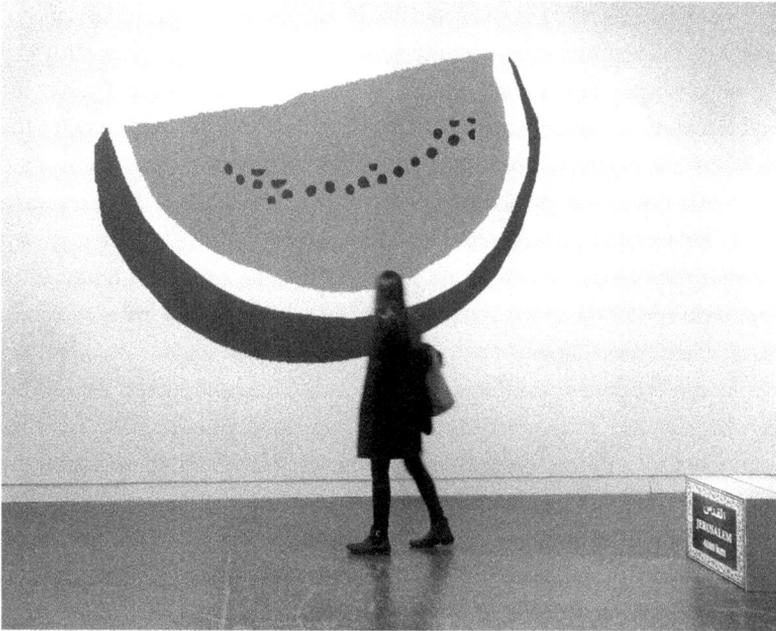

Fig 21. Khaled Hourani, *Watermelon* (Installation View), 2007
Credit: Image Courtesy of the Artist

initially suggests a complete irreverence toward the national signifier of the flag. Rendering the symbol of Palestine into a piece of fruit, Hourani's work initially incites laughter because it appears as absurd. In such a way, the work gives an impression of mindlessness toward nationalist iconography. In spite of this, the *Watermelon* maintains one important aesthetic attribute of the Palestinian flag: the use of the colours red, black, green and white.

The use of the flag's colours suggests that there is perhaps seriousness beneath Hourani's image that initially appears as one of folly. It is only when one is aware of the restrictions imposed on references to the flag in previous decades that Hourani's seemingly frivolous flag design is understood as entirely earnest. The work displays an acute awareness of the history of the flag and the censorship of its four colours in previous decades. Hourani's contribution therefore reminds us of a time of austere repression of Palestinian nationalism and takes us back to an era when artists like Sliman Mansour were not permitted to even paint a watermelon.[31]

169

Hourani's *Watermelon* is evocative of a climate of severe political censorship and repression that was capable of rendering even the most trivial of objects into icons of nationalism. Although seemingly mindless to the representation of nationalism, the work is anything but indifferent. The initial sense of absurd humour in the work is redolent of the absurd Israeli paranoia toward depictions of Palestinian nationalism. Understanding this, the use of humour might be said to puncture the dichotomy between mindfulness and mindlessness toward nationalism. The humour of Hourani's *Watermelon* displays a mindful approach toward a nationalist iconography that, although censored and repressed, was one that was deliberately constructed. Forging a self-critical bridge between Palestinian art history and nationalist iconography, the work broadens the scope of signifiers of national identity whilst engaging laughter to self-critically challenge nationalist essentialism.

The other nationalist icon to come under scrutiny in contemporary art and film is that of resistance fighters. The use of humour toward these symbols of Palestinian nationalism marks a radical departure from the revolutionary identity that prevailed in previous decades but also lays the relationship between resistance and nationalism under scrutiny. The humorous representation of freedom fighters in effect probes the ways in which they were deliberately constructed as symbols of national identity. This construction deliberately framed revolutionary fighters as void of everyday concerns and behaviours as though the sole purpose of their existence was to liberate the homeland. This essentialised perception of revolutionaries forms the humour of Monther Jawabreh's *As Once Was Known* series. Jawabreh's paintings subvert common representations of fighters by depicting them engaged in everyday behaviour such as playing cards or reading a book.[32] The disconnect between Jawabreh's paintings and depictions of fighters in militant cinema or revolutionary art elicits a humour that functions by defamiliarising the familiar.[33] Jawabreh's paintings effectively humanise revolutionaries by removing them from their heroicised status within essentialist, nationalist imagery.[34]

Ihab Jadallah's 2009 short film *The Shooter* also uses humour to question the representation of the Palestinian resistance struggle and the heroisation of Palestinian resistance fighters.[35] *The Shooter* playfully questions Palestine's staging for sensational news stories and suggests that

Palestinians are faced with another form of occupation; that of the media lens. The film centres on a news report about Palestinian resistance fighters and depicts both a Palestinian fighter (the protagonist) and a news journalist covering Palestinian resistance. As the protagonist of the film becomes active, he is seen to breakaway from the predetermined script and staging of news coverage that surrounds him. The film's revelations about the staging of resistance for the camera lens unveils the ways in which Palestinians are asked to 'perform' a revolutionary identity. By deconstructing the representation of resistance and by parodying the Palestinian revolutionary identity, Jadallah's film uses humour to self-critically analyse the nationalist emphasis on resistance and revolution.

The appreciation of the humour of Ihab Jadallah's film and Monther Jawabreh's paintings is contingent on a familiarity with the role of resistance fighters within the nationalist narrative of Palestine. Works such as *The Shooter*, the *As Once Was Known* series – and indeed Hourani's *Watermelon* – hold the images used to establish a nationalist visual vocabulary as their direct target of humour. Importantly, these icons were instrumental in coalescing a sense of 'Palestinianism' and it is the saturation of these symbols in the history of Palestinian cultural output that has leant them a certain stability. It is this saturation and ideological stability that perhaps gives license to contemporary Palestinian practitioners to use them as targets of humour.

However, one important clarification remains. Although the increasing use of humour has been seen to target deliberate constructions of 'Palestinianism', the same cannot be said of humour in regards to the event responsible for 'Palestinianess'. There is little, if any, evidence of humour directed at the experience of the Nakba in art and film despite the fact that the event is responsible for collective identification with the experience of exile. It is perhaps still too soon to broach the subject of the Catastrophe with humour. As the event responsible for the continuing experience of exile, the Nakba is of course known amongst all Palestinians. However, it arguably has not achieved the same representational stability that characterises the revolutionary movement. Evidence of this continued instability can be witnessed in the continued urgency with which texts are published about the event, each recounting oral history and disseminating documentary evidence of what occurred. Adding to the urgency of the discussion

171

and documentation of the Nakba is the threat of time, as the generation who were adults in 1948 have either died or are now in old age.

Though contemporary cultural output refrains from laughter centered on the Nakba, there is also a paucity of documentation and research around the humour of the generation who experienced the Nakba and those who preceded them. Although it is perhaps likely that the generation of the Catastrophe would have engaged with humour toward the event as a form of psychological self-defense against trauma, without any active attempts to record this humour it will be lost under the weight of history and exile. This is deeply regrettable because the humour of the period would undeniably lend insight into culture and society prior to occupation. Further, this lament over a lost humour resonates with the nostalgia toward life prior to the occupation and reminds us that 'the sweet melancholy of exile is often rooted in a nostalgia for a lost sense of humour'.[36]

Elia Suleiman's most recent film *A Time That Remains* from 2009 explores the Nakba with an occasional light touch. Although engaging laughter in scenes depicting subsequent decades of Palestinian history, the film refrains from any over incitement of laughter when dealing with the events surrounding 1948. Although this might initially suggest a hesitation toward employing humour to an event characterised by its re-telling through oral history, Suleiman's wider oeuvre is indicative of the filmmaker's determination to problematise national narration and a sense of Palestinianism. Rather than attempt to narrate the story of Palestinian history or to use film to satisfy a nationalist agenda, Suleiman explains that 'for me, there is no homeland. There is only memory'.[37] Memory subsumes national narration in Suleiman's films and becomes a vehicle of self-criticism both of Suleiman himself, but also of Palestinian nationalist ideology more broadly.

Suleiman's use of humour to destabilise national narration is most clearly evidenced in the ways the director parodies national signifiers. *Divine Intervention* is notable in this regard, particularly in its climactic ninja scene. When considered alongside the work of Jawabreh, Jadallah and Hourani, Suleiman's humour toward national signifiers is indicative of how laughter can puncture the Palestinian mindfulness and reverence toward national identity.[38] The mindfulness toward nationalism when coupled with the apparent 'mindlessness' of humour does achieve something

of considerable import: humour both reveals nationalism as an essentialist ideology and strips it of reverence. As a consequence, laughter can be said to test the boundaries of nationalist ideology and national identity. By probing the boundaries of nationalism laughter illuminates and reinforces a pluralist understanding of Palestinian identity and experience.

By challenging the boundaries of national identity and by scrutinizing Palestinian nationalism, humour problematises the idea that there is a set combination of national characteristics that gave rise to the Palestinian people. Rather than articulate a sense of national identity, humour can be said to be a manifestation of the 'general will' of Palestinians. Former PLO representative and academic Karma Nabulsi explores the general Palestinian will by utilizing the theoretical model set out by Jean-Jacques Rosseau. For Nabulsi, the general will of Palestinians is said to be distinct from nationalist ideology and is argued to be a social contract that is the glue that keeps Palestinians together, giving them a sense of shared purpose and expression.[39] Despite its merits, the general will is a potentially troublesome term because it is not empirical and is difficult to analyse, survey or classify. This is a difficulty also shared by expressions of humour.

Further correlations can be drawn between the concept of general will and manifestations of humour. As Nabulsi explains, the general will is emphatic not ethnic and 'it is neither based on language, custom, religion, race or on the nation'.[40] Rather, the general will usurps all of these characteristics and determinants whilst avoiding a reliance on any of them in isolation. This is because the general will is never static, it moves and grows and changes.[41] Like humour, it is both relational and unquantifiable. The general will is an apt model for which to consider the Palestinian relationship toward humour in contemporary cultural output. It is fitting because it reveals how humour is a form of shared will and understanding which, although related to many determinants, evades didactic nationalist framing and reductionist understandings of the determinants of shared identity.

Humour's ability to shift and grow alongside social and political change means that it shares an important characteristic with cultural identity, namely that it is diverse and never static. It is here that one must remember that diversity and dynamism are key indicators of established cultural identities, for a diverse people can be said to be a real people. Humour is indicative of the diversity of Palestinian experience and the complexity of

Palestinian identity. For this reason, humour can undermine the static and reductionist efforts of nationalist ideology whilst reinforcing a general will or collective identity.

Although the laughter incited by cultural output lends insight into how humour can coalesce a shared Palestinian identity, it is also imperative to consider the laughter of non-Palestinians toward contemporary art and film. It is useful here to return to Bergson's discussion of laughter as being that of a group. If we are to concede that laughter toward humorous cultural output is demarcated by two closed circles, we must remember that the laughter of Palestinians only makes up the narrower of the two. The broader of these two circles is made of up the laughter of non-Palestinians. Although these circles occasionally overlap, an analysis of the circle of humour made up of non-Palestinians engenders two vital questions: Who is laughing? Why are they laughing?

It is pertinent to consider the distinction between the two circles of laughter as being based on the differentiation between intracultural and intercultural humour. An investigation of intercultural laughter instigated by humour in Palestinian art and film illuminates the potential of laughter to implicate audiences in aggression, to fracture stereotypes and to demarcate the parameters of identity. It is helpful here to again return to Bergson's analysis of humour and in particular his observation that 'laughter appears to stand in need of an echo'.[42] Bergson's observation of the echo of laughter reinforces his suggestion that laughter must always be that of a group. Superficially, this interpretation of laughter's echo appears as applicable only to individuals of the same group; more specifically, only to those who share the same identity. However, the notion of laughter requiring an echo can be broadened to consider how humour functions within the intercultural exchange between groups of people of vastly different backgrounds and identities.

That said it is not just laughter that requires an echo, the same can also be said of identity. Identity always exists in dialogue with others and is the background for our actions and interactions. Identity is thus always partly shaped by recognition and misrecognition and consequently it is like an echo that informs both our actions and our reactions.[43] The laughter of non-Palestinians toward humorous art and film is therefore crucial to the demarcation of identity. Intercultural laughter is essentially

one of recognition that reinforces Palestinian identity as one that is (like all identities), in constant dialogue with others. Although both humour and identity require an echo, they take on a different gravity when they converge with trauma, an experience that also requires an echo.

It is a long accepted view that the primary agent in the recovery from trauma is an appreciative audience who acknowledge the suffering and injustice inflicted on another.[44] This acknowledgement is the echo of trauma that is vital to the facilitation of recovery. Despite appearing as counter-intuitive, it is clear that the laughter of non-Palestinians toward humorous cultural output is a signal of this acknowledging echo toward collective trauma. This is because laughter signifies an understanding of the traumatic themes explored through humour in Palestinian art and film. The inability to laugh at the black humour that characterises art and film might initially appear as an ethical decision to refrain from laughing at another's suffering. However, it may also signal a failure to understand the way that humour has been used as a form of empowerment, lifting Palestinians outside projections of victimhood. Understanding this, the inability to laugh is therefore a failure to acknowledge trauma and to participate as its echo of affirmation.

Ultimately the appearance of humour in Palestinian cultural output within international contexts raises questions about the ethics of laughter in the face of marginality, oppression and trauma. When considering the ethics of laughter in this context, it is vital to acknowledge that much of the humour in art and in film is reliant on a performance of identity and indeed of marginality. Despite the intracultural dialogue that is raised through humour in cultural output, ultimately this humour is geared toward intercultural exchange. This is because artists and filmmakers are aware that their work is destined for international audiences in exhibitions, galleries, cinemas and festivals. Within this globalised market and exhibition space, artists and filmmakers employ humour with an acute awareness of an international gaze destined to look upon their work.

Performing their marginality through humour, artists and filmmakers take aim at dominant misconceptions and stereotypes surrounding Palestine and Palestinians. Humour is an apt vehicle for the subversion of these misconceptions because ultimately it appears as a non-threatening mode of expression. This lends cultural practitioners the ability to express

and represent issues of trauma and oppression in a way that appears void of didactic politicization or ideological framing. Connected to a perception of innocence, the humorous mode contrasts sharply with the serious issues of oppression explored in cultural output. As such, humour might be said to signal a serious strategy of non-violent resistance to oppression.[45] If successful in inciting the laughter of others, the humour of Palestinian cultural output implicates audiences into this strategy of non-violent resistance, successfully recruiting them as participants in the struggle against Israeli oppression.

Audiences are coerced into participation in this act of resistance through a manipulation of the perceived innocence of humour. By implicating audiences into an engagement with issues of Palestinian oppression, humour has the effect of dislodging the ongoing trauma fatigue in international audiences toward the Palestine/Israel conflict. Luring audiences into engaging with trauma by using the vehicle of humour, contemporary Palestinian cultural output thus facilitates an alternative encounter and window of understanding toward the Palestinian experience. In such a way, humour can be seen to nurture an intercultural exchange capable of facilitating a more nuanced understanding of Palestinian identity, and a participation in non-violent resistance, all the while engendering empathy with the Palestinian experience.

In spite of this essentially positivist view of the intercultural potential of humour, there remains a body of scholarship which maintains that humour which draws upon cultural difference is one that cannot produce anything positive, but rather acts toward the detriment of cultural harmony and respectful social relations. At its essence, this debate around intercultural humour separates those who support humour as a tool of empowerment and those that view it as capable of inciting and sustaining prejudice whilst belittling those who are culturally marginalised or socially oppressed. Somewhat problematically, the scholarship around this issue inevitably relies on terms such as 'ethnic' difference, which in and of itself is a fluid and slippery term, prone to ambiguity.[46] Adding to this, much commentary and scholarship on the topic also draws on the term 'racist' humour, which immediately predicates an association to ethically abhorrent views and beliefs.[47]

A useful distinction in this minefield is drawn by Jerry Farber, who suggests that humour can be divided into two categories: derisive humour and empathic humour. Farber points out that although these two categories can arise from the same comic stimulus and can even co-exist, the two differ profoundly in the pay offs they provide.[48] Addressing this subject directly in *Comic Racism and Violence*, Michael Billig outlines the scholarly work and approaches on both ends of this debate around ethnic humour. Drawing attention to the fact that a 'healthy sense of humour' is now viewed as a virtue in assessment of character, Billing makes clear that this is not always the case by addressing the more sinister and offensive possibilities latent in humorous interaction. Claiming that those who laugh at racist jokes are quick to deny that they hold racist beliefs, Billing reminds us of one of the most common phrases in the English language, 'just joking'.[49]

The appearance of 'just joking' in effect marks the transition from a harmonious exchange to one that is at best marred by non-reciprocal sentiments, and at worst a transformation to a tense or even aggressive point of difference. As a signifier of not only our state of mind but also our social, ideological and political beliefs, the misfire of humour reminds us of our active role as audiences and recipients of humour. Our ability, or indeed inability, to laugh at something which draws upon cultural difference reveals something about ourselves; specifically whether we are willing to be implicated in an underlying argument of perspective concealed in the content we are presented with.

In the case of Palestinian art and film, a willingness to become complicit in the underlying argument or perspective of humour entails a participation in aggression that often directly targets the Israeli state. The audience's complicity in derisive humour that targets Israel signals a manifestation of laughter that correlates with both the Superiority and Relief theories of humour. Laughter toward the Israeli state is essentially an act of mockery that relates to the Superiority view of humour because it indicates a controlled form of aggression. As an act of mockery, the humour of Palestinian art and film suggests an eminency in those participating in the laughter it induces and an infirmity in those whom laughter targets. Although this laughter is derisive of the Israeli state, it is also empathic.

Whilst the laughter produced by output is derisive of Israeli state practices, it also forges an empathic connection with Palestinians

lending insight into their experiences of the Israeli occupation. This circuit between derision and empathy reinforces the suggestion that although humour can be divided into the two categories of derisive or empathic humour, it is also possible for the two forms to coexist.[50] As much humorous Palestinian cultural output utilises techniques of humour to make visible the effects of Israeli occupation, laughter toward this output serves as an acknowledgement of the codified points of reference in humour that target the occupation. The laughter of audiences may therefore signal solidarity with Palestinians against the oppression they face. If we accept the notion that laughter of the oppressed functions to render the oppressor's authority as suspect, then an audience's echoing of this laughter only serves to further reinforce the suspicion directed at the oppressor; the state of Israel.[51]

Although the laughter targeting the Israeli state is one of derision and therefore appears to resonate with the Superiority Theory of humour, it is also useful to look to how this laughter is indicative of the Relief Theory of Sigmund Freud. Freud argued that jokes are centered on aggressive thoughts that would be censured if stated directly and laughter was an indication of relief that these thoughts had been aired.[52] An expansion of Freud's analysis of jokes to encompass humour more broadly reveals the potency of Relief Theory as a frame for which to look upon humour in Palestinian art and film. For decades, Palestinian cultural output has in the Western world been deemed too critical of Israel. This critical approach to Israel is perceived as a form of political aggression that should be silenced and indeed censored.

Humour might then be understood as a way of directing aggression toward the Israeli state whilst evading reproach or reprimand. The humour of Palestinian cultural output has the ability to evade censure in two distinct ways. The first evasion is that of political censorship that has relentlessly targeted exhibitions and screenings of Palestinian art and film for decades on the grounds that it demonised Israel. The second, and arguably more important form of censure that it evades is that of individual audience members. As humour appears as non-threatening, it is able to evade the censure of audiences who look upon Palestinian cultural output with cautiousness for fear of being seen as complicit in the derision of the state of Israel. By evading these two forms of censure, humour catches

audiences off guard, and if successful in encouraging laughter, indicates an acknowledgement and participation in the criticism of Israel and compassion toward Palestinian suffering under occupation.

Thus the intercultural circle of laughter incited by the humour of art and film creates a group that momentarily stands in solidarity with Palestinians against the Israeli occupation. As laughter forges a social bond between its participants, it also engenders a joint aggression against outsiders. This circle of laughter therefore demarcates a line between insiders and outsiders. Those who remain ignorant of the cultural references that elicit humour are, through their lack of laughter, repositioned and reminded of their position as an outsider. Accordingly, the line forged by laughter both forms a bond and a division, reflecting negatively on those who remain outside the circle of laughter – even if the laughter is no way directed at them.[53]

The position of outsider is perhaps most pronounced in works that elicit laughter by subverting stereotypes of Palestinians. In failing to appreciate the subversive humour, audiences not only reinforce their outsider status, but also reveal their own complicity in the maintenance of these stereotypes. Evidence of the consequences of failing to participate in laughter toward works that deal with stereotypes can be explored through an investigation of the 2009 video work by artist Sharif entitled *To Be Continued*.

To Be Continued replicates the aesthetic codes and conventions of martyrdom videos used to record the last words of suicide bombers prior to carrying out a mission. At first glance, the video does not suggest any departure from typical martyr videos; depicting a young man with a gun laying across a table in the foreground and with a green background from the Qur'an with verse 78 from the *Sourat al-Hajj* written in white calligraphy. However, it is the face of the suicide bomber that provides the suggestion that the video is not 'genuine'. Despite his unremarkable clothes and his convincing surrounds, most Palestinians audiences would immediately recognise the face of the martyr as being that of Saleh Bakri, the son of Palestine's most celebrated actor, Mohammad Bakri.

As Bakri begins to speak and his words are translated into the English subtitles below, audiences are further prompted to acknowledge the work as distinctly different to 'real' documentary martyr videos. Speaking in a monotone voice, the words Bakri reads are not what is expected. Rather then read a justification for carrying out an impending suicide mission, Bakri is depicted

179

oppressed by the heat, he sat under a tree
and reached into his saddle-bag,

Fig 22. Sharif Waked, *To Be Continued*, Video Still, 2009
Credit: Image Courtesy of the Artist

reading from the classic text of the Islamic Golden Age, *One Thousand and One Nights*. Once the audience becomes aware of the text being read, the video becomes acknowledged as one that actively attempts to subvert our understanding of martyr videos, thereby calling into question our familiarity with these videos and their proliferation in the media.

To Be Continued thus presents two juxtaposed images of the Islamic world; the media spectacle of the suicide bomber and the rich history of the Islamic culture through the narration of *One Thousand and One Nights*. The work also creates another juxtaposition by collocating the worlds of fiction and documentary. Bringing these two worlds together, the work creates a circuit that blurs the boundaries of documentary and fiction creating an experience of defamiliarization for the viewer.[54] Significantly the work also operates through a layering Orientalist stereotypes. It does so by utilising a text familiar to Western audiences largely through Orientalist renditions in cinema, cartoons, literature and television. Thus, although Western audiences may be familiar with *One Thousand and One Nights*,

their handle over particular references and specific quotes from the text is questionable, meaning they may not initially recognise the original text as performed in the work. It is in this space of defamiliarization and the blurred line between documentary and fiction that the locus of humour can be found in the work. The work's ability to defamiliarise the familiar, instigates laughter because of an incongruity with our expectations and familiarity with stereotypical images of suicide bombers. The video therefore indicates how humour is a form of critical anthropology that not only defamiliarises the familiar but also demythologises the exotic by inverting the world of 'common sense'.[55]

The failure to acknowledge the humour created through this process of defamiliarization would suggest an inability to understand Palestinians beyond their stereotypical framing in the Western media lens. The inability to recognise Waked's subversion of these stereotypes in the work would thereby signal a complicity in the maintenance of a stereotypical view of Palestinians that pitches them as fanatical terrorists. To ignore Waked's subversion would also indicate an inability to understand how *To Be Continued* dislodges conventional identifications with Palestinians. As Kevin Strohm rightly observes, the transgression of identification in the work functions by disrupting 'the regime of identification that assigns Palestinians a place in both time and place'.[56]

The destabilization of time in *To Be Continued* is achieved through the ways in which the work engages with concepts of storytelling. It is useful here to remember the basic plot of *One Thousand and One Nights*. The story centres around the Persian King Shahryar who marries a string of virgins only to execute each one the morning after their wedding to bypass any chance his wives might dishonour him. The King eventually marries a woman called Scheherazade, who on the night of their wedding, begins to tell the king a story. The king becomes curious about how the story ends and is forced into keeping his young wife alive. Knowing this, the young bride continues to tell the King stories to prevent her own death. *One Thousand and One Nights* is therefore a story that conveys the notion that relentless narration may evade death. A line of correlation can be drawn between this aspect of *One Thousand and One Nights* and martyr videos.

The convention of martyr videos dictates that each martyr narrate their last will and testament and explain the impetus behind their forthcoming

mission. Following the completion of the mission, the videos are circulated as both political fodder (for both sides of a conflict) and as a memento mori. Circulating only after death, the videos keep the image of each martyr alive. The wide circulation of each martyr's video and personal narrative in effect allows the image to transcend the physical death of martyrs by encouraging and facilitating the memory of the martyr in others.[57]

To Be Continued's ability to draw together the seemingly disparate texts of *One Thousand and One Nights* and martyr videos serves to tease out the notion that narration is a tool that allows one to transcend death. This is also a theme that can be correlated to Palestinian cultural output that has for decades been marked by a perceived urgent need to narrate Palestinian history. Although this process was undoubtedly informed by the lack of awareness and archival presence of Palestinian history, it was also compounded by the Zionist claim that Palestinians did not exist. Edward Said repeatedly explained the incessant anxiety about the need to tell the Palestinian story, explaining that 'the moment you stop telling the story, the whole thing will just disappear'.[58] In other words, Palestinian history would not exist were it not for its continual narration. Knowing this, *To Be Continued* takes on a different pertinence. Drawing together a reference to martyrs' transcendence of death through the narration of their life story and Scheherazade's ability to evade death through storytelling, Waked reminds the viewer that Palestinians are also engaged in an act of perpetual narration. This narration sustains memory, and reminds us of their history.

Palestinian cultural output has always been marked by a narration of the Palestinian story. At each critical junction of history, the form of narration shifted alongside changes in identity and political and social contexts. Although humour can be said to be the latest form of narration of the Palestinian story, it is able to achieve something that was closed off to other forms of visual communication. Humour has the unique ability to challenge our understanding of time through its idiosyncratic relationship to temporality. Simon Critchley explains that 'humorous pleasure would seem to be produced by the disjunction between duration and the instant, where we experience with renewed intensity both the slow passing of time and its sheer evanescence'.[59] In part, the instigation of laughter comes as a result of humour's ability to fuse together the past, present and future. *To Be Continued* is evidence of this, consolidating Islamic

history with stereotypical images of Palestinians as political martyrs that have prevailed in recent decades bringing them into the contemporary international art context.

Humour not only changes our experience of time, but also allows us to reimagine and reevaluate our perceptions of the past, present and future. It achieves this by defamiliarizing our understanding of all three of these temporal spaces. Palestinian art and film uses laughter to reexamine the history of Palestine by looking at the construction of national identity, it challenges the present by revealing the absurdity and banal evil of the Israeli occupation, and it looks to the future by imagining a Palestinian state that is yet to come to fruition.

Drawing together the past, present and future, humour exposes trauma, disappointment and disillusionment whilst opening a window of aspiration and hope. Indeed, laughter is said to be synonymous with both artistic freedom and hope and this is no doubt partly the reason as to why humour is increasingly visible in Palestinian art and film.[60] Humour allows practitioners the ability to self-critically look at their past and to challenge the authority of Israeli occupation, thus allowing for artistic freedom previously denied by both Israeli and Palestinian political apparatuses. Laughter allows hope because humour is one of the few ways in which people can express their aspirations and dreams, even if they appear as though a chimera. It is precisely humour's ability to express and engender hope that can be witnessed clearly in the now celebrated *Picasso in Palestine* project.

The *Picasso in Palestine* project was a two-year struggle of both the International Academy of Art Palestine (IAAP) and the Van Abbemuseum in Eindhoven to bring Pablo Picasso's *Buste de Femme* (1943) to Ramallah from its home in the Netherlands. A remarkable feat and significant moment in the history of Palestinian art, the *Picasso in Palestine* project marked the first time a modernist masterpiece made the journey to the West Bank for the viewership of Palestinian audiences.[61] The *Picasso in Palestine* project was the brainchild of IAAP director Khaled Hourani, who claims that the idea for the project began "like a joke".[62]

Hourani's proposition to the Van Abbemuseum they should lend the Picasso painting to the IAAP happened essentially on a whim.[63] Whilst visiting the Van Abbemuseum for an unrelated project, Hourani was part of a group that met with the museum's curators. After touring the Museum,

the group of visitors and staff eventually sat down together in a conference room. Whilst talking, a rhetorical question was raised by the Museum's Director Charles Esche as to what the visitors would do if they had access to the Van Abbemuseum's collection that included works by Kandinsky, Chagall, Beuys and Picasso. To this question Hourani answered 'bring one of your Picassos to Ramallah'. Hourani's suggestion was met with laughter and incredulity, as Esche recalls, Hourani's proposition 'came up as a wild idea. And then it was laughed at [and] dismissed'.[64]

Esche would have continued to dismiss Hourani's idea as mindless and mirthful if Hourani did not work mercilessly to convince the Museum, insurers and the Palestinian Authority to support the project. Despite the efforts of Hourani and many others, the *Picasso in Palestine* project is an example of how humour can be used to say and suggest something that would otherwise warrant censure. By presenting his proposition for the project on whim, with humour and perfect comedic timing, Hourani implicated the Museum's curatorial team in a circuit of laughter that called into question their assumptions about the art industry and about Palestine. The eventual success of the project is evidence of how humour can instigate an enquiry and call into question our complicity in maintaining the status quo. The humour that facilitated the project in its germinating stage is evidence of how humour can remind us that the future is never conclusive and that it is up to us to act and to facilitate change.[65]

Laughter will always serve as a call to realization. As has been shown, laughter can reveal our complicity in maintaining the status quo, our participation in sustaining stereotypes, and our understanding of the past, present and future. Although the laughter toward Palestinian art and film can be differentiated between the two circles of intercultural and intracultural laughter, humour always has the potential to teach us something about ourselves and about the world. For Palestinians, the laughter incited by cultural output serves to reinforce a shared understanding of the world and a 'general will' that comes together in collective identity. For non-Palestinians, the increased exposure to Palestinian humour through art and film engenders a new encounter with Palestine and Palestinians. This new encounter is marked by greater intimacy, solidarity and perhaps even empathy with the Palestinian experience.

Fig 23. *Picasso in Palestine*, Installation View, 2011
Credit: Image Courtesy of Khaled Jarrar

Ironically, this humour serves to remind us that the everyday lived experience of Palestinians around the world remains marked by the traumatic experience of exile. As the world continues to lay witness to the ongoing failure of the peace process and grows weary of the political rhetoric that surrounds it, Palestinians wait. They wait for an acknowledgement of their suffering, they wait for their Right of Return and they wait for the fulfillment of the long overdue promise of a Palestinian state. Most importantly, however, they wait for a time when being born Palestinian does not entail a life marred by violence and political oppression. Stuck in a perpetual limbo fostered by the 'peace process', Palestinians nevertheless continue to exert their *sumud* and confront the fate that has been forced upon them.

They rally against this fate with stones, hunger strikes and marches on the street, but also with images, texts and films. Most remarkably, Palestinians also confront this fate with laughter. The humour found in Palestinian art and film is an urgent reminder of why it is necessary that we rally alongside Palestinians for justice and for peace, and that we share not only tears, but also laughter.

Notes

Introduction

1 St John Chrysostom quoted in Jacqueline Bussie, *The Laughter of the Oppressed: Ethical and Theological Resistance in Wiesel, Morrison and Endo* (New York: T&T Clark, 2007) 21.

2 The Nakba (or the Catastrophe) is the word used to describe the foundation of Israel and the occupation of historical Palestine in 1948. Throughout this text the Zionist takeover of historic Palestine in 1948 is described with the term 'occupation'. However, it must be noted that there is some contestation over this term. Many writers prefer to use the term 'colonisation' to describe the 1948 takeover, reserving the term 'occupation' to describe the internationally recognised occupation of land seized by Israel in 1967.

3 Amnon Kapeliouk, *Sabra and Shatila: Inquiry into a Massacre* ed. and trans. Khalil Jahshan (Belmont Massachusetts: Association of Arab-American Graduates, 1984) 62–63; Leila Shahid, "The Sabra and Shatila Massacres: Eye-Witness Reports," *Journal of Palestine Studies* 32.1 (2002) 44. Between 16-18 September 1982, Lebanese Christian Phalangist militia entered the camps and massacred, beat and raped the camp inhabitants. There remains considerable speculation as to the number of executions and casualties of the massacre. Although no census of the dead has ever been attempted, the number of dead is estimated between 3,000 and 3,500 people.

4 Tahel Frosh, 'Palestinian Artist Accuses Israeli Professor of "Colonizing" his Ideas,' *Haaretz* 13 August 2008, 20 May 2012 <http://www.haaretz.com/culture/arts-leisure/palestinian-artist-accuses-israeli-professor-of-colonizing-his-ideas-1.251612>; "Art Journal Legal Settlement," *College Art Association*, 20 May 2012 <http://www.collegeart.org/ArtJournal/legal_settlement.php>. An example of this contentious politics comes in the reception of Israeli art historian Gannit Ankori's 2006 book *Palestinian Art* which was the first substantial book in English dedicated to the subject. Supported by the League of Palestinian Artists, Kamal Boullata accused the author of plagiarism and of her work being a sign of the 'occupier's cultural appropriation of the occupied'. This caused controversy within the international art community via the two scholarly journals *The British Art Book* and the *American Art Journal*. Both journals published reviews of Ankori's book by reviewers who were sympathetic

to Boullata's claims. In response, Ankori engaged legal representation demanding both journals retract the arguments put forth. Both journals reached a settlement plan, issuing public apologies with the *American Art Journal* even requesting that its viewers tear out the Ankori review from their issues.

5 Kamal Boullata, *Palestinian Art: From 1850 to the Present* (London: Saqi, 2009); Nurith Gertz and George Khleifi, *Palestinian Cinema: Landscape Trauma and Memory* (Bloomington: Indiana University Press, 2008).

6 John Morreall, "Humor and the Conduct of Politics," *Beyond a Joke: The Limits of Humour*, eds. Sharon Lockyer and Michael Pickering (New York: Palgrave Macmillian, 2005) 67; Konrad Lorenz, *On Aggression* (New York: Bantam, 1963) 284.

7 Simon Critchley, *On Humour: Thinking in Action* (London: Routledge, 2002) 2; Michael Pickering and Sharon Lockyer, "The Ethics and Aesthetics of Humour and Comedy," *Beyond a Joke* 25; John Morreall, *The Philosophy of Laughter and Humour* (New York: State University of New York Press, 1987) 1; Elliot Oring, *Engaging Humour* (Chicago: University of Illinois Press, 2003) ix.

8 Khalid Kishtainy, *Arab Political Humour* (London: Quartet Books, 1985) ix.

9 Nicholas Mirzoeff, *An Introduction to Visual Culture* (1999; New York: Routledge, 2009) 1–20.

10 Geoff King, *Film Comedy* (London: Wallflower Press, 2002); Andrew Horton ed., *Comedy, Cinema, Theory* (Berkley: University of California Press, 1991). Notable texts dealing with the significance, meaning and consequences of the genre of comedy in cinema are Geoff King's *Film Comedy* and Andrew Horton's *Comedy, Cinema, Theory*.

11 Sheri Klein, *Art and Laughter* (London: I.B.Tauris & Co Ltd, 2007) 5.

12 Morreall, *The Philosophy of Laughter and Humor* 12.

13 Thomas Hobbes, *Oxford World Classics: Human Nature and DeCopore Politico*, ed. J.C.A Gaskin (Oxford: Oxford University Press, 1994) 54.

14 Morreall, *The Philosophy of Laughter and Humor*, 129; Michael Billig, *Laughter and Ridicule: Towards a Social Critique of Humour* (London: Sage Publications, 2005) 37.

15 Billig, *Laughter and Ridicule*, 39.

16 Morreall, "Comic Racism and Violence," *Beyond a Joke* 65.

17 Elliot Oring, *Jokes and Their Relations* (New Jersey: Transaction Publishers, 2010) 108–11; Igor Kitchtaforitch, *Humor Theory: Formula of Laughter* (Denver: Outskirts Press, 2006) 5.

18 John Morreall, "A New Theory of Laughter," *The Philosophy of Laughter and Humour*, ed. John Morreall (New York: State University of New York Press, 1987) 131; James E. Collins II and Robert S. Wyer Jr, "A Theory of Humor Elicitation," *Psychological Review* 99.4 (1992): 664.

19 Elliott Oring, *Engaging Humor*, 13–14.

20 Morreall, *The Philosophy of Laughter and Humour* 130.

21 Morreall, "Humor and the Conduct of Politics," 66.

22 Billig, *Laughter and Ridicule* 57.

23 Oring, *Engaging Humor* 11; Henri Bergson, *Laughter: An Essay on the Meaning of the Comic* (CreateSpace, 2011) 15; Simon Critchley, *On Humour* (London: Routledge, 2002) 57.

24 Bergson, *Laughter* 3.

25 Joanne R. Gilbert, *Performing Marginality: Humor, Gender and Cultural Critique* (Detroit: Wayne State University Press, 2004) 15.

26 Bergson, *Laughter* 42–52.

27 Ibid, 45.

28 Ibid, 34.

29 Bussie, *The Laughter of the Oppressed* 39; Lockyer & Pickering eds., *Beyond a Joke*; Leon Rappoport, *Punchlines: The Case for Racial Ethnic & Gender Humor* (London: Praeger Publishers, 2005).

30 Bergson, *Laughter* 6.

31 Ibid, 71.

32 Anna Balakian, "André Breton as Philosopher," *Yale French Studies* 31 (1964): 40; Andre Breton, *Anthology of Black Humour*, trans. Ark Polizzotti (San Francisco: City Lights Books,1966).

33 *Sigmund Freud, Jokes and Their Relation to the Unconscious*, ed. James Strachey (New York: W.W Norton & Company, 1989) 284.

34 Fiona Bradley, *Movements in Modern Art: Surrealism* (London: Tate Gallery Publishing, 1997) 6–17; David Hopkins, *Dada and Surrealism: A Very Short Introduction* (New York: Oxford University Press, 2004) xiv; Klein, *Art and Laughter* (London: I.B.Tauris & Co Ltd, 2007) 20; Kristen A. Murray '"Burn, Bury or Dump": Black Humour in the Late Twentieth Century', PhD Diss. The University of New South Wales 2007; Doug Haynes, "The Persistence of Irony: Interfering with Surrealist Black Humour," *Textual Practice* 21.1 (2006): 26.

35 Haynes, "The Persistence of Irony: Interfering with Surrealist Black Humour," 26.

36 Andre Breton, "Lightning Rod," *The Artist's Joke (Whitechapel: Documents of Contemporary Art*, ed. Jennifer Higgie (London: Whitechapel Gallery Ventures Limited, 2007) 47.

37 Mikhail Bakhtin, *Rabelais and his World*, trans. Helene Iswolsky (Bloomington: Indiana University Press) 1993.

38 Bussie, *The Laughter of the Oppressed* 15.

39 Ibid, 15.

40 Samuel Kinser, "Chronotypes and Catastrophes: The Cultural History of Mikhail Bakhtin," *The Journal of Modern History* 56.2 (1984): 308.

41 Gilbert, *Performing Marginality* 61.

42 Murray, *"Burn, Bury or Dump"* 30.

43 Bussie, *The Laughter of the Oppressed* 155.

44 Gilbert, *Performing Marginality* 177.

45 Peter Stallybrass and Allon White, *Politics and Poetics of Transgression* (New York: Cornell University Press, 1986) 12–19.

46 This marginalisation is also mirrored in the ways in which Palestinian art and film is exhibited and screened internationally. Palestinian cultural output is almost always framed as through it is from the 'periphery'. In art exhibitions this can be evidenced by the fact that Palestinian art gets lumped under the category of 'art from the Middle East'; a framing device that when used in the West, smacks of Orientalism. Palestinian film is faced with a similar predicament, often placed under the category of 'world cinema', a category that refers to all cinema that is not made in the English language.

47 Critchley, *On Humour* 68

48 Lila Abu-Lughod, "Return to Half Ruins: Memory, Postmemory, and Living history in Palestine," *Nakba: Palestine, 1948, and the Claims of Memory*, eds. Lila Abu-Lughod and Ahmed H. Sa'di (New York: Columbia University Press, 2007) 79.

49 Julia Kristeva, *Hannah Arendt* trans. Ross Guberman (New York: Columbia University Press, 2001) 144. The term 'banality of evil' was coined by Holocaust survivor and intellectual Hannah Arendt in her book *Eichmann on Trial: A Report on the Banality of Evil* (1963). Julia Kristeva explains that Arendt's term refers to evil that 'entails the destruction of thinking (a destruction that is surreptitious, generalized and imperceptible, and thus banal, though it is also scandalous) which prefigures the scandalous annihilation of life'.

50 Chiara De Cesari, "Anticipatory Representation: Building the Palestinian Nation (State) through Artistic Performance," *Studies in Ethnicity and Nationalism* 2.1 (2012): 86. My discussion of the 'anticipatory practice' of Palestinian artists draws from Chiara De Cesari's analysis of the 'anticipatory performance' in Palestinian artistic performance.

51 Rolf Tiedemann, ""Not the Philosophy, but a Last One": Notes on Adorno's Thought," introduction, *Can One Live After Auschwitz: A Philosophical Reader* Theodor Adorno and Rolf Tiedemann ed., (Stanford: Stanford University Press, 2003) xvi.

52 Critchley, *On Humour* 4.

53 *Sumud* is an Arabic word that means 'doggedness' or 'steadfastness' in the face of adversity. It is used to describe the ongoing struggle against Israeli occupation.

1 Palestinianess to Palestinianism: Balfour to Beirut

1 Golda Meir quoted in Ibrahim Abu-Lughod, Janet Abu-Lughod, Muhammad Hallaj, Edward Said and Elia Zureik, eds., *The Palestinians: Profile of a People,*

2nd ed. (1983; USA: Palestine Human Rights Campaign; ACT Australia: Palestine Information Office, 1987) 5.

2 Theodor Herzl, *The Jewish State* (New York: Dover Publications, 1989).

3 Edward Said, *The Question of Palestine* (London: Vintage, 1979).

4 Ilan Pappe, *A History of Modern Palestine: One Land, Two Peoples* (Cambridge: Cambridge University Press, 2006) 6; Alan Dowty, *Israel/Palestine* (Massachusetts: Polity Press, 2005) 36; Edward W. Said, "Invention, Memory and Place," *Critical Inquiry* 26. 2 (2000): 184.

5 Rashid Khalidi, *Palestinian Identity: The Construction of Modern National Consciousness* (New York: Columbia University Press, 1997) 154; Dowty, *Israel/Palestine* 61; and Pappe, *A History of Modern Palestine* 5.

6 Khalidi, *Palestinian Identity*, 145–176.

7 Ibid; Haim Gerber, *Remembering and Imagining Palestine: Identity and Nationalism from the Crusades to the Present* (New York: Palgrave Macmillan, 2008) 42–106.

8 Khalidi, *Palestinian Identity* 158.

9 Jonathon Schneer, *The Balfour Declaration: The Origins of the Arab-Israeli Conflict* (London: Bloomsbury Publishing, 2010) 75–86; Shlomo Sand, *The Invention of the Land of Israel: From Holy Land to Home Land*, trans. Geremy Forman (London: Verso, 2012) 119–170. As is now both well known and documented, Britain had engaged in international negotiations regarding Palestine during the war. The most significant of these are the Sykes Picot Agreement and the Balfour Declaration that continue to be some of the most hotly contested topics amongst historians dealing with the Middle East. In brief, the Sykes-Picot agreement was a secret pact made in 1916 by French and British diplomats to carve up the Middle East into spheres under the influence of their respective countries.

10 Khalidi, *Palestinian Identity* 159.

11 Susan M. Akram, "Myths and Realities of the Palestinian Refugee Problem: Reframing the Right of Return," *International Law and the Israeli/Palestinian Conflict: A Rights-Based Approach to Mid East Peace*, eds. Susan M. Akram, Michael Dumper, Michael Lynk and Iain Scobbie (New York: Routledge, 2011) 15.

12 Eric Hobsbawm cited in Anthony D. Smith, *Nationalism and Modernism* (London: Routledge, 1998) 120.

13 Kamal Boullata, *Palestinian Art: From 1850 to the Present* (London: Saqi, 2009) 41.

14 Ibid, 41.

15 Gannit Ankori, *Palestinian Art* (London: Reaktion Books, 2006) 17.

16 Ibrahim Muhawi and Sharif Kanaana, *Speak Bird, Speak Again: Palestinian Arab Folktales* (London: University of California Press, 1989); Hanan Karaman Munayyer, *Traditional Palestinian Costume: Origins and Evolution* (Northampton: Interlink

Pub Group, 2011); Leila El Khalidi, *The Art of Palestinian Embroidery* (London: Saqi Books, 1999). Although art history has come to acknowledge both 'high' and 'low' art as equally worthy of consideration, research and discussion, within scholarship on the Palestinians arts there remains an imbalance, where forms of craft and folk practice have received the lion's share of analysis. The perception that Palestinians did not embrace modern art practices has perhaps been amplified by this scholarly emphasis on traditional Palestinian arts, craft and folk practices.

17 Boullata, *Palestinian Art* 42.

18 'Building a Legacy of Art in Palestine', *This Week in Palestine,* 106, August 2011. 10 March 2012. < http://www.thisweekinpalestine.com/details.php?id= 3475&ed=197&edid=197>; Boullata, *Palestinian Art* 54.

19 Boullata, *Palestinian Art* 72–80.

20 Ankori, *Palestinian Art* 28.

21 Boullata, *Palestinian Art* 92–93.

22 Nurith Gertz and George Khleifi, *Palestinian Cinema: Landscape Trauma and Memory* (Bloomington: Indiana University Press, 2008) 12–19; Adnan Mdanat, *History of the Speaking Arab Film* (Cairo: United Arab Artists/ Cairo Film festival, 1993); Moshe Tzimmerman, *Signs of Cinema: The History of the Israeli Film Between 1896 and 1948* (Tel Aviv: Dyonon/Tel Aviv University, 2001).

23 Gertz and Khleifi, *Palestinian Cinema* 13.

24 Ibid, 13.

25 Ibid, 14.

26 Pappe, *A History of Modern Palestine* 141; Dan Smith, *The State of the Middle East: An Atlas of Conflict and Resolution* (London: Earthscan, 2006) 40–41.; Nur-eldeen Masalha, "On Recent Hebrew and Israeli Sources for the Palestinian Exodus, 1947–1949," *Journal of Palestine Studies* 18.1 (1988): 121; Steven Glazer, "The Palestinian Exodus in 1948," *Journal of Palestine Studies* 9.4 (1980): 101. The reasons given for the mass Palestinian flight out of historical Palestine between 1947 and 1949 vary enormously in their claims and evaluations. Analyses vary between the notion that Palestinians fled under orders from their political leaders and the claim that there was a programme of psychological warfare employed by Zionist forces, designed to incite terror among the Arab population and encourage their exodus. Following the Nakba, 1 million refugees were expelled to the West Bank, the Gaza Strip, Lebanon, Syria and Jordan and only approximately 160,000 somehow managed to stay on their land. Today, Palestinians are the largest refugee group in the world with more than 4 million officially registered with the United Nations Relief and Works Agency as refugees. The number of Palestinian refugees grows at a rate of 3% every year and of the total amount of refugees approximately one third live in refugee camps in Lebanon, Syria, Jordan, Gaza and the West Bank.

27 Pappe, *A History of Modern Palestine* 141.

28 Pappe, *A History of Modern Palestine* 145. The Palestinians exiled to neighbouring countries faced varying forms of social, political and economic restriction. The most favourable hosts for Palestinian refugees were the states in the Persian Gulf; however, they were rarely reached by most refugees. In Syria, Palestinians were permitted to participate in free enterprise but were subject to harsh employment conditions. Jordan was, by comparison, much more welcoming in that it granted citizenship to most Palestinian refugees. In contrast, Lebanon maintained an uncompromising policy of oppression toward Palestinians.

29 Rashid Khalidi, *The Iron Cage: The Story of the Palestinian Struggle for Statehood* (Boston: Beacon Press, 2006) 135.

30 Khalidi, *The Iron Cage* 136.

31 Rex Brynan, "The Politics of Exile: The Palestinians in Lebanon," *Journal of Refugee Studies* 3 (1990): 205.

32 Pappe, *A History of Modern Palestine* 144; "Exiled and Suffering: Palestinian Refugees in Lebanon," *Amnesty International Annual Report 2012*, June 8 2012. <http://www.amnesty.org/en/library/asset/MDE18/010/2007/en/35eba2ba-d367-11dd-a329-2f46302a8cc6/mde180102007en.html>.

33 Brynan, "The Politics of Exile," 206.

34 Rosemary Sayigh, *Palestinians: From Peasants to Revolutionaries* (London: Zed Press, 1979) 109; Pappe, *A History of Modern Palestine* 147.

35 Kamal Boullata, *Palestinian Art* 124.

36 Ibid.

37 Meron Benvenisti, *Sacred Landscape: The Buried Holy Land Since 1948*, trans. Maxine Kaufman-Lacusta (Berkeley: University of California Press, 2002) 11–54; Pappe, *A History of Modern Palestine* 146.

38 Khalidi, *The Iron Cage* 135.

39 Ibid.

40 Kamal Boullata, "Artists Re-member Palestine in Beirut." *Journal of Palestine Studies* 32.4 (2003): 22–38.

41 Boullata, *Palestinian Art* 29.

42 Ibid, 146.

43 Ibid, 145.

44 Helga Tawil, "Coming Into Being and Flowing Into Exile: History and Trends in Palestinian Film-Making," *Nebula* 2:2 (2005): 115.

45 Yezid Sayigh, "Armed Struggle and State Formation," *Journal of Palestine Studies* 26.4 (1997): 18.

46 David Hirst, *The Gun and the Olive Branch: The Roots of Violence in the Middle East* (New York: Nation Books, 2004) 403.

47 Mass celebrations continue to annually mark Fatah's anniversary on 1 January, the date that corresponds with the first military action declared and carried out by the *Al-Asifa* (Fatah's military wing) inside Israel in 1965.

48 Geoffrey Blainey, *A Short History of the 20th Century* (London: Penguin Books, 2005) 359.

49 Hirst, *The Gun and the Olive Branch* 400.

50 Michael B. Oren, *Six Days of War: June 1967 and the Making of the Modern Middle East* (New York: Ballantine Books, 2002) 337.

51 Gregory Harms and Todd M Ferry, *The Palestine-Israel Conflict: A Basic Introduction* (London: Pluto Press, 2008) 108; Pappe, *A History of Modern Palestine* 167.

52 Hirst, *The Gun and the Olive Branch* 408.

53 Smith, *The State of the Middle East* 52.

54 *Security Council Resolutions – 1967*, 12 July 2012, <http://www.un.org/documents/sc/res/1967/scres67.htm>. Still highly controversial for its broad phrasing, the words Palestine or Palestinian do not even appear once on the document, with Palestinians referred to merely as 'the refugee problem'.

55 Malcolm Kerr cited in W. Andrew Terrill, "The Political Mythology of the Battle of Karameh," *Middle East Journal* 55.1 (2001): 91–94; Said K. Aburish, *Arafat: From Defender to Dictator* (London: Bloomsbury Publishing Plc, 1998) 70; Abu Iyad, *My home, My Land: A narrative of the Palestinian Struggle*, ed. Eric Rouleau, trans. Linda Butler Koseoglu (New York: Times Books, 1981) 49; Pappe, *A History of Modern Palestine* 191.

56 Taking as its origin the Arabic word *fida'i,* which in the singular means one who risks their life voluntarily, the Palestinian *fedayeen* were the militants and guerillas who, with a nationalist ethos, fought for the liberation of Palestine. Historically deemed freedom fighters by Palestinians, they were referred to as terrorists by Israel and its allies.

57 Pappe, *A History of Modern Palestine* 191; Abu Iyad, *My home, My Land* 57–58; Nira Yuval-Davis, Uri Davis and Andrew Mack, eds., *Israel and the Arabs* (London: Ithaca Press, 1975) 125.

58 Abu Iyad, *My home, My Land* 243.

59 Yezid Sayigh, "Armed Struggle and State Formation," *Journal of Palestine Studies* 26.4 (1997): 20.

60 Adnan Abu-Ghazaleh, "Arab Cultural Nationalism in Palestine During the British Mandate," *Journal of Palestine Studies* 1.3 (1972): 37–63.

61 Dina Matar, *What it Means to be Palestinian: Stories of Palestinian Peoplehood* (New York: Palgrave Macmillan, 2011) 111; Abu Iyad, *My home, My Land*, 60; Sayigh, *Palestinians: From Peasants to Revolutionaries*, 154. This is mirrored in the phenomenal increase in readiness of Palestinians to fight as *fedayeen*. Indeed, according to Abu Iyad, 5,000 volunteers attempted to enlist in Fatah within 48 hours of Karameh, much more than could be absorbed at the time. In the end, the numbers of new recruits rose from 52 in 1968 to 199 in 1969 and 279 in the first eight months of 1970. With renewed faith in the power of military struggle, these *fedayeen* began systematically attacking Israel.

62 Yezid Sayigh, *Armed Struggle and the Search for State: The Palestinian National Movement 1949–1993* (New York: Oxford University Press, 1997) 688.

63 Ankori, *Palestinian Art* 51.

64 Joseph Massad, "Permission to Paint: Palestinian Art and the Colonial Encounter," *Art Journal* 66:3 (2007).

65 Kamal Boullata, *Palestinian Art* 131.

66 "Ismail Shammout," *The Palestine Poster Project*, 20 May 2012. <http://www.palestineposterproject.org/artist/ismail-shammout>. Shammout's political posters have become collector's items around the world and make up a considerable part of *The Palestine Poster Project Archives.*

67 Boullata, *Palestinian Art* 131.

68 Albeit a short period, these years served to separate and define the differences between the generation that experienced the Catastrophe as adults (*jeel al-Nakba*) and those whose formative years were spent in exile from the homeland of Palestine and whose collective experience was divorced from understanding the comforts that come alongside living in a homeland of one's origins. The generational divide was, and continues to be, one plagued with the historical consequences of exodus. For the generation of children raised in exile, their parents were often seen as deserting their homeland, prioritising their personal or familial honour over resistance and defence of the land.

69 Samia Halaby, *Liberation Art of Palestine: Palestinian Painting and Drawing of the Second Half of the 20th Century* (New York: H.T.T.B Publications, 2001) 26.

70 Joseph Massad, "Permission to Paint".

71 Ibid.

72 Ankori, *Palestinian Art* 68.

73 Joe Sacco, introduction, *A Child in Palestine: The Cartoons of Naji Al-Ali* (London: Verso, 2009) ix. It was while working as an editor, cartoonist and designer for the Arab nationalist newspaper *Al-Tali'a* in Kuwait that the artist created his most recognisable character, Handala. Standing with his hands behind his back, the figure of Handala is seen as a symbol of the witnessing of the Palestinian experience of suffering. Movingly, Handala is depicted as a young boy of ten years – the same age as al-Ali was when he was exiled to Lebanon.

74 Naseer Hasan Aruri ed., *The Palestinian Resistance to Israeli Occupation* (Willmette: Medina University Press International, 1970); Kamal Boullata cited in Ankori, *Palestinian Art* 16.

75 Boullata, *Palestinian Art* 146.

76 *Al-Nahda* translates from Arabic to mean 'the renaissance'. This is a term used to describe the cultural renaissance of Beirut prior to the civil war and the Israeli invasion of 1982.

77 Boullata, *Palestinian Art* 158; Orayb Arref Najjar, "Cartoons as a Site for the Construction of Palestinian Refugee Identity: An Exploratory Study of Cartoonist Naji al-Ali," *The Journal of Communication Inquiry* 31 (2007): 258.

The Ras Beirut artists Paul Guiragossian and Juliana Seraphim were the only artists to stay in Beirut. The refugee camp artists of Beirut were all displaced following 1982. Ismail Shammout sought refuge in Kuwait, where he would again be forced to leave with thousands of other Palestinians in the 1991 Gulf War. From the end of the 1982 invasion until his death in 2006, Shammout's work continued to use symbols of Palestinian identity but did so without obvious allusion to a revolutionary aesthetic. After being briefly detained in Lebanon in 1982, Naji al-Ali went to pursue his career as a cartoonist in exile with a relentless pen that spared no one including Iranian leader Khomeini, Arafat, the PLO bureaucracy, Israel and others, who were all savagely and repeatedly critiqued by the artist until his murder in London by an unknown assailant in 1985.

78 Gertz and Khleifi, *Palestinian Cinema* 21.

79 Ibid; "Film Bleeding Memories," *Film Crew Pro*, 14 February 2011. <http://www.filmcrewpro.com/uk/film_view.php?uid=9738>. The work of the three pioneers is now becoming more widely recognised and esteemed, even becoming the subject of a 2009 bio-epical film called *Bleeding Memories* by filmmaker Mohanad Yaqubi.

80 By this stage, Fatah's Department of Photography had created its first twenty-minute film, *Say No to the Peaceful Solution*, but was forced to leave Jordan for Lebanon following the death and expulsion of thousands of Palestinians from the Jordanian kingdom.

81 Haim Bresheeth, "The Continuity of Trauma and Struggle: Recent Cinematic Representations of the Nakba," *Nakba: Palestine, 1948 and the Claims of Memory* 163.

82 Gertz and Khleifi, *Palestinian Cinema* 20–22; Mohamed Abdel Fattah, "Arab Memory in the Palestinian Cinema," *IslamOnline*, 1 June 2000. 2 June 2011 <http://www.islamonline.net/iol-english/dowalia/art-2000-june-01/art2 .asp>. The production of films came from all factions, both large and small, each setting up their own film departments. These included The Democratic Front for the Liberation of Palestine who founded the Art Committee and the Popular Front who developed the Artistic Committee.

83 Sabrey Hafez, "The Quest for/Obsession with the National in Arabic Cinema," *Theorising National Cinema*, Valentina Vitali and Paul Willeman eds., (London: Palgrave Macmillan, 2008) 227–229; Viola Shafik, *Arab Cinema: History and Cultural Identity* (Cairo: The American University Cairo Press, 2007) 20. This was particularly marked in the Arab world were recently liberated nations began the attempt to articulate new national identities, recovering from the ideological weight of their colonisers. This was a plight that, in essence, had germinated since the turn of the century, where, despite its divergences, a common denominator was witnessed in the Arab world: the emergence of the notion of the homeland or nation, the *watan*. The exploration of *watan* in cinema was largely impossible for most Arab nations until

independence; that is, most countries had no opportunity to express themselves prior to liberation.

84 Ella Shohat and Robert Stam cited in Tawil, "Coming Into Being and Flowing Into Exile" 123; Hamid Naficy, *An Accented Cinema: Exilic and Diasporic Filmmaking* (Princeton: Princeton University Press, 2001) 30; Meriano Mestman, "Third Cinema/Militant Cinema: At the origins of the Argentinian Experience (1869–1971)," *Third Text* 25.1 (2011): 29. Though Third World theory did concern itself with colonised, decolonised and minority groups of the world, it did assume that Third World intellectuals could only express local concerns. Having treated cinema from colonised nations and minority groups with condescension, Third World theorists masked national and cultural contradictions, disregarding differences and, in effect, reducing Third World nationalism to only an echo of European nationalism, ignoring, as Ella Shohat and Robert Stam note, 'the international realpolitik that obliged the colonized to adopt a discourse and a practice of nation-state precisely in order to end colonialism'. The inherent problems with the conception of Third World Cinema theory are made clear when looking at the aesthetics and practices of Third Cinema, which sprang from the Latin-American cinema of liberation. Hamid Naficy explains that Third Cinema drew on the Cuban revolution of 1959, Italian Neorealist film and Marxist analysis and Griersonian social documentary style. It was Argentinian filmmaker Fernando Solanas and the Spaniard Octavio Getino who popularised the term with the publication of their manifesto *Towards a Third Cinema*. Third Cinema strove towards an immediate and direct political intervention via film: a militant cinema.

85 Gertz and Khleifi, *Palestinian Cinema* 23.

86 Teshome H. Gabriel cited in Naficy, *An Accented Cinema* 30.

87 Gertz and Khleifi, *Palestinian Cinema* 23.

88 John Drabinski, "Separation, Difference and Time in Godard's *Ici et Alliuers*," *SubStance* 37.1 (2008): 150.

89 Gertz and Khleifi, *Palestinian Cinema* 23.

90 Tawil, "Coming Into Being and Flowing Into Exile," 115.

91 Ibid, 116.

92 Gertz and Khleifi, *Palestinian Cinema* 28–29.

93 Ibid, 28–29.

94 Ibid, 29.The archive's manager, Khadija Abu Ali, personally approached Abu Jihad about the safety of the archive and he organised rent payments in the French embassy's basement, where it was kept under guard by the archive's staff. As violence escalated, the archive was moved to the Red Crescent's Akka hospital and from there its location is unknown.

95 The ongoing enigma of the archive (and militant cinema more broadly) can be evidenced in contemporary films such as Sarah Wood's *For Cultural Purposes*

Only (2009), Mohanad Yaqubi's *Off Frame* (2014) and Anne-Marie Jacir's *When I Saw You* (2012).
96 Homi K Bhabha ed., *Nation and Narration* (London: Routledge, 1990) 1.

2 Double Exile: 1982–1993

1 Lila Abu-Lughod, "Return to Half Ruins: Memory, Postmemory, and Living history in Palestine," *Nakba: Palestine, 1948, and the Claims of Memory*, eds. Lila Abu-Lughod and Ahmed H. Sa'di (New York: Columbia University Press, 2007) 79.
2 Ibid, 79.
3 Edward W. Said, "Emily Jacir – 'Where We Come From," *Emily Jacir – Belongings*, eds. Christian Kravagna, John Menick, Stella Rollig and Edward Said (Vienna: O.K Books, 2003) 47–48; Edward W. Said, "Slow Death: Punishment by Detail," *From Oslo to Iraq and the Roadmap* (London: Bloomsbury Publishing, 2005) 94.
4 Kaja Silverman cited in Marianne Hirsch, *Family Frames: Photography, Narrative and Postmemory* (Massachusetts: Harvard University Press, 1997) 22.
5 Hirsch, *Family Frames* 22.
6 Abu-Lughod, "Return to Half Ruins," 79.
7 Karl Mannheim cited in Ruben Rumbaut, "Ages, Life Stages and Generational Cohorts: Decomposing the Immigrant First and Second Generations in the United States," *International Migration Review* 38.3 (2004): 1162; Rosemary Sayigh, "Palestinian Camp Women as Tellers of History," *Journal of Palestine Studies* 27.2 (1998): 45.
8 Abu-Lughod, "Return to Half Ruins," 79.
9 Susan J. Brison, "Trauma Narratives and the Remaking of the Self," *Acts of Memory: Cultural Recall in the Present*, eds. Mieke Bal, Jonathan Crewe, Leo Spitzer (London: University Press of New England, 1999) 40.
10 Ilan Pappe, *A History of Modern Palestine: One Land, Two Peoples* (Cambridge: Cambridge University Press, 2006) xx; Tony Judt, Foreward, *From Oslo to Iraq and the Roadmap* xviii; Marc H. Ellis and Daniel McGowan eds., *Remembering Deir Yassin: The Future of Israel and Palestine* (New York: Olive Branch Press, 1998) ix.
11 Chrisoula Lionis, "A Past Not Yet Passed: Postmemory in the Work of Mona Hatoum," *Social Text* 32.2 (2014): 77–93.
12 Susan Slyomovics, "The Rape of Qula," *Nakba: Palestine, 1948 and the Claims of Memory* eds. Lila Abu-Lughod and Ahmad H. Sa'di. (New York: Columbia University Press, 2007) 32.
13 Janine Antoni, "Mona Hatoum," *Bomb Magazine* 63 (1998).

14 Mona Hatoum quoted in Laura Steward Heon, ed., *Mona Hatoum: Domestic Disturbance* (North Adams: Storey Books, 2001) 32.

15 Gannit Ankori, *Palestinian Art* (London: Reaktion Books, 2006) 137.

16 Mona Hatoum quoted in Ankori, *Palestinian Art* 123.

17 Jill Bennett, *Empathic Vision: Affect, Trauma and Contemporary Art* (California: Stanford University Press, 2005) 143.

18 Amal Amireh, "Between Complicity and Subversion: Body Politics in Palestinian National Narrative," *South Atlantic Quarterly* 102.4 (2003): 750.

19 Ankori, *Palestinian Art* 123.

20 Mona Hatoum in *The Eye: Mona Hatoum,* videorecording, Illuminations (2001)

21 Mona Hatoum, "Re: Image and Image Permission – Mona Hatoum Socle du Monde." Email to Chrisoula Lionis. 20 March 2015. Hatoum discourages people from approaching her work with the intention of finding references or connections to her geographical origins. Hatoum explains that references to *Deir Yassin* were not her intention at the time she created the work. Analysis drawing reference to *Deir Yassin* is entirely my own.

22 Pappe, *A History of Modern Palestine*, 128–130 and Nur-eldeen Masalha, "On Recent Hebrew and Israeli Sources for the Palestinian Exodus, 1947 – 1949," *Journal of Palestine Studies*, no. 18 (1998): 122–124. *Deir Yassin* was a consequence of *Plan Dalet*, a military blueprint co-ordinated by the *Hagana* (the Zionist military that eventually became the Israeli Defense Force), in anticipation of clashes with Arab forces in Palestine both before and after the foundation of Israel. As *Plan Dalet* was realised between April and May 1948, *Deir Yassin* was one of the first villages to be destroyed under the new military plan.

23 Ellis and McGowan eds., introduction, *Remembering Deir Yassin*, 3.

24 Frances Hasso, "Modernity and Gender in Arab Accounts of the 1948 and 1967 Defeats," *International Journal of Middle Eastern Studies*, 32 (2000): 495; "Survivor's Accounts," *Deir Yassin Remembered* 20 January 2011 <http://www .deiryassin.org/survivors.html>. Hasso notes that stories of Zionist attacks against women held particular pertinence to Muslim Palestinians, who viewed women's bodies as particularly vulnerable. The Muslim population considered sexual and physical attacks against women as prohibited even in warfare.

25 Frances Hasso, "Modernity and Gender in Arab Accounts of the 1948 and 1967 Defeats," 495.

26 Hasso, "Modernity and Gender in Arab Accounts of the 1948 and 1967 Defeats," 495. The focus on the female body in the exodus of 1948, also extended to the nationalist movement in the early years following the *Nakba*. Historical Palestine was in these years often symbolised using the female figure. Importantly, as the loss of honour was seen as the instigator of the Palestinian exodus of 1948, the nationalist movement in the 1970s employed the new catchcry of 'land before

honour', in order to counter weigh the effect of warfare tactics which would compromise honour.

27 Samera Esmeir, "Memories of Conquest: Witnessing Death in Tantura," in *Nakba: Palestine, 1948 and the Claims of Memory*, eds. Abu-Lughod et al., 243.

28 Ariella Azoulay, *From Palestine to Israel: A Photographic Record of Destruction and State Formation, 1947–1950*, trans. Charles S. Karmen (London: Pluto Press, 2009) 157–159. Azoulay's book *From Palestine to Israel* utilises photographs from Israeli state and Zionist archives to chronicle a photographic history of the Nakba. Several of the photographs included in the text document the destruction and depopulation of Deir Yassin. These photos are indicative of how Deir Yassin, unlike other villages depopulated and destroyed, was always included in the historical archive.

29 Mona Hatoum quoted in *Mona Hatoum*, eds. Michael Archer, Guy Brett and Catherine de Zegher (London: Phaidon Press, 1996) 122.

30 Mona Hatoum quoted in Archer, Brett and Zegher eds., *Mona Hatoum* 127.

31 Benny Morris, "The Historiography of Deir Yassin," *The Journal of Israeli History* 24.1 (2005): 97.

32 Stefano Cappelli, "Piero Manzoni's Lines," Piero Manzoni, 15 April 2012. <http://www.pieromanzoni.org/PDF/EN/Manzoni_Lines.pdf>.

33 Yuko Hasegawa, *De-Genderism Detruire Dit-elle/ill* cited in Guy Brett, "Itinerary," *Mona Hatoum*, eds. Archer, Brett and Zegher, 38.

34 Ellis and McGowan, Preface, *Remembering Deir Yassin* v–vi.

35 Hatoum, "Re: Image and Image Permission – Mona Hatoum Socle du Monde." Email to Chrisoula Lionis. 20 March 2015. Hatoum explains that *Self Erasing Drawing* was conceived as an essentially meditative object without any reference to Palestinian history.

36 Edward W. Said, *Reflections on Exile and Other Essays (Convergences: Inventories of the Present)* (Cambridge MA: Harvard University Press, 2002) 186; Yves-Alain Bois and Rosalind Krauss, "A User's Guide to Entropy," *October* 78 (1996): 39–40.

37 Carol Bardenstein, "Trees Forests and the Shaping of Palestinian and Israeli Collective Memory," *Acts of Memory* 158.

38 Michel Khleifi, "From Reality to Fiction – From Poverty to Expression," *Dreams of a Nation: On Palestinian Cinema* ed. Hamid Dabashi (London: Verso, 2006) 45.

39 Phillip Dodd, "Homelands," *Sight and Sound* 1.10 (1992): 19.

40 Ibid, 19.

41 Nurith Gertz and George Khleifi, *Palestinian Cinema: Landscape Trauma and Memory* (Bloomington: Indiana University Press, 2008) 38.

42 Ibid, 38.

43 Ibid, 79.

44 Ibid, 97.

45 Ella Shohat, "Wedding in Galilee," *Middle East Report* 154 (1988): 44.

46 May Telmissany, "Displacement and Memory: Visual Narratives of al-Shatat in Michel Khleifi's Films," *Comparative Studies of South Asia, Africa and the Middle East* 30.1 (2010): 79.

47 Michel Khleifi and Livia Alexander, "On the Right to Dream, Love and be Free: An Interview with Michel Khleifi," *Middle East Report* 201 (1996): 33.

48 Gertz and Khleifi, *Palestinian Cinema* 38.

49 Esther Webman, "The Evolution of a Founding Myth: The Nakba and Its Fluctuating Meaning," *Palestinian Collective Memory and National Identity*, ed. Meir Litvak (New York: Palgrave Macmillan, 2009) 38.

50 Gertz and Khleifi, *Palestinian Cinema* 75.

51 Telmissany, "Displacement and Memory," 76.

52 Khleifi, "From Reality to Fiction – From Poverty to Expression," 48.

53 The word *mukhtar*, translates from Arabic to mean 'chosen'. This is a title bestowed on the male head of a village or neighbourhood.

54 Shohat, "Wedding in Galilee," 45.

55 Ibid, 46.

56 Gertz and Khleifi, *Palestinian Cinema* 83.

57 Shohat, "Wedding in Galilee," 44.

58 In Khleifi's most recent film, *Zindeeq* (2009), he self referentially comments on his treatment of women in his works, something that has warranted mixed criticisms from audiences over the years. In a dream-like scene with his a character referencing his mother in *Zindeeq*, the mother begs the director to cease using nudity and to stop focusing on the role of women in his films.

59 Shohat, "Wedding in Galilee," 45.

60 Tim Kennedy, "Wedding in Galilee (Urs al-Jalil)," *Film Quarterly* 59.4 (2006): 40.

61 Shohat, "Wedding in Galilee," 45.

62 Dodd, "Homelands," 21.

63 Khleifi, "From Reality to Fiction – From Poverty to Expression," 48.

64 Ibid, 52.

65 Telmissany. "Displacement and Memory," 75.

66 Khleifi, "From Reality to Fiction – From Poverty to Expression," 51.

67 Ibid, 49.

68 Telmissany. "Displacement and Memory," 81.

69 Khleifi, "From Reality to Fiction – From Poverty to Expression," 76.

70 Lina Khatib, *Filming in the Middle East: Politics in the Cinemas of Hollywood and the Arab World* (London: I.B.Tauris & Co Ltd, 2006) 126.

71 Dina Matar, *What it Means to be Palestinian: Stories of Palestinian Peoplehood* (New York: Palgrave Macmillan, 2011) 155.

72 On 8 December 1987 four Gazan refugee camp labourers from the Jabaliya camp were killed when the two vans they were travelling in collided with an Israeli truck. As rumour spread that the event was no accident but rather a

deliberate act of retribution for an Israeli stabbed to death in a Gaza market several days earlier, the inhabitants of the Jabaliya camp became increasingly enraged. By the time of the funeral of the four refugees, thousands has assembled, turning their anger at a nearby Israel army post by pelting it with stones. As the instigator of the intifada, this event carries within it many of the trademarks of the consequent Palestinian uprising, namely the spontaneous outburst of protest and the use of basic weaponry for resistance.

73 Bernard Wasserstein, *Israel and Palestine: Why They Fight and Can They Stop?* (London: Profile Books, 2008) 25.

74 Matar, *What it Means to be Palestinian* 156. The heavy price paid by this generation of resistance can be measured by the number of those killed in the years between 1987 through to 1991, where out of the 1,000 Palestinians killed by Israeli forces, over 200 were under the age of 15.

75 Matar, *What it Means to be Palestinian* 160.

76 Samira Meghdissian, "The Discourse of Oppression as Expressed in Writings of the Intifada," *World Literature Today* 72.1 (1998): 40.

77 Francis A. Boyle, *Palestine, Palestinians and International Law* (Atlanta: Clarity Press, 2003) 17.

78 Pappe, *A History of Modern Palestine* 235.

79 Matar, *What it Means to be Palestinian* 159.

80 Meghdissian, "The Discourse of Oppression as Expressed in Writings of the Intifada," 20.

81 Neve Gordon, *Israel's Occupation* (Los Angeles: University of California Press, 2008) 166.

3 Oslo: Reaching the Punchline

1 William Hazlitt cited in Benjamin La Forge, "Comedy's Intention," *Philosophy and Literature* 28.1 (2004): 125; Christie Davies, "Humour is not a Strategy in War," *Journal of European Studies* 31 (2001): 396–406.

2 Kristen A. Murray, "'Burn, Bury or Dump': Black Humour in the Late Twentieth Century', PhD dissertation, University of New South Wales, 2008, 9.

3 Samira Meghdissian, "The Discourse of Oppression as Expressed in Writings of the Intifada," *World Literature Today* 72.1 (1998): 41.

4 Bernard Wasserstein, *Israel and Palestine: Why They Fight and Can They Stop?* (London: Profile Books, 2008) 62.

5 Dina Matar, *What it Means to be Palestinian: Stories of Palestinian Peoplehood* (New York: Palgrave Macmillan, 2011) 156.

6 Francis A. Boyle, *Palestine, Palestinians and International Law* (Atlanta: Clarity Press, 2003) 58.

7 Norman Finkelstein, *Image and Reality of the Israel-Palestine Conflict* (New York: Verso, 2003) xxxiii.

8 Boyle, *Palestine, Palestinians and International Law* 59. For further information and analysis around the Declaration of Independence, see Chapter Five.

9 Sharif Kanaana, *Struggling for Survival: Essays in Palestinian Folklore and Folklife* (Al-Bireh: Society of Ina'ash El-Usra, 2005) 17.

10 Ibid, 17.

11 Ibid, 19.

12 Ibid, 20.

13 Ibid, 65.

14 Shibley Telhami, "Arab Opinion and the Gulf War," *Political Science Quarterly* 108.3 (1993): 442.

15 Ann Mosely Lesch, "Contrasting Reactions to the Persian Gulf Crises: Egypt, Syria, Jordan and the Palestinians," *Middle East Journal* 45.1 (1991): 82.

16 Lesch, "Contrasting Reactions to the Persian Gulf Crises," 44.

17 Alistair Finlain, *Essential Histories: The Gulf War 1991* (New York: Routledge, 2003) 3. In many ways, Saddam Hussein needed to use the Palestinian occupation as a political draw card, without it he likely would not have achieved the popular Arab support he needed. Having amassed too many political enemies around the world and Iraq being in a dire economic situation, Hussein could no longer rely on the Soviet Union which (in its final days and under the leadership of Mikhail Gorbachev) was much more limited in its assistance and increasingly impartial in its view of the Middle East. In addition, Britain had also decided to halt arms trade with Iraq following Hussein's human-rights record.

18 Yosefa Loshitzky, "The Text of the Other, The Other in the Text: The Palestinian Delegation's Address to the Madrid Middle East Peace Conference," *Journal of Communication Inquiry* 18.1 (1994): 36.

19 Ibid, 29.

20 'Security Council Resolutions', *The United Nations*, 30 September 2011 <http://www.un.org/documents/scres.htm>.

21 Jay Rosen, "Making Journalism More Public," *Communication* 12.4 (1991): 267–284.

22 Loshitzky, "The Text of the Other, The Other in the Text," 28.

23 Gregory Harms and Todd M. Ferry, *The Palestine Israel Conflict: A Basic Introduction* (London: Pluto Press, 2008) 153.

24 Sara Roy, "Why Peace Failed: An Oslo Autopsy," *Current History* 100. 651 (2002) 14.

25 Ibid, 15.

26 Ian S. Lustruck, "The Oslo Agreement as an Obstacle to Peace," *Journal of Palestine Studies* 27.1 (1997): 61.

27 Ibid, 66.

28 Roy, "Why Peace Failed: An Oslo Autopsy," 15.

29 Finkelstein, *Image and the Reality of the Israel-Palestine Conflict* 177.

30 Meron Benvenisti cited in Finkelstein, *Image and the Reality of the Israel-Palestine Conflict* 177.

31 Ali Abunimah, *One Country: A bold proposal to end the Israeli-Palestinian impasse* (New York: Metropolitan Books, 2006) 67.

32 Finkelstein, *Image and the Reality of the Israel-Palestine Conflict* 173.

33 James E. Collins II and Robert S. Wyer Jr, "A Theory of Humor Elicitation," *Psychological Review* 99.4 (1992): 665. For further discussion on Incongruity Theory and the literature that surrounds it refer to the Introduction.

34 Miriyam Aouragh, *Palestine Online: Transnationalism, the Internet and the Construction of Identity* (London: I.B.Tauris & Co Ltd, 2011). It is noteworthy here to mention that it was arguably not only the Oslo Accords that spurred a shift in Palestinian nationalism. The timing of the peace process coincided with the emergence of the internet, a technological advance that arguably influenced Palestinian nationalism as Palestinians in exile could communicate more quickly and freely. The internet continues to play a vital role in the articulation of Palestinian identity and Palestinian transnationalism. Excellent analysis of this phenomenon is presented by Miriyam Aouragh in her book *Palestine Online*.

35 For further discussion of the work of Michel Khleifi, refer to Chapter 2.

36 Nico Baumbach, "Jacques Rancière and the Fictional Capacity of Documentary," *New Review of Film and Television Studies* 8.1 (2010): 60.

37 Ibid, 61.

38 *Notre Musique*, dir. Jean Luc Godard, Avventura Films, 2004.

39 Jacques Rancière in John Kelsey and Fulvia Carnevale, "Art of the Possible," *Artforum* 45.7 (2007): 259.

40 Ibid, 259.

41 Ibid.

42 Ghada Karmi, "Israel's Dilemma in Palestine: The Process, the failure and the prospect for a just and workable solution," *Sydney Ideas – International Public Lecture Series*, Public Lecture, The University of Sydney, October 9th, 2007.

43 T.J Demos, "The Right to Opacity: On the Otolith Group's Nervus Rerum," *October* 129 (2009): 115.

44 Ibid, 117.

45 Coleman E. Shear, "Landes Discusses Pallywood Theory," *The Dartmouth Review*, 17 December 2010. 30 August 2012. < http://dartreview.com/features -page/2010/12/17/landes-discusses-pallywood-theory.html>.

46 Demos, "The Right to Opacity," 114.

47 Ibid, 115.

48 Ibid, 128.

49 Jacques Rancière in Kelsey and Carnevale, "Art of the Possible," 258.

50 Rolf Tiedemann, ""Not the Philosophy, but a Last One": Notes on Adorno's Thought," Introduction, *Can One Live After Auschwitz: A Philosophical Reader* ed. Theodor Adorno and Rolf Tiedemann (Stanford: Stanford University Press, 2003) xvi.

51 David McNeill, "Planet Art: Resistance and Affirmation in the Wake of 9/11," *Australia and New Zealand Journal of Art* 3.2 (2002): 11–32. The description of the 'centre' of art and film refers to the markets of Europe, the United States and the United Kingdom. Perceived as 'centres' of both art and film, artists from outside these centres are deemed as from the 'periphery'. As suggested by David McNeill, the work of artists from the 'periphery' often appears as an art of unresolved tension that brings together 'local' and 'international' concerns in a way that is acutely aware of the international audience and gaze.

52 By 'incongruous elements depicted in art' I refer here to the Incongruity Theory of humour outlined in the Introduction.

53 Sheri Klein, *Art & Laughter* (London: I.B.Tauris & Co Ltd, 2007) 27.

54 The problem associated with looking at Palestinians with a compassionate gaze is an issue explored in detail in Chapter Five.

55 Slavoj Žižek in Neta Alexander, "Cinema Verite," *Haaretz Daily Newspaper* 15 June 2011. 10 September 2012. <http://www.haaretz.com/weekend/magazine/cinema-verite-1.373397>.

56 Further discussion on the debate surrounding ethnic humour can be found in Chapter 6.

57 Leon Rappoport, *Punchlines: The Case for Racial Ethnic & Gender Humor* (London: Praeger Publishers, 2005) 31; Christie Davies, *Ethnic Humour Around the World: A Comparative Analysis* (Bloomington: Indiana University Press, 1996).

58 Rappoport, *Punchlines* 35.

59 Ibid, 35.

60 Simon Critchley, *On Humour: Thinking in Action* (London: Routledge, 2002) 17.

61 Ibid, 18.

4 Finding Palestine: Humour and the Delineation of 'Palestine'

1 Rashid Khalidi, "The Resolutions of the 19th Palestine National Council," *Journal of Palestine Studies* 19.2 (1990): 33.

2 Yezid Sayigh, "Struggle within, Struggle without: The Transformation of PLO Politics Since 1982," *International Affairs* 65.2 (1989): 247.

3 Khalidi, "The Resolutions of the 19th Palestine National Council," 33.

4 Chrisoula Lionis ed., *Beyond the Last Sky: Contemporary Photography and Video* (Sydney: The Australian Centre for Photography, 2012). Having personally

worked on the presentation of Palestinian art by way of curating the *Beyond the Last Sky: Contemporary Palestinian Photography and Video* exhibition in Sydney and the working on annual national Palestinian Film Festival in Australia, this problem is an all too familiar one.

5 Areen Omari, "Re: Questions: First Lesson – Artist's interview questions for book manuscript." Email to Chrisoula Lionis. 8 February 2015.

6 Ibid.

7 Ibid.

8 Tina Sherwell, "Topographies of Identity, Soliloquies of Place," *Third Text* 20.4 (2006): 429.

9 Dario Guigliano, "A(hi)story pour les analphabetes – of Larissa Sansour's video," *Third Text* 25.3 (2011): 305.

10 Mahmoud Darwish, "Earth Narrows Before Us," *Sand and Other Poems* trans. Rana Kabbani (London: KPI Limited, 1986) 5.

11 Larissa Sansour, "Re: Image – Book Manuscript." Email to Chrisoula Lionis. 6 February 2015.

12 Ibid.

13 Ibid.

14 Wafa Gabsi, "Fiction and Art Practice: Interview with Larissa Sansour "A Space Exodus"," *Contemporary Practices* 10 (2012): 117.

15 Larissa Sansour, "Lacoste: No Room for Palestinian Artist." Email to Chrisoula Lionis. 20 December 2011.

16 Gabsi, "Fiction and Art Practice," 118; Omar Kholeif, "Political Form and Content," *Contemporary Visual Art+Culture Broadsheet* 42.1 (2013): 64–65. In her interview with Wafa Gabsi, Sansour explains that the Musee a l'Elysee reported to her that Lacoste deemed her work 'too pro-Palestinian for the brand to support'. This explanation was provided to the artist directly but did not appear in official statements by the museum or Lacoste. Refreshingly, following Sansour's press release and the international support that in garnered, the museum decided to scrap the prize altogether and to cancel their partnership with Lacoste.

17 The Dome of the Rock and the representation of Jerusalem in *Nation Estate* is also of particular importance being that it has been at the centre of breakdowns in peace negotiations and is the most hotly contested land in Israel/Palestine. Jerusalem is not only seen as the Palestinian capital but also the most important place for Palestinians to return.

18 Gabsi, "Fiction and Art Practice," 115.

19 Larissa Sansour, "Nation Estate," *Ibraaz,* 2 November 2012. 25 November 2012. < http://www.ibraaz.org/projects/32>.

20 Gabsi, "Fiction and Art Practice," 115.

21 Ibid, 116.

22 Simon Critchley, *On Humour: Thinking in Action* (London: Routledge, 2002) 7.

205

23 Amer Shomali, "Re: Questions – Book manuscript – Laughter in Occupied Palestine: Comedy and Identity in Art and Film." Email to Chrisoula Lionis. 4 February 2015.

24 Ibid.

25 Critchley, *On Humour* 65.

26 Ibid, 10.

27 "Subjective Atlas of Palestine: Asserting the Right to Narrate," *Arena of Speculation*, 28 May 2011. 20 June 2012. < http://arenaofspeculation.org/2011/05/28/subjective -atlas-of-palestine/>.

28 Hassan Khader, "A Quest for Normalcy," *Subjective Atlas of Palestine*, ed. Annelys de Vat (Rotterdam: 010 Publishers, 2007) 9.

29 Homi K Bhabha, *Nation and Narration* (London and New York: Routledge, 1990) 1.

30 Frantz Fanon, *The Wretched of the Earth*, trans. Constance Farrington (New York: Grove Press, 1995) 210.

31 Ibid.

32 Tina Sherwell, "The power of place and the representation of landscape in the work of Palestinian artists" cited in Adila Laidi-Hanieh, "Palestinian Landscape Photography: Dissonant Paradigm and Challenge to Visual Control," *Contemporary Practices* (2009) 120.

33 Laidi-Hanieh, "Palestinian Landscape Photography," 120.

34 Ibid, 120.

35 Ibid.

36 Ibid.

37 For further discussion on the ways in which artists were politically and eco- nomically bound to the PLO in previous decades refer to Chapter One.

38 Laidi-Hanieh, "Palestinian Landscape Photography," 121.

39 Ibid, 120.

40 Fanon, *The Wretched of the Earth* 210.

41 Francesca Ricci, "True Tales. Fairy Tales," *Raeda Saadeh: Reframing Palestine*, ed. Rose Issa (London: Beyond Art Production, 2012) 22.

42 Rose Issa ed., *Raeda Saadeh: Reframing Palestine* (London: Beyond Art Production, 2012) 22.

43 Ibid, 48.

44 Gannit Ankori, *Palestinian Art* (London: Reaktion Books, 2006) 64–65.

45 Tina Sherwell cited in Laidi-Hanieh, "Palestinian Landscape Photography," 120.

46 Rose Issa, "Reframing Palestine," *Raeda Saadeh* 8.

47 Refqa Abu-Remaileh, "Palestinian anti-narratives in the films of Elia Suleiman," *Arab Media & Society* 5 (2008) January 20 2013. < http://www.arabmediasociety. com/?article=670>.

48 Ibid.

49 Hamid Dabashi, "In Praise of Frivolity: On the Cinema of Elia Suleiman," *Dreams of a Nation: On Palestinian Cinema* 160.

50 For further discussion on the work of Michel Khleifi and his influence and impact upon Palestinian cinema, refer to Chapter Two.

51 Haim Bresheeth, "Telling the Stories of Heim and Heimat, Home and Exile: Recent Palestinian Films and the Iconic Parable of the Invisible Palestine," *New Cinemas* 1.1 (2002):37.

52 Bresheeth, "Telling the Stories of Heim and Heimat, Home and Exile," 37.

53 Nurith Gertz and George Khleifi, *Palestinian Cinema: Landscape Trauma and Memory* (Bloomington: Indiana University Press, 2008) 180.

54 Abu-Remaileh, "Palestinian anti-narratives in the films of Elia Suleiman".

55 Despite winning the jury prize at the 2002 Cannes film festival and being nominated for the Golden Palm, *Divine Intervention* was reportedly rejected from running for the award of Best Foreign Film at the Academy Awards because Palestine was not a state recognized in the rules of the Academy.

56 Nathalie Handal and Elia Suleiman, "The Other Face of Silence," *Guernica Mag*, May 1 2011. 10 January 2013. <http://www.guernicamag.com/interviews/suleiman_5_1_11/>.

57 Gertz and Khleifi, *Palestinian Cinema* 181.

5 Occupied Laughter: Humour and Statelessness

1 Yasir Tineh (Oregano&OliveOil). "Your love is harder to define than Israeli borders." 30 March 2012. Tweet.

2 After the signing of the Oslo Accords, the West bank and the Gaza Strip were divided into areas (A, B, and C) and governorates: 'Area A' refers to the area under PA security and civilian control. 'Area B' refers to the area under Palestinian civilian and Israeli security control. 'Area C' refers to the area under full Israeli control such as settlements.

3 Ali Abunimah, *One Country: A bold proposal to end the Israeli-Palestinian impasse* (New York: Metropolitan Books, 2006) 64.

4 Abunimah, *One Country* 67.

5 Paolo Virno, *Multitude: Between Innovation and Negation* (Los Angeles: Semiotext(e), 2008) 85.

6 Virno, *Multitude* 92.

7 Uroš Čvoro, "Last Laugh," *Beyond the Last Sky: Contemporary Palestinian Photography and Video*, ed. Chrisoula Lionis (Sydney: The Australian Centre for Photography, 2012) 30.

8 Abunimah, *One Country* 65.

9 Edward W. Said, *From Oslo to Iraq and the Roadmap* (London: Bloomsbury Publishing, 2005) 18–23.

10 Heike Munder, "Humour: The Secret of Aesthetic Sublimation," *When Humour Becomes Painful* eds., Felicity Lunn & Heike Munder (Zurich: JRP Ringier, 2005) 13.

11 Chiara De Cesari, "Anticipatory Representation: Building the Palestinian Nation(-State) through Artistic Performance," *Studies in Ethnicity and Nationalism* 2.1 (2012): 86.

12 Claire Bishop cited in De Cesari, "Anticipatory Representation," 84.

13 Nicolas Bourriaud, *Relational Aesthetics* (Paris: Les Presse du Reel, 1998)

14 Emily Jacir cited in Guy Mannes-Abbott, *In Ramallah, Running* (London: Black Dog Publishing, 2012)

15 Salwa Mikdadi ed., *Palestine c/o Venice* (Beirut: Mind the Gap, 2009) 44; De Cesari, "Anticipatory Representation," 96.

16 Regina Gleeson, "Dislocate, Renegotiate and Flow: Globalisation's Impact on Art Practice," *Circa* 107 (2004): 69.

17 De Cesari, "Anticipatory Representation," 95.

18 Jack Persekian cited in De Cesari, "Anticipatory Representation," 87.

19 Ibid; Daniel McGowan, "Deir Yassin Remembered," eds. Marc H. Ellis and Daniel McGowan, *Remembering Deir Yassin: The Future of Israel and Palestine* (New York: Olive Branch Press, 1998) 3–9.

20 "Museum of Contemporary Art – Palestine (CAMP)," *Al Ma'mal Foundation*, June 15 2015 <http://www.almamalfoundation.org/about/camp>.

21 De Cesari, "Anticipatory Representation," 91.

22 Ibid, 88; *Palestinian Museum*, January 29th 2013. <http://thepalestinianmuseum.org>. It must be clarified that Doumani was hired over a decade after the first work on the museum began. The Welfare Association supported the idea of a Palestinian Memory Museum in the late 1990s and academic Ibrahim Abu Lughod was the leader of the project at the time.

23 Operating as museums in exile and as suspended projects until the formation of a sovereign state, these Palestinian museological projects call into question the collection practices, funding models and geographical spaces of international state institutions more broadly. Though this is a line of enquiry in museological theory in places where sovereign states do exist, in the case of Palestine, this is a practical necessity. The strive to create these museums also signals the need to establish a continuing articulation of Palestinian identity and connection to the land, both of which were subjects of scrutiny for decades prior to Oslo when both Palestinian identity and the connection to the land were officially recognized internationally.

24 Jill Bennett, *Practical Aesthetics: Events, Affects and Art after 9/11* (London: I.B.Tauris & Co Ltd, 2012) 37.

25 Maureen Clare Murphy, "Palestinian Artist Khaled Jarrar Wants to Stamp Your Passport," *Electronic Intifada*, 21 July 2011. 28 January 2012.

<http://electronicintifada.net/blogs/maureen-clare-murphy/palestinian-artist-khaled-jarrar-wants-stamp-your-passport>.

26 Emily Gogolak, "Khaled Jarrar Stamps His Authority," *Rolling Stone*, 5 February 2012. 27 January 2012. <http://www.rollingstoneme.com/index.php?option=com_content&view=article&id=1145>.

27 "#12 by Khaled Jarrar," *Truth is Concrete*, 27 Janurary 2012. <http://truthisconcrete.org/graphic-project/15--12-by-khaled-jarrar.php>.

28 Gogolak, "Khaled Jarrar Stamps His Authority,".

29 "State of Palestine Stamping Action," *FotoGallerieT*, 27 January 2012., http://fotogalleriet.no/Nyheter%20og%20prosjekter/state-of-palestine-passport-stamping-action>.

30 Rashid Khalidi, "The Resolutions of the 19th Palestine National Council," *Journal of Palestine Studies* 19.2 (1990): 33.

31 Jill Bennett, *Practical Aesthetics* 37.

32 Alenka Zupančič, *The Odd One In: On Comedy* (Massachusetts: MIT Press, 2008) 217.

33 Nurith Gertz and George Khleifi, *Palestinian Cinema: Landscape Trauma and Memory* (Bloomington: Indiana University Press, 2008) 181

34 Najat Rahman, ""Laughter that Encounters a Void?": Humor, Loss and the Possibility for Politics in Recent Palestinian Cinema," *Storytelling in World Cinemas*, ed. Lina Khattib (New York: Columbia University Press, 2012) 486.

35 Gertz and Khleifi, *Palestinian Cinema* 181.

36 Rahman, ""Laughter that Encounters a Void?"," 485.

37 Patricia Pisters, "Violence and Laughter: Paradoxes of Nomadic Thought in Postcolonial Cinema," *Deleuze and the Postcolonial*, eds., Simone Bignall and Paul Patton (Edinburgh: Edinburgh University Press, 2010) 210.

38 Rahman, ""Laughter that Encounters a Void?"," 484.

39 Haim Bresheeth, "A Symphony of Absence: Borders and Liminality in Elia Suleiman's Chronicle of a Disappearance,"' *Framework* 43.2 (2002): 81.

40 *Notre Musique*, Dir. Jean Luc Godard, Avventura Films, 2004.

41 Although there has been repetition of Jacques Rancière's observations regarding the relationship between Palestinians and the documentary, it was necessary to include here as a reminder within the context of this chapter. For further analysis of Rancière's observations refer to Chapter Three.

42 Jacques Rancière in Kelsey and Carnervale "Art of the Possible," *Artforum* 45.7 (2007): 259.

43 Hamid Dabashi, "In Praise of Frivolity: On the Cinema of Elia Suleiman," *Dreams of a Nation: On Palestinian Cinema*, ed. Hamid Dabashi (London: Verso, 2006) 160.

44 Ibid.

45 Hoda El Shakry, "A Conversation with Gil Hochberg on "Queer Politics and the Question of Palestine,"" *Newsletter for the UCLA Centre for the Study of Women*, April 4 2009. June 10 2012. <http://escholarship.org/uc/item/1pm3p9d1>.

46 El Shakry, "A Conversation with Gil Hochberg".

47 Ibid.

48 Ibid.

49 Jacques Rancière in Kelsey and Carnevale, "Art of the Possible," 259.

50 Ariella Azoulay, "Getting Rid of the Distinction between the Aesthetic and the Political," *Theory, Culture & Society* 27.8 (2010): 239–262.

51 Hannah Arendt, *On Revolution* (London: Penguin Classics, 2006) 49–106; Jill Bennett, *Practical Aesthetics* 138–158; Luc Boltanski, *Distant Suffering: Morality, Media and Politics* (Cambridge: Cambridge University Press, 1999); Slavoj Žižek, "Neighbors and Other Monsters: A Plea for Ethical Violence," *The Neighbor: Three Inquiries in Political Theology*, eds. Eric L. Santer, Kenneth Reinhard and Slavoj Žižek (Chicago: Chicago University Press, 2006) 134–164.

52 This move beyond the representation of Palestinianness as defined by suffering, was most notably a conscious effort following the battle at Al Karameh during the period of militant cinema and revolutionary art. Further discussion of this transition can be found in Chapter 3.

53 William Parry, *Against the Wall: The Art of Resistance in Palestine* (London: Pluto Press, 2010). Since the appearance of Banksy's stencils, tour groups visit Bethlehem to see his works, gift stores and restaurants have popped up with Banksy's name, and books have been published that chronicle the graffiti on the Wall by both locals and international visitors; one such book is William Parry's *Against the Wall*.

54 Yazan Khalili, "Regarding the Pain of Oneself," *Beyond the Last Sky: Contemporary Palestinian Photography and Video*, ed. Chrisoula Lionis (Sydney: The Australian Centre for Photography, 2012) 26.

55 Ibid, 26.

56 GH0809 has been shown in the windows of two gallery spaces, at The Australian Centre for Photography as part of the *Beyond the Last Sky exhibition* (1/8/2012–18/11/2012) and in Lyon at LaBF15 as part of the *Troubles* exhibition (8/8/2012–10/11/2012).

57 Taysir Batniji, "Re: Questions – Artist's input in Laughter in Occupied Palestine: Comedy and Identity in Art and Film." Email to Chrisoula Lionis. 4 February 2015.

58 Taysir Batniji, "Re: Questions – Artist's input in Laughter in Occupied Palestine" Email to Chrisoula Lionis. 4 February 2015.

59 Completing their studies in Fine Arts at the Al-Aqsa University in Gaza, the twins' work is increasingly recognized around the world with shows in London, Sydney, Dubai and the United States.

60 Laura Allsop, "Colourful Shadows and Reel Journeys: A Conversation between Tarzan and Arab and Laura Allsop," *Ibraaz*, 2 May 2012. 5 August 2012. < http://www.ibraaz.org/interviews/32>.

61 Coleman E. Shear, "Landes Discusses Pallywood Theory," *The Dartmouth Review*, 17 December 2010. 30 August 2012. < http://dartreview.com/features-page/2010/12/17/landes-discusses-pallywood-theory.html>. Coined by historian Richard Landes from Boston University, the term 'Pallywood' originally referred to the contested media coverage of the death of twelve-year-old Muhammad al-Durrah in the second intifada. For Landes, 'Pallywood' is used to illustrate the perceived theatricality of al-Durah's death as emblematic of what he believes to be Palestinian propaganda and media manipulation.

62 Raija-Leena Punamaki, et al. "The Role of Psychological Defences in Moderating Between Trauma and Post-Traumatic Symptoms Amongst Palestinian Men," *International Journal of Psychology* 37.5 (2002): 286.

63 Ibid, 289.

64 *Fix Me*, Dir. Raed Andoni, Rouge International, 2010.

65 *(No) Laughing Matter*, Dir. Rousselot, eO Productions, 2010. Rousselot's film is the first documentary extensively dedicated to the exploration of Palestinian humour. Teeming with insight into the daily exchanges of humour, and featuring an interview with Sharif Kanaana on his research in the area, the documentary is significant because it illuminates the potential of humour to reveal Palestinian experience to cultural outsiders.

66 Simon Critchley, *On Humour: Thinking in Action* (London: Routledge, 2002) 68.

67 Julia Kristeva, *Hannah Arendt*, Ross Guberman trans., (New York: Columbia University Press, 2001) 144. The term 'banality of evil' was coined by Holocaust survivor and intellectual Hannah Arendt in her book *Eichmann on Trial: A Report on the Banality of Evil* (1963). Arendt conceived of the term to describe the actions of Otto Adolf Eichhman who was the former chief of the Gestapo's Jewish Office and his justifications for the crimes he committed against Jews when under trial for his actions. Kristeva explains that Arendt's term refers to evil that 'entails the destruction of thinking (a destruction that is surreptitious, generalized and imperceptible, and thus banal, though it also scandalous) which prefigures the scandalous annihilation of life'.

68 Edward W. Said, "Emily Jacir – 'Where We Come From," *Emily Jacir – Belongings,* eds. Christian Kravagna, John Menick, Stella Rollig and Edward Said eds., (Vienna: O.K Books, 2003) 47–48.

69 Lumiere's name may be a tongue in cheek reference to the Lumiere brothers who are credited with inventing cinema and who filmed in Palestine in the mid-1800s.

70 Gertz and Khleifi, *Palestinian Cinema* 44.

71 Ibid, 45.

72 *Waiting*, Dir. Rashid Masharawi, Silk Road Production, 2006.

211

73 Rashid Masharawi cited in "Palestinian Filmmaker Shows Refugee's Agony of Waiting," *Miftah*, 7 September 2005. 6 August 2012. < http://www.miftah.org /PrinterF.cfm?DocId=8397>.

74 Jacqueline Bussie, *The Laughter of the Oppressed: Ethical and Theological Resistance in Wiesel, Morrison and Endo* (New York: T&T Clark International, 2007) 53.

75 Ibid, 59.

6 Who Is Laughing?: Humour and the Boundaries of Identity

1 Henri Bergson, *Laughter: An Essay on the Meaning of the Comic* (CreateSpace, 2011) 6.

2 Ibid, 6.

3 Christinian Kravagna, John Menick, Stella Rollig, Edward Said eds., *Emily Jacir: Belongings, Works 1998–2003* (Vienna: O.K Books, 2003) 15. The original advertisement included a misspelling of the word 'Semitic'. It has been left in its original form here so as to not confuse the reader given the advertisements use of acronyms and unconventional grammar.

4 Dorris Bittar, "Crossing Boundaries – Artist Profile: Emily Jacir," *Canvas Magazine* 31 December 2008. 12 August 2012. <http://www.dorisbittar.com /DB-03-Writings.html>.

5 Simon Critchley, *On Humour: Thinking in Action* (London: Routledge, 2002) 68.

6 Dorris Bittar, "Crossing Boundaries,"; Andy Soltis, "W.Banky Panky in Personal Ad Blitz," *New York Post* 12 February 2002: 5. The use of the word 'Semite' was deliberately included in each advertisement by instruction from the artist. It was used in the hope of undermining the common understanding of the word in the United States where it is perceived as only pertaining to Jews.

7 Critchley, *On Humour* 68.

8 Ibid, 67.

9 Ibid, 68.

10 Ibid, 11.

11 Ibid, 17.

12 Ibid, 13.

13 Ibid, 68.

14 Ibid, 4.

15 Elliot Oring, *Engaging Humour* (Chicago: University of Illinois Press, 2003) 115.

16 Although Oring's work discusses the humour of Israelis toward Palestinians, it does not elaborate on Palestinian humour.

17 Oring, *Engaging Humour*, 113.

18 Mark Geoffrey Young, *The Best Ever Book of Palestinian Jokes: Lots and Lots of Jokes Specially Repurposed for You-Know-Who* (CreateSpace Independent Publishing Platform, 2012). An excellent example of the failure of this formulaic humour is *The Best Ever Book of Palestinian Jokes*. The text is made up of a series of jokes that might be applied to any ethnic group. Though claiming to be a text dedicated to Palestinian jokes, the text merely repurposes existing jokes placing Palestinians as the butt of all jokes compiled. Although some of the jokes might elicit laughter, none of them serve to reveal a sense of Palestinian cultural distinctiveness.

19 Alenka Zupančič, *The Odd One In: On Comedy* (Cambridge Massachusetts: MIT Press, 2008) 5.

20 Ibid, 4.

21 Ibid.

22 Ibid, 7.

23 For further discussion on the use of signifiers of the land within Palestinian art refer to chapters 1, 2 and 5.

24 Yezid Sayigh, "Armed Struggle and State Formation," *Journal of Palestine Studies* 26.4 (1997): 18.

25 Yair Wallach, "Creating a country through currency and stamps: state symbols and nation-building in British-ruled Palestine," *Nations and Nationalism* 17.1 (2011): 130.

26 Tina Malhi-Sherwell, "Imaging Palestine ad the Motherland," *Self-Portrait Palestinian Women's Art* Tal Ben Zvi and Yael Lerer eds., (Israel: Andalus Publishing, 2001) 167.

27 Sliman Mansour cited in Jay Murphy, "The Intifadah and the work of Palestinian artists," *Third Text*, 4.11 (1990): 124.

28 Yasser Arafat cited in Michael Billig, *Banal Nationalism* (London: Sage Publications Ltd, 2010) 41.

29 Billig *Banal Nationalism*, 41.

30 Ibid, 41.

31 Sliman Mansour cited in Murphy, "The Intifadah and the work of Palestinian artists," 24.

32 Raed Khoury and Leena Odgaard, "Palestinian Artist Shows Human Side of the Struggle," *Al Monitor: The Pulse of the Middle East* 26 September 2012. 20 January 2013. < http://www.al-monitor.com/pulse/originals/2012/al-monitor/palestinian-artist-shows-human-s.html>.

33 Critchley, *On Humour* 65.

34 Another film to explore the everyday lives and to scrtutinize popular perceptions of resistance fighters is Hany Abu Assad's 2005 film *Paradise Now*. The first Palestinian feature film to deal directly with suicide attacks, *Paradise Now* explores the everyday lives of suicide bombers and the internal pressures they face in Palestinian society.

213

35 *The Shooter*, dir. Ihab Jadallah, Idioms Films, 2009.

36 Critchley, *On Humour* 68.

37 Nurith Gertz and George Khleifi, *Palestinian Cinema: Landscape, Trauma and Memory* (Bloomington: University of Indiana Press, 2008) 177.

38 It is however striking to note that all examples of humour centred on national signifiers have emerged at a time when statehood seems both unreachable (with the failure of the peace process) but also perhaps distantly recognisable (as evidence by the successful bid for UN non-member observer state status).

39 Karma Nabulsi, "Being Palestinian," *Government and Opposition* 38.4 (2003): 479.

40 Ibid, 479.

41 Ibid.

42 Bergson, *Laughter* 6.

43 Chris Taylor, "The Politics of Recognition," *Multiculturism: Examining the Politics of Recognition*, Chris Taylor ed., (New Jersey: Princeton University Press, 1994) 25.

44 Susan J. Brison, "Trauma Narratives and the Remaking of the Self," *Acts of Memory: Cultural Recall in the Present*, eds. Mieke Bal, Jonathan Crewe, Leo Spitzer (Hanover and London: University Press of New England, 1999) 40.

45 Majken Jul Sorenson, "Humour as a Serious Strategy of Nonviolent Resistance to Oppression," *Peace and Change* 33.2 (2008): 182.

46 Leon Rappoport, *Punchlines: The Case for Racial Ethnic & Gender Humor* (London: Praeger Publishers, 2005) 5. Rappoport points out in his text *Punchlines*, that discussion of ethnic humour is difficult because both terms, ethnicity and humour, are prone to ambiguity and particularly when they are combined.

47 Rather than focusing closely on the specificities of who is behind the humour, those responding to it and the context in which it shared, taking issue with 'racist' humour closes off the discussion of the potential benefits of humour charged by cultural difference. Although humour engaged with cultural difference does in some instances undoubtedly run the risk of creating serious offence and furthering prejudice, it can also be argued that once it is removed from the frame of 'racism' it may provide a window for social empowerment, understanding and solidarity.

48 Jerry Farber, "Toward a Theoretical Framework for the Study of Humor in Literature and the Other Arts," *Journal of Aesthetic Education* 41.3 (2007): 72. Farber's division of humour into these two categories is mirrored by the debate around ethnic humour that tends to separate manifestations of ethnic humour into those that encourage aggression and belittlement and those that motivate solidarity and understanding.

49 Michael Billig, "Comic Racism and Violence," *Beyond a Joke: The Limits of Humour*, Sharon Lockyer and Michael Pickering eds., (New York: Palgrave

Macmillan, 2005) 25. An expression we are all familiar with, 'just joking' tends to appear in tense situations where a laughter situation has been met with an icy reception, deemed inappropriate or offensive. The misdirection of an expression of humour makes for an awkward exchange and an accentuation of difference between those implicated in a social encounter.

50 Farber, "Toward a Theoretical Framework for the Study of Humor in Literature and the Other Arts," 72.

51 Jacqueline Bussie, *The Laughter of the Oppressed: Ethical and Theological Resistance in Wiesel, Morrison and Endo* (New York: T&T Clark International, 2007) 39.

52 Oring, *Engaging Humour* 49.

53 John Morreall, "Humor and the Conduct of Politics," *Beyond a Joke: The Limits of Humour*, eds. Lockyer and Pickering 67; Konrad Lorenz, *On Aggression* (New York: Bantam, 1963) 284.

54 Kevin Strohm, "When Anthropology Meets Contemporary Art: Notes for a Politics of Collaboration," *Collaborative Anthropologies* 5 (2012): 115.

55 Critchley, *On Humour* 65.

56 Kevin Strohm, "When Anthropology Meets Contemporary Art," 116.

57 Arie W. Kruglanski, Xiaoyan Chen, Mark Deshesne, Shira Fishman and Edward Orehek, "Fully Committed: Suicide Bombers' Motivation and the Quest for Personal Significance," *Political Psychology* 30.3 (2009) 336.

58 Edward Said, *The Politics of Dispossession: The Struggle for Palestinian Self-Determination, 1969–1994* (New York: Pantheon Books, 1994) xviii.

59 Critchley, *On Humour* 7.

60 Heike Munder, "Humour: The Secret of Aesthetic Sublimation," *When Humour Becomes Painful*, eds. Felicity Lunn, Heike Munder (Zurich: JRP Ringier, 2005) 16.

61 The struggle to bring the Picasso in the IAAP is captured in a documentary feature film by Rashid Masharawi named *Picasso in Palestine* (2012). The documentary chronicles all aspects of the project including insurance, the construction of a site-specific gallery, transport etc.

62 "Khaled Hourani, Director of the International Academy of Art Palestine: Interview with bankleer 2010," *Youtube*, 7 July 2010. 11 September 2012. < http://www.youtube.com/watch?v=5d4hyZEovvU>.

63 Michael Baers, "No Good Time for an Exhibition: Reflections on the Picasso in Palestine Project, Part I," *e-flux* 33 (2012) March 2012. 20 June 2012. < http://www.e-flux.com/journal/no-good-time-for-an-exhibition-reflections-on-the-picasso-in-palestine-project-part-i/>.

64 Charles Esche quoted in Michael Baers, "No Good Time for an Exhibition".

65 Heike Munder, "Humour: The Secret of Aesthetic Sublimation," 24.

Bibliography

Abdel Fattah, Mohamed. 'Arab Memory in the Palestinian Cinema.' *IslamOnline*. 1 June (2000). 5 June 2012. <http://www.islamonline.net/iol-english/dowalia /art-2000-june-01/art2.asp>.

Abu-Ghazaleh, Adnan. 'Arab Cultural Nationalism in Palestine During the British Mandate.' *Journal of Palestine Studies* 1.3 (1972): 37–63.

Abu Iyad. *My Home, My Land: A narrative of the Palestinian struggle*. Ed. Eric Rouleau. Trans. Linda Butler Koseoglu. New York: Times Books (1981).

Abu-Lughod, Ibrahim, et al. *The Palestinians: Profile of a people*. Canberra: Palestine Information Office (1987).

Abu-Lughod, Lila. 'Return to Half Ruins: Memory, Postmemory, and Living history in Palestine.' *Nakba: Palestine, 1948 and the Claims of Memory*. Eds. Lila Abu-Lughod and Ahmad H. Sa'di. New York: Columbia University Press (2007). 77–105.

Abunimah, Ali. *One Country: A bold proposal to end the Israeli-Palestinian impasse*. New York: Metropolitan Books (2006).

Abu-Remaileh, Refqa. 'Palestinian anti-narratives in the films of Elia Suleiman.' *Arab Media & Society* 5 (2008) 20 January 20 2013. <http://www.arabmediasociety .com/?article=670>.

Aburish, Said K. *Arafat: From Defender to Dictator*. London: Bloomsbury Publishing (1998).

Akram, Susan M. 'Myths and Realities of the Palestinian Refugee Problem: Reframing the Right of Return.' *International Law and the Israeli/Palestinian Conflict: A Rights-Based Approach to Mid East Peace*. Eds. Susan M. Akram, Michael Dumper, Michael Lynk and Iain Scobbie. New York: Routledge (2011). 13–44.

Alexander, Livia. 'On the Right to Dream, Love and be Free: An Interview with Michel Khleifi.' *Middle East Report* 201 (1996): 31–33.

Alexander, Neta. 'Cinema Verite.' *Haaretz Daily Newspaper* 15 June (2011). 10 September 2012. <http://www.haaretz.com/weekend/magazine/cinema-verite -1.373397>.

Allsop, Laura. 'Colourful Shadows and Reel Journeys: A Conversation Between Tarzan and Arab and Laura Allsop.' *Ibraaz*. 2 May (2012). 5 August 2012. <http://www.ibraaz.org/interviews/32>.

Amireh, Amal. 'Between Complicity and Subversion: Body Politics in Palestinian National Narrative.' *South Atlantic Quarterly* 102.4 (2003): 747–772.

Bibliography

Anderson, Benedict. *Imagined Communities*. London and New York: Verso (1991).

Andoni, Raed. dir. *Fix Me*. Rouge International (2010).

Ankori, Gannit. *Palestinian Art*. London: Reaktion Books (2006).

Antoni, Janine. 'Mona Hatoum.' *Bomb Magazine* 63 (1998).

Aouragh, Miriyam. *Palestine Online: Transnationalism, the Internet and the Construction of Identity*. London: I.B.Tauris & Co Ltd (2011).

Archer, Michael, and Guy Brett and Catherine de Zegher eds. *Mona Hatoum*. London: Phaidon Press (1996).

Arendt, Hannah. *On Revolution*. 1963. London: Penguin Classics (2006).

'Art Journal Legal Settlement.' *College Art Association*. 20 May (2012). <http://www.collegeart.org/ArtJournal/legal_settlement.php>.

Aruri, Naseer Hasan, ed. *The Palestinian Resistance to Israeli Occupation*. Willmette: Medina University Press International (1970).

Azoulay, Ariella. *From Palestine to Israel: A Photographic Record of Destruction and State Formation, 1947–1950*. Trans. Charles S. Karmen. London: Pluto Press (2009).

——. 'Getting Rid of the Distinction between Aesthetic and the Political.' *Theory, Culture and Society* 27.8 (2010) 239–262.

Baers, Michael. 'No Good Time for an Exhibition: Reflections on the Picasso in Palestine Project, Part I.' *e-flux*. 33 (2012) March 2012. 20 June 2012. < http://www.e-flux.com/journal/no-good-time-for-an-exhibition-reflections-on-the-picasso-in-palestine-project-part-i/>.

Bakhtin, Mikhail. *Rabelais and his World*. 1941. Trans. Helene Iswolsky. Bloomington: Indiana University Press (1993).

Balakian, Anna. 'Andre Breton as Philosopher.' *Yale French Studies* 31 (1964): 37–44.

Bardenstein, Carol. 'Trees Forests and the Shaping of Palestinian and Israeli Collective Memory.' *Acts of Memory: Cultural Recall in the Present*. Eds. Mieke Bal, Jonathan Crewe, Leo Spitzer. London: University Press of New England (1999). 148–168.

Batniji, Taysir. 'Re: Questions – Artist's input in Laughter in Occupied Palestine: Comedy and Identity in Art and Film.' Email to Chrisoula Lionis. 4 February (2015).

Baumbach, Nico. 'Jacques Rancière and the Fictional Capacity of Documentary.' *New Review of Film and Television Studies* 8.1 (2010): 57–72.

Bennett, Jill. *Empathic Vision: Affect, Trauma and Contemporary Art*. California: Stanford University Press (2005).

——. *Practical Aesthetics: Events, Affects and Art after 9/11*. London: & Co (2012).

Benvenisti, Meron *Sacred Landscape: The Buried Holy Land Since 1948*. Trans. Maxine Kaufman-Lacusta. Berkeley: University of California Press (2002).

Bergson, Henri. *Laughter: An Essay on the Meaning of the Comic*. CreateSpace (2011).

217

Bhabha, Homi K. *Nation and Narration*. London and New York: Routledge (1990).

Billig, Michael. 'Comic Racism and Violence'. *Beyond a Joke: The Limits of Humour*. Eds. Sharon Lockyer and Michael Pickering. New York: Palgrave MacMillan (2005). 25–44

———. *Laughter and Ridicule: Towards a Social Critique of Humour*. London: Sage Publications (2005).

Bittar, Doris. 'Crossing Boundaries – Artist Profile: Emily Jacir'. *Canvas Magazine*. 31 December (2008). August 12 2012. <http://dorisbittar.com/DB-03-Writings.html>.

Blainey, Geoffrey. *A Short History of the 20th Century*. London: Penguin Books 2005.

Bois, Yves-Alain, and Rosalind Krauss. 'A User's Guide to Entropy'. *October* 78 (1996): 38–88.

Boltanski, Luc. *Distant Suffering: Morality, Media and Politics*. Cambridge: Cambridge University Press (1999).

Boullata, Kamal. 'Artists Re-member Palestine in Beirut'. *Journal of Palestine Studies* 32.4 (2003): 22–38.

———. *Palestinian Art: From 1850 to the Present*. London, Saqi (2009).

———. 'Daoud Zalatimo and Jerusalem Painting During the Early Mandate'. *Jerusalem Quarterly* 44 (2010): 70–74.

Bourriaud, Nicholas. *Relational Aesthetics*. Paris: Les Presse du Reel (1998).

Boyle, Francis A. *Palestine, Palestinians and International Law*. Atlanta: Clarity Press (2003).

Bradley, Fiona. *Movements in Modern Art: Surrealism*. London: Tate Gallery Publishing (1997).

Bresheeth, Haim. 'Telling the Stories of Heim and Heimat, Home and Exile: Recent Palestinian Films and the Iconic Parable of the Invisible Palestine'. *New Cinema* 1.1 (2001): 24–39.

———. 'A Symphony of Absence: Borders and Liminality in Elia Suleiman's Chronicle of a Disappearance'. *Framework* 43.2 (2002): 71–84.

———. 'The Continuity of Trauma and Struggle: Recent Cinematic Representations of the Nakba'. *Nakba: Palestine, 1948 and the Claims of Memory*. Ed. Lila Abu-Lughod and Ahmad H. Sa'di. New York: Columbia University Press (2007). 161–187.

Breton, Andre. *Anthology of Black Humour*. 1966. Trans. Mark Polizzotti. San Francisco: City Lights Books (1997).

———. 'Lightening Rod'. *The Artist's Joke*. Ed. Jennifer Higgie. London: Whitechapel Gallery Ventures Limited (2007). 42–47.

Brett, Guy. 'Itinerary'. *Mona Hatoum*. Eds. Archer, Michael, and Guy Brett and Catherine de Zegher. London: Phaidon Press (1996). 34–87.

Brison, Susan J. 'Trauma Narratives and the Remaking of the Self'. *Acts of Memory: Cultural Recall in the Present*. Eds. Mieke Bal, Jonathan Crewe, Leo Spitzer. London: University Press of New England (1999). 39–54.

Bibliography

Brynan, Rex. 'The Politics of Exile: The Palestinians in Lebanon.' *Journal of Refugee Studies* 3.3 (1990): 204–227.

'Building a Legacy of Art in Palestine.' *This Week in Palestine* 106. August (2011). March 10th 2012. <http://www.thisweekinpalestine.com/details.php?id=3475&ed=197&edid=197>.

Bussie, Jacqueline. *The Laughter of the Oppressed: Ethical and Theological Resistance in Wiesel, Morrison and Endo*. New York: T&T Clark International (2007).

Cappelli, Stefano. "Piero Manzoni's Lines," *Piero Manzoni*. 15th April (2012). <http://www.pieromanzoni.org/PDF/EN/Manzoni_Lines.pdf>.

Collins II, James E. and Wyer Jr, Robert S. 'A Theory of Humor Elicitation.' *Psychological Review* 99.4 (1992): 663–688.

Critchley, Simon. *On Humour: Thinking in Action*. London: Routledge (2002).

Čvoro, Uroš. 'Beyond the Last Laugh.' *Beyond the Last Sky: Contemporary Palestinian Photography and Video*. Ed. Chrisoula Lionis. Sydney: The Australian Centre for Photography (2012). 28–31.

Dabashi, Hamid. 'In Praise of Frivolity: On the Cinema of Elia Suleiman.' Ed. Hamid Dabashi. *Dreams of a Nation: On Palestinian Cinema*. London: Verso (2006). 131–162.

Darwish, Mahmoud. *Sand and Other Poems*. Trans. Rana Kabbani. New York: Routledge (1986).

Davies, Christie. *Ethnic Humour Around the World: A Comparative Analysis*. Bloomington: Indiana University Press (1996).

———. 'Humour is not a Strategy in War.' *Journal of European Studies* 31 (2001): 395–412.

De Cesari, Chiara. 'Anticipatory Representation: Building the Palestinian Nation(-State) through Artistic Performance.' *Studies in Ethnicity and Nationalism* 2.1 (2012): 82–100.

Demos, T.J. 'The Right to Opacity: On the Otolith Group's Nervus Rerum.' *October* 129 (2009): 113–129.

Dodd, Philip. 'Homelands.' *Sight and Sound* 1.10 (1992): 18–21.

Dowty, Alan. *Israel/Palestine*. Massachusetts: Polity Press (2005).

Drabinski, John E. 'Separation, Difference and Time in Godard's Ici et Alliuers.' *SubStance* 37.1 (2008): 148–158.

El Khalidi, Leila. *The Art of Palestinian Embroidery*. London: Saqi Books (1999).

Ellis, Marc H. and Daniel McGowan eds. *Remembering Deir Yassin: The Future of Israel and Palestine*. New York: Olive Branch Press (1998).

El Shakry. 'A Conversation with Gil Hochberg on 'Queer Politics and the Question of Palestine'.' *Newsletter for the UCLA Centre for the Study of Women*. April 4 (2009). June 10 2012. <http://escholarship.org/uc/item.1pm3p9d1>.

Esmeir, Samera. 'Memories of Conquest: Witnessing Death in Tantura.' *Nakba: Palestine, 1948 and the Claims of Memory*. Eds. Lila Abu-Lughod and Ahmad H. Sa'di. New York: Columbia University Press (2007). 229–250.

219

'Exiled and Suffering: Palestinian Refugees in Lebanon.' *Amnesty International Annual Report 2012 June 8 (2012)*. <http://www.amnesty.org/en/library/asset/MDE18/010/2007/en/35eba2ba-d367-11dd-a329-2f46302a8cc6/mde180102007en.html>.

Fanon, Frantz. *The Wretched of the Earth*. 1961. Trans. Constance Farrington. New York: Grove Press (1995).

Farber, Jerry. 'Toward a Theoretical Framework for the Study of Humour in Literature and Other Arts.' *Journal of Aesthetic Education* 41.3 (2007: 67–86).

'Film Bleeding Memories.' *Film Crew Pro.* 14 February (2011). <http://www.filmcrewpro.com/uk/film_view.php?uid=9738>.

Finkelstein, Norman. *Image and Reality of the Israel-Palestine Conflict*. New York: Verso (2003).

Finlain, Alistair. *Essential Histories: The Gulf War 1991*. New York: Routledge (2003).

Freud, Sigmund, *Jokes and Their Relation to the Unconscious*. Ed. J Strachey. New York: W.W Norton & Company (1989).

Frosh, Tahel. 'Palestinian Artist Accuses Israeli Professor of "Colonizing" his Ideas.' *Haaretz* 13 August (2008). 20 May 2012. <http://www.haaretz.com/culture/arts-leisure/palestinian-artist-accuses-israeli-professor-of-colonizing-his-ideas-1.251612>.

Gabsi, Wafa 'Fiction and Art Practice: Interview with Larissa Sansour "A Space Exodus".' *Contemporary Practices* 10 (2012) <http:contemporarypractices.net>.

Gerber, Haim. *Remembering and Imagining Palestine: Identity and Nationalism from the Crusades to the Present*. New York: Palgrave Macmillan (2008).

Gertz, Nurith, and George Khleifi. *Palestinian Cinema: Landscape, Trauma, and Memory*. Bloomington: Indiana University Press (2008).

Gilbert, Joanne R. *Performing Marginality: Humor, Gender and Cultural Critique*. Detroit: Wayne State University Press (2004).

Glazer, Steven. 'The Palestinian Exodus in 1948.' *Journal of Palestine Studies* 9.4 (1980): 96–118.

Gleeson, Regina. 'Dislocate, Renegotiate and Flow: Globalisation's Impact on Art Practice.' *Circa* 107 (2004): 67–70.

Godard, Jean Luc. dir. *Notre Musique*. Avventura Films (2004).

Gogolak, Emily. 'Khaled Jarrar Stamps His Authority.' *Rolling Stone*. 5 February (2012). 27 January 2013. <http://www.rollingstoneme.com/index.php?option=com_content&view=article&id=1145>.

Gordon, Neve. *Israel's Occupation*. Los Angeles: University of California Press (2008).

Guigliano, Dario. 'A(hi)story pour les analphabetes – of Larissa Sansour's video.' *Third Text* 25.3 (2011): 301–309.

Hafez, Sabrey. 'The Quest for/Obsession with the National in Arabic Cinema.' *Theorising National Cinema*. Eds. Valentina Vitali and Paul Willeman. London: Palgrave Macmillan (2008). 226–253.

Halaby, Samia. *Liberation Art of Palestine: Palestinian Painting and Drawing of the Second Half of the 20th Century*. New York, H.T.T.B Publications (2001).

Handal, Nathalie, and Elia Suleiman. 'The Other Face of Silence.' *Guernica Mag.* 1 May (2011). 10 January 2013. <http://www.guernicamag.com/interviews/suleiman_5_1_11/>.

Harms, Gregory, and Todd M Ferry. *The Palestine-Israel Conflict: A Basic Introduction*. London: Pluto Press (2008).

Hasso, Frances. 'Modernity and Gender in Arab Accounts of the 1948 and 1967 Defeats.' *International Journal of Middle Eastern Studies* 32 (2000): 491–510.

Hatoum, Mona. 'Re: Image and Image Permission – Mona Hatoum Socle du Monde.' Email to Chrisoula Lionis. 20 March (2015).

Haynes, Doug. 'The Persistence of Irony: Interfering with Surrealist Black Humour.' *Textual Practice* 21.1 (2006): 25–47.

Herzl, Theodor. *The Jewish State*. New York: Dover Publications (1989).

Hirsch, Marianne. *Family Frames: Photography, Narrative and Postmemory*. Massachusetts: Harvard University Press (1997).

Hirst, David. *The Gun and the Olive Branch: The Roots of Violence in the Middle East*. New York: Nation Books (2004).

Hobbes, Thomas. *Oxford World Classics: Human Nature and DeCopore Politico*. Ed. J.C.A Gaskin. Oxford: Oxford University Press (1994).

Hopkins, David. *Dada and Surrealism: A Very Short Introduction*. New York: Oxford University Press (2004).

Horton, Andrew, ed. *Comedy, Cinema, Theory*. Berkley: University of California Press (1991).

'Ismail Shammout.' *The Palestine Poster Project*, 20 May (2012). <http://www.palestineposterproject.org/artist/ismail-shammout>.

Issa, Rose, ed. *Raeda Saadeh: Reframing Palestine*. London: Beyond Art Production (2012).

Jadallah, Ihab. dir. *The Shooter*. Idioms Films (2009).

Judt, Tony. Foreward. *From Oslo to Iraq and the Roadmap*. Edward W. Said. (London: Bloomsbury Publishing, 2005) vii–xxi.

Kanaana, Sharif. *Struggling for Survival: Essays in Palestinian Folklore and Folklife*. Al-Bireh: Society of Ina'ash El-Usra (2005).

Kapeliouk, Amnon. *Sabra and Shatila: Inquiry into a Massacre*. Ed. and trans. Khalil Jahshan. Belmont Massachusetts: Association of Arab-American Graduates (1984).

Karmi, Ghada. 'Israel's Dilemma in Palestine: The Process, the failure and the prospect for a just and workable solution.' *Sydney Ideas – International Public Lecture Series*. Public Lecture, The University of Sydney, 9 October (2007).

Kelsey, John, and Carnevale, Fulvia. 'Art of the Possible.' *Artforum* 45.7 (2007): 259–269.

Kennedy, Tim. 'Wedding in Galilee (Urs al-Jalil).' *Film Quarterly* 59.4 (2006): 40–46.

Khader, Hassan. 'A Quest for Normalcy.' *Subjective Atlas of Palestine*. Ed. Annelys de Vat. Rotterdam: 010 Publishers (2007). 7–9.

"Khaled Hourani, Director of the International Academy of Art Palestine: Interview with bankleer 2010." *Youtube*. 7 July (2010). 11 September 2012. < http://www .youtube.com/watch?v=5d4hyZEovvU>.

Khalidi, Rashid. 'The Resolutions of the 19th Palestine National Council.' *Journal of Palestine Studies* 19.2 (1990): 29–42.

———. *Palestinian Identity: The Construction of Modern National Consciousness*. New York: Columbia University Press (1997).

———. *The Iron Cage: The Story of the Palestinian Struggle for Statehood*. Boston: Beacon Press (2006).

Khalili, Yazan. 'Regarding the Pain of Oneself.' *Beyond the Last Sky: Contemporary Palestinian Photography and Video*. Ed. Chrisoula Lionis. Sydney: Australian Centre for Photography (2012). 24–27.

Khatib, Lina. *Filming in the Middle East: Politics in the Cinemas of Hollywood and the Arab World*. London: I.B.Tauris & Co (2006).

Khleifi, Michel. 'From Reality to Fiction – From Poverty to Expression.' *Dreams of a Nation: On Palestinian Cinema*. Ed. Hamid Dabashi. London: Verso (2006). 45–57.

Kholeif, Omar. 'Political Form and Content.' *Contemporary Visual Art+Culture Broadsheet* 42.1 (2013): 64–65.

Khoury, Raed, and Leena Odgaard. 'Palestinian Artist Shows Human Side of the Struggle.' *The Pulse of the Middle East*. 26 September (2012). 20 January 2013. <http:// www.al-monitor.com/pulse/originals/2012/al-monitor/palestinian-artist -shows-human-s.html>.

King, Geoff. *Film Comedy*. London: Wallflower Press (2002).

Kinser, Samuel. 'Chronotypes and Catastrophes: The Cultural History of Mikhail Bakhtin.' *The Journal of Modern History* 56.2 (1984): 301–310.

Kishtainy, Khalid. *Arab Political Humour*. London: Quartet Books (1985).

Kitchtaforitch, Igor. *Humor Theory: Formula of Laughter*. Denver: Outskirts Press (2006).

Klein, Sheri. *Art and Laughter*. London: I.B.Tauris & Co Ltd (2007).

Kristeva, Julia. *Hannah Arendt*. Trans. Ross Guberman. New York: Columbia University Press (2001).

Kruglanski, Arie W. et al. 'Fully Committed: Suicide Bombers' Motivation and the Quest for Personal Significance.' *Political Psychology* 30.3 (2009): 331–357.

La Forge, Benjamin. 'Comedy's Intention.' *Philosophy and Literature* 28.1 (2004): 118–136.

Laidi-Hanieh, Adila. 'Palestinian Landscape Photography: Dissonant Paradigm and Challenge to Visual Control.' *Contemporary Practices* 5 (2009): 118–123.

Lionis, Chrisoula. *Beyond the Last Sky: Contemporary Palestinian Photography and Video*. Sydney: The Australian Centre for Photography (2012).

———. 'A Past Not Yet Passed: Postmemory in the Work of Mona Hatoum.' *Social Text* 32.2 (2014): 77–93.

Lockyer, Sharon, and Michael Pickering, Eds. *Beyond a Joke: The Limits of Humour.* New York: Palgrave MacMillan (2005).

Lorenz, Konrad. *On Agression.* New York: Bantam (1963).

Loshitzky, Yosefa. 'The Text of the Other, The Other in the Text: The Palestinian Delegation's Address to the Madrid Middle East Peace Conference.' *Journal of Communication Inquiry* 18.1 (1994): 27–44.

Lustruck, Ian S. 'The Oslo Agreement as an Obstacle to Peace.' *Journal of Palestine Studies* 27.1 (1997): 61–66.

Malhi-Sherwell, Tina. 'Imaging Palestine as the Motherland.' *Self-Portrait Palestinian Women's Art.* Eds. Tal Ben Zvi and Yael Lerer (Israel: Andalus Publishing, 2001): 166–176.

Mannes-Abbott, Guy. *In Ramallah, Running.* London: Black Dog Publishing (2012).

Masalha, Nur-eldeen. 'On Recent Hebrew and Israeli Sources for the Palestinian Exodus, 1947–1949.' *Journal of Palestine Studies* 18.1 (1988): 121–137.

Masharawi, Rashid. dir. *Waiting.* Silk Road Production (2006).

Massad, Joseph. 'Permission to Paint: Palestinian Art and the Colonial Encounter.' *Art Journal* 66.3 (2007): 126–133.

Matar, Dina. *What it Means to be Palestinian: Stories of Palestinian Peoplehood.* New York: Palgrave Macmillan (2011).

McGowan, Daniel. 'Deir Yassin Remembered.' *Remembering Deir Yassin: The Future of Israel and Palestine.* Eds. Mark H. Ellis and Daniel McGowan. New York: Olive Branch Press (1998). 3–9.

McNeill, David. 'Planet Art: Resistance and Affirmation in the Wake of 9/11.' *Australia and New Zealand Journal of Art* 3.2 (2002): 11–32.

Mdanat, Adnan. *History of the Speaking Arab Film.* Cairo: United Arab Artists/ Cairo Film Festival (1993).

Meghdissian, Samira. 'The Discourse of Oppression as Expressed in Writings of the Intifada.' *World Literature Today* 72.1 (1998): 39–48.

Mestman, Mariano. 'Third Cinema/Militant Cinema: At the Origins of the Argentinian Experience (1869–1971).' *Third Text* 25.1 (2011): 29–40.

Mikdadi, Salwa, ed. *Palestine c/o Venice.* Beirut: Mind the Gap (2009).

Mirzoeff, Nicholas. *An Introduction to Visual Culture.* New York: Routledge, 2009.

Morreall, John. *The Philosophy of Laughter and Humor.* New York: State University of New York Press (1987).

——. 'Humour and the Conduct of Politics.' *Beyond a Joke: The Limits of Humour.* Eds. Sharon Lockyer and Michael Pickering. New York: Palgrave MacMillan (2005). 63–78.

Morris, Benny. 'The Historiography of Deir Yassin.' *The Journal of Israeli History* 24.1 (2005): 79–107.

Mosely Lesch, Anne. 'Contrasting Reactions to the Persian Gulf Crises: Egypt, Syria, Jordan and the Palestinians.' *Middle East Journal* 45.1 (1991): 30–50.

Muhawi, Ibrahim, and Sharif Kanaana. *Speak Bird, Speak Again: Palestinian Arab Folktales*. London: University of California Press (1989).

Munayyer, Hanan Karaman. *Traditional Palestinian Costume: Origins and Evolution*. Northhampton: Interlink Pub Group (2011).

Munder, Heike. 'Humour: The Secret of Aesthetic Sublimation.' *When Humour Becomes Painful* Eds. Felicity Lunn and Heike Munder. Zurich: JRP Ringier (2005). 12–25.

Murphy, Jay. 'The Intifadah and the work of Palestinian artists.' *Third Text* 4.11 (1990): 119–126.

Murphy, Maureen Clare. 'Palestinian Artist Khaled Jarrar Wants to Stamp Your Passport.' *Electonic Intifada*. 21 July (2011). 28 January 2012. < http://electronicintifada.net/blogs/maureen-clare-murphy/palestinian-artist-khaled-jarrar -wants-stamp-your-passport>.

Murray, Kristen A. '"Burn, Bury or Dump": Black Humour in the Late Twentieth Century', PhD Diss. The University of New South Wales (2007).

"Museum of Contemporary Art – Palestine (CAMP)." *Al Ma'mal Foundation*. June 15 2015. <http://www.almamalfoundation.org/about/camp>.

Nabulsi, Karma. 'Being Palestinian.' *Government and Opposition* 38.4 (2003): 479–496.

Naficy, Hamid. *An Accented Cinema: Exilic and Diasporic Filmmaking*. Princeton: Princeton University Press (2001).

Najjar, Orayb Aref. "Cartoons as a Site for the Construction of Palestinian Refugee Identity: An Exploratory Study of Cartoonist Naji al-Ali." *The Journal of Communication Inquiry* 31 (2007): 255–285.

Omari, Areen. 'Re: Questions: First Lesson – Artist's interview questions for book manuscript.' Email to Chrisoula Lionis. 8 February (2015).

Oren, Michael B. *Six Days of War: June 1967 and the Making of the Modern Middle East*. New York: Ballantine Books (2002).

Oring, Elliot. *Engaging Humor*. Chicago: University of Illinois (2003).

——. *Jokes and Their Relations*. New Jersey: Transaction Publishers (2010).

'Palestinian Filmmaker Shows Refugee's Agony of Waiting.' *Miftah*. 7 September (2005). 6 August 2012. <http://www.miftah.org/PrinterF.cfm?DocId=8397>.

Palestinian Museum. 29 January (2013). <http://thepalestinianmuseum.org>.

Pappe, Ilan. *A History of Modern Palestine: One Land Two Peoples*. 2004. Cambridge: Cambridge University Press (2006).

Pickering, Michael, and Sharon Lockyer. 'The Ethics and Aesthetics of Humour and Comedy.' *Beyond a Joke: The Limits of Humour*. Eds. Sharon Lockyer and Michael Pickering. New York: Palgrave MacMillan (2005). 1–24.

Pisters, Patricia. 'Violence and Laughter: Paradoxes of Nomadic Thought in Postcolonial Cinema.' *Deleuze and the Postcolonial*. Eds. Simone Bignall and Paul Patton. Edinburgh: Edinburgh University Press (2010). 201–219.

224

Bibliography

Punamaki, Raija-Leena. et al. 'The Role of Psychological Defences in Moderating Between Trauma and Post-Traumatic Symptoms Amongst Palestinian Men.' *International Journal of Psychology* 37.5 (2002): 286–296.

Rahman, Najat. '"Laughter that Encounters a Void": Humor, Loss and the Possibility for Politics in Recent Palestinian Cinema.' *Storytelling in World Cinemas*. Ed. Lina Khattib. New York: Columbia University Press (2012).

Rappoport, Leon. *Punchlines: The Case for Racial Ethnic & Gender Humor*. London: Praeger Publishers (2005).

Ricci, Francesca. 'True Tales. Fairy Tales.' *Raeda Saadeh: Reframing Palestine*. Ed. Rose Issa London: Beyond Art Production (2012).

Rosen, Jay. 'Making Journalism More Public.' *Communication* 12.4 (1991): 267–284.

Rousselot, Vanessa. dir. *(No) Laughing Matter*. eO Productions (2010).

Roy, Sara. 'Why Peace Failed: An Oslo Autopsy.' *Current History* 100.651 (2002): 8–16.

Rumbaut, Ruben. 'Ages, Life Stages and Generational Cohorts: Decomposing the Immigrant First and Second Generations in the United States.' *International Migration Review* 38.3 (2004): 1160–1205.

Sacco, Joe. Introduction. *A Child in Palestine: The Cartoons of Naji al-Ali*. London: Verso (2009). ii–ix.

Said, Edward W. *The Politics of Dispossession: The Struggle for Palestinian Self-Determination, 1969–1994*. New York: Pantheon Books (1994).

——. 'Invention, Memory and Place.' *Critical Inquiry* 26. 2 (2000): 175–192.

——. *Reflections on Exile and Other Essays (Convergences: Inventories of the Present)*. Cambridge MA: Harvard University Press (2002).

——. 'Emily Jacir – 'Where We Come From.' *Emily Jacir – Belongings*. Eds. Christian Kravagna. et al. Vienna: O.K Books (2003). 46–59.

——. *From Oslo to Iraq and the Roadmap*. London: Bloomsbury Publishing 2005.

Sand, Shlomo. *The Invention of the Land of Israel: From Holy Land to Home Land*. Trans. Geremy Forman. London: Verso (2012).

Sansour, Larissa. 'Lacoste: No Room for Palestinian Artist.' Email to Chrisoula Lionis. 20 December (2011).

——. 'Nation Estate.' *Ibraaz*. 2 November 2012. 25 November 2012. <http://www.ibraaz.org/projects/32>.

——. 'Re: Image – Book Manuscript.' Email to Chrisoula Lionis. 6 February (2015).

Sayigh, Rosemary. *Palestinians: From Peasants to Revolutionaries*. London: Zed Press (1979).

——. 'Palestinian Camp Women as Tellers of History.' *Journal of Palestine Studies* 27.2 (1998): 42–58.

Sayigh, Yezid. 'Struggle within, Struggle without: The Transformation of PLO Politics Since 1982.' *International Affairs* 65.2 (1989): 247–271.

——. *Armed Struggle and the Search for State: The Palestinian National Movement 1949–1993.* New York: Oxford University Press (1997).

——. 'Armed Struggle and State Formation.' *Journal of Palestine Studies* 26.4 (1997): 17–32.

Schneer, Jonathon. *The Balfour Declaration: The Origins of the Arab-Israeli Conflict.* London: Bloomsbury Publishing (2010).

Shafik, Viola. *Arab Cinema: History and Cultural Identity.* Cairo: The American University Cairo Press (2007).

Shahid, Leila. 'The Sabra and Shatila Massacres: Eye-Witness Reports.' *Journal of Palestine Studies* 32.1 (2002): 36–58.

Shear, Coleman E. 'Landes Discusses Pallywood Theory.' *The Dartmouth Review.* 17 December (2010). 30 August 2012. < http://dartreview.com/features-page/ 2010/12/17/landes-discusses-pallywood-theory.html>.

Sherwell, Tina. 'Topographies of Identity, Soliloquies of Place.' *Third Text* 20.4 (2006): 429–443.

Shohat, Ella. 'Wedding in Galilee.' *Middle East Report* 154 (1988): 44–46.

Shomali, Amer. 'Re: Questions – Book manuscript – Laughter in Occupied Palestine: Comedy and Identity in Art and Film.' Email to Chrisoula Lionis. 4 February (2015).

Slyomovics, Susan. "The Rape of Qula." *Nakba: Palestine, 1948 and the Claims of Memory.* Eds. Lila Abu-Lughod and Ahmad H. Saʿdi. New York: Columbia University Press (2007). 27–52.

Smith, Anthony D. *Nationalism and Modernism.* London: Routledge (1998).

Smith, Dan. *The State of the Middle East: An Atlas of Conflict and Resolution.* London: Earthscan (2006).

Soltis, Andy. "W.Banky Panky in Personal Ads Blitz." *New York Post.* 12 February (2002): 5.

Sorenson, Majken Jul. 'Humour as a Serious Strategy of Nonviolent Resistance to Oppression.' *Peace and Change* 33.2 (2008): 167–190.

Spitzer, Leon. 'Back Through the Future: Nostalgic Memory and Critical Memory in a Refuge from Nazism.' *Acts of Memory: Cultural Recall in the Present.* Eds. Mieke Bal, Jonathan Crewe, Leo Spitzer. London: University Press of New England (1998). 87–104

Stallybrass, Peter, and Allon White. *Politics and Poetics of Transgression.* New York: Cornell University Press (1986).

'State of Palestine Stamping Action.' *FotoGallerieT.* 27 January (2013). <http:// fotogalleriet.no/Nyheter%20og%20prosjekter/state-of-palestine-passport -stamping-action>.

Steward Heon, Laura, Ed. *Mona Hatoum: Domestic Disturbance.* North Adams: Storey Books (2001).

Strohm, Kiven. 'When Anthropology Meets Contemporary Art: Notes for a Politics of Collaboration.' *Collaborative Anthropologies* 5 (2012): 98–124.

Bibliography

'Subjective Atlas of Palestine: Asserting the Right to Narrate.' *Arena of Speculation.* 28 May (2011). 20 June 2012. <http://arenaofspeculation.org/2011/05/28 /subjective-atlas-of-palestine/>.

'Survivor's Accounts.' *Deir Yassin Remembered.* 20 January (2011). <http://www. deiryassin.org/survivors.html>.

Tawil, Helga. 'Coming Into Being and Flowing Into Exile: History and Trends in Palestinian Film-Making.' *Nebula* 2:2 (2005): 113–140.

Taylor, Chris. 'The Politics of Recognition.' *Multiculturalism: Examining the Politics of Recognition.* Eds. Chris Taylor and Amy Gutman. New Jersey: Princeton University Press (1994). 25–74.

Telhami, Shibley. 'Arab Opinion and the Gulf War.' *Political Science Quarterly* 108.3 (1993): 437–452.

Telmissany, May. 'Displacement and Memory: Visual Narratives of al-Shatat in Michel Khleifi's Films.' *Comparative Studies of South Asia, Africa and the Middle East* 30.1 (2010): 69–84.

Terrill, W. Andrew. 'The Political Mythology of the Battle of Karameh.' *Middle East Journal* 55.1 (2001): 91–111.

Tiedemann, Rolf, Ed. *Can One Live After Auschwitz: A Philosophical Reader. Theodor Adorno.* Stanford: Stanford University Press (2003).

Tineh, Yasir (Oregano&OliveOil). 'Your love is harder to define than Israeli borders.' 30 March (2012). Tweet.

Tzimmerman, Moshe. *Signs of Cinema: The History of the Israeli Film Between 1896 and 1948.* Tel Aviv: Dyonon/Tel Aviv University (2001).

Virno, Paolo. *Multitude: Between Innovation and Negation.* Los Angeles: Semiotext(e) (2008).

United Nations. 'Security Council Resolutions – 1967.' 12 July (2012). <http://www .un.org/documents/sc/res/1967/scres67.htm>.

United Nations. 'Security Council Resolutions.' 30 September (2011). <http://www .un.org/documents/scres.htm>.

Wallach, Yair. 'Creating a country through currency and stamps: state symbols and nation-building in British-ruled Palestine.' *Nations and Nationalism* 17.1 (2011): 129–147.

Wasserstein, Bernard. *Israel and Palestine: Why They Fight and Can They Stop?* London: Profile Books (2008).

Webman, Esther. 'The Evolution of a Founding Myth: The Nakba and Its Fluctuating Meaning.' *Palestinian Collective Memory and National Identity.* Ed. Meir Litvak. New York: Palgrave Macmillan (2009). 27–64.

Young, Mark Geoffrey. *The Best Ever Book of Palestinian Jokes: Lots and Lots of Jokes Specially Repurposed for You-Know-Who.* CreateSpace Independent Publishing Platform (2012).

Yuval-Davis, Nira, and Uri Davis and Andrew Mack, Eds. *Israel and the Arabs.* London: Ithaca Press (1975).

Žižek, Slavoj. 'Neighbours and Other Monsters.' *The Neighbour: Three Inquiries in Political Theology.* Eds. Eric L. Stanter, Kenneth Reinhard and Slavoj Žižek. Chicago: Chicago University Press (2006). 134–164.

Zupančič, Alenka. *The Odd One In: On Comedy.* Massachusetts: MIT Press 2008.

'#12 by Khaled Jarrar.' *Truth is Concrete.* 27 January (2013). <http://truthisconcrete .org/graphic-project/15--12-by-khaled-jarrar.php>

Index

Index

Yaqubi, Mohanad, 195 n.79

Zalatimo, Daoud, 24
Zionism, 21–23
Zionists, 26, 52, 64, 88, 182

forces, 33, 55, 60, 191 n.26,
198 n.22 *see also*
Zionism
Žižek, Slavoj, 93, 147
Zupančič, Alenka, 139, 166

www.ingramcontent.com/pod-product-compliance
Lightning Source LLC
Chambersburg PA
CBHW050420280326
41932CB00013BA/1933